"Paulson's two magisterial volumes . . . demand notice here simply because they so brilliantly achieve, through the study of a single artist, the blending of art, history, and general culture that must stand as an exemplar for future work. In pursuit of Hogarth, Paulson takes us to Walpole's Parliament, to *Tristram Shandy,* to Garrick, Fielding, Addison and Steele, to society's strolling places and hospital routines, to popular songs, black magic, and newspapers. It is a dazzling journey through Augustan London, illuminated by an erudition which, although lightly carried, establishes irrefutably the interdependence of social, political, literary, and artistic themes. The richness of Hogarth's creativity and life has at last received its due."—*Journal of Interdisciplinary History*

"This book is, above all, an extremely serious work, aiming at and achieving a sound and balanced account of Hogarth's life and times. It has already become, and will remain probably indefinitely, the standard 'Life'."
—*Burlington Magazine*

"Mr. Paulson has carefully and lovingly traced the career of this artist, who began as a humble engraver of silver plate and designer of plates for booksellers, to become one of England's great celebrities, whose fame was eclipsed only by that of the more worldly Sir Joshua Reynolds. This monograph is the result of many years of hard work and, in its solidity and thoroughness, is not likely to be superseded soon by any book on the Master."—*American Artist*

Hogarth: His Life, Art, and Times

ABRIDGED EDITION

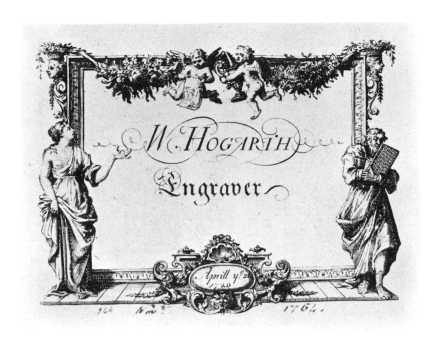

Hogarth: *His Life, Art, and Times*

RONALD PAULSON

Abridged by Anne Wilde

Yale University Press, New Haven and London

1974

Copyright © 1971 by Yale University.
Abridged edition copyright © 1974 by Yale University.
All rights reserved. This book may not be
reproduced, in whole or in part, in any form
(except by reviewers for the public press),
without written permission from the publishers.
Library of Congress catalog card number: 73–91338.
International standard book number: 0–300–01766–9 (cloth)

0–300–01763–4 (paper)

Designed by John O. C. McCrillis
and set in Baskerville type.
Printed in the United States of America by
Connecticut Printers, Inc., Hartford, Conn.

Published in Great Britain, Europe, and Africa by
Yale University Press, Ltd., London.
Distributed in Latin America by Kaiman & Polon,
Inc., New York City; in Australasia and Southeast
Asia by John Wiley & Sons Australasia Pty. Ltd.,
Sydney; in India by UBS Publishers' Distributors Pvt.,
Ltd., Delhi; in Japan by John Weatherhill, Inc., Tokyo.

Contents

Plates

Photographs have been supplied by the following: W. S. Lewis Collection, 15, 60, 83, 96, 97, 101, 102. Courtauld Institute of Art, 16, 19. Paul Mellon Centre for Studies in British Art, 17, 23, 24, 25, 26, 37, 61, 62, 93, 116. Stearn and Sons, 18. National Maritime Museum, 20,

76. Philadelphia Museum of Art, 21. Annan, Glasgow, 39. Sir John Soane's Museum, 41–48, 103–06. Frick Collection, 149. St. Bartholomew's Hospital, 140. Tate Gallery, 63, 66, 74, 75, 79, 92, 114, 119. R. B. Fleming, 64. National Portrait Gallery, 65, 117. National Gallery, London, 68–73, 115. Charles Woolf, 78. Sydney W. Newbery, 80. Foundling Hospital, London, 82, 83. St. Mary Redcliffe, Bristol, 109–11. A. C. Cooper, Ltd., 112. Beaverbrook Art Gallery, New Brunswick, 113. Birmingham Art Gallery, 118. New York Public Library, 123. John R. Freeman & Company photographed all the British Museum and Royal Collection prints and drawings.

Preface

The purpose of this abridgment is to provide a reliable introduction to the career of William Hogarth, without the immense and sometimes unwieldy detail of the total two-volume work, *Hogarth: His Life, Art, and Times* (1971). The general narrative flow has been retained, and little has been lost of the essential life. Much of the surrounding flora and fauna has had to go, and with it the analysis of Hogarth's art. Perhaps this abridgment should be called "Hogarth: The Life," omitting the other categories. The abridgment has been carried out within these criteria with great skill and care by Anne Wilde.

The student interested in annotation may refer to the unabridged version. But I might remark that the quotations from Hogarth are taken from his unpublished manuscripts in the British Museum, which have been edited by Joseph Burke ("Autobiographical Notes" in his edition of *The Analysis of Beauty*, Oxford, 1955) and Michael Kitson ("Hogarth's 'Apology for Painters,' " Walpole Society, XVI, Oxford, 1968). The movements of the Hogarths are documented in their parish baptismal records and rate books, many of them in the Guildhall Library. The other main printed sources used are listed at the end of the text.

I should like to repeat my thanks to the Paul Mellon Centre for the Study of British Art which made possible the research and publication of the original two-volume work.

R. P.

Baltimore
1973

1

The Range of Possibilities
1697—1720

Richard Hogarth, the painter's father, was born on 24 January 1663 or 1664 somewhere in the north country, quite possibly in the Vale of Bampton in central Westmorland. In one way or another, apparently without attending more than a good local grammar school, he acquired a solid grounding in Latin and Greek and set up a school of his own. Rising out of a family of farmers or shepherds to be a schoolmaster, he must have seen himself as a self-made man with a future. About 1686 he made the trip to London, attended in all probability by his friend (and presumably student) Thomas Noble and by Edmund Gibson, both of the Bampton area. Noble and Gibson traveled south to become students at Oxford, and in the latter case to begin a brilliant scholarly and ecclesiastical career ending as Bishop of London. Richard Hogarth went south to earn a living, make a name for himself, and begin the long downward course to failure, debtor's prison, obscurity, and death.

The earliest trace of his presence in London is a little textbook published in May 1689. *Thesaurarium trilingue publicum: Being an introduction to English, Latin and Greek.* In 1690 he was a lodger in a house in Bartholomew Close, just off Smithfield Market, occupied by John Gibbons and his wife Anne, who had themselves moved in only within the last year. The house was located in the close to the right of the passage to Middlesex Court, one of a row of dark and shadowy timber, lath, and plaster houses, probably in no very good condition, having escaped the fire of 1666 and therefore the opportunity of rebuilding. It was in this house, some seven years later, that William Hogarth the painter would be born.

John Gibbons had a family of at least nine children, but by the time

he settled in the house in Bartholomew Close only three still remained at home: there were two daughters, Anne, then a spinsterish twenty-nine; Mary, sixteen; and a son, John, who was fourteen and soon to be apprenticed. Besides these, the tax assessor listed "Mr Hogath [sic] Lodger" and a maid. All that now remains of the Gibbons family is their Bible, which survives because it passed through Anne Gibbons' hands to her son, William Hogarth, and bears his marks as well as his grandparents'. It is a worn, squat little volume, a King James version with Book of Common Prayer and Sternhold-Hopkins Psalms, and is manifestly a family Bible, much handled. Here it is recorded that Anne Gibbons was baptized 10 November 1661, and that "november 4 1690 richard hogarth took to wife anne dagtur of John Gibbons and of Anne his wife."

Although the act is noteworthy in view of William's parallel situation forty years later, it is not surprising that a lone stranger in the bosom of a householding family should fall in love with one of the daughters and create a place for himself in the family. Richard chose the elder daughter Anne, three years his senior, and probably (to judge by her age) either her father's chief assistant in his business or the family housekeeper. Love aside, it is easy to imagine them drawn together by mutual need. She was a strong-willed woman, and at a later time she supported the whole family by her own efforts; she possessed family and security but, at age twenty-nine, no husband.

Four children were born to the Hogarths. The first, John, was baptized 23 August 1691 and died 3 September (the spelling, Hoggard); Elizabeth Hoggard was baptized 3 September 1692 and died 20 January of the following year; Anne (the first of that name) was baptized 3 February 1693/4 and died on the twentieth of the same month. This sad list is all the record that remains of those early years of the Hogarths' married life. The first child to survive infancy was Richard, baptized 11 April 1695; the next two, William and Mary, survived into adulthood.

Six days after the birthday of King William III, on Wednesday 10 November 1697, a fifth child was born to the Hogarths, and on Sunday the twenty-eighth he was baptized William. Many of the boys baptized that week must have been given that name, and though William was a family name among the north-country Hogarths, it probably seemed a lucky choice at just the moment when the victorious Protestant king's birthday and successfully negotiated Peace of Ryswick were so

grandly celebrated. So lucky that the next child, born two years later, was named Mary after his queen. The baptismal font in which the Hogarth children were baptized, one of the two pre-Reformation fonts remaining in London, can still be seen in the south transept of St. Bartholomew the Great.

The listing of the earlier Hogarth children in the regular parish register, as well as the baptism of William and Mary, suggests that Richard was a moderate Presbyterian, but it is a telling fact that, among all the Hogarth traditions, there is none about William's religion. Jane Hogarth is portrayed in late life going to, and dominating, the Chiswick church; but I have found no record of William's actively participating in any church (although he supported many charities). One may take this lack to indicate the unimportance of religion—or at least organized religion—in his life; religion is, however, present in his works, serving sometimes an aesthetic, sometimes a conventional moral purpose. The traces of a Puritan heritage are evident in the moral framework of his prints, in his concern with the spiritual biography of the individual *sub specie aeternitatis,* and in his deep sense of the individual's responsibility for his choices and the consequences of free action. The almost obsessive concern with these matters may have its origin in his Presbyterian family background.

By April 1701 the Hogarths had moved from Bartholomew Close to a smaller house at the bottom of St. John's Street, just above Smithfield and only a short way from their former residence. The last of the Widow Gibbons' daughters, Mary, had married one Timothy Helmesley around 1700 and begun raising a family in her mother's house; this may have induced the Hogarths, with their three children and a fourth expected, to move out.

In the St. John's Street house in October 1701 was born another daughter, Anne, who would remain with William, selling his prints and keeping shop for him, till his death. By 12 November 1703 the Hogarths had moved again and were settled somewhere in St. James' ward, a little farther north than their last move. On that day another son, Thomas, was baptized at St. James' Church. It is quite possible that the family was already settled into St. John's Gate, but it can definitely be placed there at the beginning of the next year.

In the *Post Man* for 8–11 January 1703/4 Richard ran the following advertisement for a new line of business, presumably hoping to better support his growing family:

At *Hogarth's* Coffee House in St. Johns Gate, the mid-way between Smithfield Bars and Clerkenwel, there will meet daily some Learned Gentlemen, who speak Latin readily, where any Gentleman that is either skilled in that Language, or desirous to perfect himself in speaking thereof, will be welcome. The Master of the House, in the absence of others, beings always ready to entertain Gentlemen in the Latin Tongue. There is likewise design'd a Society of Trades to meet every Monday night in the Great Room over the Gateway, for the promoting their respective Trades.

It is impossible to say whether the family itself lived in one of the rooms in the Gate, but it does seem fairly certain that Richard had given up schoolmastering; he claims to be always on hand in the coffeehouse, by genteel implication to teach adults Latin. This would leave no time for a regular school of his own; and if he had a school in conjunction with, or even nearby, his coffeehouse, he would surely have alluded to it in his advertisement.

Richard Hogarth's coffeehouse was no doubt economically motivated, but, like some of his son's enterprises, it also had an idealistic aim, one consistent with an overriding desire to make Latin the standard language of civilized communication. There was nothing remarkably new about Richard Hogarth's conception of a coffeehouse. One of the early pamphlets on coffeehouses relates that patrons liked to quote the classics and show off their pedantry; even the apprentice "doth call for his coffee in Latin," and learned quotations were so numerous as to "make a poor Vicar to tremble." Even acknowledging that Richard Hogarth may have kept an especially learned coffeehouse, and thought of himself as a proselytizer for the true doctrine and an agent for the good, he must at times have viewed this as something of a comedown for the scholar and schoolmaster he had envisioned less than fifteen years earlier when he arrived in London.

A LONDON CHILDHOOD

The coffeehouse, with its conversation (Latin and otherwise) and piles of newspapers, its placards and great variety of Londoners, was a stimulating place for William Hogarth to spend his youth. However, the whole area of London in which he lived, bounded by Newgate Street on the south and open country on the north, left its unmistakable marks on him.

The center, the heart, of this area was Smithfield; not only was Ho-

garth born here but his grandmother remained, relatives were con-
stantly visited, and the market and fair enjoyed here. It was one par-
ticular paradigm of London—there were many others—that would be
stamped on his consciousness, and it consisted of St. Bartholomew the
Great with its noncomformist annex, a marketplace that for a few
weeks each year became a fairground, a hospital, and not far away two
grim prisons, Newgate and the Fleet.

Across the open square of Smithfield Market was St. Bartholomew's
Hospital, as ancient as the church, a ruinous old rambling structure
which in the 1730s would be reconstructed into a beautiful Palladian
quadrangle by James Gibbs, with huge paintings from the New Testa-
ment by William Hogarth decorating the grand staircase. The other
element of this complex was the great marketplace, crowded with
cattle and livestock brought down from the north, thronged with
people buying and selling. On this ground was spread each year, dur-
ing the first days of August, a fantastic world that was both an escape
from the London of the rest of the year and a London in microcosm.
Trading was overwhelmed by entertainment, and the shows over-
lapped into the grounds of the other two institutions that bore the
name of St. Bartholomew. As time passed, the duration of the fair also
stretched from days into weeks. Hogarth, in later life, remembered
that shows of all sorts gave him uncommon pleasure. He was referring
to Bartholomew Fair.

Although there were all sorts of marvels to be seen at the fair, from
the "Little Farey Woman" (26 inches high) to the Great Hog (10 feet
long and 13 hands high), Hogarth seems to have been interested solely
in the people he saw—the pickpockets, quacks, whores, and charlatans
—and in the play-acting he observed both onstage and off. Associated
by many writers with Babel and Babylon, the fair was attractive pre-
cisely because there people of whatever age or class could lose them-
selves in a world where their imaginary projections coincided with
the reality, and their most anarchic and aimless desires could be ex-
plored. The fair was a last place, short of the gin shop, where man
could escape civilization and return to his instincts and primal chaos.

If the fair was the most important place of Hogarth's childhood, it
becomes visible and understandable only in the context of its neigh-
bors, St. Bartholomew's church and hospital. One can guess at what
these meant to Hogarth: his father would have said the church was an
alternative to the fair, the hospital a sign that the life of the fair had

consequences. His own return to St. Bartholomew's Hospital to paint murals and to serve as a governor points to his roots in the place. Perhaps, given Hogarth's particular vision, his graphic world would have been structured as it was no matter where he lived. But one may be excused for speculating on the degree to which his proximity to this complex of institutions, unique in London—church, market-turned-fair, and hospital—influenced both his life and art. As they appear in his paintings and prints, the church, the fair, and the hospital serve as outlets (sometimes true and sometimes false) for a radical dissatisfaction with everyday life.

Although Hogarth never really left Smithfield, when he was seven his horizons were expanded to include Clerkenwell, a few streets north, a thriving suburb into which many people had moved to build new homes after the Great Fire. St. John's Street, where the Hogarths first lived, was the main thoroughfare between Smithfield Market and the north. The Gatehouse was in a somewhat better neighborhood. St. John's Square, into which the Gatehouse opened to the north, was a spacious, pleasant place. On the north side of the Square, in 1727, was born John Wilkes, later Hogarth's friend and enemy; at the time of the Hogarths' residence, Wilkes' father, a distiller, was living two blocks away in Turnmill Street, Clerkenwell Green.

While to the north of the Gatehouse stretched an elegant square, to the south the Hogarths' windows looked down on the narrow gutter of St. John's Lane, which centuries earlier had led to the entrance of the priory. The contrast between the romantic past of the Gatehouse with its ancient escutcheons and the reality of the muddy, shabby, crowded street beneath encouraged the sort of homily the Latinist might have passed on to his son. North through St. John's Court and Jerusalem Passage led to the old parish church of St. James, where the most recent Hogarth children were baptized. "The walls are lined with oak of different height," Edward Hatton recorded about this time, "that round the communion table is about 9 feet high. The pews and pulpit are also of oak, tho' pretty old; as is also the altar-piece, where the painting of the commandments is somewhat decayed. They are placed between the Lord's Prayer and Creed, and over are the Queen's arms painted." This is more or less the interior Hogarth painted thirty years later in the first plate of *A Rake's Progress*. Anglican churches, as he portrayed them, are either running to seed or filled with sleeping parishioners. It was in this church on 10 August 1705

that another short-lived Hogarth child, Edmund, born on 28 July, was baptized. And on 17 December of the same year, Richard, William's only surviving elder brother and childhood playmate, was buried here; he had lived just ten years. William was then eight; these deaths must have weighed heavily on a sensitive child, demonstrating better than Puritan homily that man's suffering was not necessarily commensurate with his guilt.

Londoners did not take much advantage of the countryside which lay a brief walk to the north. Even if they had been interested in the beauties of nature, the highways of 1706 were to be avoided. All around the edges of the city were smoking brick kilns, vagabonds and highwaymen, cow- and hog-keepers, and market gardeners. If William went to the open fields, it was not to observe nature but to watch one of the less savory public sports, such as animal baiting or pugilists fighting with bare fists and broadswords. The animals to be baited were led in procession through the streets and handbills were passed out announcing "a match to be fought by two dogs, one from Newgate Market against one of Hony Lane market at a bull . . . likewise a *green bull* to be baited which was never baited before, and a bull to be turned loose with fireworks all over him; also a mad ass to be baited . . . and a dog to be drawn up with fireworks." Such images returned in Hogarth's prints, most memorably perhaps in the *Four Stages of Cruelty.*

Another source of disreputable entertainment (one that would rise in public esteem during Hogarth's lifetime, largely due to his own efforts) lay to the south of Smithfield. St. Paul's Churchyard had for centuries been the center of London's printing and publishing trade, and the houses around the yard were shops for the sale of printed material of all kinds and quality. In these printshops Hogarth would have obtained his first glimpse of the gaudy world of London and St. Bartholomew's Fair translated into the comic or moralizing black-and-white of engravings and blockprints, which lent it a significance perhaps not immediately apparent to the boy as he experienced it.

One other area, yet farther south, must have been sometimes visited by the Hogarths—Edmund Hogarth's shop at the foot of London Bridge. Richard's brother had followed him to London. Just when he arrived is uncertain, but in 1705 he settled in the City as a victualler at the Red Cross at the Bridgefoot of London Bridge near the Waterhouse, in the parish of St. Magnus Martyr. (William's newest

brother, Edmund, was named for his uncle in August.) Edmund's house was at the south or Surrey end of the bridge or just off it, "near the Waterhouse," the waterworks or pumping station, which conveyed water to various parts of the City by wooden mains formed of tree trunks. Uncle Edmund, a practical soul, insured both house and shop. The bridge was constantly catching fire, and one house or a few would be swept away, and soon replaced; the result was a wonderful hodgepodge of architecture. Going to visit his uncle, William would also have noticed on the great stone gate at the southern end of the bridge the exhibited heads of traitors and other malefactors—much replenished after the rebellion of 1715. When he wanted to depict a prototypical merchant in *Marriage à la Mode,* he returned to Uncle Edmund's neighborhood and showed London Bridge, with displayed heads, through the merchant's window.

This then was the scope of the London of William Hogarth's childhood. The strange territory he was to explore would be to the west: first Covent Garden, then Leicester Fields, and finally a country villa in Chiswick. The City, however, remained the primary setting for his prints.

Whatever his financial status, Richard Hogarth's social position as a schoolmaster was relatively high; and even as a coffeehouse proprietor (a tradesman) he emphasized the intellectual advantages of his establishment. From William's remarks, there is every reason to think that his father may have wanted him to pursue a learned career, and inculcated in him an ambivalent attitude toward trade long before he encountered the Thornhill family.

Richard certainly sent him to school. In his autobiographical notes William recalls that he "drew the alphabet with great ease" but had a "natural turn" for drawing rather than for "learning a language." Whatever the exact arrangements for young William, schooling to him implied (as he remarked) "language," and, particularly, Latin. Not even the reformers of education like Comenius and Locke questioned the hegemony of Latin; but being brought up by a schoolmaster would only have intensified the striking contrast between the preposterous regimentation of the grammar school and the freedom of the practical education available around the London streets. At the outset, William encountered the paradox of life in a coffeehouse, full of lively characters, where Latin was spoken: the curious mixture of a visual and auditory chaos and a verbal structure quite alien to con-

temporary experience. More generally, Hogarth's youth must have
been dominated by a confusion of emphases: from his own instincts
(or the influence of some unidentified relative) the visual, the people
and places of London, their colors and shapes; from his father the
verbal pattern, the printed page, reading, and moralizing. These two
modes of perceiving, understanding, and recording would shape much
of his particular art.

THE FLEET PRISON

In the summer of 1707 Richard Hogarth was still operating his
coffeehouse, but sometime between then and the end of 1708 the cof-
feehouse failed and Richard was confined for debt in the Fleet Prison.

Two years later, on 23 September 1710, he was writing a letter from
"Black and White Court in the region called the Old Bailey within
the bounds of the Fleet" to Robert Harley, then the Queen's first min-
ister, pouring forth the woes of his imprisonment and seeking assist-
ance. Exactly how he got there is not known. It cannot have been the
booksellers who put him in debtors' prison, though the profits from
his books might have kept him out; his difficulties with that group, on
which William commented with such bitterness, came later and in-
volved sins of omission rather than commission. Richard must simply
have overextended himself, bought the stock for his coffeehouse and
perhaps books and household supplies on credit, and when the coffee-
house did not flourish, unable to pay his debts, was faced with ruin.

The situation of a debtor was appalling and his courses of action
fraught with dilemmas. He could simply go into hiding, in which case
he was considered a felon and was liable to capital punishment. He
could surrender himself to his creditors, who could declare him bank-
rupt, if he did not do so himself, and take his all (he had to swear to
the sum) or a compensation of so much per pound. Or the debtor
could be put into prison until he paid his debt in full or promised a
satisfactory compensation.

The Fleet was surrounded with walls 25 feet high with palisades on
top. The horror of the common side is hardly imaginable. There were
sometimes thirty or forty prisoners in a room not 16 feet square,
locked in at 8 P.M. in winter, 9 in summer, and the door not opened
until morning. There were no sanitary facilities and there were times
when the rooms were so crowded that half had to sleep in hammocks
slung from the walls. To gain the freedom of the Rules—to move out-

side the prison walls—one paid around five guineas and gave security. The Rules extended south from the prison on the east side of Fleet Canal to Ludgate Hill, east to Cock Alley, north on Old Bailey as far as Fleet Lane, west on Fleet Lane to the Canal, and from thence south to the prison again: an area that included Black and White Court, where the Hogarths lived in 1709. Further, for 5s 6d a prisoner could be granted Day-Rule, or a pass to go abroad beyond the Rules, for a day during term time.

One may infer then that sometime before the end of 1708 Richard took refuge or was imprisoned in the Fleet. By the beginning of the new year he had acquired enough money, through selling household items or borrowing from brother Edmund, to secure the freedom of the Rules and had settled in Black and White Court, in the Old Bailey Precinct of St. Sepulchre's Parish, whence he wrote his petition to Robert Harley, Chancellor of the Exchequer, whose most pressing duty was to cope with the alarmingly growing national debt. Various plans were offered to Harley at this time, including several by the indefatigable Defoe (in August he wrote his *Essay upon Credit*) and one by Richard Hogarth from the Fleet. Richard's remarkable letter of 23 September 1710 is a reminder of his proposals to save the economy, an address to a man of learning written in Latin of a most flowery kind, and a plea for patronage, or at least for assistance in extricating himself from his troubles.

In fact, by the end of August Harley had solved the immediate economic crisis, and no more is heard of Richard Hogarth's proposals. Harley put together his ministry during September, and on 3 January of 1711 (according to the *Commons Journals*),

> A Petition of the poor insolvent Debtors belonging to the *Fleet* Prison, in behalf of themselves, and great Numbers of distressed Persons, now under Confinement in the respective Gaols of the Kingdom of *England,* was presented to the House, and read; setting forth, that by their long Confinement, and Necessities, they are reduced to the last Extremity, and must inevitably perish, unless relieved by the House: And praying, that a Bill may be permitted to be brought in, to oblige their Creditors to accept the utmost Satisfaction they can make, and to restore them to their Liberty.

As soon as word got around that a bill was pending, petitions poured in from gaols all over England. The bill was, however, held up in

Lords and did not finally clear both houses until May 1712. By the terms of the act all debtors in prison since 7 December 1711 were given the opportunity to appear in court and present a schedule of their whole estate. After nearly four years of virtual imprisonment, Richard Hogarth was again free to come and go as he liked, and, with his family, could try to return to his old neighborhood and pick up the threads of his former life. There is no way to gauge the effect of the experience on Richard and his wife. The hardships must have been intense. The winter of 1709, for example, was one of the coldest in memory, with post boys found dead, frozen to their horses; fuel grew outrageously expensive, and the cold lasted till the end of April. During this time two more children, William's surviving brothers Thomas and Edmund, died. When he emerged, Richard was a man of fifty, his hopes behind him, though he was still at work on a dictionary.

Remembering Dickens' reaction to his experience as a youth in the blacking factory, one can hardly overemphasize the importance of Richard's collapse and confinement on William. He never mentions, in any surviving writing, that his father went to prison, although his account of those early years does suggest something of the hardships his family suffered. The record, however, may be deduced from his works, and it is a detailed one.

One day William was free in the wide expanse of London's fairs and markets, its games and illusions, the next, he was plunged into the restrictive world of prisons, sponging houses, courts, and Rules. His father was a prisoner, without employment or resources, his mother was trying to support the family by selling home remedies. At home he found himself in crowded, uncomfortable quarters, probably shared with the family of William Gibbons, and outside he found himself among some of the shadiest of London characters, including not only the shabby-genteel debtors just managing to avoid the utter squalor of the inner prison—sometimes innocent victims, often rogues, and almost always men who by trying to live up to some hypothetical standard had exceeded their means—but also the habituated denizens of this demimonde who exploited them, supplying them with food and comforts at exorbitant rates and criminal interest. This was the world that Hogarth captured in his prints as no one else did. It is easy in the light of these years to understand why the 1729 House of Commons inquiry into the Fleet was important to him, aside from his

own paintings of the Committee meeting in the prison, which first brought him to the attention of the London picture buyers. The emphasis throughout his work is on prisons, real and metaphorical, on the relationship between the individual and institutions, on punishment hardly warranted by the crime, and on the image of the deluded and isolated individual. Even when he is not dealing with people who are in a prison of one sort or another he portrays rooms that are more like prison cells than boudoirs or parlors.

The years in the Fleet may also have been the factor that delayed Hogarth's apprenticeship from 1712, his fifteenth year when it would ordinarily have begun, until January 1713/4; he probably had to work to help pay off the creditors. Years later he recalled the relatively advanced age at which he took up engraving. While delaying his apprenticeship, Richard's financial disaster may have determined it as well: if his father had intended him for something better, perhaps a learned profession, these hopes collapsed when he went to the Fleet. It seems likely that William stopped attending school entirely, unless he was intermittently tutored by his father. His irregular education—involving much reading but little disciplined learning—explains much in his autodidactic posture of later years. He knew Latin tags but could not spell them; he had a strong sense of rhetorical effect but his sentences tended to collapse in disorganized syntax.

William emerged with a deep and abiding fear of disorder and the determination never to repeat such a breakup. Both his ambivalent attitude toward chaos in his works and his careful, canny business sense—his concern to have enough money, to secure his property (all the profits of his engravings) to himself legally—may stem from this time; or at least such an inclination was strengthened by the experience. The means by which Richard Hogarth eventually gained his freedom must also have impressed itself on his son. He could not rely on the generosity of his creditors, his patrons, or even his merchant brother; the only hope left him was an Act of Parliament, and Parliament, remarkably enough, cooperated.

Although they did not extricate him, the booksellers had not altogether abandoned Richard, and he had continued to write. While within the Rules of the Fleet he completed and saw published another Latin textbook, *Disputationes grammaticales* (December 1711), and in his letter to Harley he wrote that he was working on a dictionary like Elisha Coles'. This was an English–Latin, Latin–English diction-

ary "containing all things necessary for the translating of either language into the other," first published in 1677. The manuscript itself survived, kept by William as a bitter remembrance. This was the work William referred to in his autobiographical notes many years later as the source of his distrust of booksellers. He believed that his father died "of Illness occationd by partly the useage he met with from this set of people"—"and partly," he adds enigmatically, "by disappointments from great mens Promises." The last must refer to subscriptions, without which many booksellers would not have begun so large a project. Certain "great men"—those patrons whom Hogarth was ever to distrust—apparently encouraged his father's hopes with promises of support and subscriptions from their friends, which were unfulfilled. The decent, hard-working scholar went to prison, while the roguish booksellers picked his brains and scavenged his writings without adequate recompense, and, when they could, cheated him outright. This image, together with that of the unhelpful patron, remained with Hogarth all his life, affecting at crucial moments his own actions as well as his works.

The *Disputationes grammaticales* was published when William was fourteen, and it is likely that at some point his father, the dedicated pedagogue, at least attempted to try out his methods on his son. William must have rebelled against his father's world of dead language and rules. His spelling was blatantly unstandardized, in direct contradiction to Richard's *Thesaurarium,* though his handwriting itself (when meant to be read) was not bad, and he had a decided flair, reminiscent of his father's, for pithy phrasing. One part of his father—the failure—William had to push out of his consciousness. His obsession with success, his attachment to Sir James Thornhill, and his lifelong emulation of Thornhill can only be adequately explained as an attempt to satisfy a need never fulfilled by his father.

APPRENTICESHIP

On 2 February 1713/4 the Registry of Apprentices of the Merchant Taylors' Company records the binding of William Hogarth to Ellis Gamble, engraver, for seven years.

Hogarth's apprenticeship should have begun in 1712 when he was fifteen, but the delay until February 1713/4, when Hogarth was sixteen years and three months, is probably explained by the movement of the Hogarths from debtors' prison to Long Lane. Before 1714 Wil-

liam may not have been expendable. Though there is no indication in the Registry of Apprentices that any money exchanged hands, as was usual at an apprenticing, perhaps at this point Edmund Hogarth came to the rescue; through his wife Sarah he was in some way related to Ellis Gamble, and he may have arranged for the apprenticeship and either persuaded Gamble to take William gratis or paid him to do so. All that Hogarth himself had to say about the matter in later years was that his father was too poor to do more than put him "in a way to shift for himself."

Since the thirteenth century, apprenticeship had been supervised by the guilds in order to ensure fair play among workers, to prevent one master from luring away another's apprentice, and to make sure that ignorant workmen were not allowed into the guild. The Company enrolled the names of all apprentices in a guild book, and the apprentice was bound by indentures, which were inspected by the officers of the guild, and his name and the date of binding were recorded. At a public ceremony with the apprentice, his master, and the Company officers present, the register was entered in the guild book, to cancel the possibility of fraud by the master or boy. Apprenticeship ended with a public act too: seven years later the apprentice appeared again before the assembly court, this time to ask for his freedom.

The Merchant Taylors' records for March 1712/3 show that Gamble was living in a house on the south side of Blue Cross Street (now Orange Street); he first appears in the rate books on 30 September 1714 when the second rate was paid, and so may have sublet a shop before becoming a householder. Hogarth's apprenticeship may have coincided with Gamble's taking over a whole house, for as an apprentice he moved into his master's house as a member of the family. At least one other apprentice was in the Gamble house when Hogarth arrived: a Stephen Fowler, listed in the Registry of Apprentices as son of Benedict Fowler, a waterman of St. Margaret's Parish, Westminster, who paid Gamble £15 for the apprenticeship in 1713. Another apprentice, a Flemish lad named Felix Pellett, joined them in 1717, by which time Gamble's increasing importance had raised the fee to £30.

Gamble prospered during these years, no doubt with the assistance of his talented apprentice. On 23 May 1718, toward the end of Hogarth's term, Gamble (then listed as "ingraver by the Mews," which was nearby) was elected a liveryman of the Company on payment of a fee of £15. In 1728 he was engraving plate for Paul de Lamerie, the

great Huguenot goldsmith (and probably had done so for some years before), but difficulties arose between them, and in January 1732/3 he was declared bankrupt at Lamerie's petition. Bankruptcy did not put him out of business, nor did it involve resignation as a liveryman; in 1737 he took another apprentice, though his fee had been lowered to £10 by this time.

The implication is that Gamble was a man of some talent and industry, but improvident and perhaps unlucky. A further implication, from Hogarth's later comments on his apprenticeship, is that he was no easy taskmaster. The master replaced the apprentice's father; he was responsible for the apprentice's physical and moral development, and one of the qualifications guilds looked for in a master was a wife and family of his own. But it was not an easy life for the apprentice. The work hours were long, defined by statute for artificers who worked by the day as from 5 A.M. to 7 or 8 P.M. from the middle of March to the middle of September, taking not more than two and a half hours for all meals. From mid-September to mid-March the hours were those of daylight. He received no wages, and the master was entitled to all the apprentice's products and earnings. His pay was restricted to instruction and maintenance. As the indentures state, the master supplied teaching, meat, drink, and lodging, the apprentice obedient service.

Sports and pastimes were universally frowned upon: no dice or cards, no football, in some places no plays; no mumming and dancing, use of music, or entertaining of one's friends. Extravagance in dress and personal adornment were suppressed: clothes had to be plain but decent—sober garments, hair neatly trimmed, not in curls or hanging about the ears. During these years the papers were full of accounts of unruly apprentices, and advertisements for runaways. It is certain that Hogarth felt the life constricting, and it is easy to imagine him chafing under the long hours, straining his eyes over tiny heraldic engravings, and eagerly looking forward to the little time he was given away from the shop.

During these formative years, from sixteen to twenty, Hogarth must have soaked up more than the technique of engraving coats of arms. There can have been few more alert observers of London life; and he embarked on his apprenticeship in the year Queen Anne died and the Hanoverians arrived from Germany; the Tories went into exile, retirement, or prison, and the Whigs emerged triumphant. It seems al-

most certain that, despite apprentice rules, he spent a great deal of time at the theater; and at printshops, bookstalls, and generally around London, surveying and mentally and physically recording the sights. He may have already begun his practice of memorizing the forms of what he saw or catching them in outline upon his fingernail. While the life of an apprentice would have seemed tedious to one of Hogarth's temperament under any circumstances, he was further hampered by a master who was fundamentally an artisan (a goldsmith's engraver) and in no sense an artist. Hogarth's dilemma was not a unique one; artists had been fighting since the Renaissance to clarify the distinction between craft and liberal art. It is not certain whether he yet thought of himself as an artist, or whether his comic drawings were merely an escape from the long hours of careful silver engraving; but coming from his father's house he cannot have been too happy thinking of himself as an artisan.

The goldsmith himself cast the plate, and cast, applied, or embossed the ornament. Only the simplest engraved borders were done at the goldsmith's shop; any work requiring a higher degree of skill was sent to a specialist like Gamble. This work might extend from a cypher or a coat of arms to an elaborate allegorical design, but was usually limited to heraldic motifs. Engravers upon silver fell into two general classes. Many, like Gamble, devoted themselves entirely to engraving plate, watch-cases, and sometimes bookplates, limiting themselves to heraldic designs. From Hogarth's own comments, this must have been the extent of Gamble's ambition. If tradesman is writ large on Gamble's career, the other class of engraver included those like Gribelin, and later Hogarth himself when he set up in business, who, while basically illustrators, also decorated silver for a fee. They had made the essential rise from silver to copper—at which Hogarth must have been working in his spare time long before 1720.

Historically, the important phenomenon during these years was the presence of the Huguenot refugees, who introduced changes in the style of smithing and engraving and stole business from English workmen. One wonders how Gamble, or Hogarth, felt about the incursions of the foreigners, who offered a higher standard of workmanship at the same or lower prices. English goldsmiths found themselves forced to accept these new standards (including the new style) and prices or lose their trade. The Huguenot influence was in fact to the advantage of the engraver. In the first half of the eighteenth century the main influ-

ence on English silver shifted from Dutch to French, from elaborate embossed decoration to simple forms with a minimum of decorative details—the "Queen Anne" style. In seventeenth-century England ornament was almost entirely embossed, and engraving, except for coats of arms, was out of fashion. The new style, with its plain, unembossed surfaces, allowed for a return to engraving; as a result engraved decoration reached a higher standard of excellence than ever before. Another result, of course, was an influx of French pattern books.

Thus when Hogarth began his apprenticeship the "Carolean baroque" style, with richly embossed ornament, was being replaced by the purer French forms, sometimes stripped of all ornament. Within the years of Hogarth's apprenticeship the amount and complexity of the engraving increased as the Queen Anne style developed into early Georgian. More specifically, this change involved the replacement of the square shield (in which the coat of arms was enclosed) by the circular or oval cartouche, surrounded by acanthus foliage and strap- and scroll-work, and later by swags of flowers, grotesque masks, and palmettes; all of which gave the engraver an opportunity, previously denied him, to display his virtuosity. It is unfortunately impossible to identify Gamble's engraving, and nothing is known of Gamble's style except as Hogarth may reflect devices learned from his master—which, however, are utterly conventional. Hogarth's style, insofar as it tends to humanize the heraldic forms, is easier to recognize, but only in sup porters and allegorical figures, which were by no means always part of the commission. Several pieces have been attributed to him and one or two are very likely his, but none can be attributed with certainty to the period of his apprenticeship.

Hogarth made no effort himself to foster the memory of this time, preserving no impressions of his engravings and referring to it only as a waste period that kept him from copper engraving and prevented him from ever mastering its refinements. As an apprentice to a silver engraver he was taught the handling of the tools of his trade, not the principles of art; he was made to copy, or to adapt at best, allegorical figures and emblems, at worst, purely decorative patterns, and this imitation of art to the exclusion of nature prejudiced his attitude toward "art" and copying for the rest of his life.

Hogarth's break with Gamble came around 1720, and 23 April 1720 is the date engraved on his shop card (title page), the first datable engraving that has survived. It is evident from the records of the Mer-

chant Taylors' Company that he did not complete his apprenticeship, and from his shop card that he left Gamble nearly a year before its end. Indeed perhaps the most important fact about his apprenticeship is that he did not complete it. The ordinary reason for a forfeit of indentures was that the apprentice got into trouble and his master expelled him; another, which Hogarth himself suggests retrospectively, was that he became so fed up with the life that he broke off—out of pride, ambition, or disgust with the business of silver engraving. Although he does not say so, a third possibility must be considered: that other problems made it necessary for him to get out and support his family.

In 1714, when William was apprenticed, Richard Hogarth was described in the Apprentices' Register as "of St. Bartholomews," so had presumably by then moved to the south side of Long Lane, where he remained till his death. He must have died suddenly, on 11 May 1718, without time to write a will. There was no mention of his death in the papers, no advertisements for debts outstanding or for an auction of his library (if any remained). He simply vanished from the London scene as quietly as he had come, to be replaced in the rate book by "widow Hoggarth," who continued to live in the house until 1728.

Thus by April 1720 William was back living with his mother "near the Black Bull" in Long Lane and setting himself up, outside the context of any guild, as an independent engraver. On the twenty-third of that month he dated his own shop card, with his name and the above address prominently displayed, flanked by figures of Art and History, with some of the cherubs he had grown accustomed to making for Gamble filling in the top. The break with Gamble was not necessarily an unfriendly one. In a few years Hogarth made a shop card and perhaps a bookplate for his ex-master.

Gamble's final influence on Hogarth is hard to assess. Of course, Hogarth reacted against all that he stood for: mechanical copying from art rather than nature. His constrictingly precise work for Gamble taught him a great deal about baroque forms, which he would repeatedly parody in his own work. At the same time, it started him toward refining these forms in the direction of the delicate rococo curves—the effect that he ultimately called his Line of Beauty—which became almost obsessive in some of his later works; it also lured him into an elaboration of detail which is the glory and confusion of his art. Although he did not realize it at the time, and preferred to over-

look it in later recollections, his having been trained as an engraver rather than a painter was a great piece of luck for a man of Hogarth's particular talents and temperament. This training put him in a unique position, when the time came, to appeal beyond the verdict of the connoisseurs, who he felt kept a stranglehold on taste and patronage in England, to the general public for judgment.

Early Career as an Engraver

Our prime witness to Hogarth's career, and to the general plight of the arts and the artist in his lifetime, is the engraver and antiquarian George Vertue. Born in 1684, Vertue reached apprenticeship age about 1699, and came, like Hogarth, "from parents rather honest than Opulent" (as he recalled in his autobiography). His career was, up to a point, parallel to Hogarth's. Both were apprenticed to silver engravers, craftsmen rather than artists, and both then went on to study copper engraving. Both started with book illustration. From this point on, however, their careers diverged. Vertue remained all his life dependent on printsellers or patrons, and since printsellers got rich at the expense of their engravers, his hopes rested largely on patrons, but he was not very lucky in keeping them. They seemed to die just as his future appeared to be assured.

Vertue represents the prototypical engraver of the time. Of better than average competence, he also possessed an eloquence with words that forcibly conveys the engraver's problems at the time Hogarth was entering the profession. He carefully analyzed the reasons why engraving "is the least profitable—most evidently & certainly"—of the arts. They all derive from one chief cause: engraving is a reproductive rather than an original art form. The print publisher was an entrepreneur who paid men to engrave prints for him, and published and stocked them as if they were pots and pans; he had his own shop where he retailed the prints, and he sold them wholesale to other printshops. He had to have plates that would continue to produce dividends over a long period of time. These plates represented the most important part of his invested capital; witness the advertisements of print dealers boasting of a new stock of plates purchased from a bankrupt or defunct rival.

The vicissitudes of the engraver's lot and the printseller's trade in these years can be pieced together from Vertue's notes and the newspaper advertisements. There was a new market for London-based en-

gravers, and a shift from the Netherlands to France as the source for prints, engravers, and engraving style—the same developments already noticed in silver engraving. But when Vertue embarked on his career at the beginning of the century the great Wenceslaus Hollar had been dead for twenty-five years and William Faithorne for ten. Vertue accurately describes the situation as "at a low ebb" because of the continuing wars between France and England and the resulting lack of artistic exchange. The low ebb offered an opportunity for Vertue, who began to publish around 1709.

The great subject to be encountered in printshops was Italy—its palaces, gardens, statues, paintings. Travelers who wanted pictures of what they had seen bought them nostalgically in London printshops, and those who had never been out of England wished to know what they had missed. The influence of the Italian Renaissance artists, then of the Dutch and finally of the French, was disseminated through these reproductive prints. During these years, therefore, the print industry was largely an import business. An individual would buy a lot (often including paintings, which were also usually copies) from one of the great international print centers. He would exhibit his prints in a coffeehouse, or sometimes in a private house, and after a week or so conduct an auction. There were relatively few retail print dealers, and they most often advertised maps and the like, securing what art prints they carried from the auctions. Those dealers who did advertise illustrative prints seldom mentioned native English works, prior to the South Sea Bubble of 1720–21.

While the engravings of High Renaissance paintings and sculpture were the most sought after, there was also a ready market for the original prints of foreign engravers—Callot, Ostade, Teniers, Rembrandt, and others. A word should be said about the paintings that were to be seen in London at the same time. Every week or so an auction was advertised with original works said to be by Titian, the Carracci, Pietro da Cortona, Bassano, Viviano, Claude, both Poussins, Van Dyck, Rubens, Luca Giordana, Carlo Maratti, Salvator Rosa, Gerard Dou. Such paintings were sold at the same coffeehouses as the engravings, and came from the same sources: a dealer bought a lot from overseas or a collector died and his pieces were auctioned. The number of such auctions and shows in the early eighteenth century was staggering.

Hogarth thus had an opportunity to see an enormous body of paint-

ings and engravings of the European Renaissance, north and south, and, as his works indicate, he took advantage of the opportunity. But most of the paintings were obviously copies, at best "school of" or studio works. While introducing him to many forms, motifs, and themes in the great tradition of European art, these pictures must also have been a source of irritation to Hogarth: the copies—indifferently good or bad, painted or engraved—were valued highly, an index of the public's subservience to foreign fashion and its complete lack of interest in native English art.

Because the great majority of engravers depended for their living on this demand for copies, they were often no more than employees of the print publishers. A few engravers (Vertue was one) advertised, and presumably sold, their own work at their own shops, but their profits were shared with the printsellers. The state of engraving described by Vertue changed for the better as English relations with the Continent improved. With the Peace of Utrecht in the air, the Frenchman Nicholas Dorigny, who according to Vertue had "justly the reputation of the first graver in Europe," was lured from Italy, where he had copied the major works of the Renaissance, to England where he could engrave the Raphael Cartoons: the one great monument to High Renaissance history painting that could not be found in Italy. As time passed and the work became more onerous, Dorigny sent to Paris for two engravers, Claude Dubosc and Charles Dupuis, who "agreed upon small termes" to assist him. After two or three years, with the plates only half done, they broke with Dorigny and prepared to return to Paris. In London, however, Dubosc "feigned some excuse to stay some time longer here & promis'd to follow in a few months after" Dupuis. In fact, as Vertue explains, he never intended to follow because, knowing Dupuis was a better workman, he wanted him out of the way; and further, he had concluded "an underhand agreement" with the Bowles brothers to make cheap copies of the Cartoons to undersell Dorigny's. The story was the same with all the subsequent emigrants from Paris: in London "there was much more probability to live comfortably, than at Paris where of that Art [engraving], there is so many excellent Masters."

If the first great engraving enterprise of the period was Dorigny's undertaking—a foreigner's copy of an Italian masterpiece that Charles I happened to secure for the English—the second was Dubosc's engraving of Laguerre's paintings of Marlborough's battles: a foreigner's en-

graving of another foreigner's decorations made for an Englishman's house to celebrate great English victories. The concatenation is interesting, and reflects a gradual shift toward the English side of the equation. The third great project was the engraving of Thornhill's paintings in St. Paul's cupola: an Englishman's paintings in a great English public building (though still largely based on designs of Raphael and Rubens).

Between 1714 and 1720, then, the whole direction of engraving in England changed: the French style replaced the Dutch, and French engravers came to London to practice their trade with less competition and greater rewards. The engravings that brought recognition were those that accurately reproduced the great paintings in English buildings or collections, again by foreigners—with the one notable exception of Sir James Thornhill.

To avoid the stigma of being a mere copyist, and because his natural talent lay this way, Hogarth focused from the beginning on etching. The first noticeable influence on his work is that of Jacques Callot, a professional etcher, not a painter who also etched or a copyist of paintings by others. Callot not only produced the small, lively genre works that appealed to Hogarth but also offered a solution to the etcher who must pass as an engraver. Callot achieved the effect of engraving by using a specially designed etching point, the *échope* (which he may have invented), and by occasionally applying an engraving tool to the etched line while the etching ground was still on the plate.

It was probably from Abraham Bosse, who wrote the first technical treatise on engraving and etching, that Hogarth learned the secret of Callot's swelling and diminishing line. William Faithorne, whose translation Hogarth would have read, explains that to make an etching look like an engraving the artist must employ deep biting on the important lines and in some cases add pressure on the needle so as to cut through the varnish into the plate itself. For his large works, beginning with *The South Sea Scheme* of 1721 (pl. 2), he began to experiment with the finishing and engraving of the whole plate. In the works where sustained reproduction and the appearance of an engraving were required, he again followed Bosse, who explains in his treatise on engraving how etching can be used for the preliminary work on a plate, which can then be finished with an engraving tool—a time- and labor-saving device which by Hogarth's day was in common use

among engravers; Vertue notes that Vandergucht, Dubosc, and Baron employed it. Hogarth first utilized this method with success on a large plate with his *Lottery* (1724) and the large *Hudibras* plates (1726). He continued, however, to leave sizable areas of white exposed. Not until the end of the decade and *Henry VIII and Anne Boleyn* (ca. 1728) did he completely fill the plate with the engraved system of lines, imitating the complicated tonalities of a painting. Before the *Harlot's Progress* (1732), at any rate, he was consciously attempting to produce independent prints, and not to reproduce a work in another medium.

When Hogarth set up for himself as an engraver, around 1720, he doubtless carried out any commission that would earn enough to support him. While continuing to do the same silver engraving he had done for Gamble, he also turned out ephemeral announcements and business cards. His sights were set, one supposes, on the illustration of books, the highest reach to which an apprentice like himself could legitimately aspire. Book illustration at this time, however, was hardly an improvement on armorial engraving, as most engravers were simply paid by London booksellers to pirate continental illustrations.

Hogarth's first effort at illustration, datable before 1721 or 1722 when he received the important commission to contribute illustrations to La Motraye's *Travels,* must have been the seventeen small illustrations for *Hudibras,* or at least the majority of them. These plates, with the illustrations for Gildon's *New Metamorphosis* and Horneck's *Happy Ascetic* (both published in 1724), are the only works he made that were largely copied from earlier illustrations; and the *Hudibras* plates are much cruder than those for *New Metamorphosis.* His clumsy use of the etching–engraving combination in these plates, in contrast with his mastery of the technique in works published in 1724, makes it safe to infer that they were among his first efforts. He presumably had difficulty selling them; though an improvement on the stiff 1709 illustrations he copied, they were coarse compared to Vandergucht's fluent engravings of the same period. They were finally bought and published in 1726, only after he had successfully published a larger, much more elaborate series of *Hudibras* plates. It is significant that he begins, however tentatively, with this homage to Samuel Butler, one of the great English satirists in the tradition that led to Dryden, Pope, and Swift.

The direction he will take is even clearer in his shop card (title page), dated April 1720; it is a striking performance, intellectually

and prophetically, if not artistically. The decorative work is what one would expect of a silver engraver and the etching of the figures is competent, revealing some individuality in the line, especially in the old man's robes. More interesting, however, is the balancing of this old man, History, against the female figure of Art. Even if his presence does not suggest that Hogarth has already conceived a modified history painting as his aim, it demonstrates that here is no ordinary engraver of plate or shop cards.

The artist's ambition is also plain in his ticket for the comedian Spiller, apparently executed in March 1720, a month before the shop card. In this, perhaps his earliest print as an independent engraver, Hogarth introduces a debtors' prison and the instruments of punishment for debt, here transferred to the spendthrift actor James Spiller. He uses the same sort of popular symbols as the Bubble prints, dealing with the mania for speculation in the Low Countries, which had begun to reach English printsellers in 1720. These were completely emblematic works, in which realistic figures were displayed with allegorical and idealized ones, amid contemporary buildings and explanatory inscriptions. Another early commission, a funeral ticket for Humphrey Drew the undertaker (pl. 1), is more directly reportorial. Here history is the portrayal of a public ceremony or occasion, with some psychological interest, as the mercer tries to wave away the gaping crowd. A third approach—injecting an aspect of the droll—is reflected in two tiny prints that are probably, though not certainly, by Hogarth: *Search Night* and *The Rape of the Lock*.

These three forms—the emblematic, the reportorial, and the droll—are established at the very outset of Hogarth's career, not far from the time of his shop card, with a remarkable prescience and self-consciousness. Hogarth, it would appear, knew where he was going to such an extent that even his hack work was conceived both as the working out of a problem and the search for a formula that would satisfy his buyer and lead to more commissions.

The ambitious young man might have risen gradually through competent book illustration and other engraving-to-order, but he preferred to gamble on attracting the attention of the general public. His natural talent for the comic and satiric must have led him to look around for a subject, and in 1720 he did not have far to look. The spring and summer unfolded before his eyes the boom and accompanying madness of the South Sea Bubble. Fortunes were being made in

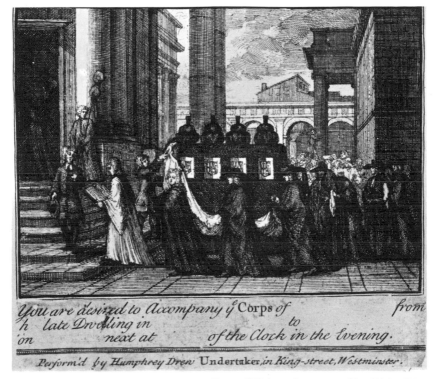

You are desired to Accompany y Corps of from
h late Dwelling in to
on next at of the Clock in the Evening.

Perform'd by Humphrey Drew Undertaker, in King-street, Westminster.

1. Funeral Ticket; after 1720; 4⅝ x 6½ in. (BM)

the summer of 1720. Sir James Thornhill, whom Hogarth was soon to meet, was decorating a luxurious house for Robert Knight, the cashier of the South Sea Company. Everyone was buying and selling and buying again. The nobility were the most deeply embroiled, and especially the Scottish Whig nobility, who had supported John Law and devoted themselves to South Sea stock; Hogarth singled them out for attack in his print (pl. 2), along with English noblemen wearing orders. In August the market began to fall; October, November, and December saw an unparalleled economic confusion in England. In December Parliament met. By the end of the month a coalition of Whigs and Tories had pressed for a Committee of Inquiry, and the really shady side of the South Sea venture became apparent to the public. Death—natural or by suicide—and disgrace followed within the next few months for several of the principals, including the king's first minister.

The first of the original English satiric prints appeared early in

1721. Of the Bubble prints listed in the *British Museum Catalogue of Satric Prints* (roughly from nos. 1610 to 1722), no more than two or three are in any sense original, and these too may derive from lost continental prints. The one noteworthy exception is Hogarth's print on the subject (pl. 2), presumably made sometime in 1721. Like many of the other prints it refers in particular to the monumental folly of the year 1720. Hogarth's bears no resemblance to the other English contributions; it follows from the Dutch prints with its elaborate architectural setting and mixture of real and allegorical figures. In an incredible study of perspective (even for him), he has placed the Guildhall at one side, the London Monument at the other, and St. Paul's and other London buildings between, each with its own vanishing point. In these surroundings he has set a remarkably coherent group of figures; the best passage in the print is the scuffling crowd under the Devil's shop window. They are small, like the figures that appear against large architectural shapes in many Dutch prints, but

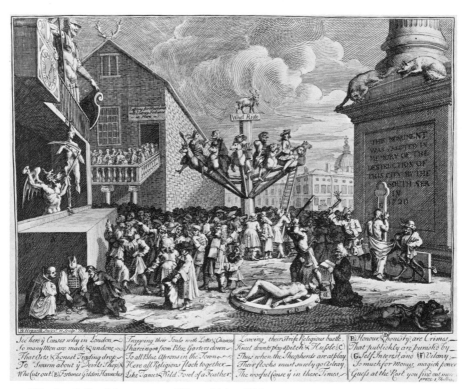

2. The South Sea Scheme; 1721; 8¾ x 12½ in. (BM)

they are drawn with a firmer line than their Dutch prototypes (the influence of Callot is apparent here) and with a much greater sense of grotesque individuality.

The South Sea Scheme is aimed at the speculators, simply a mob of all kinds of people trying to make easy money. The presence of priests of all faiths, prominently engaged in the gambling rage, illustrates the emphasis on misdirected activity: they should be watching after their flocks, as the rest of the people should be working at their normal occupations. Beyond this infatuation with money, there is only a general air of villainy at work—in the foxes around the Monument's plinth, and in the figure of Villainy labelled "F." But it is not clear that these villains or exploiters are stockjobbers or any specific agents; rather they seem to be personified aspects of the speculators themselves: Self-Interest and Villainy overcoming Honor and Honesty. The explanatory verses state as much. Presumably Hogarth, who saw himself as a "historian," wrote his own verses—they are crude enough. Certainly he engraved them (there are mistakes corrected and uncorrected); he had not yet reached a point where he could afford a writing engraver, and probably did not want a collaborator to share his profits. At this stage of his career, he thought of himself as artist-writer, a satirist in the tradition of the great Augustans.

It seems likely that Hogarth began *The South Sea Scheme* early in 1721, when the smoke was beginning to clear. But this was a carefully worked and elaborate print, and it may have taken him some months to finish it. The absence of advertisements or any contemporary comment on the print—certainly a surprising performance in light of the other Bubble satires—is puzzling, and may mean that he did not offer it to a printseller. The earliest publication line is matched on *The Lottery* (pl. 5), which though perhaps intended originally as a companion piece to *The South Sea Scheme,* was not finished and published until 1724. It is possible that Hogarth held them both until sometime in 1724 before selling them to the printsellers. One might even speculate that he did not finish *The South Sea Scheme* until the interest in Bubble prints had begun to wane—an explanation that would account for the absence of a printseller's name, and of advertising, until after the success of *Masquerades and Operas* in 1724. This possibility is supported by Hogarth's later remarks to the effect that *Masquerades and Operas* was his first attempt to publish a print on his own.

Hogarth's first important illustrating commission came early in 1721, presumably around the time Aubrey de la Motraye's *Travels through Europe, Asia, and into Parts of Africa* was advertised for subscription on 2 April (*Daily Courant*); it was announced as "adorn'd with Maps, Cuts, and other Representations proper to the Eastern and Northern Nations," and subscriptions were begun at this time. The enterprise was also important because it was executed entirely by Englishmen: Hogarth, David Lockley, Robert Smith, and George Vertue himself (who mentions the project).

The engravings done by Hogarth may have been started as early as the date of the proposals for subscription, but on the other hand at least one of the illustrations—and in general his whole conception— was influenced by Bernard Picart's great *Cérémonies et coutumes religieuses de tous les peuples,* which did not appear (at least in its entirety) until the beginning of 1723, the date on the Amsterdam edition. The engravings may well have come sometime after the proposals, since they were based almost entirely on designs, tapestries, maps, coins, and other artifacts supplied the engravers. This book represents Hogarth's only excursion into purely reproductive engraving, and accounts for the uncharacteristic compositions, with their widely spaced people and eastern style. Only the drawing, attached to one of the maps, of Charles XII at Bender reflects Hogarth's skill with the etching needle at this time (pl. 3). It is an outdoors composition, showing soldiers and potentates on horseback, in the general manner of the Laguerre *Battles of Marlborough,* engravings which had been published in 1717. This small area on a large page, carefully signed "W. Hogarth Invt et Sculpt," represents his one and only attempt at serious history in the style he was soon to parody in his large *Hudibras* plates.

The La Motraye plates, with the influence of Picart, are important in Hogarth's development because they gave him a chance to deal with contemporary (though foreign and strange) customs in compositions involving large groups of people in architectural settings or closely reported interiors. Some of Picart's own plates in *Cérémonies et coutumes* are comparable to the product Hogarth was now approaching. Uninteresting as many of its plates are, La Motraye's *Travels* must have drawn Hogarth away from the emblematic representation of *The South Sea Scheme* toward the more natural and congenial depiction of detailed contemporary scenes. The two fat volumes, for which he executed at least a dozen plates, were delivered in February

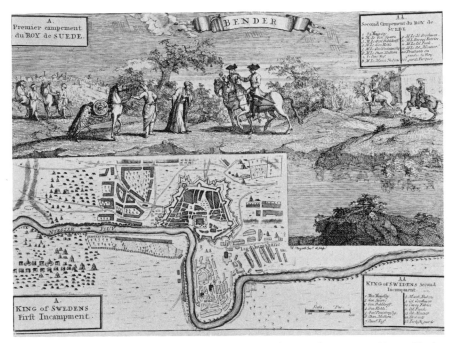

3. Charles XII at Bender, illustration for La Motraye's *Travels*; 1723/4; 9¾ x 13⁹⁄₁₆ in. (BM)

1723/4. Most of the plates were used again for the French edition, being subscribed for at the same time, but the plates were doubtless paid for outright and Hogarth can have received no more than his original payment.

These were busy years for Hogarth, when he was trying to do many things at once, not the least of which was merely to survive. If there is any truth in them, the stories of his struggle to make ends meet must refer to this time. Beyond survival, however, he was determined to rise above the circumstances not only of a goldsmith but of an engraver too; having turned from silver engraving to copper, it now became necessary to study art—to draw "object[s] something like nature instead of the monsters of Heraldry." To achieve this end, he turned (even before executing *The South Sea Scheme*) to the new art academy opened by John Vanderbank and Louis Cheron in St. Martin's Lane, where a young artist could find instruction in the formal aspects of art that would elevate him from the level of a mere mechanic, and could draw from the life. This was no casual undertaking: he had to

be able to afford a two-guinea fee and spend part of his time at the academy and at home working out academic problems that had nothing to do with the day-to-day problems of survival. But in October 1720, in the initial list of subscribers for the new academy, Hogarth's name appears.

His first twenty years offered Hogarth a range of possibilities he might choose to exploit; and while developing them to the utmost, he never transcended them. Hogarth was destined to remain not simply within the geographical confines of London (with only a few trips away, largely unrecorded), but also within the limits staked out by the accidents of his life, from coffeehouse to prison, and within the narrow liberties of an apprenticeship to a silver engraver, the assumptions promulgated by the art treatises and portrayed in the wares of print-sellers' shops, and the economic supply and demand of the London art market. He tried often to extend these limits but managed only to push to the furthest boundaries, apparently not wishing or daring to break through. The next phase of his life, leading to *A Harlot's Progress,* is essentially the dual story of his rise to prominence and the evolution of his own characteristic genre out of the talents he possessed and the limitations he faced.

2

The Evolution of a Genre
1720—1732

It was, Hogarth remembered, "the Painting of St Pauls and greenwich hospital which were during this time"—the years of his apprenticeship —"running in my head." Even if one takes into account his perspective of over forty years later, by which time he wanted to establish clearly a line of succession from Thornhill to himself and needed to defend Thornhill's diminishing reputation, it is not difficult to see why this artist was his ideal. Thornhill was a decorative painter in the grand manner, a history painter, and an Englishman—the living reply to William Aglionby's complaint that "we never had, as yet, any of Note, that was an *English Man,* that pretended to *History-Painting.*" It took a particular kind of man, as well as a particular kind of talent, to win this victory for the English artist; and this man was one of the chief influences of Hogarth's life—on his style of painting as well as of living. In the family Bible he proudly put himself down as marrying the "daughter of Sir James Thornhill"; years later when he wrote his notes on the English academies he identified Thornhill as his father-in-law.

This man, in so many ways like Hogarth, was different in one basic respect: he was a successful courtier, for whom patrons were the stepping-stones to greatness, and was on terms of intimacy with the "great" as well as the talented. He came of country gentry who had supported Parliament during the Civil War but had subsequently fallen in the world; the money and the family seat were gone but the manners and the connections remained. He was born in Woollands, Dorset, 25 July 1675 or '76, a decade after Richard Hogarth. He was apprenticed to Thomas Highmore of the Painter-Stainers' Company, a man of Dorset stock distantly related to the Thornhills. Highmore's

official connections, and Thornhill's own assiduity, brought the young artist into contact with Antonio Verrio and Louis Laguerre, the two most prominent decorative painters of the day; one Italian, the other French. He appears to have assisted Verrio with the Hampton Court decorations in 1702–04. By 1 March 1703/4 he had saved enough money to purchase his freedom of the Painter-Stainers' Company, and in the same year he received the commission to decorate Stoke Edith, Herefordshire, followed in 1706 by his decoration of the Sabine Room at Chatsworth, and his paintings of *The Fall of Phaeton* on the dome over the adjacent stone staircase.

These were important commissions for a young man of thirty-one, but in 1707 he obtained the greatest history painting commission in England—the allegory of the Protestant Succession in the great hall at Greenwich Hospital. Although the reason for his being chosen is not certain, probably nationality and timing were the important factors. He was the only qualified Englishman available for such an undertaking; Verrio, the obvious choice, had just died, and it may have seemed a good time to let an Englishman—who had the endorsement of the Duke of Devonshire for his work at Chatsworth—decorate this building commemorating England's seamen and built by her great architect, Sir Christopher Wren. It is also likely, considering their later parsimony, that the governors thought Thornhill would come less dear than Laguerre or another foreign artist.

The competition between Thornhill and the foreign artists is best documented, however, by the second great commission of his career, the cupola of St. Paul's Cathedral. By early 1709 the governors were seeking an artist to decorate the cupola. The contending artists were, besides Thornhill, the Italians Pellegrini and Cattenaro and the Frenchmen Pierre Berchet, Louis Cheron, and Louis Laguerre.

On 28 June 1715—by which time Thornhill had completed the lower hall at Greenwich—and with no explanation for the five-year lapse, the governors chose Thornhill (he was to receive £4000). Thornhill had a sharp eye for payment and was known for the steep prices he charged, and the elaborate stratagems he sometimes employed to get his money. He could also haggle over prices, and it is never quite clear whether he was standing up for the rights of the English artist or for himself. These qualities were later to appear in Hogarth, who may also have learned from Thornhill's experience that connections are necessary for obtaining any large commission. By

Hogarth's time, however, all that remained was the behind-the-scenes manipulation Vertue loved to record.

By the end of the decade Thornhill was a public figure of some prominence. In June 1718 he was appointed History-Painter in ordinary to the King (a post, considering George I's position on art, more honorary than active), and in March 1720 he was appointed Serjeant Painter, replacing his late master, Thomas Highmore. Finally, in May 1720, Thornhill was knighted—the first English-born painter to be so honored.

As Vertue points out, merit mixed with intrigue brought about Thornhill's advancement. In March 1722, having bought back his ancestral estate and become a Dorset landowner, Thornhill was returned to the last parliament of George I. On his estate he erected a tall obelisk in honor of George I, visible from all the surrounding country, and painted on the ceiling of the drawing room an allegorical representation with his own head in the center. In May 1723 he was elected a Fellow of the Royal Society.

The effect of Thornhill's reputation and his works on the young Hogarth, toiling over silverplate, filling in escutcheons, and then trying to make a living as an engraver, may be conjectured. Until he joined the St. Martin's Lane Academy, and (later) met Thornhill personally, the painter was presumably only a great name and a vague ideal. Nevertheless, the works were there for Hogarth to see and absorb. Greenwich's Painted Hall was available when he began his apprenticeship in 1715, and in October 1717 the cupola of St. Paul's could be examined. While he continued work on other parts of the dome, Thornhill had his major designs—the history paintings of St. Paul's life—engraved and sold by subscription, a common proceeding, which not only enabled Hogarth to obtain manageable copies of the paintings but also offered him a model for the engraving and distributing to a wide public of one's own history paintings. On 2 May 1720, when he was knighted, Thornhill presented a set of the prints to the king, and they were delivered to subscribers on the ninth. It is doubtful whether Hogarth could have afforded a set at this time, but the prints were among the few pictures he kept on the walls of his house long after Thornhill's death.

It may have been a wish to improve his rendering of the human figure and to understand the allegories of history painting that led Hogarth to turn toward academic training; and this offered itself with

the opening of the St. Martin's Lane Academy in October 1720. When
Hogarth joined the academy he not only came into contact with the
world of "serious" art in London but also found himself in the middle
of its broils and confusions—a battleground from which he occasion-
ally withdrew in the decades following, but to which he always re-
turned at moments of crisis (some of them of his own making). Thorn-
hill was momentarily out of the picture in the fall of 1720, which may
explain why Hogarth's first contact with the art academies was (ac-
cording to the available evidence) in St. Martin's Lane. But even a
contact with this anti-Thornhill academy was indirectly a contact with
the great man.

When the first academy of painting in England was founded in
1711, Thornhill had just returned from his first trip to the continent.
On 18 October a large group of artists met in a house in Great
Queen Street; artists and connoisseurs subscribed at a guinea each
and elected Sir Godfrey Kneller governor. Thornhill was elected one
of the twelve directors, who included Michael Dahl, Jonathan Rich-
ardson, Louis Laguerre, and Antonio Pellegrini. The academy was
evidently no more than a place where artists could assemble at night
to draw or paint from casts or from the life. Following the precedent
of continental academies, connoisseurs were also admitted, and there
must have been a large quotient of socializing.

Vertue hints that within two or three years some dissidence arose in
the academy, centered in Thornhill and Louis Cheron. Stories have
survived of personal difficulties between Thornhill and Kneller—both
proud, self-important, and domineering men. Worn down by faction-
alism or by age (he was now sixty-seven) Kneller resigned as governor
in 1715, and at the meeting the Monday before St. Luke's Day the new
governor was elected. According to Vertue, Laguerre was the logical
choice, but Thornhill's assiduity, and Laguerre's apathy, secured
Thornhill the election. It is not certain what changes Thornhill
brought about, but before long he too came under attack; "Partyes
rose against him," as Vertue put it. Thornhill, "at the head of one
party," then set up a new academy in a "place he built at the back of
his own house in the piazza" of Covent Garden; both Hogarth and
Vertue affirm that this academy was "furnish'd gratis to all that re-
quir'd admition." But, Hogarth adds, so few artists were attracted, or
remained, that it soon closed. Vertue suggests more specifically that
Cheron (Thornhill's old ally against Kneller) and John Vanderbank,

"growing tired" with Thornhill's management of the academy, withdrew.

Vanderbank, only three years Hogarth's senior, at seventeen had been a member of Kneller's original academy, and by 1720 was a joint proprietor of the new academy. At the death of his father he inherited £500 in cash, and his leadership in the academy was at least partly due to his financial contribution—several times the ordinary subscription of two guineas. He was, however, already known as an artist. So little is yet known about Vanderbank that it is hard to assess his impact on Hogarth, but (as is evident from his *Don Quixote* designs) it may have been almost as important in its way as Thornhill's. Vertue comments in 1723 on Vanderbank's combination of natural talent ("having never travell'd abroad") and free living, which must have made him an interesting teacher for Hogarth, who also claimed to like his pleasures as well as his studies. Cheron, the other partner in the academy, was at this time a man of seventy, chiefly noted for his designs for engravers, especially book illustrators—that is, for his talent as a draftsman rather than as a colorist.

The academy was located, as Hogarth noted, in an old Presbyterian meetinghouse. It was this academy, a splinter of a splinter, that William Hogarth joined in October 1720. Although he apparently came upon the scene too late to have benefited by Thornhill's academy (he would surely have mentioned it), he must have been aware of the advantages to a poor struggling artist of the free room for drawing. The usual instruction for young persons who wished an academic training was to work backward from standard idealized shapes to shapes in nature, which could then be seen in terms of these idealized shapes—a method distressingly similar to that of the engraver of heraldic arms. The model for English academies was of course the French Academy's school, in which the young artist was set to copying the works of the old masters, first in drawing, then in painting; then casts from the antique; and finally from life. It is easy to reconstruct the list of the casts used; they were standard in every academy, and taught the young artist to view the world through the eye of the Franco-classical academician. They appeared in Hogarth's compilation in his *Analysis of Beauty*, which also probably directly reflects the models in the St. Martin's Lane Academy. These were the Farnese *Hercules*, the *Apollo Belvedere*, the *Laocoön*, the *Venus de Medici*, and probably the *Gladiator*, *Antinous*, and some of Fiammingo's putti.

But, as Quennell has observed, considering Hogarth's upbringing, any system of aesthetic training that suggested the early stages of a classical education was anathema. Copying other men's works, Hogarth argued, was like pouring wine out of one vessel into another. Instead of copying he "took the short way of getting objects by heart." These he captured, not by what is ordinarily defined as sketches from life, but by a shorthand of a few lines from which memory would later supply the rest. The stories of his interest in how to draw St. George and the Dragon in three lines, or of his sketching faces on his fingernail, give some indication of the system of "visual mnemonics" he developed. Another sign of his method is the paucity of surviving sketches: he tended to rely on mental notations which he developed, perhaps much later, directly in compositions in oil or pen and ink. The great majority of the drawings that have survived are studio compositions, sketched preparatory to an engraving. The exceptions are a few life-class drawings that appear to serve no purpose beyond demonstrating that he could do as well as the other conventional copiers if he desired, and the occasional candid sketches of friends like Gabriel Hunt or Ben Read—sketches that were posted on tavern walls for the amusement of their friends.

If he was in some sense rebelling against the methods used by teachers like his father in promulgating the classical education, he nevertheless formulated his solution in verbal terms. His aim, he said, was not to copy objects "but rather read the Language of them <and if possible find a grammar to it> and collect and retain a remembrance of what I saw by repeated observations only trying every now and then upon my canvas how far I was advanc'd by that means."

It is also clear that Hogarth learned the fundamentals of academic drawing and theory and, whatever he may have said later to the contrary, began to apply them soon after matriculating in St. Martin's Lane. The change is immediately apparent if *The South Sea Scheme* (pl. 2) is placed alongside its ostensible pendant, *The Lottery* (pl. 5), which could have been constructed out of his academy sketchbook. Nevertheless, it is probable that he was something of a rebel within the academy, especially verbally, telling his colleagues about his mnemonic system and perhaps about "nature." It is also probable that the conventional pedagogic methods of Vanderbank's academy helped to foster in him the impression that Thornhill's new academy, where one simply went and painted from a model or did as one pleased, offered

more scope to the students—as the authoritarian structure established by Vanderbank confirmed his growing distrust of intolerance. At either academy, the classical preoccupation with the nude body, reflected in the emphasis on the life class, had the simultaneous effects on Hogarth of strengthening his already precocious grasp of the human form and of scanting another subject very necessary for the history painter: perspective. The simple stage setting of *The Lottery* is a great improvement over earlier works, but if he ever fully grasped the problems concerned with the architectural components of a composition—which is doubtful—it was only through his own study and experience.

The subscribers' list to the St. Martin's Lane Academy in 1720 reads like a roll call of the artists between Kneller and Reynolds. Besides the old Louis Laguerre and Louis Cheron, and the young John Vanderbank, there were, of the older generation, the Swede Hans Hysing, an established portrait painter who lived with and painted like Michael Dahl; and Louis Goupy, a less successful portraitist. George Knapton, a year younger than Hogarth, went on to Italy in 1725, returning to England seven years later to set up a fashionable portrait practice. Bartholomew Dandridge, born in London in 1691, son of a house painter, had at twenty attended Kneller's academy and was beginning to produce portraits. Arthur Pond, though never much of an artist, became what Vertue called "the greatest or top virtuoso in London." Others, about whom I shall have more to say later, were the Sympsons, father and son, and Hogarth's special friend John Ellys.

Dr. William Cheselden, later considered the best surgeon (and carver at a dinner table) in London, was also a member of the academy. Cheselden was already the greatest anatomist in London and was giving lectures that were so popular as to draw people away from the dissections at the Barber-Surgeons' Hall in Monkwell Street and to elicit a fine and censure from the Barber-Surgeons' Company. Hogarth doubtless visited the dissections, both as education and as theater, and it is quite possible that he attended Cheselden's lectures, which were prominently advertised at the same time he was attending the academy. It would have been characteristic of Hogarth to combine an aesthetic with a more broadly practical and experiential activity.

Another member of the academy was a Yorkshireman named William Kent, thirty-six years old and just returned from Italy; he was patronized by the powerful Earl of Burlington. The man who was

later to topple Thornhill was appropriately an Englishman, but an Italianized one (called "Signior"), who thus embodied the best of both worlds: English chauvinism and English reverence for Italy. This formidable young man came from a poor Yorkshire family which could not support his artistic inclination and so apprenticed him at eighteen to a coach and house painter; at twenty he ran away to London without finishing his apprenticeship. Vertue adds, however, that already he had made friends among the Yorkshire gentry and went to London with a contribution from them and letters to the proper people. If he arrived in London around 1704, the following years are undocumented until 1709, when he sailed for Italy where he attracted patrons among the young English gentlemen on their grand tours. The first great patron to whom he attached himself was the rich young orphan Thomas Coke of Norfolk, not yet seventeen and on his grand tour. They appear to have met in the spring of 1714 in Naples. They parted temporarily in Padua, and Kent returned in October to Rome, there making the most important contact of his career: Richard Boyle, third Earl of Burlington. Burlington, who set out on his grand tour in May 1714, at age twenty, was an aspiring Maecenas in need of tutoring. In February, Burlington left Rome with a large number of pictures, which probably reflected Kent's taste as well as his own. This was a short tour, and Burlington was back on English soil on 30 April (1715).

In May 1716 Kent was in Naples with Coke again, receiving payments for his lodging and support. He remained with Coke, buying and copying paintings, until the latter's departure in mid-1717. He presumably carried on in the same happy way for two more years, until the fall of 1719 when Lord Burlington, now an ardent Palladian, returned for his second tour. Again they met, toured, and this time returned to England together, with Kent settling in Burlington House, the earl's new Palladian townhouse in Piccadilly. His patron began immediately to employ him at painting decorations for the house.

By June 1720, three months before the opening of the St. Martin's Lane Academy, Kent was already painting historical works for Lord Burlington, Lord Chandos, and Lord Castlemaine. By this time he had met his literary champions Alexander Pope and John Gay, doubtless through Burlington. In 1720 Gay's *Poems on Several Occasions* was published with illustrations by Kent in the Italianate manner; in

this instance his shaky draftsmanship was combined, in the frontis-piece, with his own engraving—a mistake he was wise enough not to repeat.

At the St. Martin's Lane Academy Kent stood out among his peers in his Italianness, his familiarity with the great, his important proj-ects, and his incredible reputation; he was further distinguished, no doubt, by his positive opinions and air of self-importance. The exag-geration of his merit as an artist would have been apparent to one aware of his surprisingly feeble draftsmanship and feebler painting technique. It seems probable that Hogarth took an instant dislike to Kent, long before his career began to threaten Thornhill's. Kent's smoothness, I suspect, riled Hogarth most of all; Hogarth, as a result of his background (and perhaps by conscious design as well), was any-thing but smooth. Kent's easy sophistication—his ability to get along with and manipulate the great—was a talent Hogarth never developed, and one he must have regarded with mixed envy and contempt.

The first Thornhill–Kent confrontation took place in early 1722 when Thornhill asked £800 to decorate the Cube Room in Kensing-ton Palace (part of his prerogative as Serjeant Painter), and, without warning, Kent was given the job for £300. As Vertue wrote, "a mighty mortification fell on Sr James Thornhill." As to the quality of Kent's work, the contrast between the history painting of the novice Kent and the great Thornhill, indeed obvious, was no doubt discussed in the St. Martin's Lane Academy.

The story of Thornhill's fall from prominence goes back to 1718 when Wren was suddenly and unceremoniously ejected as Surveyor General to H. M. Works. The downfall of the old Board of Works, responsible for much of the greatest architecture in England, resulted in part from Wren's age and George I's conviction that the board was being mismanaged; but the primary force was Burlington, newly con-verted to the ideals of Shaftesbury and Colen Campbell, who wanted to purge the board of the old school of architecture.

In 1711 had appeared the Earl of Shaftesbury's *Characteristics*, which defined the aesthetic that would guide the Burlingtonians. Beauty and morality were equated, and common characteristics were order, harmony, and proportion. The ideal set forth—which through its popularizer Jonathan Richardson would have a great influence on the English nobility as a whole—was the "man of breeding," the con-noisseur who knew the "right models" for art, the literature and art of

classical antiquity. Shaftesbury—a great Whig name—was laying the foundations for a Whig aesthetic to replace what he considered the Tory and baroque aesthetic of Queen Anne's Board of Works; this aesthetic went into effect soon after the Whigs took power in 1714. It is not certain when Burlington fell under the spell of Shaftesbury's creed, but he must have been aware of Shaftesbury's doctrine by 1717 when the first volume of Colen Campbell's *Vitruvius Britannicus* appeared, arguing that the old baroque style with its "capricious ornaments" was obsolete; and Burlington promptly commissioned Campbell to begin work on Burlington House, ousting the Tory James Gibbs.

Presumably, as soon as Kent returned from Italy Burlington set him to work on the ceiling pieces for the apartments to which the staircase led. Thornhill, and later Hogarth, were undoubtedly aware of the large histories Kent had painted in Burlington House, on which he based the reputation which secured for him the Kensington Palace decorations. The Kent–Burlington kind of history painting must have contributed significantly to Hogarth's rejection of the mythological mode during the crucial years at the academy.

When the time came to decide on the commission for the decorating of the Cube Room, the judging body was an Office of Works hostile to Thornhill's art—not the same board that had given him his great commissions. Those who had not been purged were in no mood to support Thornhill, and the rest were in Burlington's pocket. Sunderland and his "Marlborough faction" were probably of little help to Thornhill after the earl's resignation from the Treasury following the South Sea scandal in the spring of 1721. The conflict of personalities had not helped Thornhill, but his fall must have been essentially doctrinal. With his removal, the school of fashionable purists led by Lord Burlington captured the Office of Works, and sealed the doom of the baroque school of Wren.

The St. Martin's Lane Academy flourished for a short while. The annual advertisement appeared in the *London Journal* for 12 October 1722 for the academy to commence on the first Monday in October:

> This Week the Academy for the Improvement of Painters and Sculptors, by Drawing after the Naked, open'd in St. Martin's Lane, and will continue during the season, as usual.
>
> N.B. The Company have agreed not to draw on Mondays and Saturdays.

The group presumably met the other nights of the week; it cannot have endured much beyond the 1723–24 season, however. Vertue writes that it survived "a few years," and Hogarth recalled that "this lasted a few years but the treasurer sinking the subscription money the lamp stove etc were seized for rent and the whole affair put a stop to."

With this collapse in mind, Thornhill in November 1724 made another attempt to get up an academy, again at his house in Covent Garden and gratis—again perhaps with a national academy, headed by himself, as his object. Whether Hogarth remained with the St. Martin's Lane Academy until the end is uncertain, but he must at this point have joined Thornhill's free academy.

Thornhill at this time, when Hogarth probably first met him, was in his late forties, evidently not as sober and staid as he appears in all the surviving portraits and self-portraits. Besides admiring him as an artist, Hogarth must have liked him as a man. Hogarth himself, though no portrait survives from this period, can be visualized by working back from the Roubiliac bust of 1740: a short, brisk young man with sharp features, more like a terrier than (as later) a pug. His acquaintances, if they had written about him, would have noted his great energy and, probably, his cocky self-assurance. Moving unhesitatingly up the ladder of acceptable artistic types, he was a person who found it necessary to prove his merit—and the Thornhills were his first important and knowledgeable audience.

In the Thornhill house he found a collection of paintings that included works by Caravaggio, Veronese, Annibale Carracci, Guido, Domenichino, Albani, Poussin, Rubens, Giordano, Sebastiano Ricci, Luti, and Pannini. Before long he became acquainted with a son named John and a daughter Jane, aged about fifteen then. In this household the great world of history painting and artistic polemic, of Burlington and Kent, was the center of discussion; and it was to become Hogarth's own world. Here it would be very evident that Thornhill, the Englishman, had for a few years enjoyed the greatest patronage (church and state) and produced subjects worthy of the grand style in which he rendered them (the growth of English national power and the life of St. Paul). Now the great patrons were turning to such as Kent, who lacked the style; and even the subject of an expanding England, if Thornhill had only known it, was becoming ludicrous in the age of Sir Robert Walpole. The phenomenon one may observe of the great painting with the great name, painted in the

grand manner for an aristocratic patron was passing, and the English denouement can be observed in Thornhill's career and its effect on Hogarth's career. This will be the story, or one story, of Hogarth's career. His first response was to satirize the perversion of "splendid patronage."

"THE BAD TASTE OF THE TOWN"

In February 1723/4 a small print, referred to in the papers as "The Bad Taste of the Town" (pl. 4, now generally called *Masquerades and Operas*), became a cause célèbre and was eagerly bought up, pirated, and reissued. This one satire ridiculed not only masquerades, operas, and pantomimes, but ignorant "connoisseurs" as well: at the center—clearly equated with these false tastes—was the gate of Burlington House, that Italian palace transplanted to the middle of eighteenth-

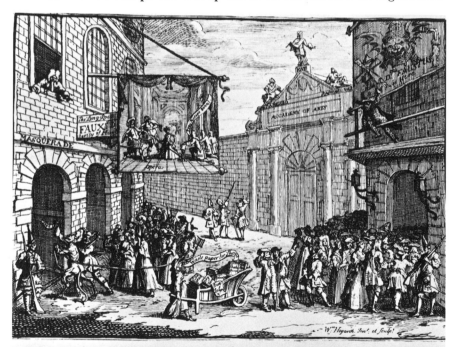

O how refin'd how elegant we're grown!
What noble Entertainments Charm the Town!
Whether to hear the Dragon's roar we go,
Or gaze surpriz'd on Fawks's matchless Show.
To be sold at y.º Golden Ball in Little Newport Street Price 1 shill. 1724.

Or to the Opera's, or to the Masques,
To eat up Ortelans, and empty Flasques
And rifle Pies from Shakespear's clinging Page
Good Gods, how great's the gusto of the Age.

4. Masquerades and Operas; Feb. 1723/4; 5 x 61¹¹⁄₁₆ in. (BM)

century London; and Burlington Gate was surmounted by a statue of William Kent, with Gay's allusion to him as a Raphael dramatized in the figures of Michelangelo and Raphael as slaves at his feet. The implication was that Burlington House was the very citadel of bad taste in London. The use of Kent must have been partly personal, but Hogarth was also indirectly retaliating for Sir James Thornhill.

To understand the genesis of Hogarth's first important print, however, two contexts must be considered. The first is his background in English literary satire, stimulated at an early age by his father's interest in books; the second, the *Spectator*, that great storehouse of socially shared Augustan attitudes, was the source, or at least the shaping influence, of many of Hogarth's satiric and aesthetic assumptions. The art treatises came later and were read through Mr. Spectator's eyes. Not that he agreed with everything in it—he took issue with Addison's statements about the ancients excelling the moderns in painting as in poetry, and he singled out No. 83 for criticism in *The Analysis of Beauty* and in *Time Smoking a Picture*. However, he accepted the general attitude toward art that Addison expresses in No. 5:

An Opera may be allowed to be extravagantly lavish in its Decorations, as its only Design is to gratify the Senses, and keep up an indolent Attention in the Audience. Common Sense however requires, that there should be nothing in the Scenes and Machines which may appear Childish and Absurd. . . . Musick, Architecture and Painting, as well as Poetry and Oratory, are to deduce their Laws and Rules from the general Sense and Taste of Mankind, and not from the Principles of those Arts themselves; or in other Words, the Taste is not to conform in the Art, but the Art to the Taste.

For better or worse, the *Spectator*'s simple aesthetic of the primacy of nature over art served Hogarth throughout his career: he consciously tried to ignore convention or rule when it did not stand the test of common sense, and he never trusted the taste of connoisseurs against that of the average man. Like the good Englishman he was, he wanted drama, with plot, speeches, and motives that could be understood. In a sense the story of his life was an attempt to apply the empiricism of *Spectator* criticism to painting, as his innate sense of color, form, and texture continually tried to reassert itself.

But in the year 1723 he was delving into satire and, like the *Spectator*, he could measure the operas, puppet shows, pantomimes, mas-

querades, and other popular amusements against a norm of common sense. Looking around for a timely subject for a satiric print, he could also refer to his memory of Kent's appalling presumption and to the shoddy paintings that were replacing Thornhill's.

Masquerades were topical throughout the 1720s; in 1723, while they were not getting any worse, they were attracting more unfavorable attention. The usual advertisements for costumes in the papers were augmented by notices of new anti-masquerade pamphlets and especially by notices of royal attendance, even patronage. The accusations against masquerades remained much the same as those made by the *Spectator* a decade earlier: "In short, the whole Design of this libidinous Assembly seems to terminate in Assignations and Intrigues."

If masquerades and operas constituted one popular source of entertainment, another was the pantomimes performed at Lincoln's Inn Fields Theatre by John Rich, a consummate pantomimist who called himself Lun. Even before he became a friend of Hogarth's, his performances, like those of many actors, were closely observed by the artist. Watching these performances, Hogarth—on his way to becoming a serious-minded moralist in the *Spectator* vein—must have felt that the drolls and spectacles of Bartholomew Fair were invading the classic English theater of the West End. Pantomimes were topics of discussion, and the subject for a satiric print began to emerge in the new popularity of *The Necromancer* and its victory over the serious theater: a subject easily dramatized by showing the plays of Shakespeare, Jonson, and Congreve being carted away from the Lincoln's Inn Fields Theatre, where *The Necromancer* is playing.

Another name familiar to Londoners of the 1720s was Isaac Fawkes (or Fawks, or Faux), the sleight-of-hand artist. His advertisements often mention his "Rewards from the Nobility"; a notice in the *London Journal* for 19 October 1723 reads "The famous Mr. Fawks, as he modestly stiles himself, has since Bartholomew and Southwark-Fairs, put seven hundred Pounds into the Bank; He may certainly challenge any Conjuror of the Age to do the like." Fawkes emerges from the papers as a symbol of distorted values, another illustration of misdirected patronage and degenerating standards of aristocratic taste. He also exemplifies the movement of sleight-of-hand entertainments from the fairs to the patrician West End. By 18 December he was performing in the same building with Heidegger, and Handel and his Italian

operas; and in the same room as the masquerades. Indeed his advertisement announced his times of performance as "beginning every Evening precisely at Five, excepting Tuesday and Saturday, being the Opera Nights, when there will be no Performance at all."

Hogarth at this point might have been reminded of the *Spectator* in which a projector explains that "he had observed the great Trouble and Inconvenience" entailed in going from one show to another in different parts of the town: the puppet shows were in one place, the dancing monkeys in another, and the opera in a third, not to mention the lions, far off in the Tower. His solution was to bring them all together in one place in a single opera.

Hogarth may have begun his print in December, but the final incentive came on 6 January of the new year, when Bishop Gibson preached the annual sermon before the Societies for the Reformation of Manners, and used the occasion to attack masquerades. He called them the chief of "the various engines contrived by a corrupt generation" to undermine public morality. They gave both sexes "the freedom of profane discourse, wanton behaviour, and lascivious practices without the least fear of being discovered." The Court, in lending itself to such designs, acts, he argues, as a model for the rest of the nation. Here, as in the *Spectator* attacks, are the implications explored in Hogarth's print and persisting in his later satires.

The print was published by 18 February; its major virtue was to unite in one image all the aesthetic follies of the time that had previously been attacked separately. The print uses the same composition as *The South Sea Scheme*, replacing the Guildhall with the Opera House, the monument with the Lincoln's Inn Fields Theatre, the merry-go-round in the background with Burlington Gate, and the chaotic mob of speculators with groups crowding to enter the respective buildings. The perspective is somewhat less eratic in the later print but, more important, Hogarth has used his composition to create parallels and contrasts: operas, pantomimes, palladianism, and Fawkes, all sharing the effect of distorting nature, attracting the nobility, replacing native talent with foreign fads, and putting out of business the representatives of true taste, whether Shakespeare and Congreve at Drury Lane or (by implication) Thornhill at Kensington Palace. The result is a design which makes its point with much greater clarity than *The South Sea Scheme*.

Hogarth's print is not aimed at the delusive quality of these enter-

tainments that the *Spectator* emphasized—though this was part of the context for a contemporary, who would have interpreted the fool drawing the infatuated crowd as the immersion in a fantasy life. The concern of Hogarth's print is, rather, with the relationship between the nobility as patrons and the crowd. In less than a week the print had achieved enough popularity to earn the dubious compliment of a piracy. On Monday 24 February Hogarth had run an advertisement in the *Daily Courant*. Evidently a cheap copy, passing for an original, was advertised the very next day, and on Thursday the twenty-seventh Hogarth replied in the *Daily Courant*:

> On Monday last it was advertised that the Original Prints, called the Bad Taste of the Town, to be sold at a Shilling a Piece; this is to confirm it, and to certify it will never be sold for less; and to prevent the Publick's having the Copy impos'd on them at certain Print Shops, by means of a sham Advertisement on Tuesday last. Note, Wm. Hogarth, Inv. et Sculp. is engraved at the Bottom of the Original.

Hogarth's earliest known advertisements, with their barely repressed indignation, already have that directness and vigor which was to characterize all his subsequent notices to his public.

The immediate culprit would appear to have been Thomas Bowles, "the great printseller" next to the Chapter House in St. Paul's churchyard, who was advertising a pirated copy on 6 March for 6*d*, and was one of those to whom Hogarth had consigned his print for sale. In 1720 Bowles' younger brother John had started a business of his own, but closely connected with his brother's, in a shop opposite Stocks Market. Although they appear to have been utterly unscrupulous, it should be remembered that prints were merely a commodity to them, that there were no laws protecting the artist, and that their contemporaries included such legendary scoundrels as the bookseller Edmund Curll. To Hogarth, looking back on his youth, this betrayal by the printsellers was to constitute one of the important parallels between his life and his father's.

It appears from his autobiographical notes that *Masquerades and Operas* was the first print Hogarth had sold on consignment, keeping the plate to himself. (The obscurity of *The South Sea Scheme,* the "first Plate" he published, makes it at least possible that he attempted the same there, with even less success.) In general, he sold his plates

outright. Having attempted this independent arrangement for *Masquerades and Operas,* he discovered first that his print was pirated, then that his own retail printshops were having cheap copies made. When he demanded his money he was told that no one had bought his originals—people had bought instead the cheap copies, on which the full printsellers' profit could be realized. In order to make any profit at all, Hogarth was at length forced to sell his plate, presumably to Bowles. The addition of Hogarth's address, "the Golden Ball in Little Newport Street," to a later state of the print may mean that he first took back his stock and tried to sell it himself, from his own shop, before giving up and selling the plate. Bowles continued to collect Hogarth's early plates and pirate his later ones, but Hogarth never again had anything professionally to do with the Bowles brothers; he turned to the other major printselling family of the time, the Overtons.

By 1724 he had left his mother's house and moved to a room or a floor in a house in Little Newport Street, evidently used as a shop, with the sign of a golden ball. He cannot have been very well off. The money, as well as the reputation, from a plate like *Masquerades and Operas* would have been of the utmost importance to the young artist; the experience undoubtedly contributed to his continued outrage over piracies in the 1730s, and it remained fresh in his mind nearly forty years later when he wrote his autobiographical notes.

But if he did not make the profits he anticipated from his print, he at least brought himself to the attention of the public. Nicholas Amhurst, for one, praised the print in *Pasquin* and employed him to make a frontispiece for his collected *Terrae filius* papers; subsequently, as editor of the *Craftsman,* he may have brought Hogarth's work to the attention of Bolingbroke, Swift, and (if the attack on Burlington had not already done so) Pope. As a satirist he was now a known force on the London scene. He had not only launched his career and experienced pirating but had also produced a print that was to influence Pope's conception of *The Dunciad* (1728) and thereafter a whole stream of satires, culminating in Fielding's farces. Satire was a form that was much appreciated in the 1720s; Hogarth came upon the scene at just the right moment, when the tradition of Butler, Dryden, Swift, Pope, and Gay had reached its ultimate fruition and prepared the public for a graphic satirist of comparable stature. Hogarth filled that need. As this timing explains something of Hogarth's very

rapid rise, so the waning of interest in satire in the 1750s explains something of his difficulties in that decade.

Masquerades and Operas either introduced Hogarth to, or ingratiated him with, Sir James Thornhill. Between its appearance in February and the opening of Thornhill's academy in November, Hogarth showed in various ways the presence of Thornhill in his thoughts. He might have seen the paintings in St. Paul's and Greenwich Hospital many times before, but only at this point did he begin to reveal what he was learning from them. With Thornhill's help, Sir Richard Steele wrote an elaborate account of the Painted Hall when it was finished in 1714, which later served as the basis for the pamphlet called *An Explanation of the Painting in the Royal Hospital at Greenwich*. It is a little difficult to imagine Hogarth grasping the significance of these coruscating figures without some such key or Thornhill's own guiding hand. But at about this time such figures began to appear in his ambitious plate, *The Lottery* (pl. 5), which reflects signs of academic training, knowledge of Raphael's *School of Athens,* and firsthand study of Thornhill's Greenwich ceiling.

Another print, *The Prince of Wales,* apparently originated at about the same time from Hogarth's contact with Thornhill's ceiling of the Upper Hall, which had been finished in October 1722. The Hercules figure, which Thornhill calls in his *Explanation* "Heroic Virtue," appears, as does Wisdom—Pallas Athena—shown on the ceiling of the Painted Hall together banishing Calumny, Detraction, Envy, and others. It is appropriate that Hercules should figure centrally in Thornhill's allegory of the Protestant Succession; as Heroic Virtue, Hercules was iconographically connected with William III, fighting the Hydra of France. Hercules appears again on the ceiling of the Upper Hall supporting a portrait of Queen Anne and Prince George, assisted by Conjugal Concord, Liberality, Piety, Victory, and Neptune. And this is the way Hogarth uses Hercules in his print, supporting the portrait of the Prince of Wales with various goddesses and muses offering homage and the riches of England. He was to refer directly or obliquely to this figure, with his associations of Heroic Virtue, the Protestant Succession, England, Greenwich, and Thornhill, throughout his career.

At about this time Hogarth was etching a satire based on the William and Mary on the ceiling of the Lower Hall—or on George I and

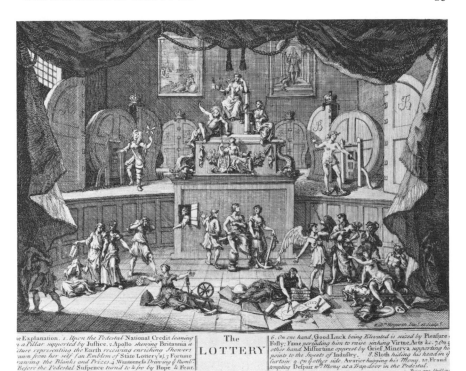

Explanation. 1 Upon the Pedestal National Credit leaning on a Pillar supported by Justice. 2 Apollo shewing Britannia a picture representing the Earth receiving enriching Showers drawn from her self (an Emblem of State Lottery's) 3 Fortune drawing the Blanks and Prizes. 4 Wantonness Drawing of Numb.r Before the Pedestal Suspence turn'd to & fro by Hope & Fear. 6. On one hand, Good Luck being Elevated is seized by Pleasure, Folly; Fame persuading him to raise sinking Virtue Arts &c. 7.On y.e other hand Misfortune opprest by Grief, Minerva supporting him points to the Sweets of Industry. 8.Sloth hiding his head in y.e Curtain 9 on y.e other side. Avarice hugging his Mony. 10 Frand tempting Despair w.th Mony at a Trap-door in the Pedestal.

Price one Shilling

5. The Lottery; publ. 1724; 8¹³⁄₁₆ x 12⁵⁄₈ in. (BM)

his family, which Thornhill was then preparing for the wall of the Upper Hall (pl. 6). In the same baroque robes and accouterments, the same cloudy surroundings as Thornhill's Greenwich paintings, he posed a king, a bishop, and a judge. The occasion for this etching, usually called *Royalty, Episcopacy, and Law* (pl. 7), had arisen in the spring of 1724 when a flurry of articles and pamphlets appeared anticipating a solar eclipse on 11 May. Amid all this excitement, Hogarth imagines what one might see through a telescope when the moon intervenes between earth and sun. The telescope reveals what was not visible at the great distance that stretches beween these regal figures and the public (whether on a Greenwich ceiling or in fact): that they are only robes hung over frames, the king's head turning out to be merely a guinea, the bishop's a Jew's harp, and the judge's a gavel. The print uses the forms and scale of the Thornhill royal families, while the details are drawn from the oldest, most primitive emblematic tradition of graphic satire, reaching back to the Reformation por-

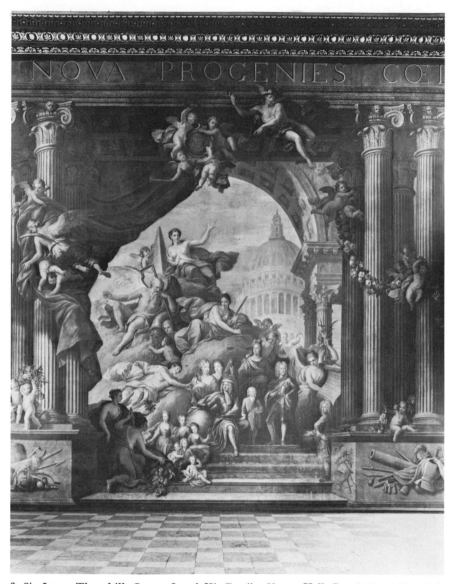

6. Sir James Thornhill, George I and His Family, Upper Hall, Royal Naval Hospital, Greenwich; 1722–24 (British Crown Copyright)

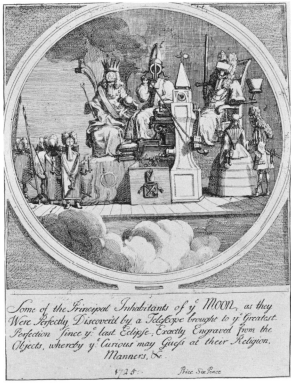

Some of the Principal Inhabitants of ye MOON, as they Were Perfectly Discovered by a Telescope brought to ye Greatest Perfection since ye last Eclipse; Exactly Engraved from the Objects, whereby ye Curious may Guess at their Religion, Manners, &c.

1725. *Price Six Pence*

7. Royalty, Episcopacy, and Law; May 1724; 7¼ x 7 in. (BM)

trait of the pope's head: on close scrutiny, it proves to be constructed entirely of symbolic popish objects like wafers and chalices. Thus the tongue of the Jew's harp which is the bishop's head is operated by the handle of a pump that resembles a church tower. Pumping the handle (around which is wrapped a Bible) rings a bell in the steeple and pours coins into a chest stamped with the bishop's armorial bearings: knife, fork, and spoon below a miter. His left foot, peeping out from under his robe, is a cloven hoof. With the increased size of the figures relative to the picture space Hogarth has advanced a long way from the tiny, crowded figures of his earlier "drolls." If in *The Lottery*—no longer a cartoon but a kind of history engraving—he stepped from purely emblematic satire into allegorical representation, in *Royalty, Episcopacy, and Law* he used these baroque shapes that appear to be king, bishop, and judge to betray the trumpery reality beneath the

garb of power. Thereafter he continued to emphasize the baroque finery, while playing down the crudely emblematic ridicule.

Royalty, Episcopacy, and Law must have been published in May or June; *The Lottery* was finished and announced for sale on 19 September in the *Daily Post*. The advertisement itself suggests that it may have been started earlier, perhaps shortly after its pendant *The South Sea Scheme*, but was only completed and published in the wake of the popular *Masquerades and Operas:* "On Monday next [i.e. 21 September] will be publish'd, a curious Print, call'd, the Humours of the LOTTERY, by the Author of the little Satyrical Print, call'd the Taste of the Town. To be sold the Corner of Hemmings Row [;] in Little Newport-street, and most other Print Shops, Price 1 s."

By the end of 1724 Hogarth must have been dividing his time between his quarters in Newport Street, his mother's and sisters' flats in the vicinity of St. Bartholomew's Hospital, and the Thornhill residence in Covent Garden. His thoughts and his work were revolving around Thornhill, and when he came to visit Thornhill's house it was probably more as a friend, or possibly a son, than as a student.

Hudibras

The next event that brought Hogarth and Thornhill together was the death of the robber and escape artist Jack Sheppard. Sheppard's last and most spectacular escape had been from Newgate Prison on the night of 15 October—"to the great Admiration of all People," as the *Weekly Journal* said, "he being chain'd down to the Floor in the Castle of the Jail, with Fetters on his Legs of a prodigious Weight." He was quickly recaptured, however, and did not escape again. *The History of the Remarkable Life of John Sheppard* was advertised on the nineteenth, and on the twenty-fourth a portrait "drawn by a Painter who went to see him" was advertised by Thomas Bowles. On 10 November the *Daily Journal* noted that "Sir James Thornhill, the King's History Painter, hath taken a Draught of Sheppard's Face in Newgate."

It is interesting to surmise why Thornhill decided to draw a convicted criminal at this particular time, and what Hogarth had to do with it. The Sheppard portrait was a unique phenomenon in Thornhill's career, but not completely inexplicable. In his huge sketchbook (now in the British Museum) allegorical designs in the grand style are

jostled, sometimes on the same page, by sketches of intimate, realistic, sometimes grotesque characters in the manner of Dutch "drolleries." This was not an unusual predilection or sideline for a history painter like Thornhill, but he never allowed this predilection to get the upper hand. He painted a number of portraits, but except for the one of Sheppard they were all conventional.

Thornhill's hobby, as it might be called, explains the origin of his regard for Hogarth and perhaps the pleasure with which he received *Masquerades and Operas*. Whenever he and Hogarth first met, they would have recognized a mutual taste for "drolleries" and a reaction against the idealized world of history painting.

Around the first week in November Thornhill went to Newgate and drew the powerful picture of the thin, almost childlike criminal, alone in his cell (pl. 8); he was hanged on 16 November, aged twenty-two. On the twenty-eighth the *British Journal* published a poem celebrating Thornhill's immortalizing of Sheppard. On the day the *Journal's* encomium appeared, the patentees of Drury Lane—Cibber, Wilks, and Booth—produced their own exploitation of Sheppard, a pantomime called *Harlequin Sheppard,* intended to out-pantomime Rich. On 5 December the Bowles brothers and George White published White's mezzotint of Thornhill's portrait at a shilling. On the tenth Hogarth's own response to Sheppard, to Drury Lane's pantomime, and in some sense to Thornhill's portrait too was published: "A Print representing the Rehearsal of a new Farce, call'd three Heads are better than one, including the famous Entertainments of the Harlequin Doctor Faustus, and Harlequin Shepherd . . . Sold at the Print Shops in and about London and Westminster. Price 6d." It is reasonable to assume that Hogarth returned to a proven subject when the occasion offered itself, and in *A Just View of the British Stage* produced an adjunct to *Masquerades and Operas*. Why, however, did he and so many of his contemporaries pick on the patentees of Drury Lane, when Rich was the more blatant offender—the Father of the Evil, so to speak? These attacks began in 1718 and continued more or less up to 1724. The answer is that Hogarth attacked not the obviously reprobate but the hypocritical, the disappointing, or the pretentious. Steele had been made governor of Drury Lane with great hopes that he would implement the strictures against bad theater he had published in the *Tatler* and the *Spectator;* theatergoers hoped for

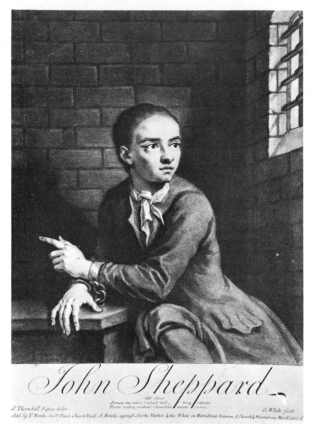

J.Thornhill Expon delin. G.White fecit.

8. Sir James Thornhill, Jack Sheppard (engraving by
George White); Dec. 1724 (BM)

a Jeremy Collier to purge the stage of indecency and the prevalent
pandering to the lower instincts of the rabble. Alas, in order to sur-
vive, Drury Lane was forced from the outset to imitate Lincoln's Inn
Fields and even the opera: introducing a pair of pantomimists from
France for harlequinades, singers for operas (albeit in English), danc-
ers, jugglers, and tumblers to follow the play, and other examples of
what Addison and Steele regarded as irrational entertainment. The
same plays that Steele had attacked also continued to be performed
and, in the early days at least, Drury Lane was successful in its rivalry
with Lincoln's Inn Fields. In 1724 Drury Lane was still professing
high ideals of art and morality while trying to outdo Lincoln's Inn

Fields in the sentationalism of its harlequin pantomimes. It was ac-
cordingly an obvious target.

After this one glimpse of a common area of experience, and Thorn-
hill's and Hogarth's reactions to it, all is in darkness until publication
of the large *Hudibras* plates—far removed from the small, grotesque
Hudibras illustrations—but it is not impossible to fill in the few years
between. While Thornhill knew all there was to know about decora-
tive and history painting, he was also intrigued by the present, which
he could only express from time to time in portraits, sketches, or a jeu
d'esprit like the portrait of Sheppard. By the same token, Hogarth had
a great natural talent for the immediate observation of contemporary
life, but wanted to learn about the higher reaches of art. Clearly
Thornhill was seriously concerned, in the working out of conflicts
in the portrayal of King, courtiers, and crowd in the Upper Hall at
Greenwich, with the problem which Hogarth was to see as the central
one of his career: how to treat a modern subject in history painting,
or, conversely, how to make history painting relevant to the con-
temporary world.

When Hogarth met him, Thornhill was no longer anchored in his
baroque Greenwich phase. The Greenwich ceiling reflects the influ-
ence of Pietro da Cortona, modified in favor of Venetian baroque by
the colors. With their rigorously conceived and executed allegories,
these paintings exerted considerable influence on Hogarth's engraved
work of 1724—in one instance as a direct imitation, in the others as
parodic forms. The panels at St. Paul's, however, and the side panels
of the Upper Hall at Greenwich, all grisaille, are quite different. They
are modeled in general on the Raphael Cartoons—at St. Paul's they
use the same subject—and are clearly defined, sculpturally composed,
and largely classical, though not without Rubensian overtones. The
designs at St. Paul's are taken from Raphael and his French imitators
and, in one instance, from Rubens.

Though Hogarth was initially influenced by the Greenwich ceiling,
as he got a grip on his engraving and worked up to *Hudibras,* he
seems to have preferred the grisaille Raphaelesque biblical subjects,
whose monochrome may have contributed to the needs of an en-
graver, over the classical mythology and the swirling Venetian forms.
Thornhill himself seems to have been moving in this direction at the

time. The more serious Raphaelesque Thornhill, while adopting the Venetians' color and, in his sketches, their freedom of brushwork, must have objected to their essentially decorative conceptions and played down their influence in his own didactic histories.

This conception of history painting was, I think it safe to surmise, presented to Hogarth as normative, free of the baroque excesses of certain old masters. Thornhill must have urged Raphael's Cartoons on Hogarth and stressed a view of history painting that is best summed up in Steele's *Spectator* essays. It is no coincidence that the essays on art that most influenced Hogarth were by Thornhill's friend, and perhaps student in things artistic, Richard Steele, who sat for his portrait to Thornhill, was a member of the Queen's Street Academy, reported an elaborate exegesis (no doubt Thornhill's own) of the completed Painted Hall in one of his periodicals, and expressed views in the *Spectator* similar to Thornhill's. Perhaps because of his connection with artists like Kneller and Thornhill, Steele took art as his own province in the *Spectator*.

The single most important dictum, as Steele says, was that moral pictures express themselves "in a Manner much more forcible than can possibly be performed by the most moving Eloquence." Hogarth frequently echoes the sentiment, insisting that his prints embody "what cannot be conveyed to the mind with such precision and truth by any words whatsoever." Moreover, according to Steele, history painting is now merely decorative and operatic, concerned with satyrs and nymphs, out of touch with real people and real problems; to be proper history painting the mythological subjects should be replaced by meaningful ones.

These precepts, combined with the conventions of history painting, were first practiced by Hogarth in the twelve large engraved plates for Samuel Butler's *Hudibras,* which he executed during 1725. Significantly, Hogarth made his initial statement about history painting as an engraver—before he could possibly have considered himself a painter, perhaps before he had even touched brush to canvas. *Hudibras* fitted into the tradition of history painting understood in Hogarth's England largely through the engraved reproductions by Dorigny, Dubosc, and Baron, rather than through the paintings themselves (which, except for the Raphael Cartoons, were far off in Italy); it implied a large painted original that in this case did not exist. In a real sense the print, not the painting, was Hogarth's history.

Sometime between the success of *Masquerades and Operas* in February 1724 and the autumn of 1725, Hogarth came to an understanding with the printseller Philip Overton about producing a set of large illustrations to *Hudibras*. Overton may have been impressed with the success of *Masquerades and Operas*, or Hogarth may have approached Overton with samples; it is impossible to know who conceived the idea, though Overton's reluctance to attach Hogarth's name to the advertisements suggests that he considered the subject more important than the artist. The scheme played on the popularity of the Coypel *Don Quixote* plates; Hogarth had seen the French edition, engraved by Beauvais. Overton published large copies, engraved by Bickham and Mynde, in 1725, and their success must have suggested to either Hogarth or Overton that "the don Quixot of this Nation," as they called Hudibras in the ads, could profitably be treated in the same way.

Hudibras was the satire Hogarth had turned to earlier, perhaps as his first engraved subject, and it is easy to imagine him experimenting, copying, elaborating, gradually inventing his own style and designs with this book which may from childhood have stimulated his impulse toward satiric art. The small etchings, based on designs in the wooden style of English book illustrations of the early eighteenth century, were rough but forceful versions of Dutch low-life pictures—an experiment in the grotesque.

By 1725 Hogarth was no longer interested only in the grotesque. Early in that year he made two illustrations for Milton's *Paradise Lost;* though quite small, they are patently in the grand manner which he had no doubt been practicing at the academy. Five plates for La Calprenède's *Cassandra*, published in September, were further efforts in the same direction. The illustrations for *Paradise Lost*, though evidently intended for an edition Jacob Tonson was bringing out, found no buyer. Thornhill had furnished designs for Tonson and may have been Hogarth's sponsor. But the illustrations must not have satisfied Tonson, or perhaps he already had an illustrator more to his liking. Hogarth's reputation, what there was of it at the end of 1724, was for facetious drawings in the Dutch manner, and foreign artists were as much the staple of book publishers as of picture dealers. Hogarth was thus drawn back to his forte, the *grotesque*.

But in the large *Hudibras* plates he successfully juxtaposed the grotesque and the heroic styles. He was able to work to a congenial size

now, as had not been the case with the tiny book illustrations. The
Coypel *Don Quixote* plates provided a general sanction for the sub-
ject as well as the size and shape, and for the idea of vending a series
of large plates from a well-known book *extra libris,* presumably for
framing. What Coypel did not supply was a model for his contrast of
the grotesque and heroic; Coypel's *Quixote* is simply delicate French
rococo. Hogarth makes his program clear in the frontispiece (pl. 9),
which includes in one design the satyrs, fauns, putti, and goddesses of

9. Frontispiece, *Hudibras* (large plates); Feb. 1725/6; 9⅜ x 13⁹⁄₁₆ in. (BM)

baroque book illustration—and, for that matter, of the history paint-
ing attacked by Steele—with the grotesque shapes of Butler's poem.
A satyr lashes Hudibras and Ralpho, yoked to the scales of Justice and
drawing his chariot around the foot of Mt. Parnassus, and leading, as
in a triumphal procession, Hypocrisy, Ignorance, and Rebellion. The
putto who sculpts this scene has for his model not ideal Nature (por-
trayed as Britannia) but Butler's satiric poem, held before him by an-
other satyr. This group is balanced on the other side of the frieze by

a faun holding up to Britannia's face a mirror which reflects an undistorted image, implying no doubt that England under the Hanovers no longer resembles Butler's picture (the caption refers to the "Vices of those Times"), and also that Hogarth has deliberately turned from ideal Nature to satire for his subject—yet still within the convention of history painting, exemplified by the putti and satyrs. In the subsequent plates Hudibras and Ralpho take over and the conventional figures disappear, although references remain in the size and relative monumentality of the contemporary figures and the heroic compositions in which they perform. The result is what might be called a grotesque history painting, one step on the path to what Steele seems to be defining as the modern history painting.

The influence of academy drawing classes is apparent, but Hogarth's principal source was the Raphael Cartoons. The rectangular plates recall the histories of Raphael, as does the horizontal band of figures, relatively large in relation to the picture space, with space above and one or more repoussoir figures below. All are more separate and clearly defined, more expressive and articulated, than in his earlier prints. The monumentality and the planimetric, almost classical composition set off the *Hudibras* plates from the rollicking low-life scenes of the Dutch baroque as well as the delicate rococo of Coypel's *Don Quixote*.

The formula is still, like Thornhill's, a somewhat baroquized Raphael, as is clear in the most baroque of the plates, *Hudibras and the Skimmington* (pl. 10). Here Hogarth has based his composition quite consciously on the decorative processional paintings that Steele must have had in mind when he referred to fauns and satyrs. The baroque shapes in *The South Sea Scheme* and *The Lottery* were ideal forms against which to judge satirically the grotesque shapes of the fools and knaves. But in *Hudibras* the baroque has become more equivocal: the curving, twisting shapes are used to portray the antics of the grotesquely deformed Hudibras, of rustics and buffoons. As a reader of Butler, however, and a follower of Dryden and Swift, Hogarth does not stop here. The contrast between the composition and the rustics and buffoons is mock-heroic. Hudibras (Butler's gross, hypocritical version of Don Quixote) is the Puritan who sallies out in search of imaginary evils and claims to see in the innocent Charles I the antichrist, and in a bear-baiting a manifestation of the devil. Here he is trying to interfere with a Skimmington, a procession celebrating a

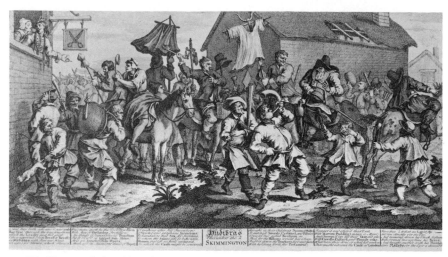

10. Hudibras and the Skimmington; $9\frac{11}{16}$ x $19\frac{1}{2}$ in. (BM)

henpecked or cuckolded husband, regarding it as much more sinister than the traditional rural sport it was. The contrast between the grotesque shapes of the rustic bumpkins, including Hudibras himself, and the swirling heroic forms of such baroque processionals as Carracci painted would have implied for Dryden and Pope the sad degeneration of the present revealed by a contrast with the heroic past: a Shadwell, Theobald, or Cibber against an Aeneas or Vergil. The theme of divine love—the god who finds the beautiful mortal, Ariadne, abandoned by her lover—is reduced to the cuckolded husband with his shrewish wife. But Hogarth, like Butler, also uses these forms to objectify Hudibras' crazy image of himself and his surroundings. Hogarth, ultimately, is attempting to create a modern history, not to denigrate moderns in terms of classical history painting.

The use of, and attitude toward, history painting may seem somewhat equivocal in the *Hudibras* plates. The history is, of course, religious and not mythological; Hudibras is a religious hypocrite. His progress is a series of confrontations with the sane, if disorderly, secular world of bear-baiting, tippling, and cuckolding. The two oversized plates emphasize the conflict: the first (pl. 10) shows Hudibras in futile combat with the Skimmington mob, and the second—the climactic plate (pl. 11)—depicts the populace rejoicing at the overthrow of Puritanism and the restoration of Charles II, launching a saturnalia that includes the burning of Hudibras and his followers in effigy. The

confrontation of Carnival and Lent is a motif that runs, in one form
or another, through Hogarth's work and reappears in almost precisely
the same guise ten years later in *Night,* the climax of *The Four Times
of the Day,* which also takes place on Restoration Day.

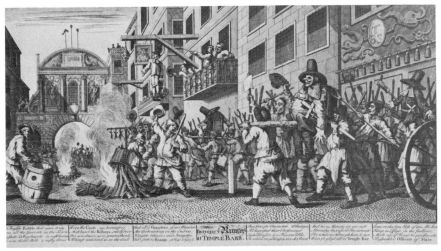

11. **Burning the Rumps at Temple Bar; 9⅑₁₆ x 19⁷₁₆ in. (BM)**

Drawings and unfinished proofs survive from this series. The draw-
ings are very competent and finished exercises in academic discipline,
probably reflecting both Hogarth's recent training and his need for
finished drawings to show Overton. The drawings for the early plates
are equally polished but in different styles: one is executed in a pale
yellow wash and finished with a delicate pen line, another is done
more boldly in red chalk. It may be significant that the drawings be-
come sketchier and less complete as they near the end of the series:
they have served their purpose with Overton, and now Hogarth can
work for himself. His own sketches are almost invariably private nota-
tions; only the ones made for submission to a publisher or for an en-
graver are relatively finished. (The careful drawing for *The Lottery*
therefore may have been for purposes of sale or an advance toward the
engraved plate.)

Something more of Hogarth's intention in these plates can be seen
in his title-page dedication to the Scottish poet Allan Ramsay. Ram-
say, both a poet and an Edinburgh bookseller, subscribed for thirty
sets and evidently sold them in his shop. It is thus difficult to say

whether Hogarth dedicated the plates to him because he bought thirty sets or because he wrote congenial poetry. There may have been some Scottish family connection, but Ramsay's north-country background, certain aspects of his career, and the kind of poetry he wrote would suffice to explain the dedication. In fact, considering the profession that Ramsay's son Allan, then twelve years old, was to follow, there was some prescience in the dedication.

Ramsay was born in 1684 or 1685, twelve years Hogarth's senior. After his apprenticeship he set up in Edinburgh in 1710 as a periwig maker. His first poems began to appear in 1713, and by 1718 he had established himself as his own publisher, an idea that might have had some influence on Hogarth. In 1719—another interesting parallel—he began a campaign against literary pirates, successfully appealing to the town council. In 1720 he published the octavo edition of his collected works and issued proposals for a subscribers' edition. Between 1723 and 1725 he gave up wigmaking for bookselling. To Hogarth, he would have appeared a Scottish Samuel Butler, with overtones of William Hogarth in his generally heroic treatment of objects both commonplace and symbolic.

The co-dedicatee of the *Hudibras* plates is a more puzzling case. William Ward of Great Houghton was a London barrister, a man of about forty-four. He reputedly commissioned Hogarth to produce a set of *Hudibras* paintings for his country house, East Haddon Hall; there is no other recorded connection between them. Although it may be placing the cart before the horse to see this commission as the reason for the dedication, such a theory would conform to Hogarth's later practice; he was likely to dedicate a series to the first subscriber, or to someone who subscribed and was so taken by the seven or eight plates he saw that he commissioned the series painted.

Proposals for the subscription to the *Hudibras* plates were published 6 October 1725, and the set was promised for Christmas. It is evident from the dimensions given that two of the seven plates finished were the *Skimmington* and *Burning the Rumps at Temple Bar*. There was no mention of the artist's name, and the set was subscribed for only 15*s*, with 5*s* paid down. By 30 November, when a new advertisement appeared, the price had gone up to 18*s*. The increase was not explained, and only two more plates were finished. Some sort of disagreement or crisis must have arisen. It is difficult to imagine Hogarth being dilatory or turning to some other work (except briefly) when

this important project was underway; an argument with Overton over the business aspect of the subscription, or illness, would be the most reasonable explanation. The Christmas publication date was not met, and there were no advertisements between 7 December and 3 February, when the plates were finally announced as ready for subscribers on the twenty-fourth (the subscription for the first impression was closed on the twelfth). At this point the information that they were "Designed and Engraved by Mr. Hogarth" was added, and the price was once again reduced to 15s. The inclusion of the name at this late date can only mean that Hogarth insisted on it, or that the fame of the plates, seen in Overton's and Cooper's shops, had spread. (The unsigned *Kent's Altarpiece,* his only achievement in the interim, would hardly have drawn attention to him.) But his name was again missing from the ads once the plates were finished and announced ready for the subscribers.

On 3 May the seventeen small plates appeared too, illustrating an octavo edition of *Hudibras.* Their belated publication was certainly elicited by the success of the large plates; in the advertisements and on the title page Hogarth's name appears prominently.

The question of what constitutes true history painting arose in a somewhat different form in 1725, when Thornhill and Hogarth clashed a second time with William Kent. Burlington and his other enthusiastic friends had been pushing Kent toward the chimera that was history painting. On 23 July 1724 Kent had written to Massingberd that he was engaged to paint an altarpiece for the new church in George Street near Hanover Square. In 1725 a commission was secured for him to paint an altarpiece for St. Clement Danes Church in the Strand, which was finished and in place by August. On the twenty-fifth the *Daily Post* noted:

> The Altar Piece at the Church of St. Clements' Dane, being a musical Representation, variously explain'd, some finding in it St. Cecilia and her Harp, and some, Princess Sobieski [the Pretender's wife] and her Son, but the Generality agreeing it was not a Thing proper to be placed there; upon Complaint to the Bishop of London at his last Visitation of the said Church, we hear his Lordship, in order to secure the Solemnity of the Place and Worship, and to preserve Peace and Unity among the Parishioners, hath lately very prudently order'd the Church Wardens to take it down.

Hogarth was so intrigued by this event that he took time off from the *Hudibras* plates (of which six or seven must have been finished), to get in another dig at Kent and to express himself on the matter of religious art. His reaction must be gauged from his version of the altarpiece (pl. 12), a scathing commentary with its great, lumpy, totally bungled bodies (no doubt a final memory of drawing sessions at the academy), its conventional cherubs and clouds, and its total lack of spiritual significance.

In the wake of the *Hudibras* plates, another major engraving project was undertaken and abandoned; perhaps it was inevitable that the "English Don Quixote" would be followed by the Spanish. Jacob Tonson, who had seen but not used Hogarth's two illustrations for *Paradise Lost,* was publishing a series of ambitious works in the mid-1720s. An elaborate edition of Racine in 1723 was followed by Tasso's *Gerusalemme Liberata* in 1724, both in the vernacular, both illustrated luxury editions. Sometime in 1726 Tonson and Lord Carteret, the Whig politician, then Lord-Lieutenant of Ireland, projected a similar Spanish-language edition of *Don Quixote.* Carteret, known as an accomplished Spanish scholar and admirer of Cervantes, apparently assumed responsibility for all aspects of the edition. The Tonson edition of Tasso had simply used re-engravings of the Bernardo Castello designs (first printed in 1590), but Carteret wanted original designs, and furthermore disapproved of Coypel's rococo illustrations. One can only conjecture on what happened at this point. Six finished engravings by Hogarth survive, and innumerable drawings by John Vanderbank eventually engraved by Gerard Vandergucht, who had also engraved small copies of the Coypel illustrations for another edition.

It is easy enough to reconstruct Vanderbank's progress. A set of sixty-two preliminary designs in the British Museum is dated between 1726 and 1729 (five, however, are marked 1730) and signed with his full name and "invenit." A set of sixty-five in the Pierpont Morgan Library replaces "invenit" with "fecit" to distinguish them from the preliminary designs; these are the finished drawings from which the engravings were made. They are all dated 1729 in Vanderbank's hand, some with the exact day of August and September. The tailpiece of two fighting horsemen, the last to be completed, is signed "December 22, 1729." This must have been the cutoff date; after that, Hogarth can have had no more contact with the project. In fact, he was prob-

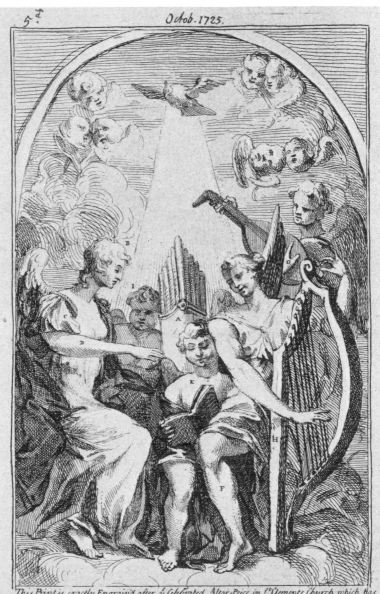

This Print is exactly Engraiv'd after y Celebrated Altar-Peice in S.ᵗ Clements Church which has been taken down by Order of y Lord Bishoᵖ of London(as tis thought) to prevent Disputs and Laying of wagers among y Parrshioners about y Artists meaning in it. for publick Satisfaction here is a particular Explanation of it humbly Offerd to be writ under y Original, that it may be put up again by which means y Parishes 60 pounds which thay nicely gave for it may not be Entirely lost 1.ˢᵗ Tis not the Pretenders Wife and Children as our weak brethren imagin 2.ᵈˡʸ Nor S.ᵗ Cecilia as the Connoisseurs think but a Choir of Angells playing in Consort

A an Organ
B an Angel playing on it
C the shortest Joint of the Arm
D the longest Joint

E an Angel tuning an harp
F the inside of his Leg but whether right or Left is yet undiscover'd
G a hand Playing on a Lute

H the other leg judiciously Omitted to make room for the harp
I Smaller Angells as appears by
K their Wings

12. A Burlesque on Kent's Altarpiece at St. Clement Danes; Oct. 1725; 11⅛ x 7 in. (BM)

ably out of the picture by the end of 1727 when he began to devote himself to oil painting. His six illustrations are for the beginning of the book and deal, with one exception, with the same episodes as Vanderbank; but the precise moment and the interpretation are different.

The commission was obviously impossible for Hogarth from the start, less because of the subject than the sponsorship. To begin with Carteret himself, it is difficult to say how much of a Burlingtonian he was politically, but aesthetically his taste had been conditioned by Shaftesbury and the Burlington circle. If Hogarth did not withdraw, he was rejected; but some sort of a contract had been made, and he was paid, for the finished drawings remained the property of Tonson, passing to Dodsley when the publishers merged and eventually published long after Hogarth's death. Two drawings have survived, one on the blue paper used for *Falstaff and His Recruits* and *The Beggar's Opera* paintings early in 1728, the other in the style of some of the *Hudibras* drawings (and the Vanderbank drawings). The decision to discontinue, however, must have been made on the basis of the prints. The etching style itself isolates the figures, making them stand out much more than Hogarth's subsequent works of the 1730s (pl. 13). They were perhaps too Coypelish in design and not delicate enough in execution for Carteret, suffering the disadvantages of a rococo design without the saving grace of Vandergucht's smooth style.

Around the time of the Tonson project, either just before or just after the *Hudibras* illustrations, Hogarth planned a large *Don Quixote* series like the *Hudibras* plates. The choice of *Sancho's Feast* is typical of Hogarth in that he takes the plebeian Sancho as his subject rather than the aristocratic Don Quixote and shows him deluded into thinking he is the King of Baratraria, with his folly being exploited by his "subjects," who are starving him. Here he is, as the caption tells us, "Starved in the midst of Plenty" because he sees himself, and thinks he is seen by the others, as king. This, rather than Hudibras and the bearbaiters or Don Quixote tilting against windmills, is the situation par excellence of Hogarth's later works. The *Don Quixote* illustrations are more important than Hogarth's own small part in the Carteret edition might imply. In art as in literature Cervantes' classic served in the eighteenth century as a bridge from classical concepts of decorum and rules to the genuine interest in the ordinary experience of everyday. Clearly, this influence was felt by Vanderbank as well as

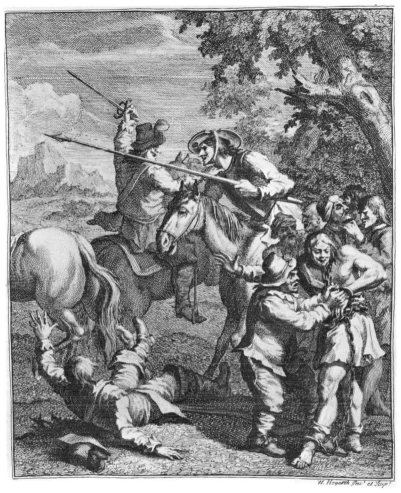

13. The Freeing of the Galley Slaves, illustration for *Don Quixote* (caption omitted); ca. 1727; 8¹¹⁄₁₆ x 7⅛ in. (BM)

Hogarth. Even Vanderbank's designs, with all their revisions, did not wholly satisfy Carteret.

Vanderbank is an interesting case, parallel in his way to Thornhill, and representative of the serious English artist of the time. Thornhill, the successful history painter, had yearnings for the particularity and disorder of everyday contemporary life. Vanderbank, the successful portraitist who also tried his hand at conventional decorative painting, was occupied for most of his short career with drawings and paint-

ings of *Don Quixote,* starting at just the time Hogarth made his
Hudibras and *Quixote* plates. Toward the end of his life he was using
these paintings to satisfy his creditors. Thus he is another case of the
schizoid English artist of Hogarth's time, making a living by portraits
but yearning for a more personal expression, relevant to his own time
and surroundings, which could only be achieved through interpreting
Cervantes' story.

It was Hogarth's aim, expressed in the abortive *Quixote* plates, to
find this outlet and make it available for all English artists. If one may
judge by his example, English book illustration of the first half of the
eighteenth century (probably from around 1720 on) contributed
strongly to the trend away from portraiture, even from idealized his-
tory painting, toward treatment of everyday subjects. Picaresque tales
and other forerunners of the English novel, above all *Don Quixote,*
served as important transitional agencies, providing artists like Ho-
garth and Vanderbank with a subject and (in book illustrations) an
outlet for concerns that were suppressed by orthodox critical stand-
ards. Vanderbank, in turning to oils as a medium for his *Quixote* il-
lustrations, parallels Hogarth, who had gone as far as he could with
engraving; oils were necessary before he could take the next step up
and far beyond Vanderbank.

After *Hudibras* and *Don Quixote* Hogarth made no further major
effort at engraving until the *Harlot's Progress,* which would solve for
him the problem he shared with Vanderbank. Considering the very
small number of engravings he issued between 1726 and 1732, it seems
certain that during these years his energies were channeled into paint-
ing. A few additional prints, however, deserve mention.

A tradition has it that Hogarth was approached by some London
doctors to present the figures involved in the Toft case. It is doubtful
whether, at the time, Hogarth's fame was quite that extensive. More
likely he once again found a timely subject and exploited its topical-
ity. On 3 December 1726 Lord Hervey wrote to his friend Henry Fox:

> There is one thing that employs everybody's tongue at present,
> which is a woman brought out of Surrey who had brought forth sev-
> enteen rabbits, and has been these three days in labour of the eight-
> eenth. I know you laugh now, and think I joke; but the fact as re-
> ported and attested by St. André, the surgeon (who swears he delivered
> her of five), is something that really staggers one. . . . In short the
> whole philosophical world is divided into two parties; between the

downright affirmations on the one hand for the reality of the fact, and the philosophical proofs of the impossibility of it on the other; nobody knows which they are to believe, their eyes or their ears.

It should be obvious which side Hogarth was on, especially considering the fools the nobility and the royal physicians were making of themselves. His satires of the 1720s show that he relished most the delusions of the great.

By 3 December the woman, one Mary Toft, had been ordered to come to London by the king and was lodged at a bagnio in Long Acre, where many people came to see her and physicians were constantly examining her, as another birth was expected momentarily. It was all over by the tenth, and Mrs. Toft had been exposed. "The Woman" was at the bagnio in custody of the High Constable of Westminster; on the seventh she had confessed but would not name her confederates till assured of the king's pardon. The porter of the bagnio, whom she had sent to buy rabbits, told all. On the tenth the *London Journal* reports that Mr. St. André, the surgeon, "has promised a particular Account of the Frauds she used, and by what Means she impos'd upon him and the publick."

A flood of pamphlets appeared, and on 24 December Hogarth's print, entitled *Cunicularii, or The Wise Men of Godliman* (pl. 14) was published, showing all the participants in characteristic poses around the laboring Mrs. Toft. Although a hasty etching in the popular style, it is carefully constructed as if on a stage, and the general composition, with Mrs. Toft in her tester bed and the credulous Londoners approaching from the doorway (like blasphemous Wise Men), closely anticipates the third plate of *A Harlot's Progress*.

If *Cunicularii* was a purely topical print, hastily—though strikingly—executed, the other three prints published around this time are unequivocally political. Hogarth was either a naturally apolitical man or a very circumspect one. His satiric prints of the 1720s follow the Augustan satirists—in some cases precede them—and so tend to fall into the anti-Walpole camp. But they remain very general for those times. *Masquerades and Operas* had a political inspiration and alludes to the ruling faction and, indirectly, to the Crown; but its impact remains essentially social and moral. *Royalty, Episcopacy, and Law (The Inhabitants of the Moon)* was political, but so general that it might refer to any reign, any ministry; moreover it appeared before

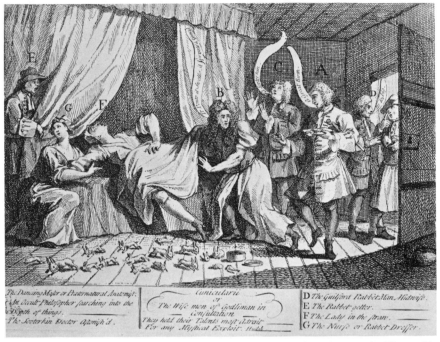

14. **Cunicularii, or the Wise Men of Godliman in Consultation**; Dec. 1726; 6⅝₆ x 9⁷⁄₁₆ in. (BM)

much concerted effort was made to attack the financial corruption of Walpole's ministry.

There really was no effective opposition to Walpole before 1726. William Pulteney made a few unsuccessful attempts, but the first important action came with the intervention of Bolingbroke and the meeting of Tories and disaffected Whigs in the summer of 1726 at Dawley, Bolingbroke's country estate. Swift was in England to prepare for the publication of *Gulliver's Travels,* which appeared on 28 October. But the "symbol of the summer's achievement" was in fact the publication on 5 December of the first number of the *Craftsman,* the anti-Walpole organ put together by Bolingbroke and William Pulteney, with contributions by the Scriblerians and some of the best political polemicists of the time, to expose "how craft predominates in all professions" and particularly "the mystery of statecraft."

It was probably coincidence that the same week that ushered in the *Craftsman* saw the announcement ("speedily to be published") of Hogarth's *Punishment of Lemuel Gulliver,* itself an allusion to the

anti-Walpole satire of Swift's work published a few weeks earlier. Hogarth had remarkably little time to read the book and make his careful and painstaking etching. His print was out by 27 December, not long after the earliest responses to *Gulliver's Travels*. His contribution was to define Gulliver's punishment as an enema, an appropriate invention, as Gulliver's crime was ejecting liquid. *The Punishment of Lemuel Gulliver*, plainly aimed at the Walpole Ministry, is about an England in decline. As in *Royalty, Episcopacy, and Law*, both church and state are represented. The purging is overseen by a First Minister carried in a thimble and a clergyman is officiating from his pulpit made of a chamber pot. The church and government are shown supervising this purging of a heroic and harmless Gulliver while ignoring the rats devouring their children and the term of Priapus being worshiped by their congregations.

The Punishment was followed sometime in 1727 by the *Large Masquerade Ticket*, which shows worshipers adoring a figure similar to that in the earlier print with a Venus added for balance; another anti-ministerial print, *Henry VIII and Anne Boleyn*, appeared sometime late in 1727 or early in 1728. The unanswered question is whether the Opposition solicited Hogarth or whether he was trying to get on the bandwagon. Nicholas Amhurst, editor of the *Craftsman* and already associated with Hogarth, would appear to be the most logical connection. Hogarth may even have received some money from the Opposition during these lean years of his apprenticeship to painting. Nevertheless, these were only tentative and rather veiled attacks.

These prints are the last tangible evidence of Hogarth's reactions to politics until the mid-1750s. What happened in 1728 is something of a mystery. By then he had begun painting some of the Court party, and he probably felt that he could not mix politics and painting. Yet during this time—at the end of 1727 or early in 1728—Hogarth carried out his most fashionable, and perhaps financially rewarding, engraving commission, the Walpole Salver (V & A). The goldsmith for whom he engraved was Paul de Lamerie (for whom Ellis Gamble did some work). Although a goldsmith ordinarily chose his own engraver, it seems quite possible, considering what is known of Sir Robert Walpole, that he personally selected Hogarth to ensure his future silence. Walpole would have been less than his usual astute self if he had not recognized two facts: that graphic satire was far more dangerous than literary, and that Hogarth was potentially the most dangerous graphic

satirist of the age. Hogarth, who wanted always to reach the largest possible audience, can have had no very strong attachment to one party or the other.

A word should be said about the Walpole Salver, Hogarth's swan song as a professional engraver (as opposed to an artist whose works were engraved). Custom, going back to the sixteenth century, required that the officer of state responsible for the Great Seal, or other seals of office, retain the discarded silver matrix when a seal became obsolete on the death of the king and have the silver made into plate. Walpole's first had been engraved by Joseph Sympson, Sr., and the second represented Hogarth at his most elaborate and careful. Hogarth returned to the allegory Thornhill had taught him at Greenwich; there the older artist depicted "*Wisdom* and *Virtue* represented by PALLAS and HERCULES destroying *Calumny, Detraction,* and *Envy,* with other Vices," and here Hogarth shows Hercules holding in subjugation Calumny and Envy, and supporting the sky to help Atlas.

Hogarth had had some practice with the Hercules figure, the representative of Heroic Virtue, who appeared in both *The Prince of Wales* and the various versions of the arms of the Duchess of Kendal. A recurrent motif in the Greenwich paintings, he now served as the central figure in Hogarth's last "heathen gods" history. But Hogarth was not to discard him, rather disguising his presence in composition after composition; one wonders, looking back to the Walpole Salver, if Hogarth considered him a kind of heroic prototype, one of the "Monsters of heraldry" he could not believe in, and at the same time a symbol of the lost greatness of England, art, and Thornhill.

At this time George Vertue first mentions Hogarth as an engraver in his notebook. Though unfortunately undated, the reference summarizes his career from *Hudibras* to the first paintings:

> another work appeared which was well enough accepted. being undertook by printsellers the several Stories of Hudibrass being designd in a burlesque manner humoring very naturally the Ideas of that famous poem. these designes were the Invention of W^m. Hogarth a young Man of facil & ready Invention, who from a perfect natural genius improvd by some study in the Academy. under the direction of Cheron & Vandᴿbank. has produced several charicatures in print, if not so well gravd, yet still the humours are well represented. whereby he gain'd reputation—from being bred up to small gravings of plate work & watch workes. has so far excelld; that by the strenght of his genius &

drawing, & now applying himself to painting of small conversation peices, meets with good encouragement. according to his Meritt.

THE BEGINNINGS OF A PAINTER

Vertue says specifically that it was only after completing the large *Hudibras* plates that Hogarth started to paint. Though this does not rule out his having experimented with paints before, it does strongly suggest that he did not devote himself to painting until 1726. For one thing, the years 1723–25 must have been largely devoted to engraving as he tried his utmost to rise above plate decoration and make a name for himself as a copper engraver. Only with his earnings from the large and demanding *Hudibras* project (still based entirely on drawings) could he afford to spend most of his time painting, turning out only an occasional print. A request for a painted version of *Hudibras* may have set him off, but his principal motivations were a general desire to rise above engraving and a particular eagerness to emulate and prove himself to Sir James Thornhill (with by this time perhaps a further incentive in Thornhill's daughter Jane).

Various clumsy, thickly painted canvases have been attributed to Hogarth's "apprenticeship" to painting. In fact, however, his career as a painter is a blank until 20 December 1727, when he was commissioned by Joshua Morris, the tapestry weaver of Great Queen Street, Soho, to paint a cartoon of "The Element of Earth." Morris was at this time preparing hangings for the Duke of Chandos' princely country house, Cannons, and Hogarth's cartoon may have been intended as part of that project (in which, perhaps significantly, Thornhill was involved).

Someone—perhaps Thornhill, possibly Vanderbank—recommended Hogarth to Morris as a person skillful in painting patterns for that purpose. Hogarth accordingly, as related in Morris' deposition in the suit that followed, went to see the tapestry maker, who informed him that he had occasion for a tapestry design of the Element of Earth, to be painted on canvas; Hogarth replied that he was well skilled in painting that way, and promised to perform it in a workmanlike manner for a fee of twenty guineas. Not long after, Morris discussed his commission with a knowledgeable friend (presumably an artist) and learned that Hogarth was not a painter but an engraver. Being therefore uneasy about the work he had commissioned, Morris sent a servant to Hogarth's studio to tell him what he had heard; to which Ho-

garth offered the sanguine reply "that it was a bold undertaking, for that he never did any thing of that kind before; and that, if his master did not like it, he should not pay for it."

It would be interesting to know what this design, now lost, consisted of; it may have been related to one of the Dutch series representing "Four Elements" or to Le Brun's cycle *The Elements,* which were copied in the Soho tapestry factory—or to his own engraving of the goddess Tellus. The discrepancy between his two statements to Morris sounds the cheeky, confident note that carried Hogarth through most of his enterprises; his comment that he had never done anything of that kind before presumably meant that he had never made a cartoon for tapestry. The challenge to produce something along the lines of the Raphael Cartoons must have been singularly stimulating to the novice painter, and he accepted. The testimony of Morris' informant that he knew only engravings by Hogarth strongly suggests that *The Element of Earth* may have been his first commissioned painting.

According to his deposition, Morris waited a long time for Hogarth to finish, sending several times to inquire after the work; which, when finally completed, Hogarth left at one of Morris' shops rather than his house, being ashamed to let him see it. More probably, Hogarth found the project less to his liking than he had thought, had trouble with the painting, put it off, and when he finished it took it to the first place he thought of, forgetting Morris' instructions (if there had been any). At any rate, Morris consulted with his workmen whether the design was so painted that they could work tapestry by it; and they were unanimous that it would be impossible.

Morris sent a servant back to Hogarth with his painting and word that it would not do but that "if he would finish it in a proper manner," he would still take and pay for it. Hogarth now promised to finish the cartoon in a month, but again ran into difficulties and took three months. When he finally showed it to Morris, the latter told him that he could not make any use of it.

Hogarth did not let the matter rest. He promptly went to court, asking £30 for his fee plus the materials required. The case was tried before Lord Chief Justice Eyre at Westminster Hall, 28 May 1728. Hogarth's argument was presumably that the agreement had been made (Morris did not contest this) and that the painting was a competent piece of work. The point at issue was whether "competence" im-

plied simply a painting or a work on which a tapestry could be based. Hogarth, arguing the former, won his case, and had his first taste of the law as a recourse in controlling unruly patrons.

It is doubtful whether Hogarth assisted Thornhill with any of his decorative work in 1726 or 1727. From his own testimony he did not work on the portrait of the royal family at Greenwich, which was in progress when he became acquainted with Thornhill. One can assume that he began to experiment with small pictures of groups of people. Relying on his success in *Masquerades and Operas* and *Hudibras,* he probably tried to make pictures of people in conversation, similar to those Philippe Mercier was doing in 1726 and 1727, but with more and livelier people.

While the cartoon for Morris was in progress, however, Hogarth was discovering a subject that would in effect inaugurate his career as a painter. On 29 January 1727/8 John Gay's *Beggar's Opera* opened at Rich's Lincoln's Inn Fields Theatre; this strange new piece, a satire on operas, itself a drama interspersed with ballads parodying opera arias, was a resounding success. The play ran for sixty-two nights during the first season, and the remark that it had made Rich gay and Gay rich was already current by 3 February when it was published in the *Craftsman.*

The first months of 1728 marked in some ways the climax of the Augustan age: in January *The Beggar's Opera,* in February Fielding's first play, *Love in Several Masques,* and in May Pope's *Dunciad. The Dunciad* and its world of emblem and allegory may have held little interest for Hogarth by this time, but *The Beggar's Opera* offered him a double incentive for thought: as the fashionable gathering place of the season, it was ripe for an artist experimenting with group portraits at card parties and other social occasions, and it contained the blend of realism and stylization, fact and symbol that appealed to him.

Hogarth was, as his earlier prints attest, an avid theatergoer. In his writings he constantly takes his examples from the theater, most often from Shakespeare but also from Ben Jonson and from contemporaries like Henry Fielding. But besides enjoying the theater, he recognized the stage as a useful compositional unit for the sort of graphic scene that interested him and a source of expressive faces, their drama heightened by greasepaint and theatrical lighting. The very nature of

the London stage was significant to Hogarth the painter as it was to Gay the dramatist, the one satirizing overblown history paintings, the other overblown operas.

Continental theaters, emphasizing spectacular and operatic style and elaborately painted scenery, were baroque par excellence in creating an illusion of unlimited space within the limited area of a stage with a proscenium arch. The English theater of the early eighteenth century adopted the proscenium arch and the painted scenery, but was different in essential ways. It was much smaller, accommodating relatively few spectators, some sitting on the stage itself, and so possessed an important feeling of intimacy; also, of course, frequent changes of scene were indicated, as opposed to the single set of classical French theater with the unities of time and place observed. The scenery of continental playhouses usually slid up and down, and so was stored above or below the stage; English sets, with the smaller stage and quicker changes, split in the middle and slid off to the wings on either side of the stage.

At about the same time he turned to *The Beggar's Opera* Hogarth painted *Falstaff Examining His Recruits* (Lord Iveagh), based on Shakespeare's *Henry IV, Part 2,* which evidently represents the scene as it was played on the stage. Sketches of this scene and of *The Beggar's Opera* survive (Royal Coll.) on the same bluish paper; presumably they were drawn not far apart. *Falstaff,* however, uses the stage as a compositional unit without giving any indication that it is a stage or is within a theater. Even the first sketch for *The Beggar's Opera* surrounds the actors with the audience.

Hogarth must have seen the first or at least an early performance, and produced the chalk sketch. He chose as his subject act III, scene 11, in which all the principals appear, the moment of greatest psychological tension: Macheath in chains, with his eyes on some distant point, completely noncommittal; the girls beseeching equally their lover and their fathers; their fathers expressing varying degrees of denial. The scene has, indeed, allowed him to repeat the composition of the Choice (or Judgment) of Hercules, which was to be a favorite with him.

To judge by the Morris experience, it is quite likely that Hogarth quickly developed the sketch into the first painting (pl. 15) and offered it to John Rich for sale. Rich, later a close friend, may at this time have been a stranger or merely an acquaintance. But whether the

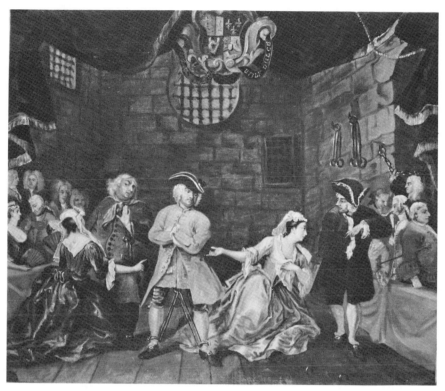

15. The Beggar's Opera I; 1728; 18 x 21 in. (W. S. Lewis)

picture established the contact or was a result of their acquaintance, their friendship grew and was maintained until Rich's death over thirty years later. Because of Pope's and Fielding's attacks, Rich has been much maligned; but Hogarth must have learned a great deal about expression and composition from watching this actor, conceded even by his enemies to be a masterful pantomimist. From him Hogarth may have learned that expression involved not only a flexible face but a pliable body. Rich bought Hogarth's small, rather awkward picture of *The Beggar's Opera,* and before the end of 1729 had commissioned a larger and more elaborate version, probably for hanging in the theater. This picture (pl. 17) is dated 1729, and by 5 November 1729 Sir Archibald Grant, M.P., saw the picture, complete or nearly so, and ordered a copy for himself.

As a picture destined for Rich, Hogarth's first version tried to recapture the first night; it is seen from the point of view of the actors,

who are painted as portraits, while the audience is reduced to good-humored caricatures. In the final version commissioned by Rich these same figures are normalized into realistic portraits like the actors. The final version also shows a completely different, and much larger, more spacious and baroque stage, with a crouching satyr at each wing. One might imagine that this painting was commissioned for Rich's new theater in Covent Garden, to celebrate the play that probably financed it, but the subscription for the new theater was not begun until 1730; or, perhaps the most obvious answer, that Hogarth simply idealized the composition.

Be that as it may, the six paintings Hogarth made of *The Beggar's Opera* are, for lack of other evidence, the best chart available of his development as a painter between 1728 and 1730. Actors in a play gave Hogarth exactly what he needed at this time: the freedom to improvise denied him in conventional portrait groups of the ladies and gentlemen whose business he now wished to attract. Moreover, the actors could be juxtaposed on the stage with their roles and with aristocratic members of the audience; thematic and psychological tensions could be suggested. A brilliant possibility for a conversation piece was offering itself; he could peddle his modello—one of the small versions perhaps—and suggest that around the standard group of actors from *The Beggar's Opera* he would introduce portraits of Lord X and his party. He evidently followed up this idea only in the last two paintings, however, and they repeat the same group of onlookers.

This final version (pl. 17), originally painted for Rich, is a remarkable synthesis of the virtues of the overly finished early paintings and the freely painted, indeed unfinished expressiveness of IV (pl. 16). The style of IV dominates the canvas, but the faces and figures of the main characters approach a high finish. The secondary figures are more casually rendered, and the background figures are only indicated. In this version Hogarth has reached maturity as a painter. If the date 1729 inscribed on it is accurate, it shows that he developed in little more than a year's time from a groping, primitive painter to one unexcelled in pure technique by any other English painter of the eighteenth century. It is hard to believe that five paintings reflecting such improvement could have been made between the spring of 1728 and the end of 1729, even considering that all were repetitions of a single scene.

The final version is much wider; more panoramic, elaborate, and in every sense more mature than any of the earlier paintings. The two

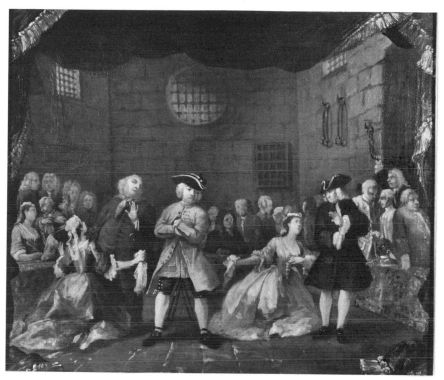

16. The Beggar's Opera IV; 1728–29? 19 x 22½ in. (Nigel Capel Cure, Esq.)

conceptions reflect essentially different interpretations of Gay's accomplishment in *The Beggar's Opera*. The first group, with large figures dominating the picture space, explores Gay's play as an alternative to opera (or, in Hogarth's terms, to decorative history painting), with its small intimate stage, subdued sets, and contemporary costumes. The last two paintings put a great deal more emphasis on the play as parody of opera.

The performance of *The Beggar's Opera* was, then, the decisive aesthetic event for Hogarth between his *Hudibras* plates of 1726—in which he had already begun to experiment with the idea of modernizing history painting—and the "comic history" of the *Harlot* in the 1730s. Besides the structure and conventions of the stage itself, which were already evident (sometimes physically present) in his engraved work, Hogarth made use of two crucial elements in *The Beggar's Opera*. First was the lowering of the Italian opera heroes and heroines —with the arias, highflown speeches, and other conventions—into the

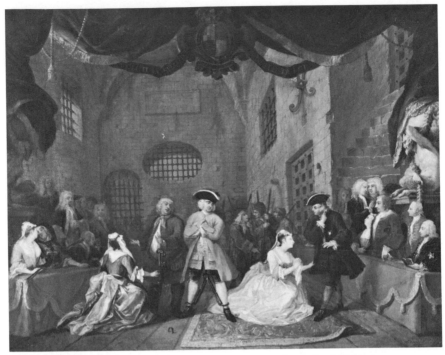

17. The Beggar's Opera V; 1729; 23¾ x 28⅞ in. (Mr. and Mrs. Paul Mellon)

figures of contemporary robbers and prostitutes. This of course was obvious to Hogarth's contemporaries, and the only distinctive Hogarthian insight was that this transference could also apply to the equivalent of opera in art—to history paintings, those extravaganzas based on a biblical or literary text, which had become as decorative and overformalized as operas.

The second element of importance in *The Beggar's Opera* was Gay's device of having his thief employ the jargon or diction of a gentleman. What Hogarth saw that his contemporaries apparently missed —or at least did not exploit—was the complex effect produced by the thief's adopting the style of the gentleman. One implication is that opera heroes and politicians, under their rhetoric and respectability, share the cutthroat values of Macheath and Peachum, the highwayman and the fence. As the beggar tells the audience at the end, he wanted to show "that the lower Sort of People have their Vices in a degree as well as the Rich, and that they are punish'd for them." The punishment, of course, is the only distinction. The "Rich" are Gay's

real game, not these poor rogues; the rich whose imitation of a false ideal is only dimly reflected in the whore and highwayman who hang for their crimes.

Hogarth exploits the fact that the nobility had seats on the stage to achieve one obvious effect: Lavinia Fenton, playing Polly Peachum, looks away from her supplicating stage lover, Macheath, toward her real lover, the Duke of Bolton. Surely Hogarth the ironist must have seen this situation (even if Bolton did not) as a realization of Gay's central proposition about the relationship between thieves and gentlemen; it very clearly conveys the play's theme, placing criminals next to the equally culpable aristocrats who are watching and urging them on. In the earlier versions of the painting the aristocrats are all over the stage, more or less surrounding the small group of actor-thieves; their faces are distorted into caricatures of exploiters and degenerates, some looking as though they were paper cutouts. In fact Hogarth has made the actors appear much more real and substantial than the aristocratic spectators, who come as close as any figures in his work to caricature. In the final version of the painting they are regularized to seem more like portraits, and segregated to either side of the stage; but there are still a great many of them.

Only with the *Beggar's Opera* paintings do the central issues and contradictions of Hogarth's career clearly emerge. These issues are clarified by Hogarth's chronology. When he was born in 1697 Jonathan Swift was thirty, Daniel Defoe thirty-seven (of Richard Hogarth's generation), John Gay twelve, Alexander Pope nine, Samuel Richardson seven. He was young for the Augustan generation, and old for the next (Fielding was born in 1707). But he was almost exactly contemporary with the great European painters Tiepolo (born 1696), Canaletto (1697), Chardin (1699), Longhi (1702), Boucher (1703), and Quentin de la Tour (1704). One should not try to draw too profound a conclusion from these dates, but the literary world was very much his concern, and his ethos fell between that of Swift and that of Fielding (Gay tends to represent a similar transition). He did come to know the works of Chardin, La Tour, and Canaletto, if not the other artists, and he must have known Canaletto personally. While his engravings (what might be called the literary side of his oeuvre) were very much defined by the tradition of the Augustans, as well as the graphic tradition of the Low Countries (itself profoundly literary), it is a curious fact that his paintings as such—as paint applied to a surface

—are of a piece with the works of the great continental artists. To look at a Canaletto or a Chardin, even a Boucher or Tiepolo, and then a Hogarth, is to look at different aspects of experience executed by hands trained in the same studio. It becomes clear very quickly in Hogarth's career as a painter—certainly by the fourth version of *The Beggar's Opera*—that he excelled at two things, sometimes quite extraordinarily hard to reconcile: a highly intellectualized satire and pure painting.

The *Beggar's Opera* paintings, as I have noted, employ two styles, sometimes in the same painting: one is a highly finished, finicky, and detailed surface; the other is unfinished, very sketchy and brilliant, with thin paint defining forms (volumes, not outlines) and giving a wonderfully fresh and expressive sense of process and discovery. The first is less satisfactory, and Hogarth's mature style is essentially a development and refinement of the unfinished style.

Though the distinction between sketch and finished painting is by no means unique, Hogarth's mingling of the two styles in "finished" paintings reminds one of Thornhill's peculiar dualism. Thornhill's sketches are executed with a bravura Venetian handling of paint; in fact, his sketches, whether in oil, chalk, pencil, or pen, are lovely and expressive artifacts. But as almost all writers on Thornhill have noticed, the finished paintings—especially the large-scale histories—lose all this charm and become quite dull if not clumsy (apart from the delicacy of his coloring). It is as though, like Hogarth, he could model figures instinctively but not finish them off. If, however, Thornhill in general moved from a baroque style and relatively free painting to a classical, more restrained manner, the procedure was reversed in Hogarth. When he turned from engraving to painting, he found himself captured by a completely different medium, one that proceeds not by linear means but by building volumes, indeed by building light upon dark—exactly the opposite of engraving; and he must have discovered very soon that this was where his real genius lay. In the developing oil sketches for *The Beggar's Opera* the classicism of the *Hudibras* plates goes out the window.

Hogarth's painting technique changed little during his career. His most important departure was to paint directly on the canvas without preliminary drawings, a departure from the academic assembling of drawings for each figure or object. Many oil sketches survive—dis-

carded first thoughts; but the only two surviving drawings connected with subject pictures are, significantly, of stage scenes: tentative sketches for the *Beggar's Opera* paintings and for *Falstaff Examining His Recruits*. And even these, compared with the final paintings, show how little he changed his original composition: he seems to have had the sketch in mind and then, without preparatory studies, drawing on his memory, attacked the canvas directly. He found that he could capture action and movement better with paint than by engraving; and, at least at the moment, he was searching for something that was more important to him than form and structure.

His method of applying paint was important for the preservation as well as the effect of his paintings. He never attempted the systematic laying on of glazes—as Reynolds, for example, did after his return from Italy—but began with a thin monochrome underpainting, usually in cool grays and greens (occasionally in sienna). Over this, once dry (and sometimes before), he applied a relatively transparent painting of the actual colors intended, with no apparent science relating them to the underpainted colors, and then finished with highlights in rich, creamy, and occasionally impasto color. One consequence was that his relatively direct painting on the canvas produced works that have aged well. A cleaned Hogarth—like those produced when the Tate Gallery cleaned most of theirs in 1965–66—looks virtually as it must have when it left his studio. The contrast with the paintings of the scholarly Reynolds is instructive. He experimented with glazes and colors; within his own lifetime the carmine had faded, and the sitters today are mere ghosts, the bitumen cracked, and the shadows now resemble peeling blisters and running sores.

The difference between individual pictures is largely dependent on the stage at which Hogarth stopped painting each one. We may question why, at the outset of his painting career, he preserved so many pictures that hover between underpainting and finishing—some of his best, in fact. Horace Walpole was one of the few who collected Hogarth's oil sketches, and these relatively unfinished works were the only Hogarth paintings he did gather. Hogarth himself obviously recognized his talent for immediate expression in oils, and perhaps often felt disappointed with the final static result. He kept these sketches first as modelli, perhaps as reminders of works that may have passed out of his hands, but also certainly because he appreciated their

beauty. They were for himself. The story of his development as a painter is the search for a style that will pass for finished without losing the fluency of the underpainting.

CONVERSATION PICTURES

One wonders to what extent Hogarth's childhood experiences of prisons, prisoners (sometimes more honest than their jailers), and criminals (real and putative) contributed to his almost obsessive treatment of *The Beggar's Opera* with its thieves, actors, and aristocratic audience. In 1729 he was drawn back to the scene of those childhood memories, the Fleet Prison itself, and given an opportunity to paint the debtor-as-prisoner confronting his warden, with a committee of members of Parliament as audience.

The Fleet at this time was much worse than when Richard Hogarth languished there. In 1713 John Huggins, the crafty friend of Thornhill and the Earl of Sunderland, had bought the patent for the wardenship, paying £5000 for his own and his son's lifetime. Huggins was a close, grasping man, who in the same year, as High Bailiff of the City and Liberty of Westminster, advertised in the newspapers against infringements of his patent for apprehending or arresting persons or seizing goods; and by 1723 prisoners' petitions were accumulating to show that self-interest was guiding his operation of the Fleet. These petitions mainly concerned Huggins' extortions: he was extracting fees (garnish) far in excess of those settled by law in 1693, charging the same fee more than once, even demanding Christmas gifts of the prisoners, and conserving on his own outlay by letting the prison run down, failing to replace furniture and bedding or to repair drains, gutters, and necessary houses.

Having secured as much money as he needed (or, more likely, discerning the storm clouds ahead) and feeling that he was "growing in years, and willing to retire from business, and his son not caring to take upon him so troublesome an office," he sold his patent to his most recent deputy, Thomas Bambridge (an attorney by profession), and one Dougal Cuthbert for £5000.

The storm clouds were indeed gathering. In 1725 Edward Arne, uncle of the composer Thomas Arne and an upholsterer and undertaker, having failed to pay his fees to the warden, "was carried into a stable . . . and was there confined (being a place of cold restraint) till he died." Then in 1728 Robert Castell, architect and author of *The*

Villas of the Ancients Illustrated (1728), grew tired of paying the exorbitant fees demanded of him by Bambridge, and for punishment Bambridge confined him in a sponging house adjoining the Fleet. This place was at the time raging with smallpox, which Castell told Bambridge he had never had, and he caught smallpox and died. Known among the Palladians for his architectural work, he was more importantly a friend of the M.P. James Edward Oglethorpe, who began agitation in the House of Commons.

In January 1728/9 Bambridge overreached himself, picking on a baronet with connections. Sir William Rich, Bart., was reported by the *Daily Post* (29 Jan.) to be "close confined in the strong Room, or Dungeon of that Prison, manacled and shackled, and a Centinel with a loaded Musquet at the Door." The strong Room was a lightless underground vault, built over the common sewer, where the dead were placed before burial, and in which recalcitrant prisoners were lodged. Sir William's friends hove into sight, and on 8 February Bambridge was called to court.

On the twenty-fifth a committee was appointed by the House of Commons on the motion of Oglethorpe to inquire into the state of the jails in England, and Oglethorpe was appointed chairman. On 8 March several of the committee came to the Fleet Prison, where Bambridge was brought before them, and examined upon several complaints. This confrontation, or a subsequent one in the next week or two, was the occasion of Hogarth's sketch of the committee meeting in the Fleet (pl. 18). The tenor of such confrontations can be imagined from accounts like that of Jacob Mendes Solas, a Portuguese who had been kept manacled and shackled in the strong room for nearly two months; when, during his testimony, a member of the committee hinted at a confrontation with Bambridge, he fainted. The effect of Hogarth's oil sketch lies in the interplay between the expressions of the prisoner and the warden, and its reflection in the committee-as-audience.

If Hogarth was not in the Fleet on that day, he attended at least one of the official confrontations in the House of Parliament and transferred his setting back to the Fleet. In either case he needed some entrée to the committee, which at this time could have been through Thornhill, who was on the committee that went to meet with Lords over the act to disable Bambridge. Thornhill might have secured permission for Hogarth to sketch the proceedings even if he was not him-

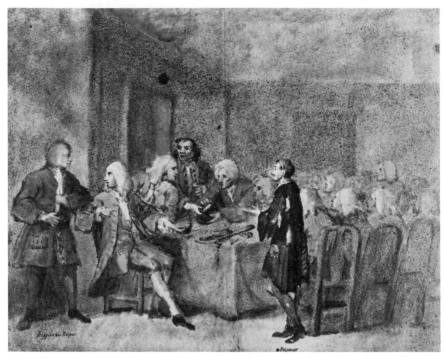

18. A Committee of the House of Commons, or The Bambridge Committee (oil sketch on paper); 1728/9; 18½ x 23½ in. (Fitzwilliam Museum)

self on the committee; or he may have secured the permission after April, when he became a member.

In the sketch Hogarth shows the chairman, a recognizable portrait of Oglethorpe, acting as a mediator between Bambridge the warden and the prisoner; it provides the sort of role inversion explored in *The Beggar's Opera*. A criminal warden opposes an innocent, persecuted prisoner, the real criminal against the reputed one, with a judge to choose between them and a polite audience looking on.

Hogarth must have attended one or more of the meetings of the committee in the Fleet Prison, sketching the room, the general scene, and probably some of the participants. He must also have let the members see his likenesses of them, and then in his studio produced the modello, which he later gave to Horace Walpole. Within the blank faces of the modello he could insert the faces of whichever committee members were interested in a picture, and, hopefully, produce as many pictures as were called for.

Several versions of the finished picture have been recorded, but the only one known to survive is in the National Portrait Gallery, London. The one documented commission, by Sir Archibald Grant, does not necessarily refer to this particular version; whoever commissioned it wanted a portrait-gallery effect instead of the dramatic scene that is portrayed in the modello. The finished painting was accordingly enfeebled—Hogarth dropped the prisoner to his knees and turned his back on Bambridge, turning the faces of several more committee members toward the viewer. The result is the loss of the central confrontation between jailer and prisoner, who have become props for the committee members.

Despite the failure of this surviving version of the finished picture, one can understand Hogarth's rationale for such a portrait group. It takes him beyond the stage of a theater to unfeigned actuality that is both historical and timeless. This immediate aim is always evident in Hogarth's later works; in the *Rake's Progress* the scene in the Fleet Prison also serves as a reminder of the garnish still required of the penniless debtor—an image which was copied in broadsides and pamphlets attacking the continuing abuses in the Fleet.

All this time, while Hogarth was practicing painting and making use of Thornhill's casts and pictures, and perhaps his influence in Parliament, he was, as he would have said, mixing pleasure with business. Thornhill's hospitality and academy provided an ideal excuse for being near his daughter Jane, a girl of about fifteen when Hogarth joined the academy in 1724, and by 1729 near the age of consent.

It is not known exactly when or where Jane Thornhill was born, where or how she spent her youth, or what kind of girl she was. Certainly she had always been well off, and even without the signs of punctilio in her father one would suspect a tendency toward social self-consciousness in the daughter. After Hogarth's death, Jane was apparently well able to conduct his business and defend his reputation; thus it seems probable that she was fairly strong and competent. This was the woman who advertised against pirates in as strident a tone as Hogarth himself, secured a special addendum to the revision of his Engravers' Act in 1767 giving her an additional twenty years' copyright on his engravings, and fought Horace Walpole and John Nichols tooth and nail when they published passages on her husband that were less than glowing. The portrait of her as a young woman

painted by Hogarth shows a handsome and statuesque, probably
proud woman, and this—taken with the portrait in old age by Zoffany
(George Howard, Esq.)—points to a woman who is tough and inde-
pendent, even crusty (pl. 19).

From what is known of Hogarth's mother and Jane, they shared one
characteristic—both were solid, capable women, pillars of strength for

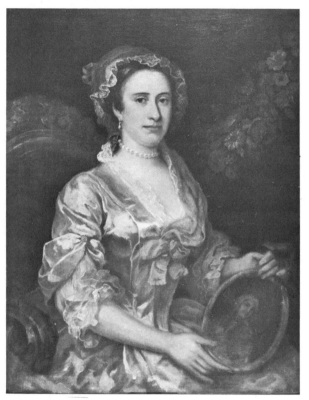

19. Jane Hogarth; ca. 1738; 35½ x 27½ in. (the Right Hon.
the Earl of Rosebery)

their husbands, if not indeed the kind of bulwark that becomes at
times a burden for the one being supported: something on the order
of Sarah Young in *A Rake's Progress*. But of course they were also very
different; Hogarth married above him when he took Jane. If he
thought of himself as wedding the master's daughter, he may have
recalled his father's marriage to the landlord's daughter. It is impos-

sible to determine whether he was urged by love of Jane, desire to be son-in-law to a great and admirable man, or both.

It could not have been entirely coincidence that he eloped with Jane immediately following the Bambridge Committee's exposé of the Fleet Prison, either just before or just after his commemoration of it in a painting: in one coup he would acquire a new father and exorcise his memories of the Fleet and the darker days of his youth. The marriage took place on 23 March, but not, as stated in the license, at St. Paul's, Covent Garden. Instead, the couple traveled out to the village of Paddington and were married at Paddington parish church.

Vertue remarked that Hogarth had married Sir James Thornhill's daughter without his consent. It should be noted that Jane was listed on the license as "above 21." If a woman was under twenty-one, the consent of parents was necessary for marriage. No birth record of Jane has been found, but Hogarth's early biographers said that she was not eighteen. When she died, her age was given as eighty, i.e. born 1709 and therefore twenty when married. Nichols suggests that this was an elopement, an idea perhaps further strengthened by Hogarth's attack on contracted marriage in *Marriage à la Mode*.

Tradition has it that the Hogarths crossed the river to live in Lambeth, but it is possible that after a honeymoon spent in Lambeth they returned to Hogarth's studio. If he did not soon go back to work, he could not have had time to transact his business with the *Bambridge Committee* picture; in fact, selecting this time for a marriage, let alone an elopement, strongly suggests that he did not get any commission until later. There can have been little real clash with Sir James or his new son-in-law would have found it very difficult to find a commission among the M.P.'s. There is a reconciliation story, of course, which sounds manufactured. Lady Thornhill is supposed to have restored good feeling by advising Hogarth to place some of his *Harlot's Progress* paintings in his father-in-law's way. In any case, there was a reconciliation, including an invitation to move into the Thornhill's house, but Hogarth and Jane evidently did not move in with the Thornhills in the Great Piazza until 1731, perhaps after the subscription for the *Harlot's Progress* had begun. Vertue locates them in Thornhill's house by that time, and the next surviving reference before Vertue's appeared in the *Craftsman* for Saturday, 5 December 1730:

LOST,

*From the Broad Cloth Warehouse, in the Little Piazza, Covent
 Garden,*
A light-colour'd Dutch DOG, with a black Muzzle, and answers
to the Name of Pugg. Whoever has found him, and will bring him
to Mr. Hogarth, at the said place, shall have half a Guinea Re-
ward.

This may be the pug who appears in *The House of Cards* (1730) or,
challenging his opposite, struts in *The Strode Family* (ca. 1738). He is
the first of a series of pugs Hogarth kept. There is no telling whether
his 1745 portrait of himself with, and resembling, his pug was a result
of long association or whether the long association with pugs was an-
other of those symbolic gestures of Hogarth's which show that he
knew exactly how he wanted to appear. The advertisement itself al-
most certainly means the broadcloth warehouse was the Hogarths'
address at the time. Here they apparently remained until invited by
the Thornhills to move across the square and join them in quarters
better suited to the daughter of a knight.

 It is unimaginable that Hogarth remained long away from his work
in these busy months. He needed money and reputation, and also
Thornhill's confidence—all of which required application. If Thorn-
hill objected to the idea of Hogarth as a son-in-law, it was because of
his probable future as shopkeeper, printseller, and engraver; this
would explain why Thornhill moved the couple into his house, where
Hogarth could paint but hardly carry on a trade, and why Hogarth
apparently made no engravings himself between his marriage in
March 1729 and *Boys Peeping at Nature,* the subscription ticket for
A Harlot's Progress, in 1731. In the meantime his only contact with
engravers was the gentlemanly and profitable one of furnishing them
with designs (a drawing brought a guinea or more), and he even tried
to get someone else to engrave the *Harlot's Progress* for him. The use
of Vandergucht, who engraved most of his designs, is significant. Al-
though they were obviously acquainted, the association was not based
on friendship alone. For the last ten years Vandergucht had been one
of the most sought-after engraver-etchers of other men's designs, in-
cluding Thornhill's and Vanderbank's (his *Don Quixote* etchings had
beat out Hogarth's); so one can imagine Hogarth now, wishing to con-
sider himself risen above the rank of engraver, and when asked to

contribute frontispieces, paying Vandergucht to do the engraving (or at least pleased that the bookseller did so). The exceptions were two etchings he made early in 1730 to illustrate Lewis Theobald's *Perseus and Andromeda* (perhaps for his friend Rich, at whose theater the play appeared), and a shop card announcing the move of his sisters' millinery shop from Long Walk to Little Britain, both addresses in the shadow of St. Bartholomew's Hospital.

Hogarth never refers to the Great Piazza house as a shop—though he was eventually to engrave and vend the six plates of the *Harlot* and one or two others there. Essentially, it gave him a good address, the sort of studio appropriate to a portraitist, and a ringside seat at the center of London fashion, theater, gambling, and wenching—and also law enforcement. Gentlemen and highwaymen, ladies and women of pleasure strolled the arcades, moving from coffeehouse to theater to bagnio to auction rooms and china shops.

In January 1730/1 Hogarth made a list of the commissions that he had not yet fulfilled. Among these were three going back to 1728, and certainly among his very first; two of these were for personal friends, who had probably ordered more and had not pressed him too hard for delivery. John Rich had commissioned a family group on the strength of the first *Beggar's Opera* painting, and at least one other picture, the large *Beggar's Opera*, which was by this time finished. Christopher Cock, the auctioneer and a neighbor of Hogarth's in Covent Garden, had commissioned two pictures in November 1728, companion pieces; it is likely that Hogarth had him in mind too when he made his modello of an auction, which probably shows Cock's auction room (private coll.). The third person was one Thomas Wood, who had commissioned two other pictures from Hogarth, portraits of his daughter and his dog Vulcan.

The next commission that can be dated is the remarkable one of Lord Castlemaine for "an Assembly of 25 figures" on 28 August 1729. Sir Richard Child, who in 1718 had become Viscount Castlemaine in the Irish peerage, was heir to the great banking family and celebrated his status by building the first of the great Palladian palaces, Wanstead House, Essex, designed for him by Colen Campbell himself. Hogarth traveled east of London to this great house and sketched the ballroom at the south end, where the "Assembly" was to take place, and no doubt took likenesses of the host and hostess. He then must

have laboriously collected sittings from all the rest of the "25 figures" in his Covent Garden studio. It was the most impressive of the early commissions; perhaps the ultimate challenge, to get such a crowd into a canvas 29 by 24 inches and at the same time convey accurately the architectural splendor of the newly decorated ballroom—decorated, ironically, by William Kent. As the list of January 1730/1 shows, it was not quickly finished (pl. 21).

On 5 March 1729 Sir Archibald Grant commissioned two pictures that were evidently to be copies of works Hogarth had already finished, *The Bambridge Committee* and *The Beggar's Opera*. While he probably took time with the paintings for friends in order to do a good job, knowing the recipients would not mind waiting, he must have delayed work on the copies of popular prototypes for Grant through sheer indifference: he cannot have been too eager to make further copies of works that had reached the final state of their evolution. And after completing *The Woollaston Family* (on loan to Leicester Art Gallery), his masterpiece among the large assembly groups, he must have realized that twenty-five figures was an excessive number; after a certain point, adding extra people became a mechanical process. Besides, by January 1730/1 he was deep in the *Harlot's Progress,* and it was probably for this reason that he made his list—to force himself to get this work off his hands.

Most of the portrait groups, or conversation pictures as they are usually called, are undatable as to commission if not completion, but there were at least two dozen of them between 1728 and 1731, by which time Hogarth had also nearly finished the *Harlot's Progress.* He was hard at work supporting his wife in the style to which she was accustomed and building up his reputation as a serious painter. As early as late summer or early fall 1729 Vertue was commenting on "The daily success of Mr Hogarth in painting small family peices & Conversations with so much Air & agreeableness," which "Causes him to be much followd, & esteemed. whereby he has much imployment & like to be a master of great reputation in that way." Vertue then goes on to marvel at Hogarth's rise: "Tis much from no View at first of being a painter. but only bred to Grave small works *in Silver.* . . ." In 1730 he writes:

Mr Hogarths paintings gain every day so many admirers that happy are they that can get a picture of his painting. a small peice of several

figures representing a Christning being lately sold at a publick sale for
a good price. got him much reputation. also another peice the repre-
sentation of the Gentlemen of the Committee of the House of Com-
mons. to jayles. setting upon the examination of those malefactors.
well painted & their likeness is observed truly. many other family
peices, & conversations consisting of many figures. done with spirit a
lively invention & an universal agreableness.

Already Hogarth seems to have grasped the proper way to sell new
kinds of paintings, through public exhibitions in his Covent Garden
studio (as a little later with the first *Harlot* painting) and public auc-
tion. Such uncommissioned but timely paintings as *The Christening*
(pl. 23), which included a portrait of John (Orator) Henley, could be
seen by many prospective patrons, sold to the highest bidder, and
serve as the basis for future commissions.

It is helpful to step back and categorize the different kinds of por-
trait groups Hogarth was painting and experimenting with in these
busy years. In the background is the fact that European portraiture in
the eighteenth century was still dominated by the aesthetic bias of
Renaissance and French classicism toward idealized portraiture,
which of course catered to the sitter's self-esteem. Naturalistic por-
traits, however much enjoyed, were felt to be a lower kind of art as
well as somewhat unfair to the sitter. Hogarth's own comments show
that he regarded portraiture as a lower branch of art than history
painting. The portrait stereotype was produced by Van Dyck and
transmitted by Lely and Kneller and all the lesser painters, English
and foreign-born, who imitated them. This model, designed for aristo-
crats, was by Kneller's time standardized as a long vertical figure
(Lely's had tended to be more horizontal and reclining) wearing a
close-fitting coat, with a plump but equine face and an especially long
nose, further standardized by a typical wig. The women all had nar-
row eyes, double chins, and identical lips.

An inevitable result of this stereotyping was that even sea captains
and merchants looked like aristocratic, sociable, but detached Au-
gustan gentlemen. When, near the end of the seventeenth century,
professional men began to have their portraits painted as a matter of
course, it was not in the attire of their professions but in that of the
gentry.

One thing that must have bothered Hogarth initially about portrait
painting was this strong element of disguise in portraiture of the pro-

fessional class. Later Hogarth would react to the foreignness of English portraiture by signing himself "W. Hogarth Anglus pinxit," but in his conversation pictures he simply sidestepped the issue and ignored a portrait tradition he deplored. Here he could convey character and social position very precisely by means of the relationships between people, the objects they kept around them, their furniture, and the drama of the resulting interplay. He could ignore portrait poses, or utterly expose them *as* poses. Conversation pictures were the first real break with the stereotyped portraiture of the time: their aim was not to produce an effigy, or to observe the Renaissance pattern of depicting an ideal image or one that conveys the sitter's whole spiritual and physical being, but rather to catch the sitter in action in a particular moment in his proper social milieu, most often with his family.

A conversation, as Vertue, Hogarth, and others used it, was a very general term. It is well, however, to subdivide according to some inherent differences. The contemporary definition of conversation picture in its most restricted sense was a representation of two or more persons in a state of dramatic or psychological relation to each other; to which a writer adds, rather proscriptively, that the figures should be smaller than life, represent real people, and be associated in an informal portrait group, and that some incident or domestic occupation be introduced. Conversations had been attempted in England a few times, but never followed up; the first signs of the vogue appeared in pictures of a favorite horse, owner, and groom in a paddock setting— in the 1690s by Jan Wyck and in the early 1720s by his pupil John Wootton and by Peter Tillemans. The particular brand reaching England was derived from the French *conversations galantes*, which softened and refined the Dutch groups; they were introduced by Philippe Mercier, a Watteau imitator who, born in Berlin and schooled in the academy there under Pesne, traveled in France and Italy and settled in England around 1719.

The conversation Hogarth evolved was distinct from Mercier's, resembling the Dutch conversation of Metsu, Netscher, Slingeland, and Musscher—with its love of objects almost emblematized—painted in the style of the French small groups of Tournières, Watteau, and Mercier, with their freedom of brushstroke and more generous sense of space, an outdoors feeling even when the scene is indoors. The earliest datable picture of this type is *The Woodes Rogers Family* (pl. 20), with three main figures, widely separated. It contains indications of

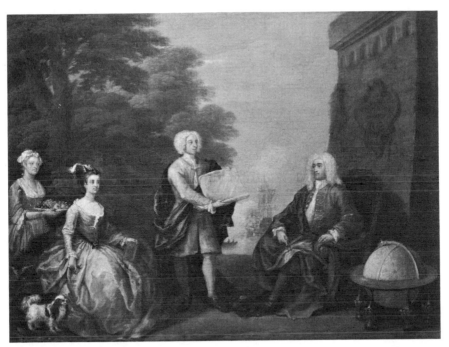

20. The Woodes Rogers Family; 1729; 16½ x 22 in. (National Maritime Museum, Greenwich)

the two basic compositions that Hogarth gradually developed for his conversations: there is a couloir between the two men, but if the figures were brought closer together a slight pyramid would be formed. The couloir, or inverted pyramid, structure is developed in another outdoor scene, *The Jeffreys Family* (National Gallery, Washington), probably painted in 1730. A lake makes a great hole in the middle of the canvas, and one person holds a fishing rod. The house on the other side of the lake, perhaps theirs, separates the mother, father, and one child from the other three children. *The Ashley and Popple Families* (SD 1730, Royal Coll.) uses the same structure as *The Jeffreys Family* but with more adults, and the two main figures are drawn together until they almost touch over the couloir (although the fishing pole and lake are still in evidence). The *Fishing Party* (Dulwich College) uses the same structure but with fewer figures—really only mother, child, and a maid. Here the relationship between humans and a natural setting has become important, the natural setting dominating.

The conversations of the Rich and Fountaine families (Fielding

Marshall Coll. and Philadelphia Museum), two versions of the same composition, are the most complex of the inverted pyramid structures. The central couple create the effect of psychological separation by facing away from each other, making two little conversation groups. Both the *Rich* and *Fountaine* pictures point to the structure Hogarth used in his large assembly, *The Woollaston Family* (SD 1730, Leicester Museum), where two groups appear, linked by the host. No such solution offered itself with the other large assembly he was commissioned to paint for Lord Castlemaine, *The Wanstead Assembly* (pl. 21). There were too many figures to get in, and the result, when he at last finished it, was merely a crowded group. The absence of subsequent paintings of this scope may have been due to his lack of interest or his clients' impatience with the dilatoriness of his performance. Although his initial impulse seems to have been to put in more figures

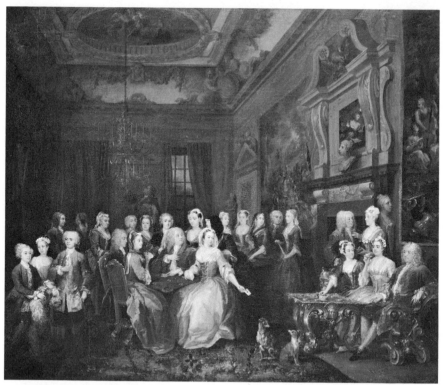

21. An Assembly at Wanstead House; 1730–31; 25 x 29¼ in. (Museum of Fine Arts, Philadelphia, John H. McFadden Coll.)

than any competitor, the best pictures are not the crowded ones but those in which a relatively few people are interestingly related.

The second general composition Hogarth used for his small private groups was pyramidal, and this seems to have been a somewhat later development. *A Children's Party* (pl. 22) has the figures still widely spaced like the split compositions, but the couloir has been replaced by the tea table which connects the children, making an off-center pyramid. In this picture the separateness, or unrelatedness, of the figures is a virtue, suggesting something true about childhood, especially about children who are playing at being grownups. The picture is charming precisely because it reflects Hogarth's literary sensibilities: it is concerned with problems of illusion and reality, as *The Beggar's Opera* was but the run-of-the-mill conversation was not. Children were always to be Hogarth's safest, freest ground for portraiture. In the *Children's Party* there is a curious interplay of irony and symbolism: the soldier boy with a toppled piece of masonry (*vanitas*), one

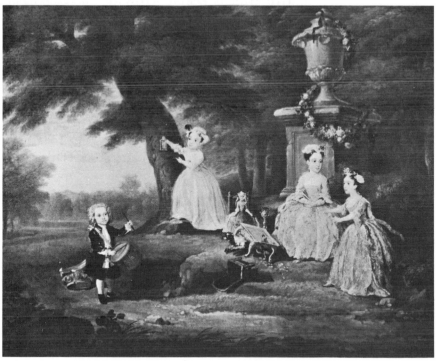

22. A Children's Party; 1730; 25 x 30 in. (private coll.)

girl looking at him and pointing to a mirror, and another girl at the opposite side of the canvas moving toward him with outstretched arms. The dog knocking over the tea table fits into the general *vanitas* theme (and looks ahead to the overturning of the tea table in *Harlot*, Plate 2).

The pyramid structure, which pulled families together, proved more serviceable than the inverted pyramid, and it was the main pattern in Hogarth's second phase of family groups. These remain small, increasingly polished conversations, and only in 1731 or later do they begin to achieve the monumentality Hogarth was striving for in his other works. These pictures begin to anticipate the best of Hogarth's conversation pictures of the mid-1730s and his ultimate masterpieces of group portraiture, the *Graham* and *MacKinnon Children* of the 1740s.

The Beckingham Marriage (1729–30, Metropolitan) may be considered as a slightly different form in that it represents a public ceremony with portraits of the family and the officiant involved. But this painting, with its primitive string of people across the canvas, fails because it has no immediate sense of the married couple, no psychological interest relating to the ceremony. The limitation of conversation pictures, large and small, is evident: the artist has to include the people required by his purchaser, in a given setting. Hogarth's best efforts are those in which he approached the purchaser with a modello, or in which, exhibiting a modello, he attracted purchasers. Even so, a picture like the *Bambridge Committee* was marred by the deviations he was forced to make from the modello in order to get in all the portraits required. It goes without saying that the conversation picture did not allow scope for Hogarth's satiric talent, except perhaps in the groups of children, where general and harmless satire was permissible.

As to his success in the field, Vertue's various estimates tend to be inconsistent, but it was nevertheless marked, and sufficed to make the public aware of Hogarth as a painter. Hogarth's own comments are succinct. His hatred of drudgery, he says, his failure to be a first-rate copper engraver, "and other reasons made him turn his head to Painting Portrait figures from 10 to 15 inches high" of subjects in conversation. But this kind of painting, "tho it gave more scope to fancy than common portrait was still less but a kind of drudgery"—i.e. like the engraving he had escaped earlier.

As Vertue noted, Hogarth had already turned from conversations to more congenial and independent subjects, which he sold at auction or to visitors to his studio. In 1729 he sold *The Christening* (or *Orator Henley Christening a Child*) (pl. 23) and about the same time *The Denunciation* (or *A Woman Swearing a Child to a Grave Citizen*, National Gallery, Dublin). Both have the same banded com-

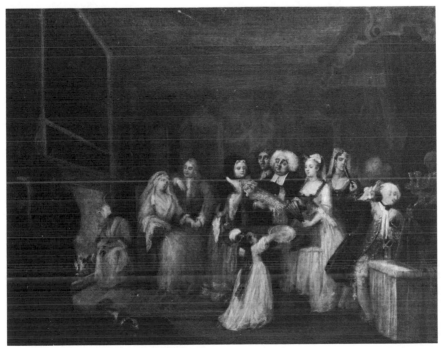

23. The Christening, or Orator Henley Christening a Child; 1729?; 19½ x 24¾ in. (private coll.)

position that came off rather well in the *Hudibras* engravings, but in the paintings Hogarth has not yet subdued the space above and below his figures.

The Christening, a work in which the portraits are satirically and topically intended, depicts a ceremony, publicly identifiable with the most notorious clergyman of the day, John (Orator) Henley, officiating, and with psychological interest directing the viewer away from the ceremony to the participants. Anticipating the situation of the first plate of *Marriage à la Mode,* the husband and wife are both ignoring

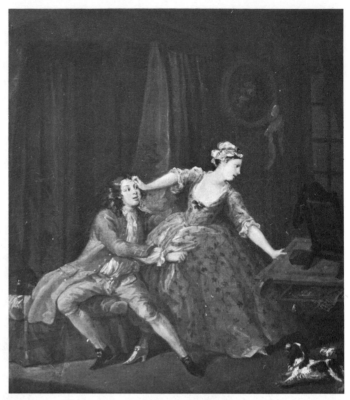

24. Before (indoor scene); ca. 1731?; 15¼ x 13¼ in. (Art Properties, Inc., J. Paul Getty Coll.)

the ceremony, he admiring himself in a mirror, she slouched in a chair and being courted by another man.

Thomas De Veil is, according to tradition, the justice portrayed in *The Denunciation;* and he may also be the man who appeared five or ten years later in *Night,* the last plate of *The Four Times of the Day.* If Hogarth put Henley in a christening, he would probably have put De Veil in a court hearing. De Veil and Sir John Gonson were the most famous magistrates at this time, but it was De Veil who would have held such a session as the painting shows in his house. He had a propensity for the fair sex (though married four times, with twenty-five children) and a reputation for helping out shady women (e.g. someone else's kept mistress) and taking his reward in trade.

Hogarth's relations with his public at this time, as he began to consider a return from painting to engraving, must have been especially

pleasant and intimate, although he threatened a certain "uncommonly ugly and deformed" nobleman, who had refused to pay for his truthful likeness of him, with exhibition of the portrait with some added unflattering appendages.

There were special commissions as well. The earliest and most notorious of these was from Mr. Thomson, probably the John Thomson

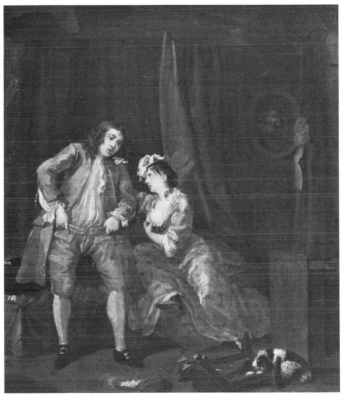

25. After (indoor scene); ca. 1731?; 15¼ x 13¼ in. (Art Properties, Inc., J. Paul Getty Coll.)

(M.P. for Great Marlow) who was on the Commons Committee for the Fleet Prison and was associated with Sir Archibald Grant in the Charitable Corporation for the Relief of the Industrious Poor. This organization lent small sums upon pledges, until the corporation members decided to define themselves as industrious poor and borrowed corporation money on sham pledges for speculation.

The pictures were the outdoor versions of *Before* and *After* (Fitz-

william Museum, Cambridge), which are consciously French (like the Watteauesque *Fishing Party*) in composition, color, and handling. The pictures, pretty as they are, contain the one detail in Hogarth's surviving work—revealed by recent cleaning—that might be classified as indecent. In *After* the boy's face has become very red—a brick red as if from heat exhaustion—and his trousers are open revealing pubic hair and a penis inflamed to match his face. Aside from the beauty of execution in these little pictures, they are chiefly notable for conveying their point by creatural realism, whereas the interior version of the same subject, painted not long after, displaces this realism to symbolic objects: an exhausted dog and a broken mirror (pls. 24, 25). Thomson never picked up his *Before* and *After*. In October 1731 he made off with his embezzled profits and the company books, sailing to France and later turning up in Rome. Sir Archibald Grant stayed to face the music but, with Thomson, was discredited and declared bankrupt and in May 1732 was expelled from the House of Commons. As a result, Sir Archibald never claimed his pictures from Hogarth either; *The Bambridge Committee* went to William Huggins, son of Bambridge's old master, as did *The Beggar's Opera*, paid for no doubt with old Huggins' ill-gotten gains from the Fleet Prison.

The drinking scene, later engraved and entitled *A Midnight Modern Conversation* (pl. 26), may have been painted around 1730 too. Generically a "Merry Company" picture (though later, to suggest classical origins, Hogarth called it a Bacchanal), it nevertheless probably contains recognizable likenesses of a group of drinking companions. This painting typifies Hogarth's work just before the *Harlot's Progress*. His characteristic olive green is present in the tablecloth and palely reflected in the grayish-green walls; the sprawling man's attire is a somewhat more garish version of the salmon red Hogarth used in so many of his later paintings. Hogarth still includes the theatrical curtain at the left (it was evidently painted over some architectural form), making the room look like a stage and the men like actors in a play. The large spaces around the figures recall the conversations and the final *Beggar's Opera* paintings rather than the works of the 1730s with their rigorously filled picture space. Two tendencies are already apparent; first, the use of a large square or block, here a table, in some part of the picture. The perspective of the table is, characteristically, slightly inaccurate; like a Cézanne table, it does not quite close. Second, there is a restlessness in the figures, for example the standing man

in the foreground, whose coat has been lengthened without all traces of the change being removed. Painting directly on the canvas, Hogarth often moved his figures about to achieve the right result. As the *Midnight* canvas was cleaned, a head emerged above the smoking parson and a door behind; also panels, a standing clock, and a different table, closer to those in the print of 1733. The shapes of the people

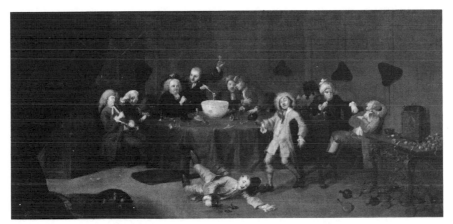

26. A Midnight Modern Conversation; 1730–31?; 31 x 64 in. (Mr. and Mrs. Paul Mellon)

were originally higher up on the wall. The change from a pillar or something similar to the curtain and the adjustment of one of the hats on the wall were made as the picture was being painted and before the pigment was dry.

It seems safe to say that Hogarth did not intend to engrave any of these paintings himself; but he may not have been averse to having someone else do it. The two Joseph Sympson, Jr., prints—*The Denunciation* and *The Christening*—can probably be dated between 1729 (when the latter painting was sold) and 1731 or '32, perhaps very near the time of the engraving of the *Harlot's Progress*. Vertue makes Joseph Sympson, Jr., sound like a young man pushed by his ambitious and proud father. Certainly his surviving work is mediocre, less competent even than his father's. It would seem likely, however, that his work appeared suitable enough to Hogarth, or that Joseph Sr. urged his son upon Hogarth; and that an arrangement was made between Hogarth and the elder Sympson, who published the prints at his shop, apparently in conjunction with the Overtons. The results were stiff and awkward—not at all what Hogarth could have desired.

A Harlot's Progress

A 9½- by 13-inch drawing (pl. 27) has survived of an old harlot and
her peglegged bunter in a shabby chamber, in the style of the *Hudi-
bras* drawings, and, interestingly enough, approximately the same size
and scale. The picture fits nowhere in the *Hudibras* narrative, but it
might represent an early attempt, which was then put aside, to pursue
in another direction the lessons learned there. We know this much:
sometime in 1730 Hogarth reiterated the general idea of this drawing
in an oil painting, but with a notable difference: the scene takes the

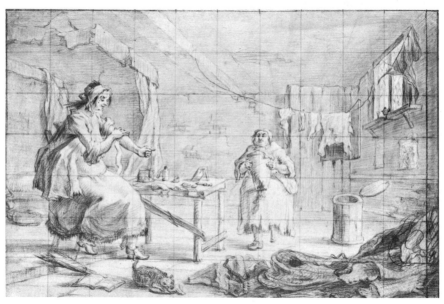

27. Sketch of a Garret Scene; 1730?; 9½ x 13 in. (BM)

mock form of a levee in low life and the harlot is now young and
pretty. At this point Hogarth had added to the Defoe or Gay subject
matter and the squalidly realistic setting the contrast of youth, bloom,
beauty, and apparent innocence. In the back of Hogarth's mind may
have been Steele's sentimental defense of prostitutes in *Spectator* No.
266 (4 Jan. 1711/2). Although it is not likely that Hogarth's experi-
ence with London prostitutes was wholly literary, it is probable that
he was indoctrinated by Steele's argument that the bawds are the vil-
lains and the girls are to be pitied. The "progress" of a harlot outlined

by Steele is essentially Hogarth's: innocent and "newly come upon the Town," "falling into cruel Hands."

Sometime in 1730 then, I would guess before August, Vertue and many others saw Hogarth's painting of a harlot in his Covent Garden studio. "This thought pleased many," Vertue writes, "some advisd him to make another. to it as a pair. which he did. then other thoughts encreas'd, & multiplyd by his fruitful invention. till he made six. different subjects which he painted so naturally. the thoughts, & strikeing the expressions that it drew every body to see them—." If Vertue had drawn attention to the presence of Gonson and the Harlot one could date the picture quite easily. Since he does not, mentioning Gonson only as part of the finished series, one must assume that the Gonson–Harlot relationship was a later addition. With this in mind, it is possible to trace the germination of the series. The only assumption necessary is that Hogarth (as was the case with every other series of his prints) followed the newspapers closely.

A thief named James Dalton, whose wig box appears atop the Harlot's bed in the third picture, is the first character in this strange history to come before the public eye. Dalton was a robber with a long, checkered career that was drawing to a close at the beginning of 1730. In December 1729 he attempted to rob the great Dr. Mead in his coach, but failed and was captured. Other crimes from the past were dredged up, and on 23 February he was indicted for robbing a person in the street and his fate was sealed.

At this point a second character enters the ken of the newspaper-reading Londoner. Nathaniel Mist, in *Fog's Weekly Journal* of 6 December 1729, wrote:

> It is reported about the Town, that a certain noble Colonel lately attempted to rob a Young Woman, a Servant Maid, of her Honour, and that to frighten her into a Compliance with his filthy Desires, he drew a Pistol upon her—He is to be sued for the Assault.

A year earlier Mist had written in a similar vein: "We hear a certain Scotch Colonel is charg'd with a Rape, a Misfortune that he has been very liable to, but for which he has sometimes obtain'd a *Noli prosequi*."

Any knowledgeable Londoner would have been aware of the identity of the "noble Colonel," and the only surprise would have been elicited by the news of 26 February that Colonel Francis Charteris (or

Chartres) had surrendered himself at the Old Bailey, an indictment having been found against him for ravishing Anne Bond, his servant.

Colonel Charteris was a man whose movements were reported in the papers as a matter of course. Allegedly worth over £200,000, gained through gambling and worse, he was most famed for his violent pleasures and had bought his way out of earlier prosecutions, including one conviction for rape. Charteris' trial was held on 26 February 1729/30, and was attended by the Duke of Argyle, the Duke of Manchester, Sir Robert Clifton, "and others of the Nobility and Gentry." Anne Bond, the plaintiff, testified against him. Charteris' attorney argued that she had made up the story to cover her discharge for stealing money. His witnesses' testimony, however, was shown to be full of inconsistencies and contradictions. After a trial of four hours, Charteris was capitally convicted and carried off to Newgate.

At this point a third strand appears in the story. On 25 February one Francis Hackabout, a highwayman, was convicted of robbery. On Saturday night, 28 February, sentence of death was passed on malefactors at the Old Bailey, and these included both Francis Hackabout and Colonel Charteris.

March burgeoned with pamphlets and prints about Charteris and his trial, as well as reports on his attempts to gain a pardon and his struggle to keep his property. On 9 April news reached Charteris from Lancashire that none of his property there had been molested, and the same day James Dalton was capitally convicted at the Old Bailey for robbery on the highway. The next day he received sentence of death, and Charteris—his and his friends' endeavors having proved successful —was discharged from Newgate, pardoned by the king. On 13 April Francis Hackabout the highwayman was ordered to be executed the following Friday, the seventeenth; and all Charteris' effects at Newgate were removed in a hackney coach to his new lodgings in fashionable Leicester Fields. On Friday, as scheduled, Hackabout and four other malefactors were hanged at Tyburn.

On 20 April the *Daily Post* reported of Charteris that "last Saturday Night, as he was going in a Hackney Coach to Chelsea, the Mob fell upon him and beat him in a barbarous Manner, for no other Reason than that there were two Women with him in the Coach." Dalton was executed on 12 May. On 23 June Henry Fielding's farce *Rape upon Rape,* with patent allusions to Charteris, was performed and published.

Toward the summer of 1730, when the various random strands came together, yet another character appeared on the scene, as famous in his way as Charteris. As early as 1728 Sir John Gonson, the Westminster magistrate, was well known for his charges to the grand jury at the Quarter Sessions of the Peace of Westminster and was repeatedly chosen chairman of the sessions for the year. His charges seem to have been remarkable productions; the irreverent *Grub-street Journal* compared them to sermons, and some claimed they were written for him by Orator Henley. But his greatest fame was as a law officer—he appears in almost every issue of every paper zealously raiding gamblers and prostitutes. On the night of 1 August he and several other justices of the peace for the City and Liberty of Westminster committed the keepers of several disorderly houses to Tothill Fields Bridewell to hard labor, in particular Katherine Hackabout. The *Grub-street Journal* for 6 August prints accounts of the raid from various newspapers, and neatly juxtaposed in the adjacent column, it prints a notice from the *St. James's Evening Post* of 4 August: "Colonel Chartres and his Lady being perfectly reconciled to each other, and having made proper dispositions for cohabiting together, he having cashiered his man trusty Jack and others of his evil agents; they are to be presented to their majesties one day this week on that occasion."

Here the apprehended prostitute Kate Hackabout, whose brother was condemned and hanged, is placed in conjunction with the aged rapist who started girls like Kate on their careers, and was condemned along with her brother but unlike him escaped hanging. For Hogarth, if he read the *Grub-street Journal*, two threads of irony must have coalesced. One was the inconsistent justice meted out to high and low, the other was the unbalanced equation pitting Gonson and Justice against the vulnerable whore. It seems very possible that on this day, 6 August 1730, the various themes, conventions, and characters floating about in Hogarth's memory came together to shape a history for the pretty harlot in her Drury Lane garret (pls. 28–33).

The Harlot's name appears on a letter in an open drawer in the third scene "Md. Hackabout," and on her coffin in the final scene "M. Hackabout." The "M" was extended to "Moll" in the sub-title of the pamphlet, *The Harlot's Progress or the Humours of Drury Lane* (1732), with no authority. Hackabout was, of course, a good generalizing name for a harlot, as well as a name familiar to Hogarth's readers.

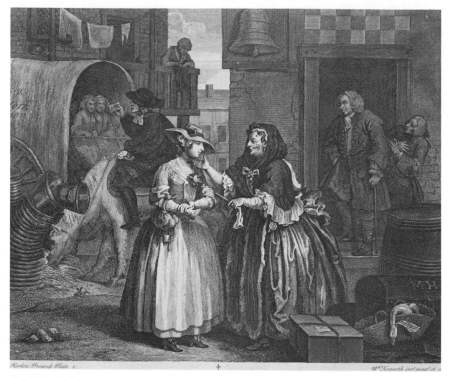

28. A Harlot's Progress (1); April 1732; 11¹³⁄₁₆ x 14¾ in. (BM)

So he puts a girl named Hackabout in her shabby room, with James Dalton's unclaimed wig box above her head and portraits on her wall of Captain Macheath the robber who talked like a gentleman and got off scot-free, and Dr. Sacheverell the gentleman who toppled a ministry with an incendiary sermon and lived very well thereafter. In Plate 1, Hogarth shows the girl just off the York Wagon, met by a bawd, with Colonel Charteris and his man, "trusty Jack" Gourly, waiting in the background. All of these were easily recognizable portraits: Vertue identified Gonson, Charteris, and the bawd Mother Needham; Gonson's initials appear on the wall of Bridewell in Plate 4; and given Charteris, "trusty Jack" is a logical inference for his companion. The recognizable presences within the framework of conventional scenes and relationships attracted buyers, lending the prints a sense of contemporary realism (as later in Fielding's novels real inns and doctors are named); but they also came to represent a level of allusion to the world of the respectable, rich, and powerful—the rake

who can rape with impunity and the magistrate who hunts prostitutes as others hunt hares.

Events did not come to a halt in August 1730. As the summer turned to fall, Gonson continued to raid brothels, his procedure becoming a refrain encountered in every few issues of a given newspaper: Gonson has a house raided, meets with his other justices, examines the prisoners, and commits them to Bridewell in Tothill Fields to beat hemp.

In the *Grub-street Journal* of 23 April 1730 is an account of one Mary Muffet, "a woman of great note in the hundreds of Drury, who about a fortnight ago was committed to hard labor in Tothill-Fields Bridewell . . . she is now beating hemp in a gown very richly laced with silver. . . . to her no small mortification"—exactly the ironic contrast Hogarth brings about in his fourth plate, which shows the Harlot carried off from her garret in Drury Lane to Bridewell to beat hemp in the same fashionable gown she was wearing in Plate 2.

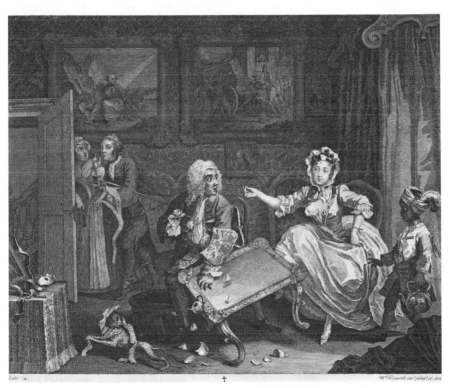

29. A Harlot's Progress (2); 11⅞ x 14⅝ in.

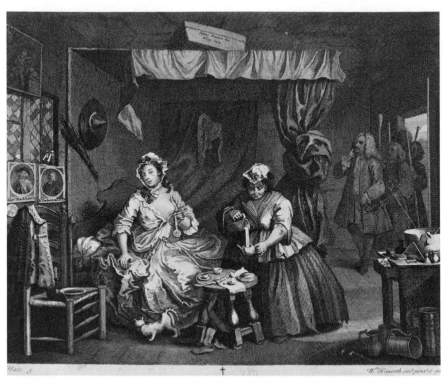

30. A Harlot's Progress (3); 11¹³⁄₁₆ x 14⅞ in.

Mary Muffet and her richly laced gown fit into Hogarth's picture of his Harlot. It should be clear, recalling the actual details of Anne Bond, the servant girl debauched by Charteris, and Kate Hackabout, that he has placed his Harlot somewhere between those extremes. She is not Anne Bond: the second plate is not her rape but her happy assumption of the role of kept woman. She is not Kate Hackabout: she never loses her air of gentility. With this pretty young girl, the gown worn in Bridewell indicates her remnants of fashionable keeping and, because she is still wearing it, her guiding motive: originating as part of a mock-levee, she tries to become a lady, manages only to be a harlot, and as a harlot thinks herself a lady. Thus the Harlot keeps her gentlewomanly clothes, always has masquerade disguises around her, and ends with a funeral unprecedented for one of her trade.

For the bawd who seduces M. Hackabout in the inn yard, Hogarth drew the most famous procuress of the time, Elizabeth Needham. On

Friday 30 April, a month after Hogarth had begun his subscription for the *Harlot's Progress*, "the noted" Mother Needham stood in the pillory facing Park Place and was so "severely handled by the populace" that she died on 3 May.

By this time Hogarth had probably completed most of his paintings, and Mother Needham's fate can only have confirmed feelings already at work in the series. She is of course the Harlot's original corrupter, the bawd who usually escaped detention while her girls beat hemp; yet she is only an intermediary for the Charterises, and her death, analogous to the Harlot's, is an ugly one, with the very people she has served clamoring for her punishment.

There are at least three foci of guilt in Plate 1: the girl herself; Mother Needham, who is exploiting her; and Charteris, who is exploiting Mother Needham, and will no doubt be one of those who pelt her in the pillory. Hogarth could easily have replaced Mother Needham's face in the print; his subscription had barely begun when

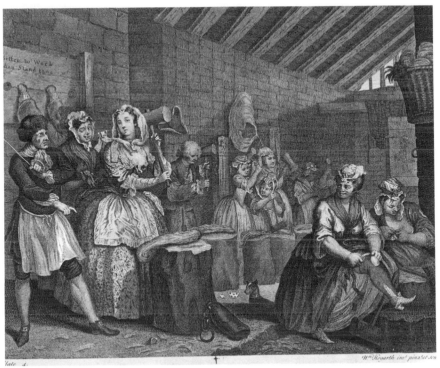

31. A Harlot's Progress (4); 11⅞ x 14¹⁵⁄₁₆ in.

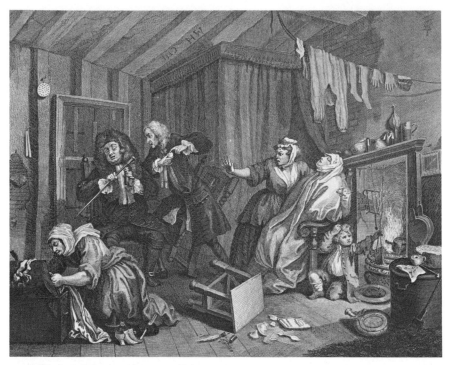

32. A Harlot's Progress (5); 12 x 14¾ in.

she died. However, the fact and the circumstances of her death added
a new dimension to his picture, or at least his own attitude toward it,
and perhaps to the viewer's reaction as well.

The clergyman is also part of the guilt explored in Plate 1, turning
his back on Hackabout, Needham, and Charteris. The letter he holds
is to the Bishop of London, who was Sir Robert Walpole's chief ad-
viser in the matter of ecclesiastical preferment: the clergyman is think-
ing about his advancement rather than his duty. Hogarth's attack on
the clergy does not end here—in Plate 2, a priest is shown stabbing
Uzzah (in the painting of the Ark of the Covenant), and Bishop Gib-
son is alluded to again in the third plate, where the Harlot uses one of
his *Pastoral Letters* as a dish for her butter. There is something obses-
sive about Hogarth's references to clergymen in these early prints;
perhaps it is significant that he regards them as the Puritans regarded
Anglican clergymen, as time-servers, always more interested in some-
thing other than the spiritual welfare of their charges.

It only remains to mention the pervasive background of remedies

for venereal disease that spotted the back page of every newspaper. In the late 1720s they begin to crowd out respectable advertisements. The two quarreling doctors in Plate 5 offer the basic choice of bottle or pill. Most are bottle cures—the "Anti-Syphilicon," 6s a pot, and the "Diuretic Cleansing Elixir" for "Gleets and Weaknesses," 5s a bottle. Another was Dr. Rock's "incomparable Electuary," "the only VENEREAL ANTIDOTE," 6s a pot, sold at the Hand and Face near Blackfriars Stairs. To judge only by the venereal disease ads, a reader might well conclude that the disease rate had appreciably increased, and this must be taken as part of the commentary of Hogarth's fifth plate, with its doctors and variety of cures coupled with the image of death and degeneration.

The final painting was presumably finished Thursday, 2 September 1731, the date on Hackabout's coffin; at any rate, Hogarth seems to have intended this date to signify the completion of the series, as an allusion or as a private memorial.

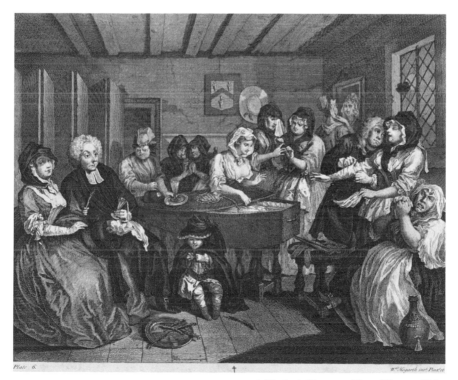

33. A Harlot's Progress (6); 11 13⁄16 x 14⅞ in.

It is misleading to view the *Harlot* series as an anticipation of *Pamela*, Richardson's sentimental account of the sufferings experienced by a young girl threatened with sexual degradation. Although Plate 1 presents the piquancy of threat, Plates 2 and 3 the fall accompanied by poverty and squalor, Plate 4 the legal and Plate 5 the physical punishment, the cumulative effect is quite different from that of the sentimental novel. Hogarth's print is packed with complicating detail which establishes a reciprocal pattern of guilt and innocence, cause and effect. While Pamela is a virtuous servant girl, Hogarth's Harlot is clearly a young girl on the make; in a sense she is the Pamela Fielding detected beneath her virtuous protestations. The effect of virtue threatened, dominating Richardson's novel, is absent from Hogarth's print. Injured or threatened innocence is the subject matter of sentimental fiction; guilt, not innocence, is the subject matter of satire, with more than one kind and degree of guilt indicated.

Here then is the pattern or structure of Hogarth's *Harlot's Progress:* an innocent encounters the ambiance of the "great," the fashionable, the respectable; turning against her own nature she imitates this "greatness," and comes to grief while the "great" themselves go on their merry way. What I have sketchily indicated are some of the more readily documented literary, social, historical, and biographical forces that contributed to the creation of this pattern: these can be distinguished as both private, perhaps pre-conscious sources, and public patterns of thought. It is, of course, impossible to separate one from the other—what appears to be personal may in fact be determined by some general social or literary pattern of thought in the period.

More than any of his Augustan predecessors, however, Hogarth pits society as a whole against the individual who desires to emulate the behavior of fashionable folk; not just the forces of pleasure and corruption but also those of law and order, drawn like sharks by the smell of blood. The guardians of society, from the doctor to the clergyman, if they do not actively prey on the Harlot, simply ignore her; each, like the lecherous clergyman in the last plate, goes about his own business. This aspect of the series is open to speculation: to what extent is the portrayal of clergymen and police conventional, like the portrayal of doctors, and to what extent is it a reflection of Hogarth's own dark memories and experiences?

By the beginning of 1731 all six paintings of *A Harlot's Progress*

must have been far enough along to be shown in Hogarth's studio, though additions and changes were made, no doubt, during the next year. By early March 1730/1 the subscription ticket known as *Boys Peeping at Nature* (pl. 33a) was etched and in circulation: an announcement, a lure, an elaborate joke, and a statement of aesthetic intention.

At the center Hogarth places the many breasted image of Nature (Diana of the Ephesians) adapted from Rubens' *Nature Adorned by the Graces,* as a compliment to his father-in-law, who owned the original painting; but Rubens' three Graces, engaged in veiling the goddess, are transformed into putti fighting over whether she should be veiled or unveiled. *Boys Peeping at Nature* should be contrasted with the frontispiece of *Hudibras,* Hogarth's earlier manifesto; here he has turned his back on a literary text to imitate Nature herself. One putto is shown painting her: his version reaches only a little below her bust and leaves out some of her numerous breasts. A faun is concerned

33a. Boys Peeping at Nature; 1730/1; 3½ x 4¾ in. (BM)

with those lower parts which are concealed by a shift hung around the statue; a second putto is trying to prevent or restrain the faun from lifting Nature's shift. A third is working on a drawing with his back turned to Nature, presumably drawing ideal forms from his imagination. The artist can thus expurgate Nature, ignore her altogether, or present her unadorned. Hogarth presents his image in terms of history conventions, specifically decorative, and supports them by learned epigraphs from Vergil and Horace. From the Vergilian motto behind the putti—Apollo's words to Aeneas, "Antiquam exquirite Matrem" (seek out your ancient mother)—one infers that this unadorned Nature is going to be the artist's model. He is also, of course, alluding particularly to the subject of the series, a harlot—and more generally to the seamy side of life. Lifting the veil is also, and perhaps most important, an allusion to the veil of allegory by which the poet traditionally protected the Truth he was conveying. Hogarth associates his plates with the double meaning—a "plain literal Sense" and a "hidden Meaning" —of epic allegory. The quotation beneath the design is from Horace's *Ars poetica:* "It is necessary to present a difficult subject in new terms . . . and license will be allowed if it is used with care." Taken together, the two epigraphs suggest that Hogarth is attempting in the *Harlot's Progress* something new and at the same time old, that is, traditional: sanctioned by ancient authority and derived from original, now forgotten (or ignored) sources.

Hogarth seems to have considered the literature–painting analogy, perhaps implicit in his reference to the *Ars poetica,* as the common denominator between the *Harlot's Progress* and the tradition of history painting. (I should emphasize that in the following discussion I refer only to the prints of the *Harlot's Progress.* The paintings were destroyed in 1755, and the general case of Hogarth's *paintings* as history will be taken up in the next chapter.)

Contemporary critics, who had already begun calling Hogarth the Shakespeare of painting, were writing from assumptions that he shared and indeed fostered. They echoed the belief of Jonathan Richardson, whose art treatises were influential among educated Englishmen of Hogarth's generation, that a history painter "must possess all the good qualities requisite to an Historian," and beyond that he must have "the Talents requisite to a good Poet; the Rules for the Conduct of a Picture being much the same with those to be observ'd in writing a Poem."

Richardson echoes Shaftesbury and both, of course, simply restated critical assumptions on history painting that went back to the Renaissance. The essential ideas involved here are that painting can render an action as completely as a poem, that it can attain the same moral end, and that its highest reach is, like poetry's, the representation of human action in its superior forms—the heroic and sublime. To say that a painter was literary meant that, educated not only in painting techniques but in the classics and scriptures as well, he based his painting on a literary text; and, more generally, that his painting was based on literary rather than (or in addition to) graphic conventions—that his works could be *read*. Different schools of history painting emphasized the literary in one or the other of these senses, and—as Poussin, for one, complained—often painters simply decorated a text. The reactions and counterreactions of Caravaggio, the Carracci, Domenichino, Poussin, Rubens, and Rembrandt, defined the course of the development of history painting.

If Hogarth never uses the term "read" (although he frequently calls himself "author"), it is probably because he thought of his pictures in terms of a stage representation—a succession of scenes, with characters speaking lines and gesturing—rather than a book. Taking Plate 3 as an example, one can trace the readability of its *disposition* by following the movement of the eyes from the Harlot and her hunter to the figures approaching behind, who are plainly law officers come to arrest her. But one does not stop there: one continues, literally reading the inscriptions and images on the pictures, papers, and wig box. A contemporary with the art treatises in mind could have seen Hogarth's first plate as a study of responses to the young country girl, Plate 2 as responses to her kicking over the table, Plate 3 as responses to a harlot in squalor, and so on. Hogarth's relationships are, of course, more complex than this: he shows the Harlot's complete self-absorption (studying a stolen watch) as well as the justice's stealthy eagerness. Expression will be a cornerstone of his aesthetic, and his reputation rested to a large extent on his ability to convey shades of facial and bodily expression (as on his ability to catch likenesses). But he was also well aware of the limitations of the concept. Hogarth's solution was to extend *l'expression* from face and body to attributes and surroundings, furniture and pictures. The cat's body is as expressive and significant in a reading of the Harlot's psychology in Plate 3 as her face; her costume (the same fashionable gown she wore in keeping in

Plate 2) contributes to her expression, as do the pictures she keeps on her walls, the hatbox above her head, and her other possessions.

The classic instance of "reading" a painting and placing different temporal stages of an action in a single spatial design is the *Tabula Cebetis,* used as a Greek and Latin textbook in many English schools (fifty-six editions before 1800 are to be found in the British Museum) and repeatedly translated into English as well (thirteen editions); considering Hogarth's background, the *Tabula* would very probably have come to his attention early in life. Years later, in the 1750s, the Scotsman James Moor was to use Hogarth's prints as his example of how different times and places were represented in pictorial space by the *Tabula Cebetis.* Certainly this work is part of the context of Hogarth's oeuvre, especially of *The Lottery,* but Cebes' use of a city in which groups of people could be at once naturalistically themselves and allegorically different stages of experience in the progress of an Everyman was only a partial solution for Hogarth, with his focus on a particular protagonist. His own use of "reading" in *A Harlot's Progress* draws rather on the tradition of history painting, on its origins in religious depictions.

The religious painter of the High Middle Ages could introduce into one picture any symbols he wished—from the past, from other stories, or from other areas of experience. But with the rise of naturalistic conventions such as perspective, the artist, no longer able to mix real and overtly symbolic objects, turned to real objects for his symbols. When a medieval artist wished to show Old Testament prophets as witnesses to the crucifixion he simply placed them at the foot of the cross; toward the same end, later artists would introduce artifacts: statues or painted images of them, on a window, a screen, floor tiles, or as the decoration on furniture. Panels might appear carved into the architectural background to represent events before and after the central moment, as Hogarth used pictures on the walls of his rooms to foretell or to make a generalized comment on the life going on in the room.

Like most of his contemporaries, Hogarth accepted the French academic interpretation of history painting, and in the *Harlot's Progress* he rejected only two of its chief precepts, one incidental and the other essential—the copying of a literary text and the representation of idealized nature. In both cases he was not only following his own inclination to draw comic reality but also reacting against the history

painting of his time that overemphasized these qualities. Both amounted to an abandonment of the heroic subject and characters through an apparent sacrifice of the universal to the particular. For Poussin the use of such adventitious and local detail—geography, dress, identifiable faces—was at odds with the universal truth for which he strove. The reader of his *Flora* (Dresden) is required to know the fourth book of Ovid's *Fasti* and recognize the various figures by their poses and attributes; but these, he would have argued, are recognizable so long as the literary tradition continues, while Hogarth consigns these stories to the walls of his rooms and takes his primary representation from the daily newspaper. The reader must recognize Mother Needham, Colonel Charteris, Sir John Gonson, and grasp the significance of local references (Drury Lane, Sacheverell) and all the "furniture" of his scene.

The essential difference between Hogarth and Poussin can be summed up in the heroes they portrayed. The central figure in Poussin's narrative pictures was either the typical Renaissance hero, idealized, greatly endowed and greatly rewarded by the gods, or the *honnête homme* who behaves properly when faced with temptation, defeat, or despair. That Hogarth's protagonist is the person who, faced with one of these tests, fails and is punished—a hero only by comparison with the knaves around him—indicates that he was following a different literary tradition than Poussin. The same applies to his use of contemporary detail, in which the universal is to be found in the particular, as the particular (named poets and critics of Pope's *Dunciad* or the particular Lord Hervey in Sporus) contributes to a generalized image of evil. The epic of Homer, Vergil, Ariosto, or Tasso is simply replaced in Hogarth's history painting by the satire of Butler, Swift, Pope, and Gay.

In general, Hogarth's aim was to parallel his modern history with a recognizable analogue of history painting. In the *Rake's Progress* (1735) the early scenes imply mythological analogues, the second plate connecting the Rake's choice with Paris' and the third a brothel scene with a *Feast of the Gods* or a *Bacchanal;* the final scene in Bedlam shows the Rake in the arms of Sarah Young, in the pose of a *Pietà*. *The Battle of the Pictures,* the ticket for the sale of Hogarth's comic history paintings (1745), makes his aim clearer by pairing each of his works with its old master equivalent: the *Harlot* with a *Magdalen, Midnight Modern Conversation* with a *Bacchanal,* the *Rake's* brothel

scene with a *Feast of the Gods.* In subsequent series the correspondence becomes more general: the prude going to church in *Morning* recalls a *St. Francis at His Devotions* and the second plate of *Marriage à la Mode* recalls the *Aldobrandini Marriage,* in which there is a thematic but no compositional relationship.

The use of compositions from *Life of the Virgin* cycles is also, however, a kind of subversion, or at any rate Hogarth's way of saying (as in the subscription ticket) that he is treating quite another kind of life. The same subversive play is at work in the first plate. If the Harlot–Mother Needham–Charteris group derives from *The Visitation,* the clergyman–Harlot–Mother Needham group refers wryly to the *Choice of Hercules* as a paradigm of the effective history painting: the Harlot is making her choice between virtue (the clergyman) and vice (Needham). The most famous, elaborate, and influential of the discussions of exactly how a history painting should be composed was the Earl of Shaftesbury's *Notion of the Historical Draught or Tablature of the Judgment of Hercules* (1713). Shaftesbury took the subject of Hercules at the crossroads choosing between Virtue and Pleasure (or Vice, as she was called by her enemies); the best-known version was Annibale Carracci's in the Farnese Gallery, but there were others by Rubens and Poussin and numerous lesser artists, including Verrio and Laguerre and of course Thornhill. Shaftesbury had a version made by de Matteis to his own ideal specifications (pl. 34).

It is altogether appropriate that Hogarth should begin his first series of modern history paintings with an allusion to Shaftesbury's paradigm of sublime history painting. But there are a number of other reasons as well. Choice is emphasized by Shaftesbury as the subject par excellence of history painting, but Prodicus' "Choice of Hercules," from Xenophon's *Memorabilia,* was deeply rooted in the curriculum of the English schools and, indeed, in the English popular consciousness. Addison's paraphrase in *Tatler* No. 97 is only one of many redactions of the story. Richard Hogarth would doubtless have made his son aware of it following one of those sessions in which his small Greek scholars had to construe it. Characteristically, Hogarth used a paradigm that drew sustenance and significance from both the art treatises and the reading of the ordinary educated Englishman.

If, with all this in mind, one returns to the first plate of *A Harlot's Progress,* it becomes evident that Hogarth has now completely reversed the Shaftesburyian paradigm. He treats the choice, not at the

34. Paulo de Matthaeis (or Matteis), The Choice of Hercules, engraved illustration for
Lord Shaftesbury's *Characteristicks;* 1714 (corr. 2d ed.)

moment when Virtue is winning, but when Pleasure is about to win.
Moreover, while Vice is supposed to be silent and Virtue to be argu-
ing, persuading by words, Hogarth depicts the clergyman who repre-
sents Virtue with his back turned, and Pleasure, in the person of a
bawd, is offering her blandishments. This reversal in his first plate
demonstrates, like the iconography of *Boys Peeping at Nature,* that he
knows the tradition of history painting and is quite consciously alter-
ing it.

The large aim of Hogarth's modern history painting, then, is to
place the contemporary world in relation to conventions of biblical or
mythological resonance; and for this he naturally turned, as a disciple
of the literature of his day, to the Augustan mock-forms. The only
way, he felt, to deal with the heroic in modern bourgeois-sentimental
life was to depict it as a subversive force. In the process he relates
Hercules to the Harlot; but his overall strategy is to connect the high—

low contrast of the Augustan mock-heroic to the gentleman–criminal analogy of Gay's *Beggar's Opera* and the stories of Colonel Charteris and the Hackabouts (the gentleman who rapes and goes free, the robber and harlot who emulate the gentry and are punished) which he reads in the newspapers. He accordingly displaces the heroic level to the false ideals that are embodied in fashionable aristocratic shapes, costume, swords, gestures, or stare out at his characters from the awful copies of old-master history paintings on their walls.

What then of the grotesque, caricature elements, apparent in the frontispiece to the *Hudibras* plates and in the series itself? In the *Harlot's* subscription ticket Hogarth wishes to dissociate himself from the grotesque as such, as a lower genre, incommensurate with history painting. There are in fact no grotesque Hudibrastic figures in the *Harlot:* they have been toned down or, more importantly, displaced to actions or to the behavior of animals—horses, monkeys, kittens—or to inanimate objects like the knot in a bed curtain.

The heroic level usually tends to represent the ideals that men seek to emulate, attempting to rise above their natural inclinations; the grotesque tends to represent the irrational and subconscious: roughly speaking, the character's id, as opposed to the super ego expressed in those pictures hung on the walls or the other trappings of gentility. If the pictures indicate the level of pretension, the dogs and cats, the grotesque shapes of punishment, sickness, and madness, the gesticulating doctors and the faces detectable in natural objects indicate the level of nature or natural consequences. In between is the character (what Fielding was to call "character" as opposed to caricature) able to act for himself, but constantly drawn into heroic or grotesque attitudes or patterns of behavior that are inappropriate on the one hand or violent and uncontrolled on the other. Thus in metaphorical terms, he becomes a caricature. At any rate, instead of transforming his characters into animals as Rowlandson and Gillray were to do, Hogarth fragments them, keeping man separate from both the hero-villain and the animal.

Some sort of juxtaposition is predicated—a collision of realism and the poetic (the heroic, romantic, and so on)—in which the ideal is absorbed and given perspective in a realistic context, and reality itself is made poetic, or suitable for painting; more suitable, Hogarth would surely have argued, than in the Dutch drolls and genre pieces or the decorative histories of nymphs and satyrs. Hogarth's attitude toward

history painting was deeply ambivalent. His natural instinct was to distrust this highflown, unrealistic, uncommonsensical rhetoric; his conditioned response was to work within that tradition. Hence he sought out the clauses of classical criticism that supported a more realistic interpretation, and for the rest turned to the literary tradition of his day.

The reason that Hogarth was closer, at least in his early progresses, to the Raphaelite tradition and Poussin than to the great rebels like Caravaggio and the early Rembrandt was simple: the ideals of Raphael and the Carracci had usurped the main tradition of art criticism from Bellori to Félibien and Du Fresnoy and to Shaftesbury and Richardson. Hogarth stays as close as he çan to this tradition as it appeared in his time. According to the central concept of decorum, a painter in theory sinned equally by painting a humble subject in an exalted style and an exalted subject in a low style. But in fact the second misdemeanor was regarded as much the more heinous; Caravaggio and Rembrandt were attacked for treating a history in terms of a genre piece, for lapsing into vulgarity. Hogarth's procedure was to treat genre subjects—everyday occurrences—in terms of history. He was even being strictly orthodox in his subsequent attacks on "dark masters": the paintings he ridicules are usually offenders against decorum that introduce low elements into mythological or biblical subjects.

Well aware of the status enjoyed by history painting, and unwilling to devote himself to the alternative of showy religious art (though his training and abilities were not those of a history painter), Hogarth conscientiously explored all the possibilities open to him. One solution was to carry on seriously in the sublime tradition, and in the 1751 revision of *Boys Peeping at Nature,* used as a ticket for the engravings of *Paul before Felix* and *Moses brought to Pharaoh's Daughter,* he blotted out the faun peering at Nature's private parts, retaining the modest putto. Hogarth's sublime histories are Raphaelesque and broach no other subject than the Bible. The second possibility, which he considered his invention, was to treat the contemporary, local, and commonplace as history rather than genre. The effect could be either to elevate the present or denigrate it. Within Hogarth's lifetime the former developed into Reynolds' heroicized portraits of the aristocracy and middle class, which made the portrait a popular and characteristically English equivalent of history painting by turning the nondescript middle-class Englishman into a heroic shape in the grand

style, passing off a burgher as a king, hero, or saint. By the decade after Hogarth's death, English history painters were portraying the death of General Wolfe as a *Pietà*, with none of the irony present in the final plate of the *Rake's Progress*.

The opposite solution was Hogarth's in his comic histories: to point out the *in*appropriateness of history painting to contemporary English life. In these works the middle-class man who adopts the pose of the hero, or even the aristocrat, meets disaster. While Reynolds and West attempt to show the harmony between eighteenth-century man and his ideals, Hogarth shows man violently at odds with them. This man is on his own, trying to rise above his present social position, or trying in some way to order his surroundings, and he is overcome by recalcitrant nature. Musicians are confronted by a society of noisemakers, and a poet is pursued to his garret by duns and hungry dogs. Even animals (faithful friends in Reynolds' portraits) either quietly mock their human masters or rebel against them. In this sense, for all his ties with the main tradition of history painting, Hogarth was a Caravaggist rebel who attempted to subvert its basic idealism.

The important engraving venture between *Hudibras* and the *Harlot's Progress* was *The Life of Charles I* (1728)—another subscription conducted, according to Vertue, by the printsellers. Clearly Hogarth wished his audience to think of the *Harlot* as another of these impressive engraved series—a life, like the St. Paul, Marlborough, and Charles I paintings, but one that ends with an apotheosis very different from that of King Charles. From the business point of view too, the *Harlot* was a continuation of these engraved series.

Subscription publishing, usually of luxurious or esoteric works, was well established by the seventeenth century; the first important model in England was Tonson's edition of Dryden's translation of the works of Vergil, which appeared in 1697. Dryden was entitled to a proportion of the sums subscribed, so naturally went about recruiting subscribers; his total profit, which included the added earnings from sale of the manuscript, was £1400. The next great improvement in terms for the author occurred with Pope's *Iliad*. Bernard Lintot allowed Pope the entire revenue from subscriptions, and in addition paid him £200 for each volume. He reserved for himself the profit from all subsequent editions. In other words, the subscription rights and £200 a volume were Pope's pay, by which Lintot bought his

property. There were 575 subscribers who took 654 copies, and Pope made £5320 4s. The whole work, both *Iliad* and *Odyssey*, brought him nearly £9000.

Subscriptions were invited through advertisements in the newspapers, through mailing prospectuses to likely purchasers, and through the personal entreaties of the author and his friends. Partial payment was usually demanded with the subscription. One difficulty was that advertisements were too commercial for a proud poet, and the alternative, begging letters or calls upon the great, was no better. The artist who wished to break with patronage had more to overcome than the writer, whose words were easily registered by any printer on any page; the artist had a unique object, impossible to duplicate. The engraver, in a still more precarious situation, had naturally less leverage with his printseller than the author with his bookseller because he was essentially a middleman between artist and publisher. The artist and engraver were dependent on each other, and the distribution of profits usually depended on whether the artist or the publisher controlled the engraver and the subsequent copperplate.

Hogarth's clever stratagem with the *Harlot's Progress* was to eliminate the publisher or, rather, assume the role himself. He kept not only all the profits from the subscription but also all subsequent profits, plus the profits from the sale of the paintings on which the prints were based and any cheap authorized copies. Now a well-known painter, commencing his subscription in the spring of 1731, Hogarth published no advertisements to announce his proposals. He completed his subscription presumably by word of mouth, through the contacts he had already made in Parliament, and by exhibiting his paintings in his studio, which of course was in an area much frequented by people of all classes looking for something new (and, it might be added, theatrical). His price, as given on the ticket, was one guinea, half to be paid on subscription, the other half on receipt of the prints.

Hogarth's original intention was to disseminate reproductions of his paintings in a deluxe edition. He intended to print off as many as were subscribed for and no more. He may also have assumed that a subscription would exhaust the finer capabilities of the copperplates.

Further, he intended to have the series engraved for him. He wanted to be a painter and not an engraver; he wanted to move above the craft. But he also needed to spend much of his time in 1731 (as his

list of unfinished paintings indicates) finishing up work already con-
tracted and half paid for. He may at this time have tried Joseph Symp-
son, Jr., as a mezzotinter, to see whether the most painterly of media
would adequately transmit his paintings. But the samples Sympson
produced in this medium and in straight etching-engraving were dis-
appointing. Over the next ten months after his subscription began
Hogarth must have searched in vain for an engraver and finally begun
the job himself. By eliminating the reproductive engraver as well as
the publisher, he saved himself a great deal of money. Hogarth's own
engraving, once under way, proceeded slowly; a reproductive effect, a
fully covered plate that tonally resembled a painting, was called for,
and this was quite a different thing from the *Hudibras* plates. The en-
graving of the *Harlot,* Hogarth's most carefully done work to date,
was not improved upon until the 1750s.

On 14 January 1731/2 he announced in the *Daily Journal* and the
Daily Post:

> *The Author of the Six Copper Plates,*
> representing a Harlot's Progress, being disappointed of the Assist-
> ance he proposed, is obliged to engrave them all himself, which will
> retard the Delivery of the Prints to the Subscribers about two Months;
> the particular Time when will be advertised in this Paper.
> N.B. No more will be printed than are and shall be subscribed for,
> nor Subscriptions taken for more than will receive a good Impression.

Beginning on 8 March he ran a new advertisement in the *Daily
Post:*

> The six Prints from Copper Plates, representing a Harlot's Progress,
> are now Printing off, and will be ready to be deliver'd to the Subscrib-
> ers, on Monday, the 10 Day of April next.
> N.B. Particular Care will be taken, that the Impressions shall be
> good. Subscriptions will be taken in, till the 3d Day of April next, and
> not afterwards; and the Publick may be assured, that no more will be
> printed off than shall be Subscribed for within that Time.

By March Hogarth may have become aware of how wide a popular-
ity his subscription was enjoying; but with the prints themselves on
display, of course, the subscription was building to a climax. These
advertisements, sounding like notices to already enrolled subscribers,
were in fact designed to solicit subscriptions; no address is given
where the subscriptions may be taken, and the general impression of

the individual advertisement is that a private party is inserting a personal column. The effect is very reticent, subdued, dignified, and detached; this is an artist speaking to his patrons, not a merchant soliciting strangers.

According to Hogarth's friend William Huggins, Christopher Tilson, one of the four chief clerks of the Treasury, told him that at a meeting of the Board of Treasury held a day or two after the appearance of the third plate, "a copy of it was shewn by one of the Lords, as containing, among other excellences, a striking likeness of Sir John Gonson. It gave universal satisfaction; from the Treasury each Lord repaired to the print-shop for a copy of it." Since it is probable that no prints would have been released before or after the subscription was over, it is likely that Huggins' story refers to the day Plate 3, or its painting, was first exhibited in Hogarth's studio (not yet his "print-shop"), that the account was brought by word of mouth, and that the Lords went over to subscribe. Whatever the facts, however, the story indicates something of the way Hogarth's *Harlot* was received.

Two newsworthy events probably sold further subscriptions. Just as Hogarth was finishing his prints, the town was talking about the case of the Jesuit Jean-Baptiste Girard and his "harlot" Catherine Cadière, about whom Fielding wrote a comedy that appeared that same spring. Transcripts of the trial were published, as well as pamphlets, and, more to the point, a series of prints portraying the couple's lovemaking. One, a series of thirty-two etchings, may have been partly after designs by Gravelot. These "obscene Pieces of Impiety," to be sold in printshops, were attacked by newspapers, and may have led Hogarth to remove the obscenities that appeared on early impressions of the fifth plate. Also, the death of Colonel Charteris, which had taken place on 24 February at one of his northern estates, and news of his disgraceful funeral, at which garbage and dead dogs and cats were thrown by the outraged populace into the grave after his coffin, combined with the likeness of the old sinner displayed in Hogarth's shop, must have sold subscriptions.

Although there was no further announcement in the papers, the finished prints were doubtless delivered as scheduled on 10 April. If by the time the prints were delivered Hogarth had become aware that his true audience lay in the great mass of ordinary purchasers, he kept his promise to his subscribers. In his subsequent advertisements, he always notes that all his prints are available at his shop "except the

Harlot's Progress." For twelve years he kept his word, and presumably the value of impressions rose steeply; and then on 8 November 1744 he announced in the *Daily Advertiser:*

WHEREAS Mr. HOGARTH, in the year 1731, published by Subscription a Set of Prints, call'd *The Harlot's Progress,* and according to the Conditions of his Proposals printed off no more than were then subscribed for; and

Whereas many of the Subscribers themselves, (having either lost, or otherwise disposed of their Prints; and being desirous of completing their Sets, and binding them up with his other Works) have frequently requested and sollicited him for a second Impression:

The Author (in Compliance with their Desires, and presuming that he shall be indulged by the rest of the Subscribers, with their Permission to print the Plates again) proposes to publish a second Impression of

THE HARLOT'S PROGRESS:

And begs Leave to conclude, (unless it be otherwise signified to him before the 1st of December next) that he hath the general Consent of all his Subscribers to the present intended Publication.

WILLIAM HOGARTH

He distinguished the second impression by a cross centered beneath the design on each plate, and by minor revisions.

It is also clear that when he engraved the *Harlot's Progress* he had no intention of vending his own wares. He still considered himself a painter, not a merchant, and when the subscription was over he remained a painter. His plan was to have an engraver-printseller, Giles King, make authorized copies. Although it is not impossible that King came to him with the plan, the particular form King's copies took shows Hogarth's guiding hand. Here he was consciously addressing a lower, less educated audience—the audience he turned to in the prints of the late 1740s. The scenes were now graced with explanations and simple moral captions. The upshot was that King sold the nonsubscription *Harlot*s in a cheaper engraving (4s, 5s on "super-fine Paper," to Hogarth's one guinea) from his shop, and Hogarth presumably took a percentage. It is difficult to estimate how much Hogarth made out of the *Harlot's Progress* before his second impression in 1744. But it was clearly considerably more than 1200 guineas. If 1240 sets were actually printed, as Vertue was told by the printer, Hogarth received

that many guineas. His sole costs were his printing assistants and around sixty-five advertisements at 2s each. One can only speculate on the percentage and the size of sales from Giles King's copies. The many pamphlets, poems, stage productions, and the like which drew upon the *Harlot* must have stimulated sales that could be satisfied only by King or one of the pirate printsellers. On the other hand, as Hogarth must have recognized with regret, King's set had little to recommend it over the pirates'—Kirkall's pirated deluxe mezzotint series was a distinct improvement. He must have seen how much money was slipping through his fingers because he could not sell any more of his original product. The lessons of the pirates and the viability of his own product were not lost upon him: within a year he had corrected his error.

The audience he had discovered with the *Harlot's Progress* went beyond the connoisseurs and picture buyers. As to the actual makeup of what he later called the public in general, whose support he retained in large part until the end of his career, it included not only the ordinary purchasers of art prints but also the wits who bought Swift and Pope, the clergymen who bought moral prints, and the professionals and tradesmen who bought occasional comic or political prints. The full range of his "public in general" extended to the great substratum of the servants, clerks, and apprentices who saw and appreciated these prints, bought the piracies when they could not afford the originals, were the audience for whom King's copies were intended, and who in time were often given sets by their employers for Christmas presents. The overwhelming significance of the *Harlot* lay in the fact that its popularity stretched from the highest to the lowest. This was a mass audience never reached by an earlier printmaker, at least with any regularity, and by few English writers. The range of the audience is important because to retain it intact Hogarth had in the future to produce prints that worked on several levels, and yet keep them from being mutually contradictory.

On 21 April, little more than a week after the *Harlot's* publication, a shilling prose pamphlet appeared, called *The Progress of a Harlot. As she is described in Six Prints, by the Ingenious Mr. Hogarth.* This Grub-street work was the first of such parasites to flourish on the *Harlot's* popularity. Three days later appeared *A Harlot's Progress, or the Humours of Drury Lane,* a shilling pamphlet based on Hogarth's series and including a series of small copies. This verse redaction de-

fined all the implied grossness of the prints, and much more, and was so popular that it went through four editions in little more than two weeks, by which time its price had gone up to 2s. Encouraged by the success of this work, the author put together by 5 May *The Progress of a Rake, or the Templar's Exit,* in ten hudibrastic cantos this time— the logical transition from a harlot to a rake, which Hogarth himself made a year later.

Meanwhile, as early as 16–18 May, three days before the first of King's authorized copies appeared, the *London Evening Post* was advertising the Bowles brothers' copies as "this day published, . . . the same Size as Mr. Hogarth's"—engraved by Fourdrinier. No price is given, but these were followed by piratings by the Overtons at 6s a set (King's sold at 4s). In November, also under the sponsorship of the Overtons, Elisha Kirkall issued his green-tinted mezzotints, with explanations under each plate, at 15s. The result was, like many of Kirkall's works, attractive, but much too soft and painterly for the clear reading required by Hogarth.

Joseph Gay (i.e. John Durant Breval) dated his preface to *The Lure of Venus; or, A Harlot's Progress. An Heroi-comical Poem. In Six Cantos,* a 1s 6d pamphlet, 30 November 1732, not long after Kirkall's piracy appeared. He condemns piracy in art and literature, remarking that "whenever a curious painting is finished, we are sure of a number of paltry copies," but his own redaction includes copies of Hogarth's prints.

Progresses of all kinds followed, and it was inevitable that the Opposition should pick up the idea and use the analogy that offered itself. In April 1733 *Robin's Progress* was published "(With Eight curious Copper Plates) . . . in Eight Scenes; from his first coming to Town, to his present Situation." Other satires on Walpole that adopted Hogarth's form included *The Statesman's Progress; or, Memoirs of the Rise, Administration, and Fall of Houly Chan. Premier Minister to Abensadir, Emperor of China. In a Letter from a Spanish Father Missionary to his Friend at Madrid,* published on 7 June. This 6d pamphlet is no doubt the source of the story, first told by Horace Walpole, that the Opposition approached Hogarth after the *Harlot* was published and asked him to produce another series called *The Statesman's Progress,* and that he refused. It seems quite possible that he was approached, but that he did not wish to be limited by a connection with either party, and that paid hacks then went ahead with the work.

The relation between Hogarth's progresses and the stage has often

been pointed out. Certainly the *Harlot*'s theatrical possibilities were quickly realized. On 13 November 1732 the *Daily Advertiser* noted that *The Harlot,* a comedy by Charlotte Charke, "shortly to be acted," had been printed by Curll. On 5 February 1732/3 the *Daily Advertiser* announced publication of *The Decoy, or The Harlot's Progress* (on 14 February called *The Jew Decoy'd*), a new ballad opera, said to be performed at Goodman's Fields. On 15 March there was a "new Pantomime Entertainment" at Sadler's Wells called *The Harlot's Progress;* and on 17 April Theophilus Cibber's *The Harlot's Progress, or The Ridotto-Al-Fresco* was performed at Drury Lane, and proved a great success that helped to bolster the shaky fortunes of the company through the next year and a half.

Much more important, however, was the influence the *Harlot* exerted on Henry Fielding, whose next farce, *The Covent Garden Tragedy,* was played on 1 June. The *Covent Garden Tragedy* shows at once the impact and the popularity of the *Harlot*. Like Hogarth, Fielding includes a Mother Needham character: Mother Punchbowl, who makes her relationship to Needham obvious by rehearsing her sad end in the pillory. Stormandra summons up Plate 1 when she cries, "dost think I came last week to town, / The waggon straws yet hanging to my tail?" There may also have been allusions in the sets and costumes. The *Grub-street Journal* noticed the similarity when, in its customary unsympathetic discussion of Fielding's new play, it linked Stormandra with Hackabouta as whores Fielding paraded on his stage. The relationship between the two men goes back at least to 1728, and to Fielding's first published work, *The Masquerade,* a poem informed if not inspired by Hogarth's *Masquerade Ticket*. The two may have known each other personally by this time. Hogarth was a prodigious theater-goer, a denizen of the Covent Garden area, and he would certainly have pursued Fielding's dramatic career and soon made his acquaintance. If Fielding's imitation in *The Covent Garden Tragedy* was in some sense a recognition of what Hogarth was up to, his actual formulation of this theme did not occur until the *Champion* essay of June 1740 and the preface to *Joseph Andrews* in 1742. The earliest indication that Hogarth's intention was recognized by contemporaries is James Ralph's essay on painting in his *Weekly Register* No. 112, 3 June 1732:

> Now nothing is a greater Objection to the Genius of the Painters than their Want of Invention; few of them have Spirit enough even to

touch upon a new Story, or venture on a Subject that has not been very often handled before. . . . But fewer still have commenc'd Authors themselves, that is to say, invented both the Story and the Execution; tho' certainly 'tis as much in their Power as the Poet's, and would redound as much to their Reputation, as the late *Progress of a Harlot* by the ingenious Mr. *Hogarth* will sufficiently testify.

On Friday, 26 May, Hogarth and some of his close friends spent the evening at the Bedford Arms Tavern, at the corner of the Little Piazza facing St. Paul's Church. And they were in such high spirits that, instead of returning home for the night, they merely stopped off at their respective houses for a change of linen, set off on foot toward the Thames, and did not return until the thirty-first—just in time for Hogarth to catch a breath and make the first night of Fielding's *Covent Garden Tragedy* on 1 June.

This outing, preserved in a journal by one of the travelers, Ebenezer Forrest, was no doubt one of many enjoyed by Hogarth and his friends. The plan was evidently Forrest's. Hogarth drew pictures of their stops, and Forrest kept notes, which he turned into a parody of an antiquarian tour, transcribing inscriptions from monuments and old churches and recording old wives' tales told them by the natives. Forrest was a lawyer with literary inclinations; he finished making a fair copy of the manuscript of the journey, had it bound, and read it at the Bedford Arms two days after their return. The result is a long thin folio of nineteen sheets bound in brown leather and stamped in gold on the cover, "TRAVELS, 1732. VOL. 1" (BM), as if other travels were to follow. On the title page it is called a "Five Days' Peregrination," and this is what the trip has been called ever since.

Hogarth made five drawings and a head- and tailpiece; he was assisted in one drawing by Samuel Scott, the marine landscapist, and two more were added. Scott too was engaged on an important commission—the painting of six views of East India Company settlements to decorate the Court Room of East India House in Leadenhall Street. He comes through the clearest of the group: testy, short-tempered, a natural butt for the jokes of the others. The fourth member of the "peregrination" was Hogarth's brother-in-law John Thornhill, who furnished the map that documents the route of the peregrination. No clear picture of him emerges from the journal.

The fifth member, the only altogether nonliterary or artistic one, was Hogarth's old friend William Tothall, the woolen draper and

rum dealer, with whom he had lived before and perhaps after his marriage.

In the narrative compiled by Forrest, the erudite examination of churches and the antiquarian-like drawings made by Hogarth and Scott are constantly undercut by what appears to be the real focus of the trip: eating, drinking, defecating, and highjinks. As in so much of Hogarth's life, it is impossible to say where nature leaves off and art begins. The peregrination was primarily a vacation of dung-throwing and letting off steam; the occasional encounters with churches and landmarks, which curiosity made them view and Hogarth draw, were purely incidental. But when they got back and Forrest began to write up the narrative, the incongruity between the topographical drawings and the actual trip must have been evident; at any rate, they placed their journey in the context of a serious endeavor (anticipating Fielding and Smollett), and Hogarth's final comments were the head- and tailpiece which he added, altogether on his own authority, after the manuscript was complete.

He begins the manuscript with a picture of Mr. Somebody, who is surrounded with antiquarian objects, and ends with Mr. Nobody, who is hung with knives, forks, spoons, glass and bottle, all implements of the table (pls. 35, 36). Hogarth associates Somebody with the antiquarian aspect of the peregrination and Nobody with the pleasurable, but he does not see them as extremes: Somebody is the one who gets all the credit, Nobody the underdog who, though he only eats and drinks, sees the truth of life. An early allusion to Nobodies in relation to patrons and connoisseurs, these figures also represent Hogarth's general feeling, reflected in the *Harlot's Progress,* about the little people in relation to the respectable, the "great."

One may well question, in concluding this phase of Hogarth's work, his failure to directly attack the respectable folk, the ruling class, the "great," since it is clear that they were the real evil in the world of the *Harlot.* A variety of answers can be offered. One of the principles of satire is indirection: the best way to get at the nature of a social evil is through investigating its consequences. Presumably what Hogarth saw as uniquely pernicious in the "great" was precisely their influence on the lower classes. Perhaps he was more interested in the person who tries to behave like an aristocrat than in the aristocrat himself. But in the final analysis, one cannot altogether dismiss his probable desire to have his cake and eat it, to expose the evil of the ruling class without

35. Frontispiece, *Peregrination;* 1732; 7⅞ x 12 in. (BM)

36. Tailpiece, *Peregrination;* 7⅞ x 12 in. (BM)

alienating it; and the way to achieve this was to make his sinner a member of the lower orders who tries to act like one of the upper with disastrous results. I am not suggesting that Hogarth is to be condemned for this solution, but only that it was worked out within a range of possibilities that was not unlimited: the satiric conventions of his day as well as the realities of the social structure, personal and public patronage, and his own private concerns.

3

Challenge and Response
1732—1745

PATRON AND PUBLIC

A highlight of the social season in which the *Harlot's Progress* appeared was the children's production of Dryden's *Indian Emperor* at the Conduitts' town house in St. George Street, Hanover Square. John Conduitt, a gentleman who had begun his career in the army, married Sir Isaac Newton's niece, Katherine Barton, shortly after the end of her long and ambiguous relationship with Lord Halifax. Conduitt, a genuinely learned man in monetary matters, assisted Sir Isaac in his last years as Master of the Mint and succeeded him on his death in 1727. Mrs. Conduitt, admired in her youth by Swift and capable in later years of disturbing Pope, had good connections and no doubt arranged the party. The center of attraction was the children's performance of Dryden's play, which had been successfuly revived in 1731 at Drury Lane. The Conduitts' performance was directed by Drury Lane's Theophilus Cibber; their daughter Kitty played Alibech, Lady Sophia Fermor played Almeria, Lord Lempster Cortez, and Lady Caroline Lennox (daughter of the Duke of Richmond and later Henry Fox's wife) Cydaria: all the children were around ten years of age. The audience included the royal children, the Duke of Cumberland and his sisters the Princesses Mary and Louisa, and the daughters of their governess the Countess of Deloraine; among the adults present were the Countess of Deloraine, Stephen Poyntz (the Duke's governor), and the Duke and Duchess of Richmond.

Conduitt had decided to commemorate the occasion with a conversation piece drawn by Hogarth of the young people of quality who had acted at his house. Conduitt's choice of Hogarth may have owed something to the particular occasion, which would have recalled his *Beggar's Opera* paintings. In fact, the scene he chose to paint (pl. 37) was very like the one he painted in *The Beggar's Opera*. The prompt-

book shows act IV, scene 4, where Cortez is "discovered bound" and
the rival princesses Cydaria and Almeria debate the captive conqueror
in much the same manner that Lucy and Polly debated Macheath,
who wore the same fetters. The Conduitts' performance, even more
than *The Beggar's Opera*, gave Hogarth the opportunity to recall
Richardson's opinion that the stage suffered the disadvantage (vis-à-
vis history painting) of having to use real people in ideal roles, with

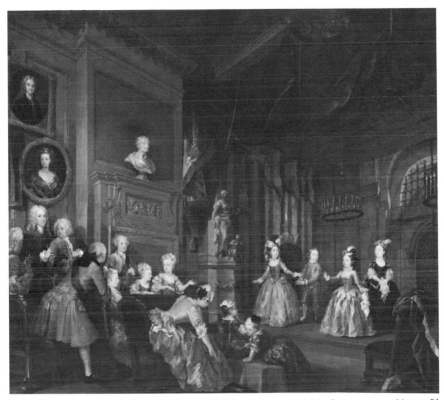

37. A Scene from *The Indian Emperor* (or *The Conquest of Mexico*); 1732; 51½ x 57¾
in. (the Viscountess Galway)

the audience able to detect the discrepancy. Here he can show Dry-
den's great Cortez and the two princesses in one of the most heroic of
English plays being acted by children, watched by their parents.

Hogarth was also fortunate in this picture to have been assigned a
relatively small number of portraits. The children, the focus of atten-
tion whether on stage or in the audience, are all fairly visible; but
only three of the adults have faces that show. The host and hostess are

discreetly portrayed in pictures hanging on the wall, near the mantel-
piece bust of Sir Isaac. This painting parallels Hogarth's best conver-
sations; in short, the real, feigned (acted), carved, and painted are all
related within a single picture. The richness of literary content cannot
be dissociated from the effect of the purely formal elements—the
wedge-shaped audience balanced by the children on the stage, itself
balanced (as the eye moves up) by the mantelpiece, the bust, and the
two portraits, and finally (completing the zigzag path of the viewer's
eye), the upper reaches of the stage set.

The Indian Emperor shows that the *Harlot* itself was, in one sense,
another step up the ladder of patronage. More portrait commissions
followed that success, and Hogarth must have been busy with these for
the rest of the year. Far from alienating his aristocratic buyers, the
Harlot had confirmed his hold on them, and in 1732–33 he painted
the most exalted sitters of his career and received a commission to
paint a conversation of the whole royal family.

Despite these commissions, by the fall of 1732 Hogarth must have
decided that he needed another large print with which to follow up
the success of the *Harlot's Progress;* but too busy to produce a new
painting, he turned to one he had done a year or so before of a drink-
ing club, called it *A Midnight Modern Conversation*, added an in-
scription claiming that no portraits were intended, and this time ad-
vertised the subscription (pl. 38). He not only advertised, he used his
own name and gave his address. His advertisement was repeated in
every issue of *The Daily Advertiser* through December and (with
slight changes) January. By 25 January Hogarth had come to an im-
portant decision: he increased the post-subscription price from 5s to
3 half-crowns each. It is possible, of course, that the subscription went
badly, but it seems more likely, considering the great popularity of
this print, that he decided to print up some more. He had probably
discovered that his method of engraving-etching produced impres-
sions by no means exhausted after some 1500 had been printed. By
this time it had occurred to him that he could increase the take by
keeping both the profits of his subscription and all subsequent profits;
so instead of limiting the printing to those subscribed for, he raised
the price after the subscription.

The print's popularity can be documented by the piracies that im-
mediately appeared and the infinite variety of copies and adaptations
to be found on everything from snuffboxes and punchbowls to fan-

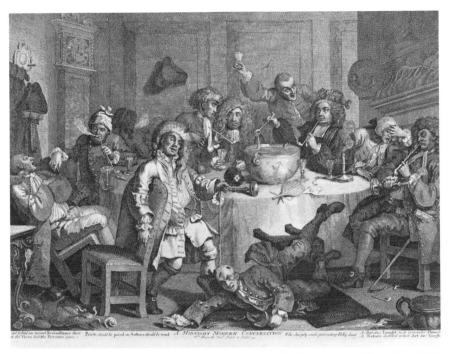

38. A Midnight Modern Conversation; March 1732/3; 12¹⁵/₁₆ x 18 in. (BM)

mounts. Some salt glazeware mugs, dated as early as March 1732/3, are evidence that pirates had already gotten the idea of going to Hogarth's house, looking at the original, and making a copy from memory.

While Hogarth was conducting the subscription for *A Midnight Modern Conversation* he must have noticed in papers for 5 February 1732/3 the first account of a particularly grisly murder: two old women and their maid were found in their beds with their throats cut from ear to ear. Next day the *Daily Courant* noted that four laundresses in the Temple had been committed to Newgate for the crime, one confessing and impeaching the other three. The *Daily Journal* of the same day mentions Sarah Malcolm by name. Late Thursday night, the eighth, the coroner's inquest brought in a verdict of willful murder against Malcolm only, refusing to accept her word about accomplices. (She had presumably expected to turn state's evidence and get herself off.)

On 21 February was published a pamphlet called *A Full and Par-*

*ticular Account of the barbarous Murders of Mrs. Lydia Duncomb.
. . . With a Narrative of the infamous Actions of Sarah Malcolm, now
in Newgate for the said Murders,* price 2d, and a second edition with
an account of the trial was out on the twenty-sixth. On the twenty-
second Malcolm had been arraigned; she pleaded not guilty, and on
the next day the trial took place. After a trial of about five hours, the
jury brought in a verdict of guilty and she was sentenced to be hanged
on 7 March.

The contrast between her bloody crime and her youth (she was just
twenty-two), sex, and cool behavior after the murders, as well as her
Roman Catholicism, must have attracted Hogarth. Accompanied by
Thornhill, he went to Malcolm's cell on the Monday before her exe-
cution and drew her portrait. It is evident that Hogarth's taking Mal-
colm's portrait was considered appropriate, this being his public role
in the community. In the small oil sketch (pl. 39) he balances her
against the heavy bars of her cell door, emphasizes her bare muscular
forearms resting heavily on a table, and places her rosary beads before
her on the table. It is a powerful picture, whose strength is dissipated
in the etched version that quickly followed. The face is still interest-
ing, but the body might as well be posing for a society portrait.

Malcolm's hanging on 7 March was marked by the same kind of
melodrama that characterized her trial and imprisonment. Dressed in
a black gown and a white apron, she appeared very serious and de-
vout, crying and wringing her hands. Some of the stands constructed
for the crowd collapsed, and several persons suffered broken limbs.

All of this contributed to the lively interest in Sarah Malcolm, and
in the same newspapers of 8 March that described her death appeared
Hogarth's advertisement:

> *On Saturday next* [10 March] *will be publish'd,*
> A Print of SARAH MALCOLM, engrav'd by Mr. Hogarth, from a Pic-
> ture painted by him two Days before her Execution. Price 6d.

This was repeated on the ninth, with the added information that it
was "To be sold at Mr. Regnier's, a Printseller in Newport-street, and
at other Print-shops." It looks as if Regnier offered Hogarth a lump
sum for his plate, so large that he could not refuse it. (One is re-
minded of the various stories of his being offered for a particular cop-
perplate its weight in gold.) It is possible, however, that Hogarth still
distinguished at this time between serious modern moral subjects, to

39. Sarah Malcolm; March 1732/3; 18½ x 14½ in. (National Gallery of Scotland, Edinburgh)

be painted, subscribed, and sold at his house, and an ephemeral catchpenny print. The latter, at 6*d*, was almost as easily sold as a newspaper. As time went by, he accepted this source of income too.

Thus was Hogarth poised uneasily between the world of high society and the lowest depths; at this time he frankly wished to span the two worlds, suggesting (as in the *Harlot's Progress*) that in important ways they were one and the same. Whether his patrons would be as willing as the general public to accept an artist who portrayed both kinds of life, let alone implied a connection, was another question.

In 1733 Hogarth was commissioned to paint a conversation piece of the royal family and made two *modelli* to this end (National Gallery, Dublin, and Royal Coll.). The first was an outdoor scene, presumably

a preliminary proposal before he was granted sittings; the Duke of Cumberland was evidently drawn *ad vivum,* but whether this or the full-length portrait (the Hon. Colin Tennant) came first, or both were based on the figure in *The Indian Emperor,* is uncertain. Hogarth then decided, or was asked, to move the group indoors, and now the Prince of Wales' portrait appears to have been based on a sitting (the rest of the faces are generalized).

At this point, riding the crest of his fortune, he looked to the most impressive ceremonial that had yet come within his reach: the marriage of the Princess Royal and the Prince of Orange, which was to take place that fall. According to Vertue he "made application to some Lady about the Queen that he might have leave to make a draught of the ceremony & chappel & paint it & make a print of it for the public." It is difficult to say what Hogarth, given free rein, might have made of this pair—perhaps something like the sympathetic yet troubling, ambiguous portrait of Bishop Hoadly (pl. 63). The situation, as writers were to say of later ones, demanded a Hogarth: a princess who, like Jane Austen's Charlotte Lucas, must marry this one or die a maid, and marries with the utmost dignity; a prince, deformed but noble and delicate of bearing; the king, appallingly rude, reminding the prince that his sole importance is as son-in-law to the King of England; the Prince of Wales, hating his father and mother and equally despised by them; and all the courtiers fawning on one side or the other. The picture might have been a cross between *Marriage à la Mode* and the Harlot's wake; but it was doomed from the start.

His plans, however bold, ignored one important factor—unless they were indeed based on this knowledge, intending to precipitate a test of some sort. For the Master Carpenter, in charge of decorating St. James' Chapel for the ceremony, was none other than William Kent, and Kent could claim that Hogarth was impinging upon his prerogative. Grafton, Burlington's son-in-law and one of Kent's most prominent patrons, could claim that Hogarth had gone over his head and wrongfully secured the queen's permission, interfering with *his* prerogative. Hogarth lost out and newspaper reports were as close as he got to the scene. Vertue fills in the details:

> when Hogarth came there to begin his draught. he was by Mʳ Kents interest orderd to desist. Hogarth alledgd the Queens orders. but Ld Chamberlain himself in person insisted upon his being turnd out, and

not to persue any such design. at least was deprivd of the oppertunity of persuing it of which, when the Queen had notice. she answerd she had granted such a leave but not reflecting it might be of use or advantage to Mr Kent, which she woudnt interfear with, or any thing to his profitt.

Nor was this the end of Hogarth's distress: Vertue noted that "Mr Hogarth complains heavily. not only of this usage but of another, he had some time ago begun a picture of all the Royal family in one peice by order the Sketch being made. & the P. William the Duke had sat to him for one. this also has been stopt. so that he can't proceed."

Still, Hogarth had already turned to *A Rake's Progress* and *Southwark Fair*, and had finished their subscription ticket, *The Laughing Audience*. And evidence points to a shift in his attention, from the king and queen to the rival camp of the Prince of Wales—continuing to play in both leagues, public subscriptions and private patronage, but with the former clearly occupying the greater part of his attention.

On the twenty-fourth of the following October the *Daily Advertiser* announced: "*This Day is publish'd,* A Print of the Ceremony of the Marriage of her Royal Highness the Princess Royal with his Serene Highness the Prince of Orange in the Chapel at St. James's, from Mr. Kent's Design. Engrav'd by Mons. Rigaud. To be had at several Printshops."

At the other extreme from the royal marriage procession in the Chapel Royal at St. James' Palace was the procession led by a beautiful but plebeian drummeress advertising a show booth, surrounded by riffraff, beneath the towering booths and signboards of Southwark Fair. An actor in ducal costume, perhaps part of the same procession, is being arrested by a bailiff. Even a church is present, and kings played by actors are falling off their rickety stage. Did one not know the date of the painting one might conclude that it constituted Hogarth's attack on the ceremony he was prevented from painting. As it is, *Southwark Fair,* much larger than Hogarth's earlier works of a similar nature, is a comment on the assemblies and entertainments of the aristocrats which he had been painting, and the reverse of *The Indian Emperor* (a painting of a similar size): the audience and performers are poor people, whose illusions are harrassed and threatened by bailiffs and by the shoddy construction that allows their stage to collapse.

The scene divides into three distinct layers: at bottom moiling humanity, in the middle the dreams and illusions fostered by players and mountebanks, and at the top the church steeple and open sky and, through gaps between buildings, the open countryside. The picture shows a side of Hogarth that is suppressed in his fashionable portrait groups; at the same time it is the sort of "droll" Kent doubtless pointed to as evidence of Hogarth's unfitness to paint a royal marriage.

The painting (private coll.) was made sometime prior to 9 October, when the subscription for its engraving (pl. 40) was first advertised.

40. Southwark Fair (engraved version); Jan. 1733/4; 13½ x 17¹³⁄₁₆ in. (BM)

Hogarth may have been planning if not working on it for years. His memory, and his stored visual impressions, went back to his early youth. It was to his advantage, however, to base a work on the fairs this particular year. Two versions of the *Harlot's Progress* (one "with the Diverting Humours of the Yorkshire Waggoner") were playing at both fairs throughout the season, and were still on the boards when

he announced his subscription for what he called *The Fair* and a new progress, with eight (not just six) plates. The events of that spring and summer were also responsible at least for the *Stage Mutiny* showcloth that fills the upper right corner of the painting. Aside from the congenial subject, the inspiration of the work was the topos of the fall of kings—very possibly as he encountered it in the entries in Swift's *Bickerstaff Papers* that juxtapose the fall of a booth at Bartholomew Fair and the affairs of the Kingdom of Poland. But also in his mind was the falling puppet stage in Coypel's *Don Quixote* illustration, with its associations of delusion, and perhaps also the falling scaffoldings during the execution of Sarah Malcolm.

The announcement of Hogarth's new subscription read as follows:

> MR. HOGARTH being now engraving nine Copper Plates from Pictures of his own Painting, one of which represents the Humours of a Fair; the other eight, the Progress of a Rake; and to prevent the Publick being imposed upon by base Copies, before he can reap the reasonable Advantage of his own Performance, proposes to publish the Prints by Subscription on the following Terms; each Subscription to be one Guinea and a half; half a Guinea to be paid at the time of subscribing, for which a receipt will be given on a new etched Print, describing a pleased Audience at a Theater; and the other Payment of one Guinea on delivery of all the Prints when finished, which will be with all convenient Speed, and the time publickly advertised. The Fair being already finished, will be delivered to the Subscribers on sight of the Receipt on or before the first Day of January next if required; or it may be subscribed for alone, at five Shillings, the whole Payment to be paid at the time of subscribing.
>
> Subscriptions will be taken in at Mr. Hogarth's, the Golden Head in Leicester Fields; where the Pictures are to be seen.

Even the subscription ticket concerned the theatrical audience—not, this time, at a fair, but at Drury Lane or Covent Garden. Only the audience is visible, implying perhaps that the stage will be supplied by the prints themselves.

Southwark Fair, like the subscription ticket, fits into the general pattern of the *Rake's Progress* cycle, and in fact its existence in October 1733 argues for the *Rake's* being pretty far along by that time. A kind of Vanity Fair, it meshes thematically with the conception of the *Rake* and acts as a prologue, announcing its juxtaposed themes of clothing and nakedness, acting and nature, tightrope walking and falls

of various sorts; and including such literal parallels as gambling, an arrest similar to that in Plate 4, and the broadsword fighter of Plate 2.

The year 1733 must have been largely devoted to the paintings of the *Rake's Progress* (pls. 41–48), though their conception may date back to 1732. A rake's progress was so obvious a sequel to a harlot's that a poem of that title was out a month after the publication of the *Harlot;* it is not necessary to suppose that Hogarth got the idea from this poem, or that the poet had heard that Hogarth intended to follow his harlot with a rake. The sequence was conventional; the rake was the male counterpart of the harlot in popular picture stories and the like. Hogarth departs from the conventional elements of other rake series in which the protagonist is ruined by courtesans and such. Like the Harlot, Tom Rakewell is ruined by his own extravagance, which takes the form of the middle-class youth imitating the aristocrat. Hence the first plate must establish his social class and origins, as the earlier series had begun with the Harlot's arrival from the country.

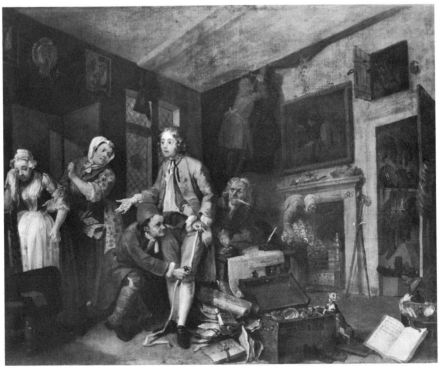

41. A Rake's Progress (paintings: 1); 1735; 24½ x 29½ in. each (Sir John Soane's Museum)

In the *Rake's Progress* those institutions that most dominated Hogarth's youthful memories, the "fair" (Plates 2, 3, 6), the church, the prison, and the hospital, all appear; and in the final analysis, all are escapes from the unsatisfactory self the protagonist is trying to change in Plate 1. By the wedding scene in the church, escape and consequences have become one, and so it continues in the hellish gambling

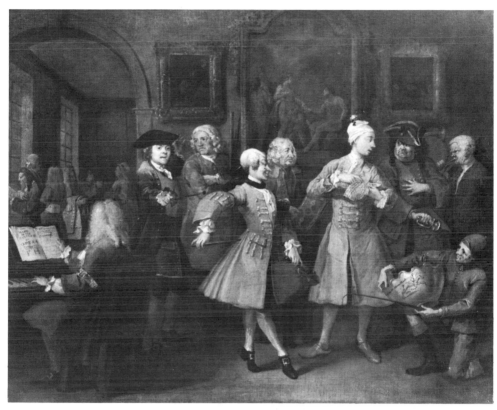

42. A Rake's Progress (2)

scene, the cell in the Fleet Prison (with the various means of escape devised by the prisoners, including alchemy and Icarus-wings), and the final escape through madness and death in Bedlam.

Hogarth must have visited Bedlam many times, looking at Caius Gabriel Cibber's statues over the stone piers of the great gate. His epitome of Bedlam includes his versions of these statues and depicts the visitors as well: they offer the contrast that most impressed him in

Bedlam. While this voyeurism was acceptable to mid-eighteenth-cen-
tury London, it was especially characteristic of the fashionable folk
Rakewell emulated, who now come to observe him.

All of the details work in this double way: as Hogarth reports, the
mad were kept nearly naked to save clothes (it was cheap, and they
might destroy clothing), and slept on straw which was easily cleared
away; but these facts become symbols of Tom Rakewell's reduction to
nothingness and connect with a metaphor of apparel that runs
through the series. Plate 1 begins with the tailor measuring him for a
suit, with the portrait of the closely muffled miser in the background.
From the elaborate dressing gown in 2, Rakewell descends to dishevel-
ment in 3 and the elegant attire in which he is arrested in 4; from 6 to
the end he is gradually stripped down to the bare forked animal he is
in Bedlam—and significantly witnessed by two of the well-dressed
denizens of the society he entered in the first plate. At the same time,
while tracing the typical descent from folly to vice, from prison to

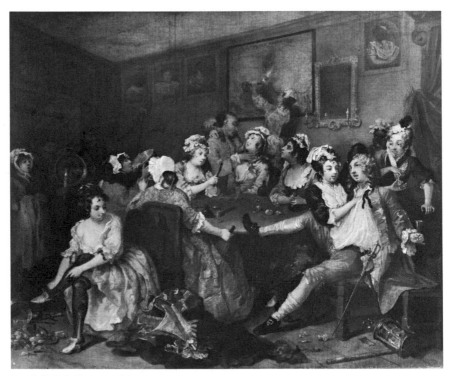

43. A Rake's Progress (3)

madness and bestiality, one should notice that the prisoners in the
Fleet and the madmen incarcerated in Bedlam are implicitly com-
pared with the fashion-mongers of the earlier plates, who are still free.
The madhouse acts as a reflection on the society that has appeared in
the earlier plates—people madder than any of the inmates are allowed
to come in and observe them.

The painting, indeed the engraving, of the series is extremely un-
even, as if Hogarth had many things on his mind at once. There are
some brilliant passages in almost every picture, but also some awk-

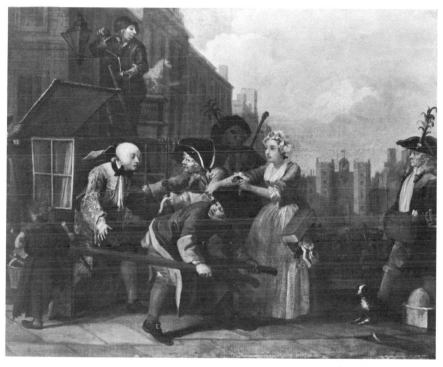

44. A Rake's Progress (4)

ward ones, particularly—unheard of for Hogarth—in the facial ex-
pressions, which are either hit off just right or labored. This series also
draws attention to Hogarth's habit, very evident in 3, of giving his
women monotonously bright white-and-pink complexions; as though
he were unable to make the leap from society pictures, in which the
women were always painted like this, to his métier where pasty off-
shades are often preferable.

From contemporary evidence, it would seem that the series of prints, when it finally appeared after many delays in 1735, was as well received as the *Harlot's Progress*. The unsympathetic Abbé Le Blanc, visiting England in the late 1730s, noted its universal vogue: "the whole nation has been infected by them," he remarks. "I have not seen a house of note without these moral [Le Blanc's irony] prints."

Plate 2 of the *Rake* made its acid comment on patronage, from the

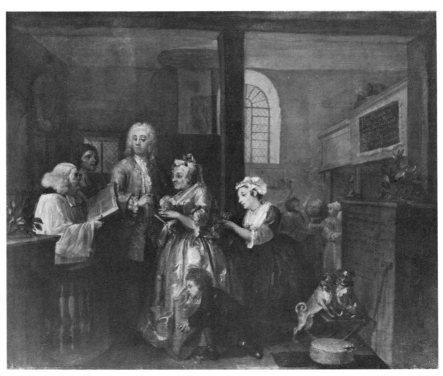

45. A Rake's Progress (5)

viewpoints of both patron and dependent. The closest Hogarth came to a true patron in these years was Mary Edwards, one of those strange Hogarthian people who throughout his career seem to have found him a kindred spirit. In 1728 Miss Edwards inherited from her father, Francis Edwards of Welham, an enormous fortune completely unencumbered and at her own disposal. At twenty-four she became the greatest heiress in England, said to enjoy an annual income of between £50,000 and £60,000. She was dazzled by a young Scotsman five years

her junior, resplendent in guardsman's uniform, with the fine name
Lord Anne Hamilton (after his godmother, Queen Anne) and the
fourth Duke of Hamilton for his father. She fell under the dashing
nobleman's spell and their romance led to a hasty Fleet wedding in
1731.

This pretty, headstrong young girl was attracted to Hogarth and his
work. On 4 March 1732/3 a son, Gerard Anne, named after Lord

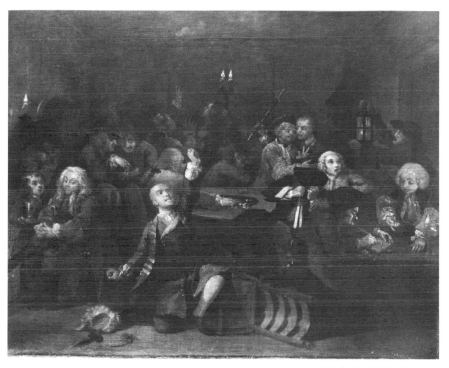

46. A Rake's Progress (6)

Anne and his mother's family, was born, and within the year Mary
commissioned Hogarth to paint the child in his cradle (Viscount Bear-
sted). There is also a single portrait of Lord Anne, in his uniform of
the 2d Regiment of Guards (which, if painted by Hogarth, is his earli-
est surviving head-and-shoulders portrait) and in 1733 a conversation
of her family.

The catastrophe of her marriage was by now apparent to Mary Ed-
wards; Lord Anne was spending her money like water. There were the
child's interests to safeguard, and she had no apparent recourse: no

married women's property act, and of course no marriage settlement. However, she made use of the fact that her marriage had been clandestine. There had been no contract, and she simply effaced all record of the transaction, from the registers of the Fleet chaplains to those of the church where the child was baptized. She replaced the latter with a notice describing herself as a single woman and making her child a bastard. She was willing to assume this equivocal reputation to save her fortune for herself and her child.

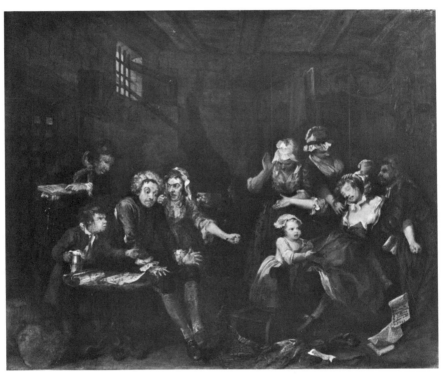

47. A Rake's Progress (7)

Having recovered her property, Miss Edwards carried on her own financial affairs, assisted by legal advisors—as is attested by the great mass of deeds, leases, and agreements that survived in the family. In 1734 or 1735 she bought from Hogarth the completed painting of *Southwark Fair*. This was a remarkable act for a woman and a spinster. She may have bought others as well that, like *Southwark Fair*, were not retained in the family after her death. To her more respect-

able heirs, only the portraits seemed suitable. Sometime around 1740 Hogarth painted the splendid single portrait of her in an overwhelmingly red dress, strong and independent, with Lord Anne replaced by a faithful dog on whose head she rests her hand (pl. 49). The happy relationship with Hogarth lasted until her death in 1743.

Although still a fashionable square, Covent Garden's reputation was no longer of the best. The announcement on 9 October 1733 of

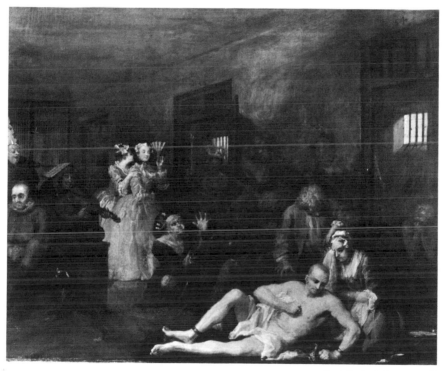

48. A Rake's Progress (8)

Hogarth's new subscription was also the announcement of his new address, the Golden Head in Leicester Fields. The house was three windows wide and contained a basement and four stories. It was plain but handsome, its front broken by band courses above the second and fourth stories, and the door fairly elaborate with flanking pilasters and a cornice hood on carved consoles. Above the projecting hood Hogarth placed his sign, the "golden head." In this, his one essay in sculp-

ture, "he, out of a mass of cork made up of several thicknesses compacted together, carved a bust of Vandyck, which he gilt, and placed over his door. It is," Nichols writes at the end of the century, "long since decayed, and was succeeded by a head in plaster."

Thus the new house was a handsome residence a step up (in location at least) from the Thornhills' house in Covent Garden, but at the

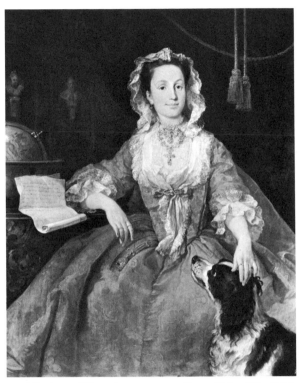

49. Miss Mary Edwards; ca. 1740; 49⅜ x 37⅞ in. (The Frick Coll., New York)

same time distinguished by a shop sign; and out of sight, behind the house, Hogarth built a painting room, probably necessary since the house faced east and west, and he needed a good north light for his painting.

When George and Caroline lived in Leicester House the area had been a center of intellectual activity. Newton lived on the south side of the square and was often carried in his chair to Leicester House to participate in the philosophical discussions. When Hogarth moved

into the square, a scattering of high nobility remained, and some high-ranking army officers; for the rest, there was the magistrate Thomas De Veil, the painter Hans Hysing, and a few years later the writer Paul Whitehead. It is interesting to consider Hogarth living in this square, even then in one of the busiest parts of London, but cut off and a quiet, aristocratic haven; and just a block away from the long snake of St. Martin's Lane, the arts and crafts street of eighteenth-century London, where artists rubbed shoulders with musicians and writers, and booksellers with tavern- and coffeehouse-keepers. Here was the sphere of Hogarth's activity: he was of it and yet withdrawn from it—around the corner, so to speak.

ARTIST AND ACTIVIST

In view of Hogarth's multifold activities of the mid-1730s, his most frenetically active years, one might imagine him a compulsive joiner and a very sociable man; this is the Hogarth who frolics among his friends in the "peregrination" and drinks with Frank Hayman in other anecdotes. Every relationship with a group, however, proves on closer examination to be directed either to self-advancement or to self-improvement. But this aim incorporates a generalized desire for the advancement of the larger body of English engravers, of English artists, of all Englishmen. Each enterprise, club, or friendship extends a personal position into a public one. Hogarth was naturally gregarious and translated thought into conversation and then into action. But he was also typical of the *vir bonus* of his time: the member of the Kit Kat or Scriblerus Club whose life was public, enacted in the context of the *polis*. Henry Fielding, who spent his most vigorous years as a Westminster magistrate, is the best example, but any writer or artist of note between 1700 and 1750 would serve nearly as well. Any personal action, to be meaningful, had to have a public significance.

One might begin with Freemasonry: Hogarth was a mason from the early 1720s onward. In 1731 he was a member of the lodge that met at the Bear and Harrow in Butcher Row and was later named a steward. But the center of Hogarth's social life as an artist was Old Slaughter's Coffee House, which Baron Bielfield in 1741 compared to Paris's Procope Coffee House (another analogue would be the Café Royal of the 1890s). Obviously, an important group among the Slaughter's habitués was that later connected with the St. Martin's Lane Academy, in many ways an offshoot of the coffeehouse.

The most influential member of the group was Hubert François Gravelot, a young Frenchman of thirty-three (two years Hogarth's junior), who had come to England around 1732 to help Dubosc with his engravings for Picart's *Cérémonies et coutumes*. He was, as his apprentice Charles Grignion noted, a designer, but he could not engrave; it was as a designer that he influenced the Slaughter's group by introducing ways of using the rococo c- and s-curves as the basis for both decorative work and larger compositions. In 1735 Gravelot had made his illustrations of royal tombs in Pine's *Heads and Monuments of the Kings* (1736), followed by decorative frames for Birch's *Heads of Illustrious Persons* (1738). Almost at once he appears in collaboration with other artists of the Slaughter's circle. Besides the work with Pine, Vertue notes, he made designs for silver (it may also be significant that Lamerie began to experiment with rococo forms on his plate in the 1730s), and he is known to have worked with Francis Hayman on the illustrations for Hanmer's edition of Shakespeare (1743–44) and, most important of all, with both Hayman and Hogarth on the Vauxhall decorations. In October 1745 he left London for Paris, not to return, presumably because of the war between England and France.

Hayman, who seems to have been one of Hogarth's closest friends, was apprenticed in 1718, at about fifteen years of age, to Robert Browne, a history painter of the Painter-Stainers' Company, and worked as an interior decorator and scene painter at theaters. As an artist, Hayman was Gravelot's most avid student, or at least the one who most directly and literally took over his small decorative patterns and applied them to large, even heroic compositions, especially at Vauxhall Gardens. After Hogarth he was the most various and experimental painter of the group—a fact sometimes obscured by the lively but crude product.

Perhaps the closest relationship of all was between Hogarth and George Lambert. Two years Hogarth's junior, Lambert is first mentioned by Vertue in September 1722 as a pupil of Warner Hassell, "a young hopefull Painter in Landskape, aged 22. much in Imitation of Wotton. manner of Gaspar Poussin." Like any judicious landscapist, aware of his position in the aesthetic hierarchy, Lambert heightened his scenes with figures. While Hogarth avoided landscapes—he was never adventurous in that direction—he painted figures for Lambert's landscapes in the 1730s.

John Ellys (or Ellis) should also be mentioned. He had been ap-
prenticed to Thornhill and may have assisted him at Greenwich. He
and Hogarth first met and their common attitudes were reinforced in
the Vanderbank Academy. As an entrepreneur, Ellys had bought Van-
derbank Senior's tapestry works and office of Tapestry Maker to the
Crown when they were sold to free the young Vanderbank, and as a
painter he stuck to portraiture and made an easy living, though he is
also reported to have done some genre subjects. Like Hogarth, he had
painted Lavinia Fenton as Polly Peachum and Walker as Macheath
soon after *The Beggar's Opera* opened. He was later Hogarth's
staunchest supporter in the original founding of the St. Martin's Lane
Academy, perhaps contributing financial assistance.

From all accounts, Hogarth appears to have been the first of the
group to know Jonathan Tyers and grasp the potential of a public
pleasure garden as a location for showing contemporary art. Tradition
has it that Hogarth met him shortly after he went to Lambeth with
his new wife in 1729, or during one of his early summers there. Tyers
took a lease of Spring Gardens at Vauxhall in 1728 and reopened the
gardens in 1732. One may gather that Hogarth gave Tyers ideas for
ways of attracting the public. John Lockman's *A Sketch of the Spring-
Gardens, Vaux-hall. In a Letter to a Noble Lord* (1752), after listing
all the pictures, adds: "the hint of this rational and elegant *Entertain-
ment* was given by a *Gentleman,* whose *Paintings* exhibit the most
useful lessons of *Morality,* blended with the happiest strokes of *Hu-
mour*"—the terms in which contemporaries identified Hogarth. The
debut of the newly decorated gardens was 7 June 1736. An orchestra
stand had been erected, and a number of pavilions and supper boxes,
"ornamented with paintings from the designs of Mr. Hayman and Mr.
Hogarth, on subjects admirably adapted to the place; and each pavil-
lion has a table in it that will hold six or eight persons." Ultimately
there were fifty supper boxes surrounding the central quadrangle,
called the Grove, and each contained pictures, most of them eight feet
wide. Hogarth's *Henry VIII and Anne Boleyn* hung in one supper
box—but it was presumably a copy of the engraving; copies of his *Four
Times of the Day* paintings graced another pavilion. There may have
been a few actually painted by Hogarth; it would be surprising if he
acted only in a supervisory capacity, though it must have been pain-
fully evident to him that the life of a painting at Vauxhall was pre-
carious indeed, endangered by flying bottles or food.

Another member of the Hogarth circle was an older man, the sculptor Henry Cheere, who sometime around 1737 introduced François Roubiliac to Tyers. The result was Roubiliac's statue of Handel (Fitzwilliam Museum), the most important manifestation of the Slaughter's circle in its early days, unveiled at Vauxhall in 1738—the first great informal portrait in English sculpture, catching its subject with wig off, vest unbuttoned, and slippers askew. Besides Hogarth, Hayman, and Gravelot, George Michael Moser decorated the Rotunda, Richard Yeo designed the medals used for admission, and it is likely that Lambert had a hand in many of the background landscapes. In 1737–38 Hayman and Gravelot designed vignettes and decorations for the music sheets of the Vauxhall Songs (the words were by Hogarth's friend John Lockman, who later wrote an early description of Vauxhall). Indeed, Vauxhall looks almost like a group project.

What these artists offered was a breath of fresh air in the stuffy world of English art in the 1730s but, more generally, the group was unified by a mutual impatience with the authority and idealism of Renaissance-derived French academic dogmas, and a desire to return to nature: human nature and English, empirical nature. In his manuscript notes Hogarth is constantly reiterating the characteristic approach of this group: a conviction that the artist should not filter his view of the world in the manner of Palladio or even Raphael, but should depict what he sees with his own eyes.

What the English rococo did was to provide for nature a shape and a subject: the present time, the ordinary place whether city or country, the ordinary person, and certainly the forthright approach. Hogarth's artist friends, decorating houses or pleasure gardens and painting stage designs or landscapes, were reacting to the new mode by replacing cherubs and satyrs with squirrels and foxes, abstract designs with oak and laurel leaves, or assemblies of gods with Hayman's swinging, dancing rustics.

The questions of academic theory, rules, and old stereotypes all came to focus for the Slaughter's group in the economic situation of the English artist. There was no dominating patron after Burlington: the artists who met at Slaughter's earned much of their living from book publishers and printsellers, gold- and silversmiths, manufacturers of pottery, cabinets, and furniture, and theater managers for whom they painted scenery. These outlets were adequate but hardly satisfactory to ambitious artists. They were fully aware that only by dis-

playing their original works *as works of art* could they hope to undermine the prejudices of powerful connoisseurs; and facilities for display being meager at best, the native artist was, in effect, trapped in his role of craftsman.

Hogarth and others like him therefore expended much energy on both the production of artistic propaganda and the problem of exhibiting. Part of his particular genius was the ability to sense where new patrons could be found and how the artist could exploit them. It is noteworthy that Hogarth's name is connected with the instigation of every new stage in the English artist's emancipation: freeing the engraver from printsellers by his own subscription; freeing the designer from the pirates by the Engravers' Act; freeing the painter from patrons by turning to impresarios like Jonathan Tyers of Vauxhall and to public buildings like St. Bartholomew's Hospital and, a few years later, the Foundling Hospital.

This, however, gives only a general perspective of the 1730s and '40s. The climate of English connoisseurship was still favorable when Jacopo Amigoni (or Amiconi) arrived in 1730, followed a few years later by Jean Baptiste Vanloo. Since the elder Ricci's departure in 1716, Amigoni was the first foreigner of note to try England. Another Venetian ("a still fainter imitation of that nerveless master Sebastian Ricci," as Horace Walpole wrote), by 1732 he had painted the ceiling of Rich's new Covent Garden Theatre, had decorated several stately homes, had painted many portraits, including the three princesses, and had been hired by Benjamin Styles to paint seven or eight panels at Moor Park. And in all, he was, for Hogarth at least, a target in a personal as well as a general sense.

Probably early in 1734 when he was busy in the subscription for the *Rake's Progress,* Hogarth learned that Amigoni was negotiating with the governors of St. Bartholomew's Hospital unofficially for the decoration of the new hospital building's staircase and perhaps Great Hall. Here indeed he was treading on Hogarth's home territory. Hogarth seems to have known John Lloyd, the "Renter," or rent-collector, of the hospital, and set straight to work exploring the situation. The upshot was that Hogarth volunteered to decorate the stairway gratis, as an Englishman vs. a foreigner (echoing Thornhill's old cry), and Lloyd, on behalf of the governors, agreed. On the twenty-third James Ralph could crow in his *Weekly Register* (23 Feb., 1734): "We hear that the ingenious Mr. *Hogarth,* is to paint the Great Stair-Case in *St.*

Bartholomew's-Hospital, with the Histories of the *Pool of Bethesda* and the *Good Samaritan.*"

Ralph's next move was as much a defense of English painters like Hogarth as an attack on Amigoni. On 20 April he began a discussion of history painting in which he emphasized Steele's admonition on "the judicious Choice of a Subject," and in the issue for 4 May—the same day, as it happened, that Sir James Thornhill died—he launched into an attack on Amigoni.

Although in general the *Grub-street Journal* merely ridiculed Ralph, in the issue of 27 June it faced the issue of English vs. foreign painters and solidly supported Amigoni against all English competitors. The death of Thornhill, the only recognized English history painter, while the controversy was raging, was symbolic of the plight of English painting. But Thornhill's day was past: soon his name would signify the sad discrepancy between the quality of native English history painting and the continental tradition. The surest signs of his reputation were not the respectful obituaries but the inactivity of his last years and the low prices brought early in 1735 by the auction of his own paintings from his collection.

On Thursday 18 July Hogarth and a Mr. Jolliffe were nominated governors of St. Bartholomew's Hospital by Sir Richard Brocas, the president (and ex-lord mayor). A presidential nomination was reserved for a few people of exceptional merit and was not, unlike other nominations, contingent upon a donation of £50 or £100. It is clear, however, that a donation of a sort—his paintings—was behind Hogarth's election.

He became part of quite a different organization on 11 January 1734/5 when John Rich, with twenty-three of his friends who included Ebenezer Forrest, George Lambert, Robert Scott, John Thornhill, William Huggins, William Tothall, and Gabriel Hunt, founded The Sublime Society of Beefsteaks. According to tradition, Lambert, working at his job of scene painter for Rich, had no time for a regular dinner, and so he contented himself with a beefsteak broiled on the fire in the room behind the stage, near the Bow Street entrance. Sometimes he was joined by visitors, and by and by the Beefsteak Club was born; it assembled once a week in the painting room, and later in a room in the playhouse. This group met every Saturday from October to June, wearing the ribbon and badge of the society, shaped like a silver gridiron and dated 1735, with their motto "Beef and Liberty."

There was an elaborate set of rules, ceremonies, and traditions, masonic in its symbolism and complexity; but all was directed toward merriment and schoolboyish highjinks, very reminiscent of Hogarth's "peregrination," from which the Beefsteaks drew three members. The club is most famous now for its beefsteaks and its hoaxes.

In 1733 a purchaser could go to Philip Overton and obtain prints of the *Harlot's Progress* at 15s, or to Giles King for the authorized copies at 4s (the originals, at a guinea, were unavailable); and *Midnight Modern Conversation* could be had for one shilling (as opposed to five for the original). Hogarth was in a much stronger position than the ordinary engraver who was completely at the mercy of the printsellers' monopoly, but he suffered the double annoyance of seeing large sums of money he felt rightly his going to other parties, and of seeing wretched copies made of the works he had labored over with such care.

In 1734 he was probably revising and rearranging the *Rake's Progress* and also having his accustomed troubles with engravers (as the states of Plate 2 show). It is possible, however, that the adding of several characters was part of a tactic to delay publication until a copyright law could be enacted. There is little doubt that Hogarth had by this time begun to build up support and perhaps write, or have someone else write, the pamphlet that took the form of a petition to Parliament. Hogarth was the obvious person to lead such a campaign. He had helped to prove the assumption upon which the Engravers' Act was to stand: that the publication of a painter's work gave it a new value. With the proof in his successful print ventures, he could turn to the law: the artist's invention was now a valuable property, as open to theft as any other property, and thus in need of legal protection.

"Hogarth's Act," as it came to be known, was based on the literary copyright act of 1709 (8 Anne cap. 19). As the case is presented in Hogarth's pamphlet, the artists—designers and original engravers—are oppressed by the tyranny of the rich printsellers. The pamphlet's subject, however, is only partly the exploitive printseller. More important is the "Improvement of the Arts" in England, which can only be brought about if the English artist can receive his just profits and spread his wares and his fame through good engravings (not shabby copies). Then the purchaser too will have a greater choice of prints at a lower price. Even the printseller will increase his profits, because he

will have a greater range and better quality of prints to offer as alternatives to the imports from the continent.

The solution, as the pamphlet argues, is simply to pass a law against one artist's copying the designs of another. The names signed to the petition that was presented to the House of Commons on 5 February 1734/5 were, besides Hogarth, George Vertue, George Lambert (who was now having his landscapes engraved), Isaac Ware, John Pine, Gerard Vandergucht, and Joseph Goupy (who carried with him the influence of the Prince of Wales). "Artists and Designers of Paintings, Drawings, and Engravers of original Prints, in behalf of themselves, and others" presented the petition to the House.

On 2 April the bill was returned from committee with report and amendments; on 11 April it was given its third reading, and the clause giving Hogarth's friend John Pine a monopoly on the engraving of the House of Lords tapestries (a project dear to Vertue's heart) was added at this time. It passed and was carried to Lords. The bill had its first reading in Lords on 15 April, and a committee went over it a week later. On the twenty-fourth Lords gave the bill a second reading, and on the next day a third; it was then returned, approved, to Commons. The act that resulted ensured against unauthorized copies for a period of fourteen years from the date inscribed on each print, and for every illegal print discovered a five-shilling fine was to be imposed.

At this point a piratical printseller put into motion a strategy which Hogarth had evidently not foreseen—although there is evidence that someone may have employed a similar technique to copy *A Midnight Modern Conversation*. The plagiarist engraver presumably used a series of agents: one person would have aroused suspicion after many visits, and one visit would not have sufficed to memorize eight pictures. These men visited Hogarth's display room and returned to their employer with a description of what they had seen, from which copies of the yet unpublished *Rake's Progress* were made. The engraver then worked by hearsay, from garbled and probably contradictory descriptions, as a police artist does in reconstructing the face of a criminal from eyewitness reports. The engraver must also have been plagued by the necessity for haste, borrowing earlier traditions or motifs from the *Harlot* whenever he met a snag (pl. 50).

On 15 May the Engravers' Act received the royal assent. By the beginning of June the plagiarist engraver had done his work, and the *Daily Advertiser* for the third announced: "Now printing, and in a

few days will be publish'd, the Progress of a Rake, exemplified in the Adventures of Ramble Gripe, Esq; Son and Heir of Sir Positive Gripe; curiously design'd and engrav'd by some of the best Artists." The ingenious publishers were Henry Overton, John King, and Thomas and John Bowles. Hogarth had by this time learned of the trick, and the same day published his notice informing the public of the piracy. Only now did he decide to have cheap copies made (as he

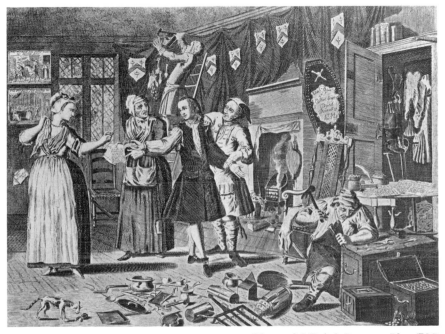

50. Piracy of A Rake's Progress, Pl. 1 (BM)

had with the *Harlot*); apparently he had not expected to. In the *London Evening Post*, 17–19 June, he added to his announcement:

> Certain Printsellers intending not only to injure Mr. Hogarth in his Property, but also to impose their base Imitations of his RAKES PROGRESS on the Publick, he, in order to prevent such scandalous Practices, and shew the RAKES PROGRESS exactly (which the Imitators of Memory cannot pretend to) is oblig'd to permit his Original Prints to be closely copied, and the said Copies will be published in a few Days, and sold at 2s. 6d. each Set by Tho. Bakewell . . . all persons may safely sell the said Copies without incurring any Penalty for so doing. . . .

The Bakewell copies at 2s 6d were aimed at those buyers who could not afford either the originals at two guineas or the piracies at 8s; and were smaller than either of these.

The next issue of the *London Evening Post* (21–24 June) carried only the advertisement; and on the twenty-fifth—as the act took effect —the genuine *Rake's Progress* was delivered to subscribers. But four days earlier the *Whitehall Evening Post* announced the Ramble Gripe piracy of the *Rake* as published. Having now seen it, Hogarth repeated his complaint in the *London Daily Post* for 27 June, with angry variations: the piracy is "executed most wretchedly both in Design and Drawing"; and he notes nervously that his own authorized copies will be ready "in a few days." There was, in fact, a delay of six weeks before his copies appeared on 16 August—again showing how late had been his decision to employ Bakewell. Finally, on 19 July (*Craftsman*) he opened the original *Rake's Progress* to the general public.

Either the Engravers' Copyright Act worked better than the writers' or it was easier to enforce or many pirated prints have vanished. The only ones that can be cited with any certainty are Dublin copies. The act, of course, presumed that a pirate would have little interest in copying a fourteen-year-old print. This was to underestimate, however, the continuing popularity of Hogarth's prints, the copyrights of which began to expire in 1750. He apparently made no complaints in the 1750s, and indeed in 1754 he issued a print in celebration of the act's success in advancing English arts and industry, but at his death his widow noticed the damaging effect of piracies on her sales, and in 1767 the act was revised to extend protection to twenty-eight years from date of publication. For Mrs. Hogarth, protection was extended for another twenty years.

Vertue's description of the engraver's sad lot, written long after the Engravers' Act was passed, shows that in the long run only unusual cases like Hogarth's were materially benefited by the act; most engravers were still weighed down by handicaps. Dealers may have been forced to offer more advantageous terms to artists, but the ordinary copyist engraver like Vertue, who might be underbid by another copyist of the same unprotected subject, still had to rely on a patron who owned the work in question and allowed only him to engrave it. In Vertue's own case the act left a bitter taste: it was he who suffered by John Pine's special permission to engrave the Armada tapestries in

Lords. If he blamed Hogarth it would explain something of the grow-
ing asperity of his remarks over the years, especially his emphasis on
Hogarth the intriguer; he is silent on the subject of the act itself, as
important as it was to the history he was writing. While Hogarth be-
came increasingly independent as an engraver, Vertue continued to
survive largely through personal patronage.

In the second week of June, while Hogarth was waiting outraged
for the piracies of the *Rake's Progress* to appear, the whole problem
was temporarily eclipsed by the death of his mother, who died of
shock following a fire in St. Martin's Court where she was living with
Anne and Mary. His attachment to her may be judged by his digni-
fied, almost monumental portrait, with the inscription "His Best
Friend" (pl. 51).

The year that began with the introduction of the engravers' peti-
tion ended with the reestablishment of an artist's academy, which had
been in abeyance since the early 1720s. Vertue noted that "this Winter
1735 an Academy for drawing from the Life sett up in St Martins lane
where several Artists go to Draw from the life. Mr Hogarth principally
promotes or undertakes it." Elsewhere he says that Hogarth and Ellys
were jointly the moving forces, and an English academy may be seen
as a logical extension of the artist's circle at Slaughter's and of their
attacks on Amigoni and foreigners. Hogarth presented the academy
with a proper table for the model to stand on, a large lamp, an iron
stove, and benches—Thornhill's equipment—but he himself remained
"an equal subscriber with the rest signifying at the same time that
superior and inferior among artists should be avoided especially in
this country." Looking back from the time of crisis thirty years later
when threats to his academy's continuance had arisen in the form of
a proposed state academy, he remembered stressing even then that it
was the presence of directors and other hierarchical elements in imi-
tation of the French Academy that destroyed the earlier English acad-
emies—and he adds that his democratic plan did indeed work for
thirty years. And, although rifts began to appear in the 1750s, it sur-
vived in some form till his death.

Hogarth and Ellys were listed as the proprietors, and Vertue notes
that before long Gravelot was teaching drawing and Hayman paint-
ing. It was in this school that most of the artists of the period received
their training. Here Hogarth's activism found its most important out-
let in these years, in teaching, supervising, and advising young artists.

For him, however, the academy was also a means of consolidating the artists who had been loosely bound together by Slaughter's; it was in fact closer to guilds like the Painter-Stainers' Company than to continental academies (which were, of course, founded for the sole purpose of circumventing guilds).

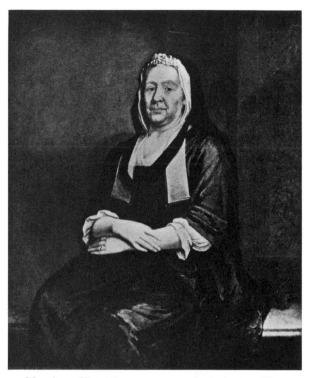

51. Mrs. Anne Hogarth; 1735; 50 x 40 in. (private coll.)

The founding of the academy was the last in a series of actions that turned Hogarth (and, for the moment at least, his fellow artists) toward a middle-class audience, the professional and mercantile interests he had first welded into a base of strength with his moral prints. Without oversimplifying too much, one can mark a retreat from the "great" after the failure to paint the royal family and the Prince of Orange's wedding. From this failure Hogarth returned to his prints, to public gardens and hospitals (which of course housed pictures that might be seen by a great patron); passing the Engravers' Act to protect his prints in the public domain; and founding an art academy, which

followed logically from his assumption that patronage lay with those below—not above—the artist.

With the publication of the *Rake's Progress*, he conquers the print-sellers and pirates and checks the patrons and connoisseurs who seemed to threaten his position. He has now exhausted the particular gloomy fiction of the Harlot and Rake. Thereafter, for a few years, his work becomes less mordantly satiric; the dark, unresolved world of the Harlot and Rake is replaced by a world of contraries, the respectable and the unrespectable balanced with a happy unconcern.

One other public pronouncement should be mentioned, though it means looking ahead to 1737. In the *Daily Post* of 2 June was an account from Paris of François Lemoyne's suicide, which said he died "of several Stabs he gave himself . . . with a Dagger; his Head was out of Order ever since the four Faults that were found by some rigid Criticks in that vast Work, which he had been four Years about." The reporter adds: "The Painter of the great Hall of Greenwich Hospital had much more Resolution; notwithstanding there are as many Faults as Figures in that Work he died a natural Death, tho' an Englishman."

Hogarth replied within the week in an essay signed "Britophil," published in the *St. James's Evening Post* of 7–9 June. English art, he says with sharp eloquence, is undervalued by the critics, who try to make reputations for themselves by showing up English pictures and by criticizing details instead of wholes, and by the picture dealers, who try to make their fortunes by selling foreign pictures. As his pseudonym suggests, he speaks as a "Well-wisher to Arts in England" and a defender of Thornhill.

The importance of the essay lies in its being Hogarth's first substantially authenticated piece of writing: the reprint in the July *London Magazine* attributes it to "the finest Painter in England, perhaps in the world, in his Way." He probably drafted or supervised *The Case of Designers, Engravers, Etchers, &c.*, but "Britophil" set the tone for all the writings, and many of the pictures, that were to follow.

COMIC AND SUBLIME HISTORY PAINTING

In his second essay on history painting (*Weekly Register*, 27 April 1734), Ralph raises the question of why English artists never venture beyond portraiture to history painting. He begins by reminding his readers that "Sir James Thornhill and Mr. Hogarth are almost the only Persons who have lately made it their Study, and," he adds, "I am

sure no Body can say they have not found their Account in it both in Interest and Reputation." In another of his essays (20 April) Ralph distinguishes between "that which copies real Events, and that which feigns both Character, and Fable." The latter is either based on a text or, most difficult of all, invented by the painter.

From the evidence that has survived, Hogarth seems to have been praised for his attempts at history, whether comic or sublime, in the 1730s. Ralph was admittedly a partisan, but in eighteenth-century London partisans were usually offset by fiercer denigrators; this was the case with Pope and Fielding, but not with Hogarth until a somewhat later date. His desire in the mid-1730s to attempt sublime history cannot be attributed only to the shadow of his father-in-law: it was the natural, even inevitable step for any painter indoctrinated by the artists' manuals and treatises of the time. However original, Hogarth was still deeply rooted in the tradition of the art treatises; some part of him still believed what they had to say about sublime history. But he had already made clear his contempt for histories portraying heathen gods and heroes, and a religious subject, even given a commission, was a dangerous undertaking since the artist had to cope with the English Protestant distrust of Roman Catholic church decorations, images, and counter-Reformation iconography.

The second possibility was a nobleman's house. Although Hogarth later noted the incongruity of some biblical subjects painted in a dwelling (on a ceiling or along a staircase), his main deterrent, as with churches, was absolute lack of encouragement. A nobleman would think twice before commissioning the painter of small conversation pictures to fill a large wall space.

One solution had come through Hogarth's contacts with St. Bartholomew's Hospital. His own account, written years later, was that before he devoted himself wholeheartedly (or so I interpret his ambiguous phrases) to "Engraving modern moral Subjects, a Field unbroke up in any Country or any age," he made an attempt at "the grand stile of History." This interpretation would fit with the gap between the completion of the *Rake* in the spring of 1735 and the next print in the fall of 1736. "I then as a specimen without having done any thing of the kind before Painted the staire case at St Bartholomew Hospital gratis." His aim, he explains, was not solely to paint sublime history himself but to ensure that other English artists might

also paint histories, that England might be decorated with English art, and that the English public might see it.

While he painted for a hospital, Hogarth had one eye on churches as well. The emphasis of the theologians who controlled the bishoprics, and those with whom Hogarth presumably sympathized (considering his friendship with the Hoadlys and other Latitudinarians), was not on religious mystery or devotion but on acts of charity. It is significant, I think, that Hogarth chose (for he was not chosen) a public hospital as the place to donate a biblical subject, and chose as his subject two scenes of Christian charity: Christ healing the halt and lame and the parable of the Good Samaritan. The latter was both the safest subject for religious history painting in Hogarth's time and the one most readily applicable to assumptions he had already illustrated in his modern histories.

Although the agreement with St. Bartholomew's went back to early 1734, and Hogarth was elected a governor of the hospital that summer, presumably he had waited to begin the work until the *Rake's Progress* and the Engravers' Act were off his hands. It would appear, from the size of the canvas, that he painted it at the hospital, but not *in situ;* it would have been far too large for his studio.

True fresco as the medium for wall paintings (pigments applied with a water medium to a surface of wet plaster) was seldom used in England because of the damp climate. Since it was less affected by damp, oil was applied to plaster, wood, or canvas. Even the continental artists—Verrio, Ricci, and the others—brought up on either true fresco or *fresco secco,* turned to oil when they came to England. The main disadvantage of oil is the glare produced in the light, avoided by water paints. Hogarth's murals were painted in oil on canvas, and the *London Evening Post* of 8–10 April 1736 announced the first part of the project as completed. Vertue's general reaction may have been typical. He admits Hogarth's "extraordinary Genius," which up to now "has displayd it self in designing, graving painting of conversations charicatures. & now history painting—, joyn'd to a happy—natural talent a la mode.—a good Front and a Scheemist—but as to this great work of painting it is by every one judged to be more than coud be expected of him." To judge by Vertue, the first reaction to the completed *Pool of Bethesda* was incredulity mixed with admiration.

Through the remainder of 1735 and into 1736 Hogarth worked al-

most exclusively on this enormous canvas. As soon as *The Pool of Bethesda* was finished, however, he seems to have felt a need to make up for the money he had lost on that gift to the hospital. In fact, it is quite likely that he was engraving *Before* and *After,* as secular a subject as he ever attempted (based on the paintings of the indoor version, ca. 1730, pls. 24, 25 above) at the same time that he was painting *The Pool of Bethesda*—or at least shortly after he had finished. He returned to his popular audience, and in October published *The Sleeping Congregation,* in December *Before* and *After,* in January *Scholars at a Lecture,* in March *The Company of Undertakers* and *The Distressed Poet,* and at the same time issued the various small prints of faces (i.e. *Chorus of Singers, Laughing Audience, Scholars at a Lecture,* and *Company of Undertakers*) as *Four Groups of Heads.* With the advertisement for *The Distressed Poet* at the beginning of 1736/7 he took the significant step of announcing bound volumes of his engraved works.

Thus began the accretion of a body of morality, with an implicit unity of its own, in the shape of a book. The major engravings would be included, the ephemeral ones excluded, and one of the greatest of eighteenth-century moral anatomies compiled, to which in time would be added a portrait of the "author" as frontispiece and eventually a tailpiece as well. It must have been galling for Hogarth to know that he could not include his *Hudibras* plates in his volumes or sell them at the Golden Head, for they were still on sale in Philip Overton's shop and frequently so advertised. The time was approaching when he would find a way to include the *Harlot's Progress,* and the remainder of the works he was to produce in the next twenty-five years were at least partly conceived with this repository, this structure in mind.

During the lull at St. Bartholomew's, with one wall remaining empty, Hogarth was also planning and probably painting *The Four Times of the Day* as cartoons for larger designs for Tyers' Vauxhall, as well as *Strolling Actresses Dressing in a Barn.* All of this was far enough along for him to announce his subscription in the *St. James' Evening Post,* 10–12 May 1737, but then no more was heard about these paintings and prints until nearly a year later, early in 1738, when the same advertisement was published, only adding that no copies would be made of them.

What happened to delay the project is open to speculation.

Whether waiting for some initiative on the part of the hospital, or as the result of a quarrel or his own lack of interest, Hogarth had been inactive a year on the St. Bartholomew staircase. Suddenly, in the issue for 14–17 May 1737, the *London Evening Post* announced: "A few Days since a Frame was fix'd in the Staircase of St. Bartholomew's-Hospital, in order for painting the History of the good Samaritan, by that celebrated Artist Mr. Hogarth."

The Good Samaritan was apparently painted *in situ* in order to sustain the tone of the finished work next to it. The *Grub-street Journal* of 14 July noted that "Yesterday the scaffolding was taken down from before the picture of the Good Samaritan, painted by Mr. Hogarth, on the stair-case in St. Bartholomew's hospital, which is esteem'd a very curious piece." On Thursday the twenty-first the General Court met as scheduled, with an "elegant Dinner" (Henry Overton was one steward), and it was "Resolved That the Thanks of this Court be given to W^m Hogarth Esq^r one of the Governors of this Hospital for his generous & free Gift of the Painting of the great Stair Case performed by his own Skilfull Hand in Characters (taken from Sacred History) w^ch illustrate y^e Charity extended to the Poor Sick and Lame of this Hospital." Hogarth was himself absent from the meeting, but the *London Evening Post* (admittedly a spokesman for the hospital), of 21–23 July reported that the paintings were "esteem'd the finest in England."

The result (pl. 52) is not unimpressive. Hogarth himself, in recalling the pictures, emphasizes the size of the figures ("7 foot high"), and it is startling to move from one of his 1735 paintings to this huge wall: the figures are indeed larger than life size, and they loom up as one ascends the staircase. From the top landing, outside the entrance to the Great Hall, lighted only by three windows and a chandelier, they are at eye level, but even at that distance one is impressed first by the color, the brilliance of execution, and the excellent state of preservation. All of these, including the last, are important characteristics of Hogarth's art.

The two paintings are rather different. *The Pool of Bethesda,* with its many figures, complex arrangement, and many precedents (Murillo, Ricci, and others), is in sharp contrast to the relatively perfunctory *Good Samaritan;* all of Hogarth's interest and enthusiasm must have gone into the first. The subject of charity is secondary. What caught Hogarth's interest, and drew upon his long knowledge of the

52. The stairway, St. Bartholomew's Hospital (reproduced by permission of the Governors of the Royal Hospital of St. Bartholomew)

hospital, was the matter of disease and injury. He has realized the diseases cured by Christ in terms of those treated at the hospital, bringing the story up to date and, in this sense, creating another modern history in fancy dress with a puzzled-looking Christ in the middle. The patients are carefully observed: the infant with the prominent forehead, curved spine, and enlarged joints is a classic case of rickets, as first described by the hospital's Dr. Francis Glisson in 1650. Also painted with clinical accuracy are a woman with inflammation of the breast, a man whose gouty hand has received a painful knock from the blind man whose staff is near it, a girl unhealthily fat, and an emaciated old crone.

The main reaction to Hogarth's paintings may have been a small resurgence of interest in history painting among London artists. As to Hogarth himself, one or two special commissions may have followed, but from the great religious or state patrons there was no response, and he turned once more to his "modern moral subjects."

Even though there were no more commissions from church or state, one may be sure that the St. Bartholomew paintings were not Hogarth's only excursions into sublime history during these years. He never did things by halves. His *Scene from 'The Tempest'* (Nostell

Priory Coll.), though undatable, was probably painted around this time. It was a serious equivalent of his earlier *Falstaff Examining His Recruits,* an attempt to make Shakespeare a subject for history painting, a vein to be exploited by Hayman and others. It may also have been in the mid-1730s that Hogarth began a history painting out of Milton's *Paradise Lost.*

Hogarth seems in a few instances to have sought to treat history subjects in a blatantly "modern" manner. Unfortunately, one such instance is no more than hearsay and the other only a photograph. A painting of *Danaë* was sold at his 1745 auction, in which, according to Walpole, "the old nurse tries a coin of the golden shower with her teeth, to see if it is true gold. . . . It is a much more capital fault that Danaë herself is a meer nymph of Drury. He seems to have conceived no higher idea of beauty." The other painting is a *Samson and Delilah* with the familiar trinity at the center: Delilah in the middle, in a curtained bed, between Samson and a young man cutting off his hair. If this painting was indeed by Hogarth, it was an experiment that was not repeated.

It is worth noting that the prints concerned with physiognomy are concentrated during the time of Hogarth's painting at St. Bartholomew's Hospital: his fascination with the clinical was evidently as strong a force as the desire to paint sublime history. The histories, as well as the *Groups of Heads* and even *Before* and *After,* are concerned with physical states or manifestations as they relate to the mental, and the moral is temporarily in abeyance. In fact, morality, one must conclude, was a secondary consideration for Hogarth during the last years of the decade.

The one "group of heads" which is topical and, as Hogarth was later to put it, "timed," was *The Company of Undertakers* (pl. 53, sometimes called *The Consultation of Physicians*). To begin with, this print is another offshoot of Hogarth's observations at the hospital; some of the Bartholomew's physicians have been identified among the physicians portrayed below the wavy line. The three quacks posing as figures on the "chief" part of the shield are John Taylor, Sarah Mapp, and Joshua (Spot) Ward, who were associated as a sort of medical triumvirate and were much in the news during the fall of 1736 (the print came out in March 1736/7). Although their association was emphasized in 1736 and '37, they had been individually attacked earlier, most notably in the pages of the *Grub-street Journal.* The question,

however, is what they meant to Hogarth and what he did with them in his print. The quacks in the fifth plate of *A Harlot's Progress* are there not only because they are quacks but also because they represent the natural consequences of the Harlot's folly and the further reactions of the society she has chosen to emulate. Moreover, as Hogarth portrays

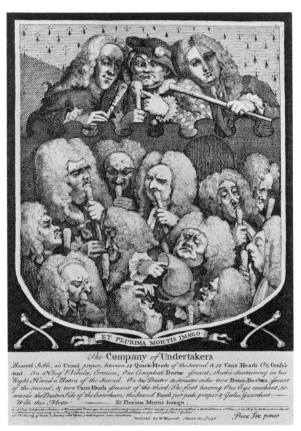

53. The Company of Undertakers; March 1736/7; 8⅝ x 7 in. (BM)

them, it is evident that the dying Harlot herself is the consequence of their quackery.

Mrs. Mapp was simply a broadly comic figure—a female bonesetter; but Ward and Taylor were serious targets for satire and were so treated by the *Grub-street Journal*. Taylor, an oculist, was not, properly speaking, a quack. The *Journal* carefully emphasized the fact that he was a regular surgeon of talent, but one who subjugated his talent

and profession to the demands of a commercial enterprise. The point of Hogarth's presenting him on an escutcheon is plain. Taylor himself represented another example of pretension vs. reality.

Joshua Ward, the most famous quack of his time, was attacked by the *Grub-street Journal* for creating the reputation of being—like Taylor—an apparent wonder-worker. But his claims were based only on an antivenereal "Pill and Drop," made of antimony and arsenic, which had a powerful purgative effect and sometimes killed instead of curing. The *Journal* listed case after case which demonstrated the horrifying results of his "cure": blindness, paralysis, and death.

On 23 January 1737/8 Hogarth began to advertise his subscription for *Strolling Actresses* and *The Four Times of the Day*, first announced as "in great forwardness" in May 1737, using nearly the same words. On 25 April he announced that the prints were finished and would be ready for delivery to subscribers the next Monday, 1 May, at the Golden Head.

Strolling Actresses Dressing in a Barn (pl. 54), underway in May 1737, may have required some rethinking after Sir Robert Walpole at the end of that month pushed his Licensing Act through Parliament. At any rate, Hogarth added a paper labeled "The Act against Strolling Players" across the actresses' bed. This plate, by commemorating the closing of the theaters in 1737, represented a gesture toward Fielding, at whom the Licensing Act was originally aimed; it forced him to retire from the stage and live by the practice of law (and ultimately write *Joseph Andrews* and the other novels). *Strolling Actresses* presents in a single image all Hogarth's comments on society up to this point, but in Fielding's particular idiom. In his farces and burlesques Fielding showed shabby mortals acting the roles of gods and goddesses, kings and queens: he attacked the gods and heroes as delusive, and the humans as low and gross only because they were imitators of those fraudulent gods.

Hogarth demonstrates here that he knows everything there is to know about the heathen goddesses: their attributes, their poses, their surroundings, as defined by the ancients. But he subverts them: they are appropriate and useful only in a theater, and probably worth no more there than in a history painting. The satire is therefore not directed to the actresses themselves as people, nor to their pretensions, which are, after all, part of their job. Rather, Hogarth attacks the in-

appropriate ideals of a certain kind of art, and by extension the shibboleths or conventions of society: those crowns, orbs, miters, heroes' helmets—the crown used by Jupiter's eagle as a stand for her baby's pap, the orb the plaything of kittens, the miter for storing promptbooks, and the hero's helmet for a monkey to relieve himself in.

In vague and uncertain ways Hogarth's whole project owes something to Fielding's *Tumble-down Dick, or Phaeton in the Suds* of

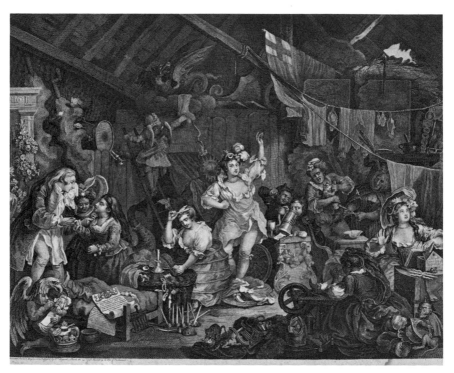

54. **Strolling Actresses Dressing in a Barn; May 1738; 16¾ x 21¼ in. (BM)**

1736. This most flagrant of all Fielding's travesties apparently made a strong impression on Hogarth; many of its elements appear in one form or another in the five prints he published in 1738. But Fielding's farce also introduces a rascally justice, once again (as in *Rape upon Rape*) based on the notorious Thomas De Veil. There are also a barbershop and a cuckolded cobbler quarreling with his wife. *The Four Times of the Day* could have been put together from such hints.

The paintings were, according to tradition, originally made as de-

signs for the Vauxhall supper boxes; copies hung there for years afterward. Perhaps the most general of all Hogarth's moral subjects, they were perfect embodiments of the four ages of man, the seasons, or such topoi as would have been popular among the diners and strollers at Vauxhall. But even here particular allusions were not lost on the public of 1738. The drunken Freemason in *Night* was recognized as Justice De Veil—whom Hogarth had supposedly portrayed in *The Denunciation*, who was a member of Hogarth's first lodge which met at the Vine, and who, until recently, had lived nearby in Leicester Fields.

The Four Times of the Day (pls. 55–58) represent the progress of a day, as his other series show the progresses of a harlot, a rake, a marriage, two apprentices, or an election. But the division into four times, instead of simply morning, afternoon, and night, suggests a parallel with the seasons that is emphasized by at least two of the plates depicting weather that could not have occurred on the same day: snow and extreme heat. The same people do not appear in more than one print, though the same or parallel types do. The prints are not about a person or persons but about a phenomenon, in this case temporal; the only protagonist is an implied one related to the four ages of man.

In the first plate, the pious old maid stands alone, self-sufficient and unhelpful, outside the drinking, love-making, begging crowd that is trying to warm itself; in the same way, the face of the church is only another cold, geometrical façade above the makeshift man-made hulk of Tom King's tavern. In the second scene, *Noon,* a church and a tavern are again contrasted: the street, divided down the middle by the gutter, juxtaposes churchgoers with their pious faces or (alternatively) French customs and fashions, and the eating, lusting, sloppy people who ignore the church. Beyond piety and impiety, they are the structured and the unstructured. In each plate there is a sturdy, buxom, attractive girl with a man's hand in her bosom, perhaps less unequivocally normative than in *Strolling Actresses.* The third and fourth plates offer one alternative each: order or anarchy, wifely control or husbandly escape to the Freemasons' lodge, drink, Jacobite fantasies (Restoration Day), and saturnalia. If the problem of *Morning* is how to stave off the cold, in *Evening* it is how to escape the heat. Warmth, no longer absent, has become oppressive. It is the crushing heat of the London afternoon, of marriage, of responsibility, perhaps of maturity. And in *Night* heat has become an outlet, a form of destructiveness (of

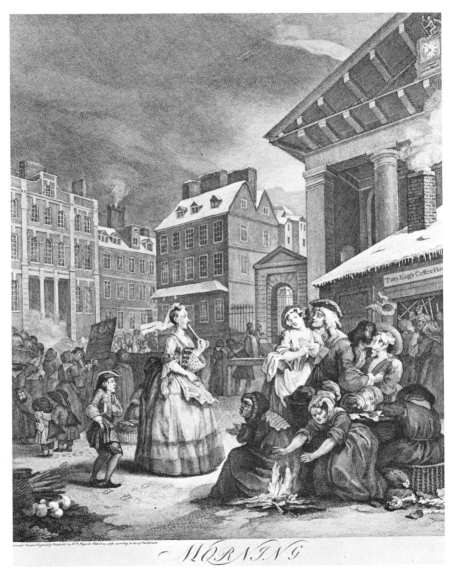

55. The Four Times of the Day: Morning; 1738; 17⅞ x 14¹⁵⁄₁₆ in. (BM)

the coach, and of houses in the distance), and a light to see drunken Freemasons home from their lodge meetings.

One way to describe the effect of *The Four Times of the Day* is to say that Hogarth no longer takes sides or condemns or admonishes. Another is to say that he has—unfashionably—taken sides with the rev-

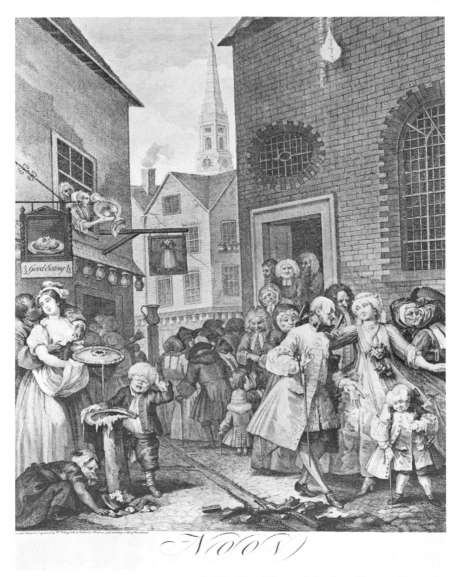

56. The Four Times of the Day: Noon; 17¾ x 15 in.

elers against the church, and prefers to leave it a draw rather than im-
pugn his own orthodoxy.

The painting of *Strolling Actresses* no longer exists, but the paint-
ings of *The Distressed Poet* and *The Four Times of the Day* show that

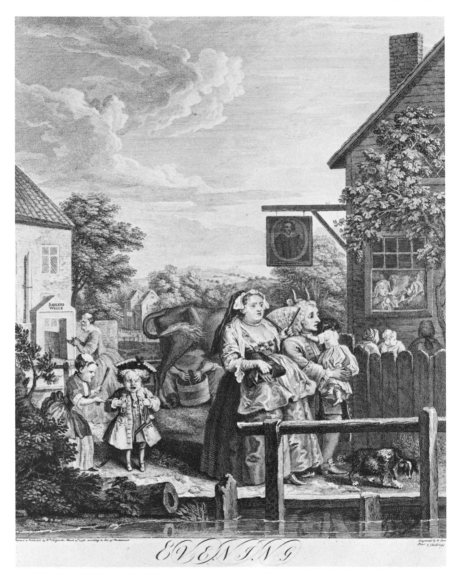

57. The Four Times of the Day: Evening; 17⅞ x 14¾ in.

by this time Hogarth had reached a point where he could no longer express all he wanted to say in his prints. In fact, he never produced better work than these paintings. At this time Hogarth must have felt the need for color even in his prints; for the only time in his career he introduced a reddish ink in *Evening* for the woman's flushed, hot face,

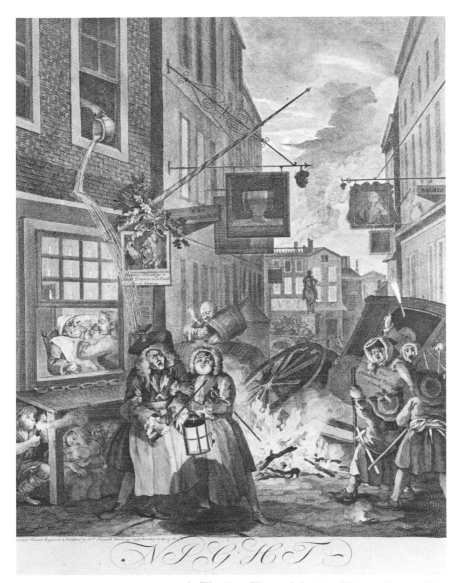

58. The Four Times of the Day: Night; 17$\frac{5}{16}$ x 14$\frac{1}{2}$ in.

and blue for her husband's ink-stained hands. Black and white were apparently no longer sufficient.

Since the paintings of the *Harlot's Progress* were destroyed, leaving only the monochrome prints, the result appears no different from the *Hudibras* prints, which have only drawings as surviving prototypes.

Only with *Southwark Fair* and the *Rake's Progress* is it possible to consider history painting as it appears on the one hand in an engraved reproduction and on the other in the painting itself. Turning from the austere, still relatively classical engraving of the *Rake* to the paintings, it is something of a shock to discover that they are so small. The print still conveys a sense of kinship to Raphael and history painting, partly by implying large paintings, while the paintings themselves do not; and they raise the whole question of Hogarth's intention. The prints are, in a sense, only an allusion to the subject of history painting. One would expect an innovator in history painting to maintain the monumental size if not the subject matter. Hogarth begins with very small paintings (*Southwark Fair* is larger but the scale remains small) in which, as opposed to the engravings, he produces something close to genre. While small in size, they are painted with flair, and the viewer admiringly studies their color and texture.

The most interesting difference between Hogarth's prints and paintings is that the clear focus of the prints, which helps to render the Raphaelesque effect, is replaced in the painting by a shifting focus: some faces, some costumes, some details are carefully finished and clarified, while other areas (sometimes as important for the story) are vaguely sketched in. His colors are broken and require the viewer to stand back; sometimes he places tones and half-tones next to each other, lights and shadows, so that the work looks like a sketch and falls to pieces if the viewer comes too close.

The first important fact about Hogarth as printmaker *and* painter, whose product was both the engraving and the modello for the engraving, is that, faced with the engraver's problem of reversal, he chose to paint his modello in reverse rather than paint it straight and then engrave it in a mirror. While often careless in the painting of details of reversal like hands and buttons, he was careful to reverse the general "reading" structure of the design so that the print made his moral point. Studies of visual perception show that in "reading" a picture the eye moves from the lower left up and into the depth of the picture and toward the right.

In *The Distressed Poet* (pl. 59) the eye moves from the consequences of the Poet's folly—the dog eating his last chop and the milkmaid with her unpaid bill—to his wife and child, the innocent victims, and finally to the Poet himself, the guilty victim and the cause. The painting reverses this order, first establishing the nature of the Poet's

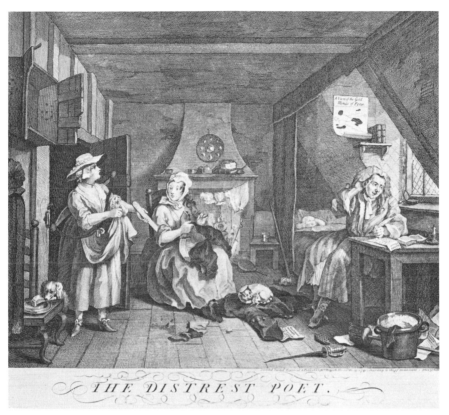

THE DISTREST POET.

59. The Distressed Poet; March 1736/7; 12⅞ x 15⁵⁄₁₆ in. (BM)

folly and then forcing the viewer to follow to its consequences: he has
withdrawn from the real world, leaving a trail of chaos in his wake. In
the print there is still a kind of causality. Judging by the other prints
of this period, one must conclude that the print rather than the paint-
ing represents Hogarth's intention. He is now less concerned with the
consequences of an action (indeed he has abandoned the series of six
or eight plates, which must stress causality or become a mere medley,
for single or balanced plates) than with a contrast: between the real
world and the Poet's, or elsewhere between desire and fulfillment, pas-
sion and prudery, order and disorder.

 The matter of reversal suggests that Hogarth's prints are more ex-
pressive than his paintings as narrative and didactic structures. The
print conveys the moral point, and the painting something beyond. In
his paintings Hogarth consciously sacrifices the story-telling function

if not the compositional sense of his engraved design. On the representational level, the reversal negates the particular causal or juxtapositary pattern of the print, replacing it with a less subordinated, and less tendentious, pattern. The addition of color and texture, even when directed toward the end expressed in the print, again diffuses the attention which in the print is coalesced. The painting develops independently, more as a genre piece, a simple portrayal of manners.

It might be argued that the print presents a satire, a moral and rhetorical structure, and the painting then offers Hogarth the opportunity to flex as well as elucidate his ideas (within the limits of the general composition). He surely realized the difference that color made, as he realized the effect of reversal. He could have painted straight and reversed his engraving; perhaps recognizing that he could achieve greater fluency with the brush than with the burin, he chose to block out the picture backward and paint it freely, *con amore,* and then draw it carefully on the copperplate. His attitude toward the painting is therefore curiously ambivalent: it is an end in itself, and yet it is always painted with one eye on the print that will follow. It is seemingly painted to please the artist himself, and also to appeal to a collector-purchaser. Color may have been intended as a bonus, something to make the paintings a more deluxe item than the prints. The paintings hung in his picture room with those prints that were finished as subscriptions were taken, and the prospective subscriber might compare them.

Is color no more than an aesthetic addendum in Hogarth's comic history paintings? It is perhaps less meaningful to say that the painting has some left over form than to say that the artist appears in a different relation to his subject. In the print he is effaced, and form as such is less evident because the print is reproductive to begin with, a copy of a copy; the "idea" is all that remains. The "execution," the self-expression, pertains again in the painting. These "flourishes" produce a picture that relates both to the print's subject and to the artist who shapes his view of reality in this way. Experience is embedded in amber, and while one result is to draw attention to the artist who can make a beautiful thing out of it, another is to suggest that there is a beauty and vitality in even the most sordid events. This is the effect of Hogarth's best comic history paintings.

In these years Hogarth seems to have moved from the position that the engraving is the history, and the painting merely a modello like a

cartoon for tapestry, to the position that the painting can be the real thing and the engraving in fact merely a copy. At any rate, this is one interpretation of the change in his work in the late 1730s, as the possibilities of Vauxhall and hospitals and the like arose; it must have been then too that the possibility of an auction of his paintings began to glimmer.

At the same time, with his attempts at sublime history painting at St. Bartholomew's hospital, Hogarth began to be interested in the artist and his problems. It was at this point that he produced his fables of the artist—of a poet, a musician, and actresses. He even announced one of a painter, though it has not survived. The image of the artist that emerges is interesting: the poet is up in a garret, remote from reality, unable to pay for food, wearing inappropriate clothes, and writing poems, thinking of a gold mine in Peru. The musician (pl. 60)

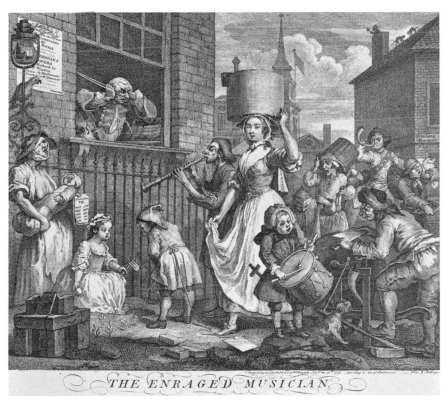

60. The Enraged Musician; Nov. 1741; 13¼6 x 15¹¹⁄₁₆ in. (W. S. Lewis)

is like the artist in Arthur Koestler's essay "The Novelist's Temptations" who closes his window to the outside world.

The general trend in Hogarth's art in these years is analogous to the change from the print to the painting, from a strong causal pattern and left-to-right reading to balance and juxtaposition. The progresses, necessarily as a series but also as individual pictures, were constructed causally. The compositions themselves were causal, *this* leading to *that* and *that*. The prints of Hogarth's successful and contented middle age, however, are based on simple juxtapositions, this against that, and are less tendentious. In the engravings of *Before* and *After* the causal relation is, of course, paramount, yet it leads to no admonition —and is in fact only apparently the connecting link. Here it serves to produce the simple contrast which is the real point of the pair: not *this* produces *that* but the opposition of desire and fulfillment. In *The Four Times of the Day,* as I have noted, causal connection is ignored: a single cast of characters is abandoned for four casts, and London is the only common denominator. Each scene is constructed of juxtapositions—old and young, prudish and passionate, cold and hot, ordered and disordered—as the group of scenes balances the four times.

The pattern of parallel and contrast in the early progresses is also notably reminiscent of the Puritan's heavy emphasis on choice, as in Hogarth's obsession with the Choice of Hercules paradigm as a basis for psychological relationships between characters. In the mid-1730s, when Hogarth diminished the number of plates in a series to four, two, and one, contrast received the whole emphasis. In *The Four Times of the Day,* the chooser is pushed out of the picture and the choice is given to the viewer—to opt for prude or lovers, churchgoers or lusty eaters and drinkers.

As the emphasis moves in the comic works from choice to contrast, the moral issues tend to be replaced by aesthetic ones. The Harlot or Rake becomes the Poet, who is a moral figure if the picture is read causally (he brought this squalor upon himself and his family by his folly), but who is merely a representative of art removed from reality, or of the unnatural, if the picture is read as a contrast between the Poet and the outside world. In *The Enraged Musician* there is nothing but the aesthetic choice between art and nature.

PORTRAIT PAINTING

In 1733, when he moved into his house in Leicester Fields, Hogarth had designated himself a portrait painter by placing the sign of Van

Dyck's Head over his door; and in 1734, in the *Gentleman's Magazine* obituary of Thornhill, he was identified as a painter of "curious Miniature Conversation Paintings." But the real, or at least symbolic, signal for his single-minded activity as a portraitist appears to have been the challenge of Jean-Baptiste Vanloo's appearance in December 1737. Indeed almost every one of Hogarth's acts during this period can be seen as a self-appointed response to a challenge: the eight plates of the *Rake* were, among other things, an attempt to outdo the six-plated *Harlot;* the St. Bartholomew's paintings were an attempt to outdo Amigoni, who was just then in the news for his histories, and the foreign history painters in general; and now the portraits, at least one of which is signed "W. Hogarth Anglus pinxit," were his reaction to the English aristocracy's wholehearted acceptance of Vanloo and the portraitists who were either foreign or foreign-influenced.

In December 1737 Vanloo arrived in London from Paris, a man in his late fifties, "tall well shaped and of good aspect" (by which Vertue indicates the courtliness that the English had come to expect of their portraitists since the time of Van Dyck). He had painted French royalty and nobility, but after the death of his patron the Regent, and a commission lost to his brother Carlo, he headed for London—without, as far as Vertue could discover, any invitations or connections at the English court. He set up a studio at the Crown and Ring, the house of his countryman Duhamel the jeweler, in Henrietta Street. He tried a portrait of General Dormer, which Vertue noted was "very like—and soon after being less than 3 or four months [he] had a most surprising number of people of the first Quality sat to him for their pictures."

The *London Evening Post* of 16–18 February 1737/8 noted that Vanloo was "now painting in the Portrait Way most of our English Nobility" and that Amigoni was decorating the additional buildings at Greenwich Hospital—both items which would have meant something to Hogarth. Another foreigner, the Florentine Soldi, who had been in England for two years without notable success, now adopted Vanloo's mannerisms and also was soon in great demand. The French tradition reintroduced by Vanloo offered a more mobile face, one with a more minute technique in the rendering of the features. But it was just a tinge of modishness—i.e. foreignness—that brought him his following and that he now injected into English portraiture. One might say that Vanloo served portraiture as Gravelot had the more decorative arts.

When Hogarth came on the scene and signed a portrait "W. Ho-

garth Anglus pinxit," he was reacting not only against Vanloo and Soldi but against the two hundred years in which the British had seen themselves through the eyes of foreign painters (or of British artists who imitated them) and against the aristocratic stereotype of elongated bodies and faces as regularized as masks. He himself had produced occasional portraits, but up to this point his experimenting with single portraits was confined to genre pieces like *Sarah Malcolm* and to members of his own family. As early as 1730/1 (as recorded in his list of work at that time unfinished) he was painting a full-length of Sir Robert Pye, but it looks like little more than a depopulated conversation picture. The full-length portrait called *Gentleman in Blue* produces the same effect, as do the small standing portraits of Lady Byron and Viscount Boyne, which are datable around 1736. Only *The Duke of Cumberland* of about 1733 and *Thomas Western* of 1736 begin to look like single portraits in their use of the picture space. The most forward-looking experiments, however, are pictures of family and friends. Hogarth's portrait of his mother (1735, pl. 51) is the first to make the sitter dominate the picture space. Next comes the seated full-length of Dr. Benjamin Hoadly in 1737 or 1738, a small and as yet timid version of what he attempted in *Captain Coram* (pl. 61). Then, either just before or just after the *Coram*, comes the small full-length of Bishop Hoadly (Huntington Art Gallery), a very close ecclesiastical version of *Coram*.

His serious effort, however, was devoted to other kinds of painting, or portrait groups, which demonstrated his particular talent for rendering active crowds of people. He was no doubt aware that his strength lay in relating two or more figures, and that single portraits gave no scope to his particular talents. There was another reason as well. Richardson, as both theorist and practicing portraitist, had stressed how important it was for the English gentleman to have portraits of himself and of absent friends and relatives, to "keep up those sentiments which frequently languish by absence" and to keep portraits of the great nearby to inspire oneself with noble thoughts. This was, of course, the idea at which Hogarth poked fun by having the Harlot keep near her bedside portraits of Macheath and Dr. Sacheverell.

If the tradition of portrait painting itself was singularly dim at this time, the first real break from the Kneller pattern came in the school of sculpture. From the point of view of the English gentlemen

brought up on Richardson's treatises, the portrait was augmented if not superseded by the bust, with its echoes of antiquity, which meant much to the Englishmen who—with help from the Burlington circle— liked to think of themselves as reincarnated Romans. By 1730 Vertue was noting that the reputation of sculpture was higher than ever before; in 1732 Rysbrack, who did more than anyone else to introduce this kind of portrait, had some sixty sitters, and by 1738 Vertue believed sculpture had made "greater advances" than painting.

In 1738 Roubiliac produced his *Handel,* a more intimate and individual portrait than the Roman senators of Rysbrack, and it is to him that Hogarth owes details like the unbuttoned coat and comfortable pose of some of his portraits of men. Even the liveliness of his application of paint tends to recall the sculptor's fingers in Roubiliac's terra-cottas, which are more like Hogarth's canvases than the finished marbles. It can be no coincidence that Hogarth began to be seriously interested in portraiture just after the unveiling of Roubiliac's first great success, his *Handel;* and his own first great success was his *Captain Coram,* which is very much the same sort of portrait, given the difference in media and professions. It is, in the same sense as the *Handel,* sculptured, and quite a different object from those stiff painted icons of Vanderbank and the other contemporary portraitists.

Richardson, who wished to exalt the painter to the level of the poet, had used history painting as the obvious genre in which painter and poet could vie with each other; portraiture naturally suffered by comparison. Therefore he argued for a portraiture that would act as history painting and elevate the particular individual. This theory supported the practice of painting an apothecary as if he were a baronet, and his wife as if she were a king's mistress posing as a Magdalen or a St. Catherine. Shaftesbury, more objective than the interested portrait painter Richardson, simply dropped portraiture from the ranks of serious art, the only exception being small likenesses to serve as snapshots of friends.

Hogarth expresses a very similar opinion, with his own uncompromising logic. He sees no difference between the majority of examples of this genre and still-life painting, to which he more than once compares it. "Portrait Painting," he wrote, "tho a branch that depends chiefly on much practice and an exact Eye as is plain by men of very middling natural parts having been at the utmost heights of it, hath always been engrossed by a very few Monopolisers whilst many others

in a superior way more deserving both as men and artists are every-
where neglected and some starving." Although he must include Eng-
lish artists as "Monopolisers," he makes clear who he intends in this
instance: "Vanloo, a French portrait painter, being told by friends
that the English are to be run away with, with his grandeur and puff-
ing monopolised all the people of fashion in the kingdom." One can
imagine the indignation of the author of the "Britophil" essay as he
goes on to say:

> This monopoly was agravated by being by a foreigner. I exhorted
> the painters to bear up against this torrent and to oppose him with
> spirit—my studies being in another way. I spent my own in their be-
> half, which gave me enemies among his espousers, but I was answered
> by [the English painters] themselves: "You talk, why don't you do it
> yourself?" Provoked at this, I set about this mighty portrait, and found
> it no more difficult than I thought it.

"This mighty portrait" sounds as if he means, or wants the reader to
think, that he set to work at once on the major portrait he shortly dis-
cusses, *Captain Coram*. He recalls that

> upon one day at the academy in St. Martin's Lane I put this question,
> if any at this time was to paint a portrait as well as Van Dyck would it
> be seen and the person enjoy the benefit? They knew I had said I
> could. The answer made by Mr. Ramsay was positively No, and con-
> firmed by about twenty who were present. The reason then given very
> frankly by Mr. R: "Our opinions must be consulted and we will never
> allow it."
> Upon which I resolved if I did do the thing, I would affirm I had
> done it. I found my advantage in this way of doing myself justice, rec-
> onciling this violence to my own modesty by saying Vanity consists
> chiefly in fancying one doth better than one does. If a man think he
> does no more than he doth do, he must know it, and if he says it in this
> art as a watchmaker may say, "The watch I have made I'll warrant you
> is as good as any other man can make you," and if it really is so the
> watchmaker is not branded as infamous but on the contrary is es-
> teemed as an honest man who is as good as his word.

Mr. Ramsay was Allan Ramsay, the young son of Hogarth's old
friend Allan Ramsay the poet. It is noteworthy that Hogarth should
locate the beginning of his portrait painting in a conversation with
him. In August 1738 the young Ramsay, just back from Italy, set up

in the Great Piazza, Covent Garden, as a portrait painter. He arrived, with Italian training, just when the fashion for portraits was at its peak, immediately established a successful practice, and joined the St. Martin's Lane Academy, where he and his father's friend clashed.

But Ramsay was not just the Italianate opponent; his style conveyed an intimate realism, and he possessed a remarkable ability to catch a likeness. Led by Ramsay, the new generation produced a kind of portrait that allowed for a good likeness, which effectively broke the Kneller mask but kept the aristocratic formality intact; after completing the face, the painter sent the canvas to Joseph Vanhacken to fill in the fashionable body, costume, and stage props. Vertue attributed much of Ramsay's success to his drapery painter, and, indeed, in much of his work before Vanhacken's death in 1749 (and this included the great full-lengths of *Dr. Mead* and *The Chief of Macleod*), Ramsay painted only the head and worked out the composition, and Vanhacken filled in the rest—thus adding another desirable attribute to Ramsay's portraits, for Vanhacken was a genius at rendering silks and satins. Hogarth, Highmore, and a few others refused to turn out factory products, and as far as Hogarth was concerned a painter who did was not a true artist.

Hogarth emphasizes, in the autobiographical notes, the primacy of the Coram portrait: that he did it first, as a test, and "without the practice of having done thousands, which every other face painter has before he arrives at doing as well." While for propaganda purposes it was appropriate that the Coram portrait should be his first as well as most famous one, there is a certain poetic truth in the assertion. It was his first public portrait, his first portrait on a large scale and with a monumental composition that consciously invited comparison with Van Dyck. It would be interesting to know whether the scene at the academy preceded or followed his first connection with the Foundling Hospital, or whether having associated himself with Coram for philanthropic purposes it occurred to him that here was the place for a great English portrait to be publicly exhibited in perpetuity.

Whatever the exact chronology, on 17 October 1739 Hogarth appears on the Charter for Incorporating the Society of the Foundling Hospital as a governor, and was present at the first meeting at Somerset House, Tuesday 20 November, to receive the royal charter (along with six dukes, eleven earls, and many other peers and famous Englishmen, including merchants, bankers, and such physicians as Dr.

Richard Mead). It is also clear that he subscribed his money and attended the Courts of General Meetings as an active member (as opposed to the great majority of the 375 governors named in the charter). The charter authorized the governors to appoint persons to ask for alms on behalf of the charity and to receive subscriptions toward the founding; Hogarth presumably did both, and his first known contribution was the headpiece he designed for the subscription forms, which was engraved by La Cave.

But he had also been busily at work on the full-length portrait of his friend Captain Thomas Coram, the founder and moving spirit of the whole enterprise; so monumental a painting was clearly destined for a public building. On 14 May 1740, seven months after the granting of the charter, at the annual Court of Governors, Martin Folkes, a vice president of the hospital, "acquainted the Governors That M^r Hogarth had presented to them a whole length Picture of M^r Coram for this Corporation to keep in Memory of the said M^r Coram's having Solicited, and Obtained His Majesty's Royal Charter for this Charity." The corporation voted its thanks to Hogarth.

Captain Coram (pl. 61) shows a decidedly plebeian man raised by his own moral strength to authentic greatness. Hogarth has painted him life-size and given him a beaming face full of self-confidence and good nature. His body appears to be about to move vigorously forward, perhaps because of the fluttering motions made by his great red coat. The seal attached to the royal charter of the Foundling Hospital is firmly grasped in one hand, a symbol of his own accomplishment, as is the globe, turned to show England and New England linked by the Atlantic Ocean (he made his fortune by trading across that body of water), and the prospect of the sea studded with sailing ships. The viewer looks up at Coram—is forced to by the angle of vision—but there are no falsely aristocratic features, and instead of robes of state only his coarse coat.

This is, however, Hogarth's first great portrait, and he has not yet quite made up his mind about his treatment of the sitter. While maintaining Coram's true value as a moral agent, he gives the garments a wild fluttering look and places behind Coram the conventional pillar and other accessories of elegant French portraits. To understand the effect of *Coram,* however, one must compare it with Ramsay's full-length portraits of the period—*Viscount Deerhurst* and *The Hon. John Bulkeley Coventry*—that established his repuation, and his monu-

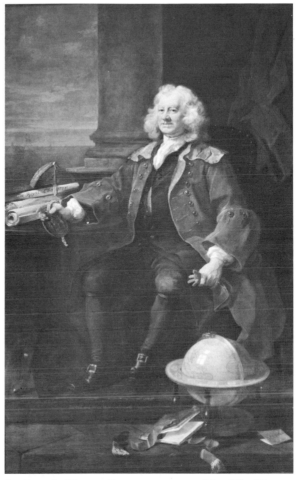

61. Captain Thomas Coram; 1740; 94 x 58 in. (The Thomas Coram Foundation for Children)

mental *Dr. Mead,* which he presented a few years later to the Foundling Hospital. It is evident from the dates, and from the story Hogarth recalled, that he and Ramsay considered each other rivals. Ramsay's *Dr. Mead* (pl. 62) turns the rich physician into Rigaud's Louis XIV himself.

With few exceptions Hogarth was able to be at once honest and benign in portraying his sitters. Since there were few Corams, his large, heroic portraits were limited to children, actors playing roles, and ecclesiastics who are either genuinely impressive in themselves or

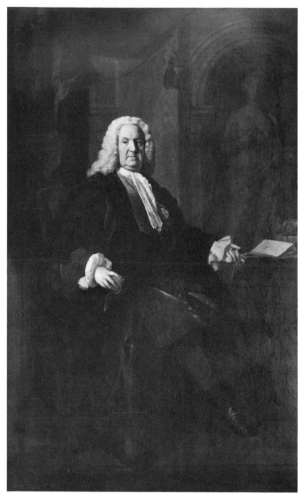

62. Allan Ramsay, Dr. Richard Mead; 1747 (The Thomas
Coram Foundation for Children)

mere vessels of God, frail human beings surrounded with the robes of
authority. For the ordinary professional man, he used a smaller canvas
and a half-length or quarter-length pose; he added no fancy dress, no
official robes, and filled the picture space with details indicating the
man's prosperity and community importance, but declined to raise
him to a status he did not possess. If he was responsible for what Wa-
terhouse has called a "heroic middle-class art," it is clear that this
applies only to *Coram* and a few other portraits like that of Frankland,

and that he regards these sitters as worthy of attention on his own terms. He may occasionally beautify, but he seldom inflates.

The main reason that society did not seek portraits from Hogarth may have been that he shattered the Kneller mask, the standardized oval, with the long nose and narrow eyes. He replaced these with round, beaming faces, whose mood was most often cheerfulness and a kind of unaristocratic busyness and vitality that makes them appear to be anxiously awaiting the end of the sitting. The fashion, set by Vanloo and the French school, was all in Ramsay's favor. Hogarth's evident need to fiddle with his pictures, his unwillingness to let them leave his studio, and his occasional requests for their return while he made further changes may also have deterred the more fashionable clientele. Moreover, the determined straightforwardness of his portraiture was reflected in his studio habits; later stories describe his impatience with long sittings and the baiting to which he sometimes treated his sitters. His prices have not survived from this period, but one may be sure (judging by his later prices as well as by his temperament) that they were at least eight guineas a head, or equal to Ramsay's and his other competitors'.

Hogarth had a small circle of patrons, those who owned a few of his paintings: the Hugginses and Hoadlys, Mary Edwards, later Horace and Edward Walpole, William Beckford, and a handful of others. It is never really certain whether the painting or the friendship came first, but with these patrons both pertained: apparently the sort of man who liked Hogarth would like his paintings. They were an odd lot. Some, like Horace Walpole and Beckford, never deigned to seek a portrait of themselves, collecting only what they considered his drolls.

The family that received the greatest benefits from Hogarth as portraitist, however, was the Hoadlys. Hogarth knew young Benjamin in the early 1730s when he painted the Betts family, into which Benjamin had married: a physician who wrote plays, a fat, jovial, and learned man who later polished Hogarth's prose in *The Analysis of Beauty*. Even before this he may have known Benjamin's mother, Sarah Hoadly, who had been a portrait painter of some reputation (a pupil of Mary Beale) before her marriage to the future bishop. The bishop, most famous of the political prelates of the day, attached himself to the Whig cause, wrote pamphlets indefatigably for Walpole, and was rewarded with preferment. On the other hand, he was notori-

ous (at least according to opposition pamphlets) as an absentee bishop, who because of his badly crippled legs could not carry on his duties, could hardly even preach a sermon, but continued to enjoy all the perquisites of profitable offices while residing comfortably in London. Whether one views Bishop Hoadly as a typical place-hunting clergyman of his time, as most historians do, or (more sympathetically) as an important and thoughtful Latitudinarian theologian who over-came crippling physical handicaps and saw that his contribution lay with his pen, one need not doubt that he was a good husband, father, and friend. The painting (pl. 63) is a masterpiece. Hoadly's body looms up, one hand raised, the face as hideous and moving as one of

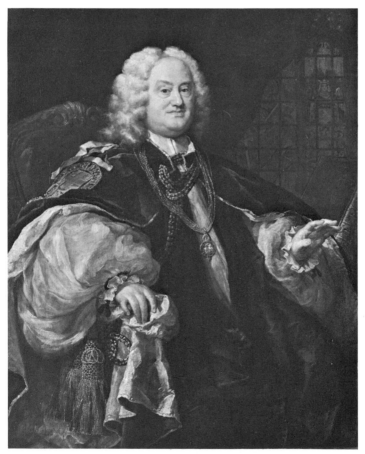

63. Benjamin Hoadly, Bishop of Winchester; ca. 1743?; 49½ x 39½ in. (Tate Gallery)

Velasquez's dwarfs, surrounded by billowing robes. It is a great and problematic ecclesiastical portrait—as if the Velasquez dwarf were dressed in the robes of his royal master. The portrait's power derives from the conflict between the frail human being and the robes of state in as incongruous a juxtaposition as Hogarth later employed in *The Bench*.

Nothing is known of the other great portrait of this period, *George Arnold,* but there may have been a personal connection here too, for one story has it that both Arnold and his daughter Frances (Fitzwilliam Museum) were painted by Hogarth on a visit at Ashby Lodge, Northamptonshire. Arnold was a retired merchant, who built Ashby Lodge in 1722 and collected pictures by the old masters.

As with his full-length works, Hogarth's first three-quarters-length portraits were of his family, with Jane Hogarth holding an oval portrait of her recently dead father. His treatment of this size was much improved in *George* and *Frances Arnold,* reaching its climax in *Bishop Hoadly.* The half-length portraits culminated in the portrait of Martin Folkes. As if fully aware that he was ready to achieve the flawless modello, Hogarth saw to it that he obtained sitters like Hoadly or Folkes, important people whose portraits could be expected to be engraved and disseminated; and then took great pains perfecting the works. In the case of *Folkes,* as later of *Garrick as Richard III,* the apogee of another kind of portrait, he undertook the engraving himself. *Folkes* appeared in 1742, and *Bishop Hoadly* (engraved by Baron) not long after, in 1743. His chief portrait in full length was of course *Captain Coram,* and this was engraved in mezzotint by McArdell in 1749, as *Archbishop Herring* was by Baron in 1750. Each was his best work in a particular line, a modello for other commissions.

These final great portraits were not, however, followed by similar works. By the mid-1740s his portrait painting had come to a halt, with a brief resurgence in the later 1750s for a final ambitious group (of Garrick and his wife) and a number of head-and-shoulders commissions.

The earliest head-and-shoulders portraits would appear to be *Sir James Thornhill* (which at present survives only in Ireland's etching), painted sometime before Thornhill's death in 1734, and the self-portrait in a wig (pl. 64). As with the full-length of his mother, it is likely that Hogarth began with himself and his immediate family as sitters.

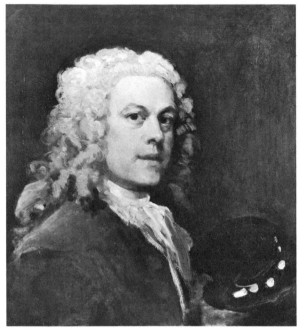

64. Self-Portrait; 1735–40?; 22 x 20½ in. (Mr. and Mrs. Paul
Mellon)

Only these two relatively private experimental portraits focus on the
face, limiting the body to head and shoulders. The self-portrait, in
fact, is only a face, the rest very sketchily filled in. The style is that of
the middle or late 1730s, the handling of the face consistent with the
other faces of those years. It bears a definite resemblance to the Rou-
biliac bust of 1740 or '41 (pl. 65), which is undoubtedly an accurate
likeness. Strangely, however, it lacks the scar on his forehead, said to
have been received in childhood, that is prominent in Roubiliac's
bust. Hogarth himself emphasizes it in his self-portrait of 1745 (even
moving it to the correct side in his reversed engraving), and John Ire-
land records stories of his wearing his hat cocked back so that the scar
was visible.

A contrast between this portrait and Roubiliac's bust is instructive.
Hogarth has caught his own likeness, but he is less interested in inter-
preting his character than in the free and brilliant application of
paint; it is largely an exercise in painting. Roubiliac's bust, based as
it must have been on long and personal contact rather than a few sit-
tings, is one of the primary sources of information on Hogarth's char-

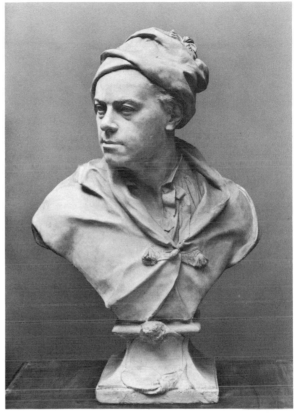

65. Louis François Roubiliac, William Hogarth; 1740/1
(terra-cotta; National Portrait Gallery, London)

acter. Here he is as he appeared in life, caught in movement, with his
head sharply turned, jutting assertively, with incredibly sharp and
observant eyes. Pugnacious is the word to describe the face and its
movement. Only with his last self-portrait, in which he shows his face
in profile, does Hogarth himself catch anything of this. Significantly,
Roubiliac included a separate statue of Hogarth's pug Trump to ac-
company the bust (V & A).

With a few exceptions like the actor Quin, with his head thrown
back, pleasantly posing (Tate), Hogarth added nothing in pure face
painting to the compositions of Kneller and Richardson; his contribu-
tion was in the direction of humanizing, rather than particularizing,
the sitter. Nevertheless these head-and-shoulders portraits reveal bet-

ter than the others his debt to Kneller. For, while he put Van Dyck's head over his door, attempted in *Captain Coram* to recapture the Van Dyck formula for his own time, and broke the fashionable mask of the Kneller portrait, he still continued to paint in Kneller's way. The meaty flesh, the corporeality of Hogarth's faces, and above all the evident brushwork, are Kneller's bequest.

If most of his portraits offered Hogarth no chance for his literary method, and little for elaboration or character analysis (at which he was probably, without appurtenances, not as talented as he has been thought), they did provide him with an opportunity for pure painting. In this sense his five years of face painting follow from the growing joy in applying paint to canvas that is evident in the modern history paintings of 1735–38. The histories end and the portraits begin; to be enjoyed, the majority of those heads he painted after 1738, many of them in feigned ovals and intended primarily as decorative devices for overmantels, must be regarded as exercises in playing with paint. As such they are delightful, the color and brushwork exciting, and they exude the sense of freedom Hogarth must have felt as he painted them.

The single portraits were an interval, and a necessary transition, between the last few conversations painted between 1735 and '38 and the great group portraits of the early 1740s, the real climax of Hogarth's portrait painting because they combine the best of his histories with all that he has learned about portraits.

The most ambitious portrait after *Coram* was *The Graham Children* (SD 1742), which, typically, was not the commission of a great nobleman, for whom such scale would be plausible, but of the apothecary at the Royal Hospital, Chelsea. Daniel Graham was appointed apothecary in 1739; he came of a family that kept an apothecary's shop in Pall Mall, and one story has it that he owed his place to the Duke of Newcastle in order "to get rid of a long apothecary's bill." He prospered, and to show his prosperity he ordered the grand portrait of his children—the choice of painter, I suspect, a sign of his *nouveau richesse*, for no established family ever ordered such a portrait from Hogarth. In a sense *The Graham Children* (pl. 66) is simply a conversation, with the children grown much larger in relation to the picture space. I think, however, that it is the intervening portrait of *Captain Coram* rather than the earlier conversations from which the three great children groups, *The Graham Children, The Grey Children*

(Washington Univ. Gallery, St. Louis), and *The MacKinnon Children* (National Gallery, Dublin) derive. These are essentially the Coram composition, size, monumentality, and heroic rendering extended to two or more figures.

In May 1743 Hogarth set out for Paris, "to cultivate knowledge or improve his Stock of Ass[urance]," as Vertue put it. Although an im-

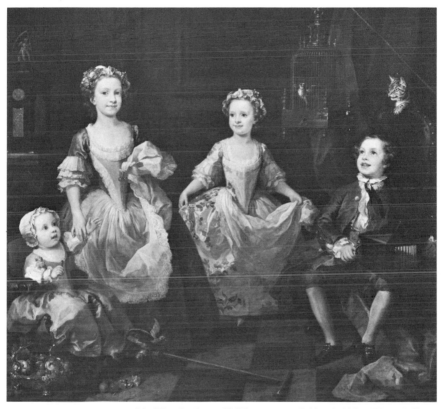

66. The Graham Children; 1742; 63¼ x 61¼ in. (Tate Gallery)

portant portrait resulted from the trip, he had in effect by this time returned to history painting. His portrait attempts thereafter are occasionally adventurous, but hardly designed to win the market. It would thus appear that, while Hogarth did his best and could be grouped with the portraitists who did well, he did not achieve the success he wished for, and this may have decided him to return to comic history painting in 1743.

Marriage à la Mode

In the *London Daily Post and General Advertiser* of 2 April 1743 appeared an advertisement:

> MR. HOGARTH intends to publish by Subscription, SIX PRINTS from Copper-Plates, engrav'd by the best Masters in Paris, after his own Paintings; representing a Variety of *Modern Occurrences* in *High-Life,* and call'd MARRIAGE A-LA-MODE.
>
> Particular care will be taken, that there may not be the least Objection to the Decency or Elegancy of the whole Work, and that none of the Characters represented shall be personal.
>
> The Subscription will be One Guinea, Half to be paid on Subscribing, and the other half on the Delivery of the Prints, which will be with all possible Speed, the Author being determin'd to engage in no other Work till this is compleated.
>
> N.B. The Price will be One Guinea and an Half, after the Subscription is over, and no *Copies* will be made of them.

When the advertisement next appeared, in the issue of 4 April, a parenthesis was added after "his own Paintings": "(the Heads for the better Preservation of the Characters and Expressions to be done by the Author;)." These notices were repeated in the *London Daily Post* and the *London Evening Post* off and on until the end of July.

As he grew older Hogarth put more of himself into his advertisements. The one for *Marriage à la Mode* is particularly revealing. In it he is careful to note that he is going to use French engravers, though he will do the heads himself, that there can be no objection to "the Decency or Elegancy of the whole Work," and that no particular contemporaries will be portrayed. Finally, he emphasizes that it will deal with "a Variety of modern Occurrences in High Life."

Apparently the ad was in part a reaction to the dearth of portrait commissions, or the inadequate revenue they brought in (as he himself claimed); but also Hogarth was in a sense answering the praise of his earlier works, and even the calls to return to prints, that appeared from time to time during the period of portrait painting.

On 10 June 1740, in the very middle of Hogarth's period of portrait painting, Henry Fielding devoted an essay in his periodical *The Champion* to the subject of satire, making two generalizations: the first (essentially that of Steele in his *Spectators* on history painting) is that "the force of example is infinitely stronger, as well as quicker,

than precept; for which Horace assigns this reason, that our eyes convey the idea more briskly to the understanding than our ears"; and second, "that we are much better and easier taught by the examples of what we are to shun, than by those which would instruct us what to pursue." The obvious instance of these two generalizations is "the ingenious Mr. Hogarth," whom Fieldings says he esteems.

Later in 1740, Samuel Richardson's *Pamela* appeared; in 1741 Fielding responded with his parody *Shamela*, and in 1742 at greater length with *Joseph Andrews*. In his preface Fielding defines the "comic epic in prose" he projects in terms of the extremes it avoids—of romance and burlesque, two different ways in which reality may be distorted, to glamorize and to vilify. He is, of course, reacting against *Pamela*, which he equates with the romances of *Jack the Giant Killer* and *Guy of Warwick;* but he is also steering clear of burlesques like his own early plays. By burlesque he means "the Exhibition of what is monstrous and unnatural."

> Now what *Caricatura* is in Painting, Burlesque is in Writing; and in the same manner the Comic Writer and Painter correlate to each other. And here I shall observe, that as in the former, the Painter seems to have the Advantage; so it is in the latter infinitely on the side of the Writer: for the *Monstrous* is much easier to paint than describe, and the *Ridiculous* to describe than paint. . . . He who should call the Ingenious *Hogarth* a Burlesque Painter [as Somerville had done], would, in my Opinion, do him very little Honour.

This is the only specific mention of Hogarth in the preface, but his presence hovers over the whole, and one senses that in other ways than "character" he offered Fielding the best model for what he intended in *Joseph Andrews*. By calling Hogarth's productions comic history painting, and his own, comic epic in prose, Fielding is trying, as Hogarth had done, to secure a place in the classical (and contemporary) hierarchy of genres higher than satire, the grotesque, or the comic would command. Hogarth never seems to have used the term "comic history painting" himself.

All the evidence points to the influence running from Hogarth to Fielding before 1742, and to Fielding's subsequent influence on Hogarth relating primarily to the verbalization of his theories. In 1726, before he even met Fielding, he had produced his polemical frontispiece to *Hudibras,* which sets forth his aesthetic intention in relation

to history painting (very similar to Fielding's in relation to the epic), and in 1731 he issued a second print to explain his intention in the *Harlot's Progress*. Only with *Characters and Caricaturas* (pl. 67) in 1743 did he adopt Fielding's terminology and begin to add commentary ("for a farther Explanation . . . See yᵉ Preface to johᵉ Andrews"), and by the time he engraved *The Bench* (1758) the commentary filled more space than the graphic design. Fielding's immediate effect on Hogarth was perhaps to galvanize him into producing another series to prove the claims made in the preface to *Joseph Andrews*, and certainly to make the particular subscription ticket dealing with caricature; in the long run, Fielding's influence may indeed have made Hogarth more self-conscious and defensive, more verbal and polemical than he had been before.

In the *Craftsman*, 1 January 1742/3, in a letter to Caleb D'Anvers, Fielding's contrast between caricature and character was distorted into one between caricature and the beautiful: "The *Outré*, or Extravagant, requires but a very little Portion of Genius to hit. Any Dauber, almost may make a shift to portray a *Saracen's* Head; but a Master, only, can express the delicate, dimpled Softness of Infancy, the opening Bloom of Beauty, or the happy Negligence of Graceful Gentility." This misunderstanding may have been the specific goad that led Hogarth to produce in the next month or so the etching *Characters and Caricaturas* (pl. 67) as subscription ticket for his new series. As noted in reference to *A Harlot's Progress*, caricature was part of his art only in the sense that he portrays people caricaturing themselves; faces in his modern histories may appear at the moments when they become caricatures. He was probably aware that "caricature" was applied to the work of any artist who ventured very far beyond the Raphael formulae.

His unease was increased by Arthur Pond's publication, since 1736, of caricature portraits in the Italian manner after Ghezzi; these had become very popular, drawing attention to the concept of caricature, one from which Hogarth was anxious to detach himself. The term and practice were Italian, from *caricare* (to charge or overcharge, i.e. with distinctive features; in French *charger*). Begun in the late sixteenth century by the Carracci brothers, caricature was implemented by the theoretical discussions of Agucchi (1646), Bellori (1671), and Baldinucci (1681), who defined it as the bringing to light of the victim's *faults*. If the idealism of history painting or heroic portraiture is one

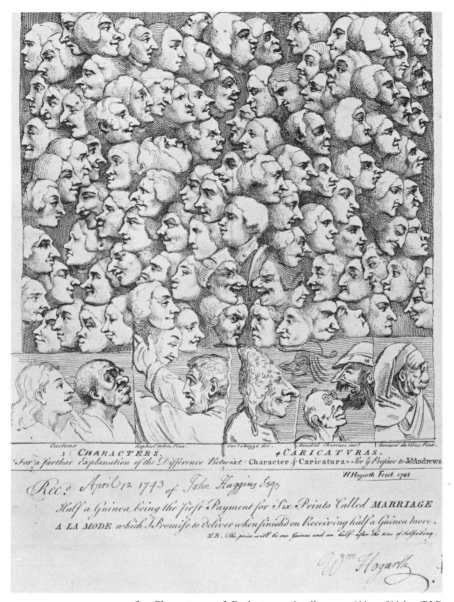

67. Characters and Caricaturas; April 1743; 7¹¹⁄₁₆ x 8⅛ in. (BM)

extreme that Hogarth tried to avoid, caricature is its equally perni-
cious opposite. With Pond's publications, and the sanction of the art
treatises, caricature appeared to Hogarth as a fashionable art form
brought over from the Continent, practiced by amateurs and pur-

chased by connoisseurs, which relied on distortion or reduction of the infinitely variable human face.

In *Characters and Caricaturas* he portrays idealized heads of St. John and St. Paul and puts between them what would ordinarily have been considered a grotesque head of a beggar: all three are from the Raphael Cartoons, his constant referent for defending his histories—the undeniable example of great history painting. With these, he contrasts caricatures by Ghezzi, the Carracci, and Leonardo. Above them rises a cloud of faces that express the variety of character—like Raphael's beggar rather than the caricatures *or* the idealized faces. His point is to demonstrate that comic history painting, while not filled with "the opening Bloom of Beauty, or the happy Negligence of Graceful Gentility," is in fact part of the great genre of history painting, and not descended from caricature.

A glance at the print would have shown a contemporary connoisseur that Hogarth was departing from the classic treatise on expression: Le Brun's *Traité sur les Passions* (1698, tr. 1701), which reproduced innumerable heads (engraved by Picart), each classified as to expression illustrative of a certain passion. But Hogarth's faces are particularized and given a large range of everyday expressions instead of standardized passions. The facial structure and the muscles play a much larger part than in Le Brun; and this points to Hogarth's source, his friend Dr. Parsons, the assistant secretary of the Royal Society, author of *Human Physiognomy Explained*. Parsons showed that the changes of expression following from passions were caused by the movements of muscles, and he illustrated this with a series of drawings of the same face with different passions (made by himself, engraved by S. Mynde). Hogarth goes much further than Parsons in the variety of his expressions, suggesting by the cloud of faces the infinite possibilities. The extremes of heroic and grotesque enter into Hogarth's comic history. Even in *Characters and Caricaturas* the various heads derive meaning only from the contrast with idealized and caricatured heads beneath. Hogarth always includes the heroic shape *and* the grotesque in order to help define the middle area of "character." In short, while Fielding defines an intermediate genre between romance and burlesque—the comic—and between extremes of goodness and evil—the ridiculous—Hogarth defines his intermediate genre between sublime history painting and burlesque, the idealized and the caricatured, called "character."

"Elegancy" and high life were evidently intended by Hogarth as the keynotes of the new series, announced in April. By the first of May he was on his way to Paris. It is strange that nothing is known about this trip, Hogarth's first visit to Paris and direct contact with continental art, save for its possible influence on his works. It seems likely that he had not finished, or more than begun, the paintings of *Marriage à la Mode* before he left for France; from the evidence of the finished paintings, he picked up a new lightness and fluency of touch, in the French manner. His primary purpose for visiting France, however, was to secure French engravers for his project. Whenever he had used engravers before—and one can only guess at the extent—he minimized (and perhaps even concealed) their share in the work. With *Marriage à la Mode*, with its Frenchified title and fashionable scenes, he advertised the fact and attached the engravers' French names to each print.

It was at this time, as *Marriage à la Mode* was being prepared for publication, that war broke out with France; early in 1744 an invasion was feared. Hogarth had apparently intended, and arranged, to send his paintings to Paris to be engraved—evidently he had only finally finished them to his satisfaction around the time the war began. The long advertisement he printed in the *Daily Advertiser* for 8 November 1744 tells the rest. It begins with a stopgap, an announcement of the republication of the *Harlot's Progress*—the public's first opportunity to obtain the original work since its publication twelve years before; also perhaps a preparation for the eventual auction of the paintings. It goes on to explain the delay in the appearance of his new series.

> Note, the six Prints, call'd *Marriage A-la-Mode,* are in great Forwardness, and will be ready (unless some unforeseen Accident should intervene) before Lady-Day next; Notice of which will be given in the Papers.
>
> In the Month of June 1743, the following French Masters, Mess. Baron, Ravenet, Scotin, Le Bas, Dupre, and Suberan, had entered in an Agreement with the Author, (who took a Journey to Paris for that sole Purpose) to engrave the above Work in their best Manner, each of them being to take one Plate for the Sake of Expedition; but the War with France breaking out soon after, it was judged neither safe nor proper on any Account, to trust the original Paintings out of England, much less to be engrav'd at Paris: And the three latter Gentle-

men not being able, on Account of their Families, to come over hither, the Author was necessitated to agree with the three former to finish the Work here, each undertaking two Plates.

The Author thinks it needless to make any other Apology for the Engravings being done in England, than this true State of the Case, none being so weak as to imagine these very Masters, (who stood in the first Rank of their Profession when at Paris) will perform worse here in London; but more probably on the contrary, as the Work will be carried on immediately under the Author's own Inspection. . . .

His advertisement, of a record length, did not go unnoticed. Orator Henley, always anxious to be topical and ridicule the ridiculous, published an advertisement for an oration on the subject, and Vertue noted both in his notebook.

In short, Hogarth seemed to be giving this ambitious series a great deal of fanfare. Joshua Reynolds, who was in London at this time, recalled that Hogarth had told him, "I shall very soon be able to gratify the world with such a sight as they have never seen equalled!" He evidently wished to think of himself as a painter rather than an engraver; and this explains his emphasis on the "French Masters" who were going to engrave his paintings, as well as the careful painting of the pictures, and the announcement that accompanied the last stages of the subscription that his paintings of this sort would soon be auctioned.

The paintings were made once again in reverse—which might mean that he had originally planned to engrave them himself; ordinarily a professional copy-engraver produced a direct image of the original, and must have been instructed in this case to reverse the series. The paintings themselves (pls. 68–73) can be explained as both an attempt to make a salable object, a finished picture, brilliant and elegant, which the connoisseur would want to buy; and a precise cartoon for the foreign engravers to work from. Hogarth must have worried over them too long, trying to make them a clear masterwork that would fulfill Fielding's claims for him once and for all. Behind them too may have been the feeling that he must meet the criticism that his paintings for the progresses were merely sketches or modelli. This is the first series that is so carefully and uniformly finished, the last of the *Beggar's Opera* paintings being the closest precedent. It is even possible that as the years passed, and his various attempts to sell the paintings failed, he continued to touch them up.

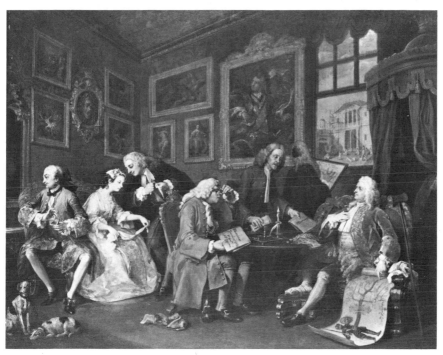

68. Marriage à la Mode (1); 1745; 27 x 35 in. each (National Gallery, London)

The title may have come from Dryden's old comedy, *Marriage à la Mode* (1672); its reprinting by Tonson in 1735 may have brought it to Hogarth's attention if he did not already know it. The comic subplot concerns a husband and wife whose "marriage à la mode" means that each supports the sentiment:

> Why should a foolish marriage vow
> Which long ago was made,
> Oblige us to each other now,
> When passion is decayed?

and takes a lover as remedy. Hogarth may also be indebted to another play, Garrick's *Lethe* (1740), in which Lord Chalkstone comments on marriages of convenience: "I married for a Fortune; she for a Title. When we both had got what we wanted, the sooner we parted the better." (Hogarth simply showed what would happen if they could not part, if they were compelled by social forms to remain together) The subject was conventional: (the *Spectator* argues long and loudly that marriage can be based only on love (e.g. No. 268), that disaster follows

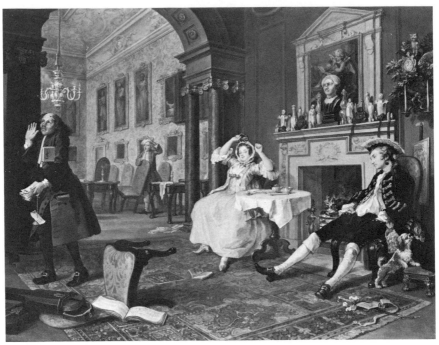

69. Marriage à la Mode (2)

upon marriages arranged by parents (Nos. 220, 533), and that marriages between a man of money without class and lady of quality without money will end in unhappiness)(No. 299). At the same time that Hogarth was painting his series Richardson was writing *Clarissa* and attacking the "property marriage," the economic pressures on young women, the "system" in which matrimony was a matter of money rather than affection, with overtones of chaining, martyrdom, and the perverting of nature.

(Hogarth conveyed these concrete images through the parallels between his characters and chained dogs and martyred saints in the pictures on their fathers' walls. He went even further, suggesting in Plates 3 and 5 a parallel between contracted marriages and prostitution. He has indeed borrowed and injected a part of the traditional Harlot's story from the popular Italian print cycles that he did not use in the *Harlot's Progress:* the rivalry of lovers for the harlot's favors, which leads to a fatal duel.

The bawd of the *Harlot's Progress* has now become the parent. But

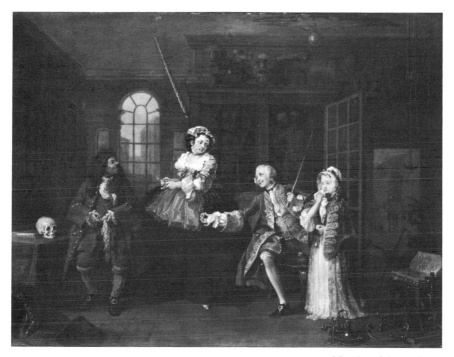

70. Marriage à la Mode (3)

in the earlier series the Harlot was faced with the alternatives of the parson and Mother Needham, and this involved choosing a way of life. In *Marriage à la Mode* the way of life is already fixed, the boy and girl have no choice as to the marriage. It is the merchant who aspires, not the daughter, who has already been taught the way of the world by her father. And the series is about both the married couple and the fathers, who hang like malign presences over the plates in which they do not appear: the earl as we learn of his death, which prevents his deriving much benefit from the marriage he has arranged, and as we see his line dying out in the last plate in the syphilis-tainted girl child; the merchant as we see him in the last plate pulling off his dying daughter's wedding ring before rigor mortis deprives him of this meager salvage from a disastrous match.

The advance over the earlier series is in the direction of complexity. This is the first progress in which Hogarth employs two protagonists, anticipating the even greater bifurcation in *Industry and Idleness,* where the two protagonists take different courses of action. Here they

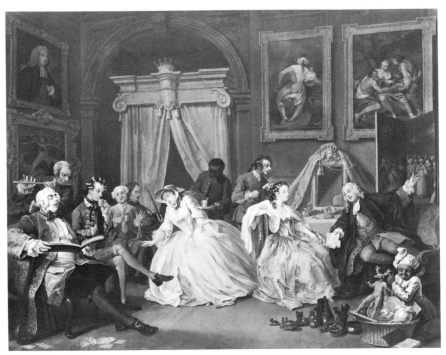

71. Marriage à la Mode (4)

still follow the same course, and causality remains all-important, the difference from the earlier series being the protagonists' relative lack of freedom of choice. The structure of the scenes is again a triangular arrangement of people: in 1, the earl, the merchant, and the usurer make one group, and the lawyer Silvertongue, the groom, and the bride another. The first pivots on the usurer, the second on the bride, suggesting a parallel in the relationships. In the last plate the bride has become the dying countess flanked by her baby and the merchant her father, who is removing from her finger the wedding ring she was playing with in Plate 1.

In Plate 2 the young married couple sit with the yawning fireplace between them—its empty mouth topped with meaningless bric-a-brac, suggesting the emptiness of their marriage and the absent third party (implied by the cap hanging from the young earl's pocket, sniffed at by an inquisitive dog). In Plate 3 the triangle is realized in the feeble-looking child who is the earl's mistress, the earl and the bawd and quack who cater to his sexual wants. This is paralleled in Plate 4 by

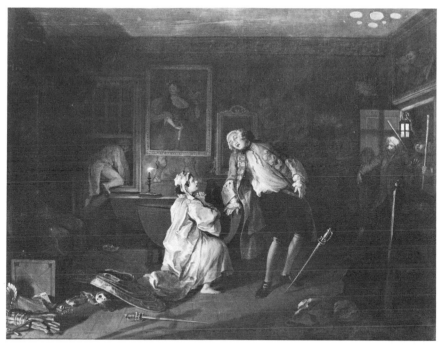

72. Marriage à la Mode (5)

the countess' lover, Silvertongue, the countess herself, and the denizens of her world—hairdressers, fashionable ladies, eunuch singers, and the like. Then in Plate 5, where the earl and countess are reunited, the countess is placed as in Plate 1, on one side of her the dying earl and on the other the fleeing lawyer, his murderer.

This fifth plate will serve as an epitome of the complexity Hogarth's method has reached in *Marriage à la Mode*. It is especially useful because it is also, in execution, the clumsiest of the six. The curiously awkward pose of the dying earl calls for explanation: it can only be an echo, and a conscious one, of a *Descent from the Cross*. As if to bring the point home, Hogarth has outlined a cross on the door—a shadow thrown by the constable's lantern, which is much too close to the door to cast such a shadow without recourse to poetic license. Hogarth must have taken the earl's pose straight from a painting, probably Flemish, seen in France on his 1743 tour, not even adjusting for the absence of the man supporting Christ's body under the arms. In paintings and blockprints of the *Crucifixion* and *Descent from the Cross*, the female

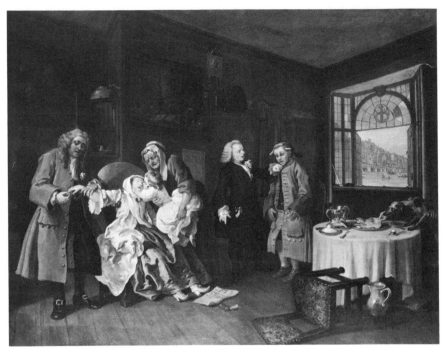

73. Marriage à la Mode (6)

figure who, like the countess, "stood near" Christ wringing her hands,
or spreading her arms wide, or kissing his feet, was Mary Magdalen;
while Mary the Mother was some distance away silently watching or
being supported by an apostle.

It is appropriate, of course, that in this context Hogarth produces a
Magdalen—a prostitute—mourning Christ, who died for her sins. The
traditional story of the Magdalen was actually rather close to that of
the countess: she was born of a good family, but after her marriage her
husband deserted her and she turned to a life of sin and was possessed
by seven devils.

Here we see at its most elaborate a characteristic which doubtless
contributed to the popularity of Hogarth's prints. This is a sense of
"to read" all Hogarth's own, which has much in common with the
writers of his time, the Augustan poets, and their use of allusion. At
one extreme Hogarth uses certain topical and historical prototypes, at
the other he alludes to pictorial images from the tradition of popular
or classical European art, and invites the reader to participate actively

in the experience of the picture. That contemporaries were aware of Hogarth's borrowing of motifs from the continental tradition may be deduced from Paul Sandby's *Burlesque sur le Burlesque* (1753, pl. 99), in which Hogarth is shown painting at his easel to which are attached "Old-prints from whence he steals Figures for his Design."

Plate 5 is also typical of *Marriage à la Mode* in that the rooms have become even more important than in the earlier series. Each one defines and comments on its owner, in fact dominates him, reflecting his entrapment in the rut that leads to disaster. The first shows the old earl's quarters with old masters he collects, pictures of cruelty and compulsion from which his present act of compulsion naturally follows, his portrait of himself as Jupiter *furens,* and his coronet stamped on everything he owns. Plate 2 shows the next generation's house, with its fashionable Kent decorations, its saints and curtained pornography, its disorder and emptiness. Then follows the empiric's room, with his mummies and nostrums; the countess' boudoir with her pictures of the *Loves of the Gods* and the bric-a-brac she bought at an auction, including Romano's erotic drawings and a statue of Actaeon in horns; the bagnio with its attempts at gentility in the tapestry and paintings; and the merchant's house with its vulgar Dutch genre pictures, meager cuisine, and worn furnishings. Here art has become an integral part of Hogarth's subject matter: it is here for itself, a comment on itself, and also on its owners and on the actions that go on before it. In no other series is the note so insistent: it permeates the *Harlot,* Plate 2, or the *Rake,* Plate 2, to a degree, but here it dominates every room, every plate. The old masters have come to represent the evil that is the subject of the series: not aspiration, but the constriction of old, dead customs and ideals embodied in bad art. Both biblical and classical, this art holds up seduction, rape, compulsion, torture, and murder as the ideal, and the fathers act accordingly and force these stereotypes on their children.

The trends toward art as theme and reader as active participant are further underlined by the importance placed on viewing. In Plate 1 the Medusa looks down in horror on the scene. In Plate 2 the steward turns away, and his disdainful face is repeated in the Roman bust on the mantel, even to the broken nose of the one and the pug nose of the other. In Plate 3 the skeleton whispers to a stuffed man that is its companion, in 4 Silvertongue himself looks helplessly down from his canvas on the way events are developing, in 5 St. Luke and the Shepherd-

ess watch. Only in Plate 6, when it is all over, are the pictures unconcerned—the Dutchman turns his back on the scene to relieve himself as the doctor walks away, having given up the case.

These trends began with the shift, noticeable in the prints of the late 1730s, from the protagonist as chooser to the reader as chooser; more complex reactions are expected of him as he pursues and tries to understand the meaning, the visual puns and allusions, and as he is linked with observers like Medusa and St. Luke within the scenes. Very similar is the elaborately contrived and underlined author–reader relationship in Fielding's novels of this decade.

At the first of the new year, 1745, the second impression of the *Harlot's Progress* was announced as published, and the *Marriage à la Mode* plates were "in great Forwardness, and will be ready to deliver to the Subscribers on or near Lady-Day next," i.e. 25 March. On 25 January Hogarth issued a set of proposals for an auction of his "comic history paintings" and distributed them among his friends and visitors to the Golden Head. In the *London Evening Post* for 31 January–2 February he began to advertise the auction. It seems likely that Fielding's preface to *Joseph Andrews* with its talk of "comic history painting," which emphasized the painting rather than the print, contributed to, if it did not inspire, the idea of the sale of the paintings from which the engravings were made.

The first set of proposals, dated 25 January (BM), begins:

Mr. HOGARTH's / PROPOSALS / For Selling, to the Highest Bidder, the Six Pictures call'd / The HARLOTS PROGRESS: / The Eight Pictures call'd / The RAKES PROGRESS: / The Four Pictures representing / MORNING, NOON, EVENING, and NIGHT: / AND / That of a Company of STROLING ACTRESSES Dressing in a Barn. / *All of them his Original Paintings, from which no other Copies than the Prints have ever been taken; in the following manner; viz.*

A BOOK will be open'd on the First Day of February next, and will be closed on the last Day of the same Month, at his House the *Golden-Head* in *Leicester-Fields;* in which, over the Name of each Picture, will be entered the Name of the Bidder, the Sums bid, and the Time when those Sums were so bid; so that it may evidently be seen at one View how much is at any time bid for any particular Picture; and whoever shall appear, at the time of closing the Book, to be the highest Bidder, shall, on Payment of the Sum bid, immediately receive the Picture.

N.B. The Six Pictures call'd *Marriage A-la-mode,* will be sold in the same manner, but the Book for that Purpose cannot be closed till about a Week after the Plates now Engraving from them are finish'd, of which public Notice will be given.

CONDITIONS of SALE.

I. That every Bidder shall have an entire Leaf, number'd, in the Book [of Sale,] on the Top of which will be entered his Name and Place of Abode, the Sum bid by him, the Time when, and for which Picture.

II. That on the last Day of Sale, a Clock (striking the Quarters) shall be placed in the Room, and, when it hath struck a Quarter after Ten, the first Picture mention'd in the Sale-Book will be deem'd as sold; the second Picture when the Clock hath struck the next Quarter after Ten; and so on, successively, till the whole Nineteen Pictures are sold.

III. That none advance less than Gold at each Bidding.

IV. No Person to bid, on the last Day, except those whose Names were before entred in the Book. . . .

His advertisement was repeated intermittently until the issue of 19–21 February when he announced the publication of revised proposals and first mentioned his subscription ticket, *The Battle of the Pictures.* There are a number of interesting changes. For one, he has now decided that he should offer the possibility of breaking up sets of pictures. The time of the sale was changed to 12 o'clock and to five-minute intervals in the new proposals.

The advertisement Vertue and Orator Henley had noted, the elaborate auction, and the subscription ticket—these public acts seem to have augmented certain private remarks like the one recorded by Reynolds, made at the St. Martin's Lane Academy and probably Slaughter's and elsewhere, and served not so much to support the idea of a new art form as to underline a kind of "gamecock" arrogance in Hogarth. At just this time Vertue wrote his first long and fairly passionate meditation on Hogarth as one whose success had gone to his head.

The auction took place at noon on the last day of February. One of those present was a young man named Horace Walpole, who had just returned to England from his grand tour in 1741. He went immediately into Parliament, and during the next few years he divided his time, until his father Sir Robert Walpole's death in March 1745, between Houghton Hall and a house in Arlington Street next to his

father's. In August 1743 he had completed his first work of art history, *Aedes Walpolianae,* a catalogue of Sir Robert's art collection at Houghton, and in the introduction he discusses the merits of the various schools of painting, ending with the characteristic sentence: "In short, in my opinion, all the qualities of a perfect Painter, never met but in RAPHAEL, GUIDO, and ANNIBAL CARACCI." It was this young man, already set up for life by sinecures his father had secured him, who attended Hogarth's auction and purchased the small portrait of Sarah Malcolm for five guineas. He may already have begun collecting Hogarth's prints; he gathered one of the first great Hogarth print collections. He did not let Hogarth in any way interfere with his admiration for Guido and Annibale Carracci: he was only interested in Hogarth's modern moral subjects, and the only paintings he collected were his small informal sketches like the *Malcolm.* He never asked Hogarth to paint his portrait, but in 1750 he commissioned him to go to the King's Bench Prison and paint King Theodore of Corsica, who was imprisoned there for debt. It is difficult to imagine them on any other than business terms, but Walpole claimed in later years to have been Hogarth's friend and is said to have arranged a notable meeting at his house of Hogarth and Thomas Gray. The drawing room of his house at No. 5 Arlington Street is supposed to have been the model for the room in Plate 2 of *Marriage à la Mode.*

William Beckford, another young man like Walpole with great parental funds and political ambitions, was the successful bidder for the *Rake's* and *Harlot's Progresses.* This does not mean that Hogarth's paintings were being bought by merchants or men of the City. Beckford was as yet neither. He had inherited large holdings in Jamaica sugar, but he was as much a gentleman-about-town (educated at Westminster, Oxford, and Leyden) as Horace Walpole. In two years he would take a seat in Parliament, for Shaftesbury, as a Tory supporter of the fourth Earl of Shaftesbury and the Prince of Wales. Beckford seems to have shown no further interest in Hogarth: he appears in no subscription lists, and did not even notify the artist that the *Rake's Progress* had survived the Fonthill fire in 1755 that destroyed the *Harlot.* He probably bought them as Walpole did, as Dutch genre subjects.

Most of the other buyers too were great landowners or, at the least, country gentry—the same people who bought pseudo-Correggios and Guidos and had their portraits done by fashionable foreigners or

their English equivalents (not by Hogarth). The Duke of Ancaster, who had connections with the Slaughter's circle, employing some of them to decorate his country seat Grimsthorpe, bought the paintings of *Noon* and *Evening* and also the one sublime history on sale, *Danaë* (added after the proposals of 11 February). Hogarth evidently also sold twenty-five heads from the Raphael Cartoons, either by Thornhill or by Hogarth and Thornhill; these too went to Beckford but, since the purchase does not appear on the receipt he made out to Hogarth, it may have involved a separate payment to Lady Thornhill.

Although Hogarth never sounded satisfied with the proceeds from this sale, it was a respectable amount, especially considering that the majority were sets and were not separated; and this sale probably represents the peak of his popularity as a painter of modern history. The *Harlot* and *Rake* brought him £273, *The Four Times of the Day* altogether £127 1s (*Morning* and *Night* went, for ten or so pounds less than their compeers, to the banker Sir William Heathcote), *Strolling Actresses* twenty-six guineas, *Danaë* sixty guineas, and *Sarah Malcolm* five. The total proceeds were nearly £500. These were not contemptible prices if one considers what Sir Robert Walpole, one of the foremost collectors of his time, paid for old masters in the years preceding Hogarth's sale. Michael Dahl's collection of Italian, French, and Dutch paintings, sold at Cock's 9–10 February 1743/4, just a year before Hogarth's sale, brought in only £700, partly because at the moment the market was low. Hogarth would appear to have been paid well in relation to the old masters; but of course, he would not be satisfied until his prices equaled theirs, an utterly chimeric ambition in those days.

The auction for the *Marriage à la Mode* paintings does not seem to have taken place. Could Hogarth, unhappy with the amounts he had received from the other pictures, have withdrawn this set? What happened is not known, but the set was not actually sold until another auction—described in grim detail by Vertue and others—was held five years later.

Meanwhile, Lady Day passed, and at the end of April Hogarth announced that the prints of *Marriage à la Mode* would be ready for subscribers on the last day of May; and at that time they presumably reached the subscribers.

4

From Morality to Aesthetics
1745—1754

LOOSE ENDS AND BEGINNINGS

In 1745 Hogarth was forty-eight years old. Having published *Marriage à la Mode* and sold his paintings, he commemorated the year by painting a self-portrait (pl. 74) which was not only to hang in his house (perhaps in his showroom) but, engraved (pl. 128), was to grace the bound sets of his prints; not only to convey a likeness but to project an emblematic image of the "comic history painter." His self-portrait is on an oval canvas resting on a pile of books, the works of Swift, Shakespeare, and Milton; these are flanked by his alter ego, the bluff, honest-faced pug, and his painter's palette. The painting is built up in Hogarth's usual way: he must have begun it as a simple self-portrait, then painted in the dog as an afterthought (some red of his smock shows through). His black waistcoat (under the red smock) was originally a white ruffle, and the fur cap was at first a bonnet of some sort. The dog and the other symbolic objects are placed with reversal and engraving in mind; one is to read up through the pug to Hogarth (both looking to the right), and then to the palette and the books. Even Hogarth's prominent scar is moved in the print so it will remain on the right side of his forehead.

Thus Hogarth gives us his own face, and the no-nonsense pug to explain it. In the art treatises, old masters were characterized by animals—Michelangelo by a dragon, Leonardo by a lion, Titian by an ox —and Hogarth draws mockingly on that tradition. The pug, who appeared as a kind of trademark in several of his works prior to the self-portrait, is also a satiric mask representing the artist's watchdog function and his moral toughness, reminiscent of Fielding's Captain Hercules Vinegar. Hogarth owned a pug named Pugg in 1730, and by 1740 he had replaced him with one called Trump, who was sculpted separately to accompany Roubiliac's bust of his master. Trump added

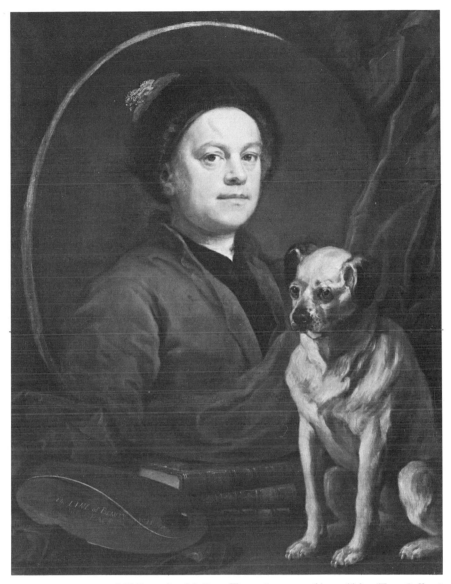

74. Self-Portrait with Pug (Trump); 1745; 35½ x 27½ in. (Tate Gallery)

a Hogarthian comment, and the self-portrait put the seal on Hogarth as Painter Pugg, as he was later called by his detractors.

By nature, he could not present himself as a Captain Coram or as a pretentious artist exalting himself via his palette, burin, and a few

paintings. But why give himself this peculiar ontological status? It is significant that he has isolated himself from his attributes, presenting himself as a lesser order of reality. The real man seems to be separated from the mask, the symbols, the aims of the moralist-artist. It is not certain when he engraved the painting. At the beginning of *The Analysis of Beauty*, explaining the origin of the Line of Beauty, he writes that he "published" the "frontispiece to my engraved works" in 1745; but an early state that has survived has 1749 penciled in, and in March 1748/9 Vertue took note of the painting as if it had just appeared.

The handling of the portrait itself is not that of *Marriage à la Mode* but of his best portraits: broad modeling, with the meaty fleshiness of the face so clearly defined in the final version of *Bishop Hoadly*, and in the background the neutral olive shade that frequently surrounds his faces. In a sense, if one regards *Marriage à la Mode*, important as it was, as an interlude, the self-portrait introduces the climactic phase of Hogarth's portrait painting. He was producing other, and perhaps superior, portraits at this time. The final version of *Bishop Hoadly* was completed around 1743, and the head of Elizabeth Salter (Tate) is dated 1744. It was in these years that he reached the most exalted of his clergyman sitters, Thomas Herring, Archbishop of York (soon to be of Canterbury). The portrait (pl. 75), like that of Mrs. Salter, is dated 1744, the period when Hogarth said he would be working on nothing else until *Marriage à la Mode* was finished; but perhaps he referred only to the *Marriage* paintings, his contribution to that project. Besides, he could hardly turn down a commission from the Archbishop of York. He exerted all his abilities on this portrait, or portraits (there may be more than one version), and may even have gone to York to do it. It was the first painting that allowed exploration of ideas he had acquired in France, especially the pastel work of Quentin de la Tour, which he admired and later recommended to Philip Yorke and perhaps to Allan Ramsay. An examination of the work shows that a thin overpainting was added after thick, vigorous underpainting—perhaps an indication that he returned from France and repainted in the light of his discoveries (the Tate *Hoadly* shows similar signs).

Another portrait group painted in the wake of *Marriage à la Mode* was *Captain Lord George Graham in His Cabin* (pl. 76), for the youngest son of the first Duke of Montrose. Graham was captain of the *Nottingham* and M.P. from Sterlingshire, the first of Hogarth's

Scottish portrait subjects that can be dated. The portrait group was probably commissioned to celebrate Graham's successful action off Ostend in June 1745. In command of the frigate *Bridgewater* (24 guns), he had pursued and attacked a squadron of French privateers with a convoy of valuable prizes. He was congratulated for this successful action by the Admiralty and appointed to command the large frigate *Nottingham* (60 guns). Hogarth's picture is far removed from

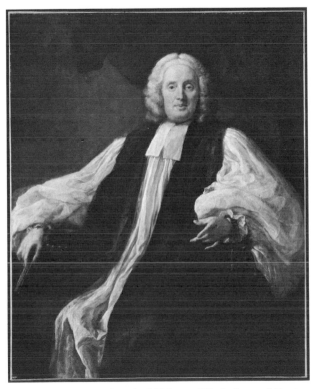

75. Thomas Herring, Archbishop of York (later of Canterbury); 1744; 49 x 40 in. (the Hon. Colin Tennant)

the heroism of the battle: it is probably set aboard his new command, which in the autumn of 1745 was in the Downs, and shows Graham smoking in his cabin before dinner. His chaplain and clerk are singing a catch to the music of a drum and fife played by his black servant. His dog and Hogarth's join in, one wearing his wig, with the music supported by a wine glass. The steward bringing in a roast duck upsets the gravy down the chaplain's back.

The handling of paint is reminiscent of *Marriage à la Mode,* though perhaps less spirited and free; but that is always the case in portrait groups like this one, when Hogarth had to worry about a third party between himself and the ordinary viewer. Each figure seems curiously unrelated to the others; the viewer's eye does not move naturally from one to the other as in *Marriage à la Mode,* but stops, hops, and begins anew each time.

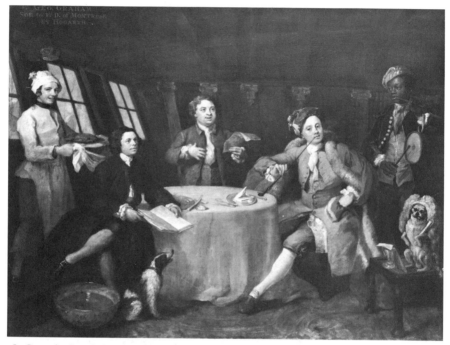

76. Captain Lord George Graham in His Cabin; 1745; 28 x 35 in. (National Maritime Museum, Greenwich)

Captain Lord George Graham in His Cabin shows what happens when the style and composition of *Marriage à la Mode* are transferred from an object of attack—the high life of the doomed earl and countess —to an object of commendation. The foolery and play of a "merry company" picture is necessary, and some sort of contrast, if only between this fun and the heroic battle, must remain. Not long after, Hogarth went one step further and began to paint a *Happy Marriage* to counterbalance the grim satiric picture of his recent cycle. As usual, he reacted to an outside stimulus.

In July 1745, not long after the appearance of *Marriage à la Mode,* a set of twelve plates by Joseph Highmore illustrating Samuel Richardson's novel *Pamela* was published. Highmore, who seems to have been a friend of Hogarth's, was a portraitist who also tried his hand at sublime history by painting a *Good Samaritan* ('Tate) that adapts forms and motifs from Hogarth's St. Bartholomew's Hospital paintings. Perhaps thinking to offer a purified version of Hogarth's comic histories, he produced paintings that were much happier in subject and simpler in composition, less crowded with incident, with less to read and little to distract the viewer from the form and colui. They were, in short, much closer to the compositions of a French contemporary like Chardin.

Hogarth almost certainly saw Highmore's paintings; but even if he did not, the prints alone offered him a competitor and an alternative version of reality to that depicted in *Marriage à la Mode.* The alternative was already, to some extent, offered by Richardson himself in *Pamela* (published in 1740); the novelist, another literary friend of Hogarth's, drew on his progresses. The scenes Pamela describes in her letters (and much more those described in the various letters of *Clarissa* [1748]) are very like Hogarth's plates: a striking innovation on the simple narrative flow of earlier English fiction, they are—more than any other scenes before Sterne's, certainly more than Fielding's—conceived and presented in visual terms. Richardson approached Hogarth to make illustrations for *Pamela* in 1740. Whether these were to be paintings or drawings is not known; but on 29 November Aaron Hill wrote to Richardson: "The designs you have taken for frontispieces seem to have been very judiciously chosen; upon pre-supposition that Mr. Hogarth is able (and if any-body is, it is he), to teach pictures to speak and to think." It does not emerge whether Hogarth refused to do them or whether the result did not satisfy Richardson. Another reference, by Hill, on 9 February 1740/1, shows that the illustrator (whoever he was at this time) was not succeeding. Not until the sixth edition, in 1742, did illustrations appear, engraved after designs of Gravelot and Hayman.

Highmore saw the possibilities in *Pamela* that apparently interested neither Hogarth nor Gravelot–Hayman: he made an independent series of paintings, intended for reproduction as engravings, which invited comparison with Hogarth's progresses, and specifically with his most recent series, *Marriage à la Mode.* These constituted the first

English attempt to base paintings on a contemporary novel. High-more's project was initiated in 1743/4, a year after *Marriage à la Mode*'s subscription had been announced. The *Daily Advertiser* of 18 February announced his proposal to publish by subscription "TWELVE PRINTS, by the best French Engravers, after his own Paintings, representing the most remarkable ADVENTURES of PAMELA: In which he has endeavour'd to comprehend her whole Story, as well as to preserve a Connection between the several Pictures, which follow each other as Parts successive and dependent, so as to complete the Subject."

The twelve plates, dated 1 July 1745, were delivered on 22 July. They were engraved by Antoine Benoist and Louis Truchy in a loose, careless style in imitation of Lépicié or engravings after Watteau. The product is much less interesting than the work Hogarth got out of his French engravers. But then there was much less detail, and the problem posed for the engraver was altogether different. The difference between Highmore's and Hogarth's typical scenes, and between the realism of Richardson and Hogarth (and Fielding), can be judged by comparing the first plate of the *Harlot's Progress* with Highmore's "Pamela preparing to leave the House of the Squire" (pl. 77). In Highmore's picture Pamela, having by this time lost any doubts she might have had as to the intentions of her employer, Mr. B., is preparing to leave his house and return home to her parents. Both Hogarth and Highmore present a pretty, innocent girl of the lower classes, and an aristocratic threat to her virtue. Highmore shows this and no more, and while Richardson's novel has, of course, a great deal more to offer than the titillating situation of a virgin's virtue threatened, this was the essential effect that established it as a best seller and created a whole genre of the interrupted seduction and the pursued maiden. It is interesting to note how much space is taken up by Pamela and the housekeeper in Highmore's print; in Hogarth's print relatively little space is given to the girl, who is almost lost among the threats that surround her.

Highmore's paintings and prints did, however, have their effect on Hogarth. Friends had probably been urging him to try a more positive line: people seem always to have been suggesting this or that subject to him, as far back as the suggestion of a "Statesman's Progress." The result was his "Happy Marriage" series. Although "happy" is the operative word, he may have conceived it also as a "Country Mar-

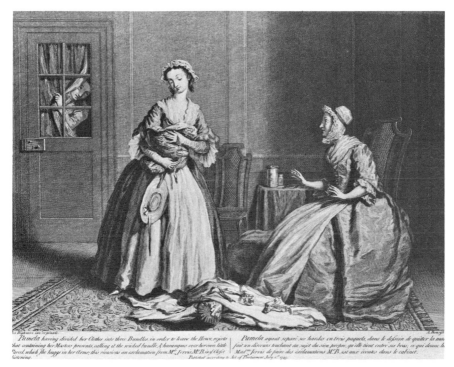

77. Joseph Highmore, Pamela having divided her clothes. . . . (engraving by A. Benoist); 1745 (BM)

riage" to contrast with his "City Marriage" in *Marriage à la Mode*, roughly like Bosse's contrasting series of those names. *Marriage à la Mode*, Plate 1, draws upon Bosse, and one might see this as parallel to *The Wedding Banquet* in the second series (pl. 78), where the father of the bridegroom passes the loving cup to the happy bride. But if the *Happy Marriage* began, as appears from Samuel Ireland's copies, with pictures of courtship and the marriage procession, there is no plate-for-plate parallelism. Moreover, if (as seems likely) the so-called *Stay-maker* (Tate) belongs to this series (it looks like the fitting of the bridal gown, and its size corresponds to the rest, as does the style of painting), there were seven paintings. Hogarth had probably not decided on an exact number or progression when he discontinued the project.

The interesting points about this group of paintings are the high quality of the painting and the lack of incident—it is easy to see why they were never engraved. Hogarth faced in the *Happy Marriage* the

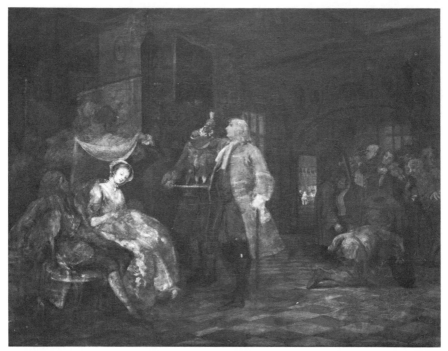

78. The Wedding Banquet; ca. 1745; 28 x 36 in. (Cornwall County Museum and Art Gallery, Truro)

same problem he faced in most of his portraits: there was no drama, in the first place, and in the second, due to inherent shortcomings in human nature there were no gestures and expressions, hardly even symbolic objects, with which to convey the emotions of joy and happiness. As he put it a few years later in *The Analysis of Beauty,* still thinking in terms of the character–caricature problem: "it is strange that nature hath afforded us so many lines and shapes to indicate the deficiencies and blemishes of the mind, while there are none at all that point out the perfections of it beyond the appearance of common sense and placidity"—which are not, of course, the makings of his sort of painting. And so, as with some of the portraits, he ended by performing exercises in pure painting and never finished the canvases.

If the degree of finish in the chandelier and open window of *The Country Dance* (pl. 79, one of the most brilliant of all Hogarth's paintings) had been maintained throughout, the final work would have matched the style of *Marriage à la Mode.* Some of the dancers are

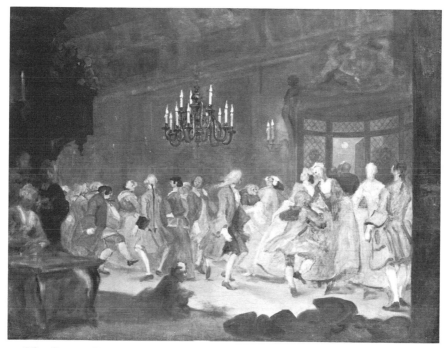

79. **The Country Dance**; ca. 1745; 27 x 35½ in. (South London Gallery, on loan to the Tate Gallery)

broadly indicated with reds, salmons, greens, and blues; other figures are very sketchily laid in with cool green and gray shades. The background still shows its olive ground and the general impression is of this color and ochers. The execution is splendidly free: I doubt if the painting would have been improved by additional polishing.

Another project of this year, along with the emblematic self-portrait, was the publication of commentaries on his engraved works. This took the form of Hogarth's stimulating and encouraging his friend Jean André Rouquet to put together an explanation of his prints in French for his continental purchasers. Possibly inspired by the bilingual explanations accompanying Highmore's *Pamela* prints, Hogarth was well aware of "the use such an Explanation in French might be to such abroad as purchased my prints and were unacquainted with our characters and manners"—a much more serious problem with his prints than Highmore's.

Rouquet, if one may believe the title page of his *State of the Arts in*

England (1755), was residing in England by 1725; he was certainly there by 1729. In the fall of that year, Vertue remarked of the enameler Zincke, then so well employed that he charged from ten to fifteen or twenty guineas for a small head, that "others have endeavourd to immitate and follow him close, particularly . . . Roquet Enameller has best succeeded, and now is much imployd." Rouquet's growing success may be partly attributed to the deaths of Richter and Lens and to Zincke's failing eyesight. He was also no doubt the unknown "Riquet" who is mentioned as doing the chinoiserie decoration for the central Chinese pavilion at Vauxhall. Born in Geneva around 1701, he spent much of his time in England, though occasionally returning to France. From the one surviving letter he wrote to Hogarth (of 1753), it is clear that he was a close friend and, evidently, a fervent admirer and disciple.

He published in April 1746 his pamphlet *Lettres de Monsieur * * à un de ses Amis à Paris, Pour lui expliquer les Estampes de Monsieur Hogarth*. Hogarth always included a copy of Rouquet's pamphlet with the sets of his prints he sent abroad. Around 1750 Rouquet added an explication of *The March to Finchley*, which was subsequently bound up with the earlier pamphlet.

Hogarth can have had little or nothing to do with the writing of Rouquet's pamphlet. If he had written it, he would probably have started with some generalizations about comic history painting, but Rouquet was writing to a French audience and, like the French interpreters of Fielding's novels, he felt that he must first explain Hogarth's concern with low life. Rouquet was apparently still in England in 1749, when Vertue says "News papers Journal—mentions the reputation & character of Mr Roquet Enameller. works." He must still have been there in early 1750 when he wrote the addendum on *The March to Finchley*, which describes the painting before the print was made. Perhaps he described the painting because he could not wait for the print.

An unauthorized poetic description of *Marriage à la Mode*, published in the *London Evening Post* February 1746, began with the problem of genre, concluding that "dramatic painter" was a more apt designation for Hogarth than history painter. Hogarth had himself drawn attention to this aspect of his art with his portrait—one of his most ambitious—of David Garrick as Richard III (pl. 80), the role that

made him famous in 1741 and reportedly introduced his new style of acting to London. This was a myth Hogarth helped to propagate by his painting, which was finished in the fall of 1745; shortly thereafter he gave it his seal of approval by engraving and publishing it (1746).

If in one way this new phase of Hogarth's career begins with the turn toward formalism and reduced complexity suggested by both the Line of Beauty and the *Happy Marriage* paintings, in another it begins with his sublime history portrait *Garrick as Richard III*. This

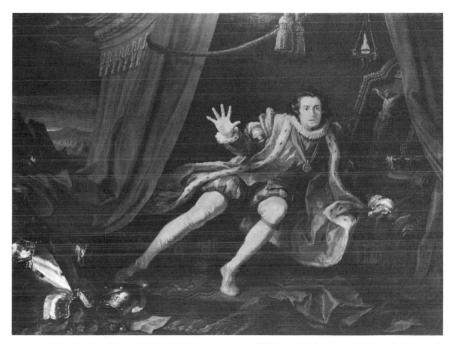

80. David Garrick as Richard III; 1745; 75 x 98½ in. (Walker Art Gallery, Liverpool)

painting commemorates a performance as important to Hogarth as *The Beggar's Opera* of twenty years before. That ushered in his comic history paintings; this opened a new phase in which he produced simpler, more unified and formalized histories in the sublime manner.

To see exactly what Garrick's acting was, and to what extent the parallel with Hogarth was apt, one must consider the historical situation of the theater. Acting, like history painting, goes through cycles: Betterton acted with restraint, using few gestures and never raising his arms above his waist, relying heavily (in the small theater of the time

with its apron stage) on facial expression. With the operatic effects of
the more grandiose theater of the 1720s, and with opera as a competi-
tor, the Wilks–Cibber–Booth school overacted and either spoke in ca-
dence or ranted, modulating from the declamatory monotone to the
vocal claptrap.

The counterreaction began with Charles Macklin, almost an exact
contemporary of Hogarth's (Garrick was twenty years, almost a gen-
eration, younger), a roistering actor who made his way through the
1720s and '30s trying to develop a new style that was in some sense a
return to Betterton. The first great triumph of Macklin's reaction
against the old bombastic style was his Shylock in February 1741.
Then just eight months later, as if to snatch the fruits of victory, an
unknown young actor, Garrick, made his indelible impression upon
London in *Richard III*. Acquaintance, perhaps insight, or more likely
the public's reception, enabled Hogarth to grasp that with this per-
formance Garrick did for the stage precisely what he was doing for
painting and Fielding for fiction—replacing heroic posing with rela-
tively naturalistic acting. The effect, indeed, paralleled that of the
realism practiced by Fielding and Hogarth: natural and restrained,
sometimes common and undignified.

Accounts of Garrick's acting indicate that facial expression accom-
plished as much for him as body movement or voice. After he took
over the management of Drury Lane in 1745 he cleared the spectators
off the stage and replaced the stage chandeliers with footlights, which
focused the light on the actor's face and expression. If Hogarth tended
to make his painting look like a play, Garrick made his play look like
a painting. The instant he entered the stage, he transformed himself
into Richard. Clearly he also illustrated the matter of "character," and
in the engraving that followed from the painting, Hogarth had the
work finished by Charles Grignion except for the face, which he did
by himself, designating this in the publication line. Later, Grignion
related that Hogarth attempted the face several times, each time with-
out satisfaction, rubbing it out until he finally got it right. Hogarth no
doubt had Garrick's encouragement for both painting and print; like
Reynolds, Garrick cultivated people of other professions, especially
artists and writers. Besides Hogarth, those who eventually painted
him included Reynolds, Gainsborough, Hayman, Dance, Cotes,
Hone, and Zoffany; also Angelica Kauffman, Batoni, and other con-
tinental artists; and he used their works to spread his fame. As time

went on he had enough money to patronize and collect pictures, and his house was full of portraits of himself.

He was different from Hogarth, perhaps a useful complement, in that he very quickly achieved a social position never approached by the artist; he possessed an ability to rise and pass in the society of Lord Burlington, the Marquis of Hartington, and others—not only because the eighteenth century was receptive to dramatic talent, but also because Garrick (his profession notwithstanding) was himself a gentleman, his father a captain in the army with entrée to the best military society, and his mother from a clerical family of Litchfield, with connections in the best ecclesiastical society. To some extent this set Garrick apart from Macklin and Hogarth, but it never seems to have caused friction between the actor and the painter, who remained friends—with occasional bouts of suspicion on Hogarth's part—until the end.

Fairly exact dating of the portrait is possible: Hogarth must have been busy with *Marriage à la Mode* and his auction until March or April. Garrick was acting at Drury Lane during this season, and it was at the end of the 1744–45 season that Lacy bought the Drury Lane patent and approached Garrick about sharing it. During part of the summer he was away from London, presumably with Peg Woffington. Sittings for the portrait were completed by the end of the summer. The criticism advanced by later writers that Hogarth's portrait did not resemble Garrick misses the point. In *The Beggar's Opera* Miss Fenton and Walker were clearly themselves, dressed as a maiden and a highwayman—an impression Hogarth does not want to convey in *Garrick as Richard III*. Garrick has indeed transformed himself; he has *become* Richard III.

The picture may be an entrée into a new attempt at sublime history painting: here, without sacrificing the salability of a portrait, Hogarth can show what he is capable of in a new, simplified history. Although he presumably shows the scene as Garrick staged it, with the properties he used, he takes his composition from Le Brun's *Tent of Darius*, well known as an engraving and perhaps seen by Hogarth in the original on his trip to Paris if he visited Versailles. The colors and textures, as in the portrait of Archbishop Herring, also show signs of the trip to France. But perhaps the most important evidence of this trip is the remarkable subordination of detail to broad design, so different from the equally large but crowded group in *The Pool of Bethesda*.

Hogarth shows Richard waking terrified from his dream of retribution, staring at the ghost, invisible between him and the viewer. There is only a slight suggestion of the old choice pattern in the cross on one side of him and his armor on the other; objects are held to a minimum. Everything that would have been important in the earlier paintings is subordinated to form and color and texture. The static, stylized, almost hieratic pose of Richard—surely an attitude uncharacteristic of Garrick—reveals almost nothing about the actor's style but does prefigure the kind of sublime history Hogarth was beginning to paint. It is also important to notice that while there were some Lines of Beauty in *Marriage à la Mode*, Garrick's whole posture is a serpentine line, emphasized by the long sweep of his robes and the curtain of his tent.

Hogarth presumably made the painting and then simply waited for a buyer; certainly he did not make it for Garrick, and it would seem a remarkable coincidence had it been commissioned just at that time. There is no record of an auction, or of any other disposal. Nevertheless, it was sold—perhaps at least partly through its subject matter—to a Mr. Duncombe of Duncombe Hall, Yorkshire, for £200, which, as Hogarth himself noted with pride, "was more than any portrait painter was ever known to receive for a portrait."

Art and Charity

The eighteenth century was the first great period of philanthropic activity in England, and its two most notable achievements were the charity schools and the hospital movement. The former developed before Hogarth's time, but he was exactly contemporary with the hospital movement. In 1700, aside from one or two special institutions like Bethlehem Hospital, there were only the Royal Hospitals of St. Bartholomew and St. Thomas; but between 1719 and 1750, the years of Hogarth's maturity, five new general hospitals were founded in London and nine in the country (by 1800 there were thirty-one). St. Bartholomew's and St. Thomas' were the links between the old and modern conceptions of a hospital—as a refuge for the poor and infirm and as a specialized institution for the care of the sick. Throughout this period the concern of the hospital was with the sick poor only.

One of the central facts of Hogarth's life is that he was connected in some way with almost all the great philanthropic and humanitarian projects of his time—from the Parliamentary Committee on prison re-

form of 1729 to the Foundling Hospital, from St. Bartholomew's Hospital to the London and the Bethlehem. One cannot dissociate this obvious interest and involvement from the theme that runs through his engraved works and, perhaps significantly, becomes stronger in the 1740s as the Foundling Hospital, his main charitable interest, developed into what has been called the most imposing single monument erected by eighteenth-century benevolence.

Behind the philanthropic movement as a whole were motives of a very mixed nature. They do not appreciably detract from the benefits produced, but because Hogarth himself was (to use Fielding's term) a "mixed character," they ought to be sketched in. Puritan ideas about the use to which money should be put were important in creating the basic assumptions, and also the Latitudinarian emphasis (operative in Hogarth's St. Bartholomew paintings) on charity and the ideal of benevolence, as opposed to the mere forms of worship. Both of these contributed to the ideal of sensibility and the enjoyment of the sympathetic emotions, which came into fashion as Hogarth matured in the 1720s. The humanitarian's instinctive response to the suffering of others was charity. A tendency of the Latitudinarian epistemology was to confuse the object with the subject, as though the fact of one's sympathy was as important as the problem that aroused it. But there was also an assumption of a common humanity which led people to protect even those who appeared most different from themselves. Such doctrines, whetted by daily contact with the reality itself, must have combined to make a powerful influence for amelioration if not reform.

The more practical aspect of the charity movement was influenced by the basic belief (deriving from the same Latitudinarian doctrines) in the natural goodness and perfectibility of man—the conviction that, given proper care and instruction, he would probably grow up to be virtuous. This, of course, corresponds to the assumption underlying Hogarth's progresses, that if the Harlot and Rake or the earl and countess had been allowed to develop naturally or been properly educated, they might not have come to such sad ends. And there were the strictly utilitarian motives: too many bastards murdered by their mothers lowered the population. The death rate was an issue about which contemporaries knew little but were uneasy. A foundling hospital not only preserved some of the working class populace but offered a scheme for putting these poor to work and teaching them a

craft and their proper place in society. Captain Coram saw his orphans as a source of supply for the navy, for crafts, and for the colonies.

The hospital movement in particular followed from a mixture of complex motives—social and scientific as well as humanitarian. Hogarth himself, from what is known of his activities at St. Bartholomew's Hospital in the 1730s, was clinically as well as charitably interested in what he saw there. In Hogarth, as in many philanthropists of the time, the humanitarian motive was almost always supported by an awareness of how the situation could be exploited for his own purposes—aesthetic and perhaps also commercial. St. Bartholomew's offered him scope for a particular kind of history painting and also a dignified place for permanent public exhibition of those works— something enjoyed by no other contemporary English artist.

The hospital that seems to have permanently interested Hogarth was the Foundling: here he donated and worked and attended meetings relatively frequently for at least five years before the idea occurred to him (or the opportunity arose) to turn the hospital into an art gallery. By no stretch of the imagination could one say that his original association with the Foundling was based on personal interest, except in the general sense that being a governor was a sign of status for him as an artist. His friendship with Coram would probably have led to a portrait of the founder in any case. He may have assisted Coram in various ways in his long campaign for support for the hospital before the charter was won. Both were childless men and perhaps they had some of the sensitive feeling for children that childless men are apt to have. The sight of babies left by the roadside, dead and alive, and in one case of a mother in the act of deserting her child, led Coram, the successful seaman and trader, to retire and start agitating for a foundling hospital.

Hogarth, a founding governor, was at the meeting for incorporation on 17 October 1739, and again at the first meeting at Somerset House, 20 November, when the Royal Charter was received; in May 1740 he presented to the hospital his monumental portrait of Captain Coram. At the same meeting that accepted his portrait of Coram it was voted that sixty children be taken in as soon as possible. After a search for a site, the governors secured a lease in December 1740 on a house in Hatton Garden, where the hospital was temporarily located until a permanent building could be planned and built. In January 1740/1 a "Daily Committee," drawn from the governors, was set up to handle

the day-to-day affairs inside the hospital. By March a staff had been engaged, and the twenty-fifth was set for the opening.

On the opening day, around seven in the evening, the committee met and prepared to receive the children. The Minute Book describes the scene with great vividness. A great crowd assembled long before eight o'clock, the time of opening. The committee, "resolved to give no Preference to any person whatsoever," was attended by the peace officers of the parish, and two watchmen were ordered to assist the watchman of the hospital:

> About Twelve o'Clock, the House being full the Porter was Order'd to give Notice of it to the Crowd who were without, who thereupon being a little troublesom One of the Gov^rs went out, and told them that as many Children were already taken in as Cou'd be made Room for in the House and that Notice shoud be given by a publick Advertisement as soon as any more Could possibly be admitted, . . .

> On this Occasion the Expressions of Grief of the Women whose Children could not be admitted were Scarcely more observable than those of some of the Women who parted with their Children. So that a more moving Scene can't well be imagined. . . .

Thirty were admitted that night. Hogarth did not attend the next day, nor even Coram. No children had been left on the parish, however, as had been feared, and already, on this first day "many Charitable Persons of Fassion visited the Hospital, and whatever Share Curiosity might have in inducing any of them to Come, none went away without shewing most Sensible Marks of Compassion for the helpless objects of this Charity and few (if any) without contributing something for their Relief." Hogarth was back on duty the next day, the twenty-seventh:

> We found that in the night a Child (N° 14) dyed it is imagined to have dyed of an Inflamation in the Bowells we imagine this to be one of the Children who we observed Stupify'd with Opiates and after it came to itself never left complaining. We found two other's Ill one wanting the assistance of a Surgeon from some Hurt on its arm. M^r Sainthill was sent for and Cap^t Coram was desir'd to ask D^r Mead to visit the Hospital this afternoon to direct what was proper for the Safety of the Sick Children.

In that first year, instead of the intended 60, 136 infants were admitted; of these 56 died, but the survival rate was still well above

that of other poor children, and many of those left at the Foundling were already nearly dead when delivered.

At the meeting of governors on 1 April Hogarth was present and "delivered in Mr Drummond's Receipt for Twenty one Pounds paid the 28th of the last Month being his Benefaction to this Hospital, And was pleased to give the Corporation the Gold frame in which Mr Coram's Picture is put." He participated freely, giving generously of art, time, and money, but never appeared on any committee. The meetings, it should be noted, were deadly dull, and very few of the governors attended them. In 1742 Hogarth missed even the annual meeting, which was well attended; there is no record of further money subscribed. He attended the annual meeting in 1743, but missed it again in 1744. It is possible that Hogarth simply devoted himself to other matters during this period—it was a busy time for him, as he was painting *Marriage à la Mode*. But, significantly, Coram's severance from the Foundling, which was primarily his creation, took place around the time Hogarth's interest seems to have temporarily flagged, and the last committee Coram attended was on 5 May 1742. His last years were spent in lodgings in the south side of Leicester Fields, and he and Hogarth must have seen a good deal of each other, with the Foundling and its mismanagement a principal topic of conversation. The problems of admittance were certainly great. The applicants increased until by October 1742 often a hundred women arrived with babies when there was room for ten boys and ten girls. The result was unruly scenes—women fighting and scrambling to be first at the doors, the ensuing disorder bringing discredit to the hospital.

The next meeting attended by Hogarth was on 26 December 1744, and he was clearly there for a purpose: at this meeting Taylor White, the treasurer, proposed among other names for governors that of Michael Rysbrack (living "near Oxford Chapel"). Hogarth may have wished to be there to support White's proposal, even perhaps to suggest it; however, he was absent the following meeting when Rysbrack was duly elected. But Rysbrack was necessary as his confederate in the scheme for advancing the cause of the English artists, which must have been at this time maturing in his mind.

Behind Hogarth's plan was doubtless the idea of the new building, designed by Theodore Jacobsen (whose portrait he painted) and at this time in process of construction. The land had been purchased in 1740, and the west wing was finished in October 1745 and the Hatton

Garden premises abandoned; the first meeting in the new building was held on the second. Here was a new and empty building waiting to be appropriately decorated. Hogarth was absent from all of these meetings, and exactly how negotiations took place is unknown. A reliable source, Hogarth's friend Rouquet, states that the artists volunteered to decorate the building only after the governors had refused to apply any of the charitable contributions to this use.

All the sources give Hogarth credit for the initiative, which followed from his idea of donating the portrait of Coram and his earlier work for St. Bartholomew's. An exhibition was the traditional recourse for the artist who wished to circumvent hostile or prejudiced critics and connoisseurs and appeal to a wider public, as established by Velasquez in 1650. The English artists' motive, of course, was more general: to prove they were as good as the foreign artists in whose favor the critics and connoisseurs were prejudiced. Here they could paint and exhibit the kind of work they would *like* to be commissioned to paint rather than turning out the usual run of what was expected of them.

Rysbrack was essential to Hogarth's plan. Horace Walpole's high estimate of Rysbrack reflects contemporary taste, and by bringing him into the Foundling Hogarth was allying himself with the leading sculptor and one of the most famous artists in Britain. It should be noted that Rysbrack, though a foreigner, was (unlike Kneller, Handel, and Roubiliac) able to speak and write fluent English; that, although a Burlingtonian classicist, he did not overgeneralize his portrait busts. Records show that a relief by Rysbrack to go over the fireplace in the new Court Room was received in 1745; this was probably only the design, and the relief itself may not have been in position until 1746. The offer of a marble relief to go over the fireplace would have served to broach the subject, and Hogarth must have suggested at the same time, or shortly after (though no record of it appears in the Minute Books) that contemporary English painters decorate the rest of the room.

The official announcement of the donations was not made until the quarterly meeting of governors of 31 December 1746 (by which time most of the works were nearly finished):

The Treasurer also acquainted this General Meeting, That the following Gentlemen Artists had severally presented and agreed to pre-

sent Performances in their different Professions for Ornamenting this
Hospital vizt Mr Francis Hayman, Mr James Wills, Mr Joseph High-
more, Mr Thomas Hudson, Mr Allen Ramsay, Mr George Lambert,
Mr Samuel Scott, Mr Peter Monamy, Mr Richard Wilson, Mr Samuel
Whale, Mr Edward Hately, Mr Thomas Carter, Mr George Moser, Mr
Robert Taylor and Mr John Pine. Whereupon this General Meeting
elected by Ballot the said Mr Francis Hayman, . . . [etc.] Governors &
Guardians of this Hospital.

 Resolved

That the said Artists and Mr Hogarth, Mr Zinke, Mr Rysbrach and
Mr Jacobsen or any three or more of them be a Committee to meet
Annually on the 5th of November to consider of what further Orna-
ments may be added to this Hospital without any expence to the
Charity.

Brownlow, the first historian of the Foundling Hospital, thinks that
Hogarth's plan originated in "a conjoint agreement, between Hay-
man, Highmore, Wills, and himself, that they should each fill up one
wall of the Court Room with pictures uniform in size, and of suitable
subjects taken from Scripture." Next came the plan for adding small
landscapes by Wilson, Gainsborough, and others.

 Hogarth's first thought for a history painting appears to have been
The Angel of Mercy: a mother about to strangle her offspring is pre-
vented by the interposition of an angel, who points to the Foundling
Hospital as a sanctuary, while an evil spirit, who has tempted the
mother to murder, steals away. The subject he eventually chose, how-
ever, was an obvious one: "the affair Mentioned in the 2nd of Exodus
of Pharaoh's daughter and her Maids finding Moses in the ark of Bul-
rushes."

 But while Hayman, the Vauxhall artist, chose for his painting Phar-
aoh's daughter and her maids on an outing along the Nile discovering
the babe in the bulrushes (pl. 81), Hogarth as characteristically por-
trayed the moment in the story when the child Moses was poised be-
tween his nurse (his real mother, whose skirt he holds onto) and
Pharaoh's daughter, producing another "choice" picture (pl. 82). Seen
in relation to the social setting of the hospital, Moses is choosing be-
tween Virtue, a hard but honest life with his true mother, and the
languid reclining Pleasure, the easy life of the court. Lurking within
a simple, very classically conceived history is a blunt statement about
the social function of the Foundling Hospital and an admonition to
its charges.

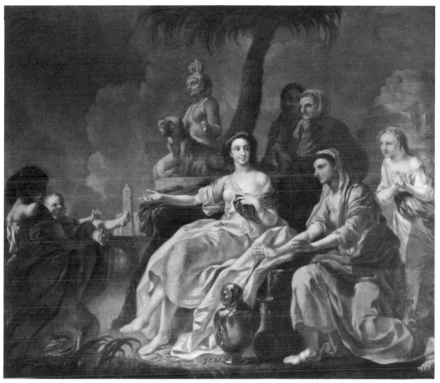

81. Francis Hayman, The Finding of Moses; 1746 (The Thomas Coram Foundation for Children)

As a painting, however, *Moses* followed close on the heels of *Garrick as Richard III*. Hogarth had finished that heroic portrait by the fall of 1745, and he probably began *Moses* not long after. Although Hogarth is telling a story of choice, the visual pattern does not correspond with complete faithfulness to the psychological: Pharaoh's daughter, who makes a languid Line of Beauty rather like Garrick, dominates the picture instead of Moses. She appears to be formally decorative rather than functional. Indeed the picture's chief interest lies in the beauty of its formal and color relationships. The colors are jewel-like, recalling Poussin (as, in a general way, does the composition): Pharaoh's daughter wears a salmon skirt-robe with the upper part a yellowish white; Moses, with golden hair, is in a greenish tunic, and his mother is in blue. Against emphatic form, psychological touches like the negress whispering the secret of Moses' parentage to an astonished friend seem intrusive. The curious dominance of Phar-

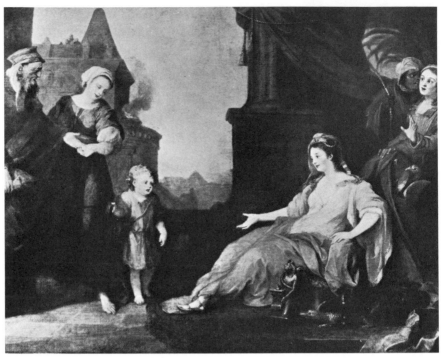

82. Moses Brought to Pharaoh's Daughter; 1746; 70 x 84 in. (Coram Foundation)

aoh's daughter then requires some explanation; at least two later com-
mentators, Tobias Smollett and Joseph Warton, were to be disturbed
by this picture and *Paul before Felix*.

The four histories hang now where they did then, Hogarth's facing
Highmore's across the length of the room: Hogarth's is the one first
seen as you enter. The pictures by Hayman and Wills, flanking the
fireplace, are on the wall facing the windows. They are all in identical
frames. Highmore's *Hagar and Ishmael* (Coram Foundation) is the
simplest, with only three figures, forming a triangle: the announcing
angel at top, Hagar at right, and Ishmael asleep at the left bottom. It
is a very competent picture, although the angel appears to be perched
on a rock. Hayman's seven figures, Pharaoh's daughter with her maids
and the babe in the bulrushes (pl. 81), are elegantly arranged, but
they have the Hayman bulging eyes and bottle noses. The fourth
painting, Wills' *Suffer the Little Children* (Coram Foundation), is a
dreadful, soft, and sentimental composition in the Pellegrini tradition
of Venetian history with innumerable figures (or so it seems). None of

the pictures except Hogarth's reflects the place in which it hangs or a sense of social consciousness; and in Hogarth's it is a strangely muted consciousness, contradicted by the colors and forms in which it is expressed.

The paintings by Highmore, Hogarth, and Wills were finished and hung by February 1746/7, as were evidently some of the landscapes. Hayman's was not yet finished. Ramsay's portrait of Dr. Mead and Hudson's of Jacobsen also went up around this time. At last, on April Fool's Day, the whole was unveiled. The meeting was at twelve noon, the dinner at 2 P.M.; a hundred tickets were printed for friends.

Hogarth had once again created for himself and his fellow artists an occasion for history painting, and a place to demonstrate their abilities, such as they were. Within ten years the collection, by this time including work by Reynolds, Gainsborough, Richard Wilson, and almost every noted English artist of the time, drew crowds of spectators and a morning visit to the Foundling became fashionable during the reign of George II.

After that first exhibition in the spring of 1747, the Foundling artists, consisting mostly but not altogether of the St. Martin's Lane Academy group, met annually on 5 November to consider what further ornaments might be added to the building. Every year they dined there at their own expense, on the day commemorating the landing of William III, toasting liberty as the parent of the fine arts out of a blue and white china punchbowl that was preserved into the nineteenth century. The artists' committee expanded over the years to include most of the artists of the day and their patrons, and the Foundling served as the first permanent art gallery for the English public; it still offers an illuminating cross section of all the developing styles of the 1740s and '50s. In addition, it laid the groundwork for the organization of the artists and the annual exhibitions that began a decade later, with many of the same artists involved. This corporate sense Hogarth imparted to the group, however, was to prove the starting point of his own alienation from the artistic society of his time. But then Hogarth was always a puzzling mixture of the organizer and the individualist.

A few commissions were reaped from the Foundling donations. Hogarth himself received a commission he cannot have denigrated, for an amount as large as he had received for *Garrick as Richard III,* but once again from a public institution. As Vertue, a good weathercock,

observed of the Foundling paintings, it was generally agreed that Hogarth's work gave "most strikeing satisfaction." Not long after, Hogarth was approached by representatives of the Society of Lincoln's Inn and asked to submit a design for a history to go at the west end of the chapel.

There is no telling what size the Lincoln's Inn Benchers specified. Vertue noted, after it was finished, that "this large peece was done for to be placed in Lincolnns Inn chappel but there being no propper room for it is placed in Lincolnns Inn hall over the Seat where the Lord chancellor sitts"; 14 feet wide by 10 feet 7 inches high, the painting is on a scale that dwarfs the Foundling painting and constitutes a return to the monumentality of the St. Bartholomew's staircase.

The selection of the subject was undoubtedly based primarily on the appropriateness of St. Paul's plea before Felix, and secondly on the opportunity it provided to create a work directly comparable to Raphael's St. Paul Cartoons. In June 1748 Hogarth, having finished the painting in his studio, moved it to Lincoln's Inn, where it became apparent that it would not fit, or show off well, in the chapel. It was at any rate placed on display for the Benchers. Hogarth, "solicitous to learn if it met the approbation of the Benchers, waited on them for that purpose, when he was invited to dine with them,—a favour seldom conferred but on legal or ecclesiastical characters, and generally members of the Society." On 28 June Hogarth wrote to John Wood, at this time treasurer, and included a sketch of the frame he proposed for his picture. The Council met the next day, 29 June, and "Ordered that the £200 left by my Lord Wyndham be paid to Mr Hogarth," and the money was in Hogarth's hands by 8 July.

One final extension of Hogarth's reputation as a history painter and decorator of public buildings should be mentioned. On 27 February 1750/1 Dr. John Monro, of Bethlehem Hospital, a watercolorist in his own right, and Moses Mendez, who had just been elected a governor, were desired by the Court of Governors "to Ask Mr Hogarth what Painting he thinks wou'd be proper for the Altar in the Chappel of this Hospital and to Report to the next Court." No sketch or painting that can be connected with the enterprise has survived, or any record of what was hung in the hospital chapel. It would appear, however, that he did do something, for at the meeting of 26 February 1752 he was elected a governor.

The roll call of other hospitals with which Hogarth was in some

way connected should include at least the London, for which he de-
signed a headpiece for subscriptions around 1740. His most enduring
relationship was, however, with the Foundling—a relationship that
seems to have gone beyond painting to a real social awareness, espe-
cially as concerned children. There is no way of knowing all that he
did, but where records have been kept his name tends to appear. As a
result of the high mortality rate among infants at the hospital, the
committee decided to board children up to three years old with foster
mothers in the country. These were essentially wet nurses, and at five
years (at four after 1755) the children were readmitted to the hospital.
Hogarth was one of the inspectors appointed to select and superintend
the nurses in the district.

It is not certain when Hogarth began this job, but when the Book
of Inspections first records Chiswick in 1756 he was the inspector;
Jane Hogarth was added as a separate supervisor, and Anne Hogarth
signed at least one account. The survival rate of babies in the country
was not much better than in the city, but it seemed to improve. Out
of five children in 1756, only one lived to be returned to the hospital
in 1761; the others died within one or two years. All the children
taken in 1757 died, but two of the three taken in 1758 lived, being re-
turned in 1765 after Hogarth's death.

A final glimpse of Jane Hogarth, and of her husband's hospital
work, comes through her reply to Mr. Collingwood (in the Foundling
records), who had decided that the children who remained under her
supervision after Hogarth's death should be sent back to a branch of
the Foundling. She answered on 28 June 1765: "imagining that if the
Children which are under my inspection was Brought to the House
when the Year was expired which is but a few months to come; it
would be but a triffling Expence to the House; but perhaps a Material
Difference to the Children as they would enjoy the Benefit of a Run
in the Country for the Summer Season, which in all probability would
quite establish their Healths." This presumably expresses the attitude
of both husband and wife toward the Foundling children, and tells
something about Hogarth's long service to the foundation Captain
Coram had begun.

The Popular Prints

If Hogarth's interest in the London hospitals and charitable foun-
dations led to his idea to decorate public buildings and exhibit con-

temporary works by English artists, it also revealed a growing social awareness. At the same time he was painting his most successful sublime history paintings, between 1746 and '48, he also conceived and executed the first of a series of popular prints that sought to remedy social abuses. The sublime histories themselves were, indirectly, comments on contemporary social injustice—the lure of luxury for the poor and the plight of the innocent before a corrupt judge. As so often in Hogarth's career, apparent gaps between phases conceal underlying continuities.

Watching him move from the progress of an earl and countess to that of two apprentices, however, one cannot escape feeling that he had been in some sense disappointed with the response to his most ambitious attempt at "comic history painting," consciously designed for the connoisseurs and upper classes. At this point he abandoned the painted modello completely for a drawing, and turned from a description of high life, in which "Particular Care" was taken, "that there may not be the least Objection to the Decency or Elegancy of the whole Work," to the lower classes. In form and subject matter, both "objectionable," he was proclaiming either that (as no one had ever denied) he could portray the lowest as well as the highest, or, much more likely, that he had given up the connoisseurs in favor of his true audience and was producing a more honest and useful art.

One cannot say, however, that Hogarth abandoned other sorts of work and devoted himself to the lower classes. Rather he simply turned one eye in that direction, adding another kind of work (and another source of income) to his repertoire. Financially, he wanted (as Vertue suggests) to save money on engravers and reach the large public that could afford only cheap copies of his other prints. Aesthetically, he sought a new source of inspiration, and in the process broadened his conception of modern history painting. Morally, he probably intended to correct some of the abuses he observed through his connection with the hospitals, and that Fielding, the Bow Street magistrate, was to analyze at length four years later.

Hogarth's first print after *Marriage à la Mode* and *Garrick as Richard III* was the full-length portrait of Simon Lord Lovat, one of the wiliest and most newsworthy of the rebels of the '45, a living symbol of duplicity. Lovat had been apprehended by the British Navy, searching the western coast of Scotland, as he hid in a hollow tree (or, according to another account, in a cave) on an island in Loch Morar where, thinking he had the only boat, he felt safe. Brought south, he

reached St. Albans on about 12 August and rested there at the White Hart Inn for two or three days under the care of Dr. Webster, who seemed to think his patient's illness was more feigned than real. In fact, Lovat was an old man of seventy and in very poor health.

Hogarth had spent part of July with Garrick at the Hoadlys' in the south of England, but he was back in London by the end of the month. Dr. Webster told Samuel Ireland that he had invited Hogarth to come up and meet Lovat during his layover; there would be no further chance once Lovat was in the Tower. Webster was apparently another case of a Hogarth admirer who invited him to portray some particularly Hogarthian figure—analogous to the frequent invocations of Hogarth by novelists introducing a striking character.

The portrait, probably a pencil sketch, was made as Lovat talked. Hogarth returned to London and made a simple etching (pl. 83), one of his most accomplished works, and published it on 25 August: Lovat had reached the Tower on the fifteenth, Lords Kilmarnock and Balmerino and others had been executed and other indictments lodged on the eighteenth, and more rebels arrived in London on the twentieth, with three more rebel officers executed two days later. The moment was opportune, and although the presses worked through the night for a whole week, not enough impressions could be made to meet the demand. For several weeks thereafter the etchings were said to have brought Hogarth £12 a day; and the story circulated (said of other works as well) that when the plate was finished he was offered its weight in gold by a rival printseller. At a shilling a sheet, many of which must have been sold wholesale to other print dealers, he would have sold something like 10,000 impressions and earned upward of £300.

Perhaps the financial success of a shilling print, quickly etched and yet supporting some thousands of impressions, convinced Hogarth that he should undertake more of the same. Deep and repeated biting produced lines strong enough to approximate the durability of an engraving, with much less time expended and no assistance needed. Nonetheless, the next few months were devoted to the painting of *Moses Brought to Pharaoh's Daughter,* and at the same time he must have been mulling over the twelve designs of *Industry and Idleness,* making the many drawings that have survived for that series, and beginning to etch some of them (pls. 84–91). He was not planning too far ahead: there was no subscription for this series, and of course, considering the audience intended, there could not be.

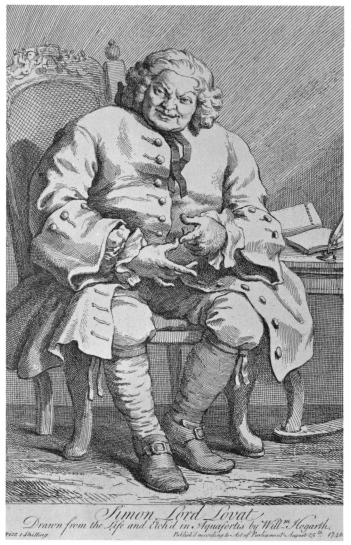

83. Simon Lord Lovat (caption omitted); Aug. 1746; 13³⁄₁₆ x 8⅞ in.
(W. S. Lewis)

Industry and Idleness was announced on 15–17 October:

This Day is publish'd, Price 12s.
Design'd and engrav'd by Mr. HOGARTH,
TWELVE Prints, call'd INDUSTRY and IDLENESS: Shewing the
Advantages attending the former, and the miserable Effects of the
latter, in the different Fortunes of two APPRENTICES.

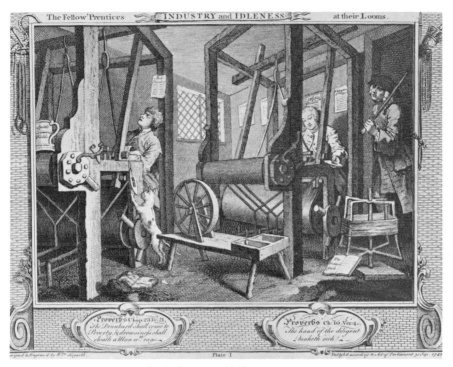

The Fellow 'Prentices ~ INDUSTRY and IDLENESS ~ at their Looms.

Proverbs Chap. 23 V. 21.
The Drunkard shall come to
Poverty, & drowsiness shall
cloath a Man w.th rags.

Proverbs Ch: 10. Ver. 4.
The hand of the diligent
maketh rich.

Plate I

84. Industry and Idleness (1); Oct. 1747; 10⅜6 x 13⅜ in. (BM)

To be had at the Golden Head in Leicester-Fields, and at the Print-
Shops N B There are some printed on a better Paper for the Curious,
at 14s. each Set. To be had only at the Author's in Leicester-Fields.
Where also may be had all his other Works.

The special paper was a concession to his old audience and a way of
distinguishing the Golden Head from the other printshops. They
were only a shilling a plate, but there were twelve plates; one wonders
how many Londoners could afford to expend nearly a month's wages
on morality. His mass audience was probably the merchants rather
than the apprentices, and may not have differed too strikingly from
that of his earlier prints. In this case, however, an account of the pub-
lic's reaction on the first day the prints were published has been pre-
served, which suggests something of the excitement, and the attrac-
tion, of a new set of Hogarth's prints at the moment of their
publication. The series was topical enough: Idle hangs out in the
Blood Bowl house in Hanging-Sword Alley, a disreputable haunt
whose keeper, James Stansbury, had recently been tried at Sessions for
breaking open and robbing a linen-draper's. Pinks, in his *History of*

Clerkenwell, believes that Hogarth alludes here to a group of murderers known as the Black Boy Alley gang who terrorized Clerkenwell around this time. But it is also clear that Hogarth expected his viewers to read into his prints any likenesses they wished; that he aimed at not so much precise identification of his figures as the viewer's active participation, along the lines of *Marriage à la Mode.* The viewer recognizes one face and then senses in others a resemblance within a certain range of possibilities, much as a reader of Pope's satires recognizes one

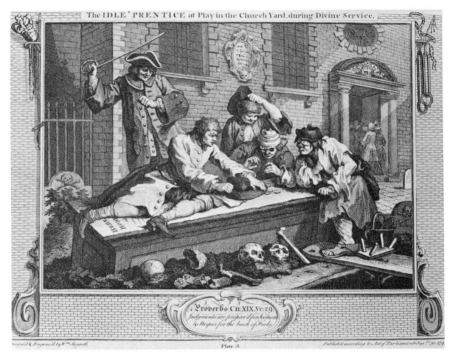

85. Industry and Idleness (3); 10⅛ x 13⁷⁄₁₆ in. (BM)

or two obvious figures and then is left to choose whether S—k is the particular Selkirk or the general Shylock or somebody else.

Vertue's summary expresses another view of the series:

> as the View of his Genius seems very strong & Conversant with low life here as heretofore, he has given a fresh instance of his skill, rather to compass or gripe the whole advantage of his Inventions & to prevent the shop print sellers any benefit he has gravd them in a slight poor strong manner. to print many.—& engross that intirely to himself.—

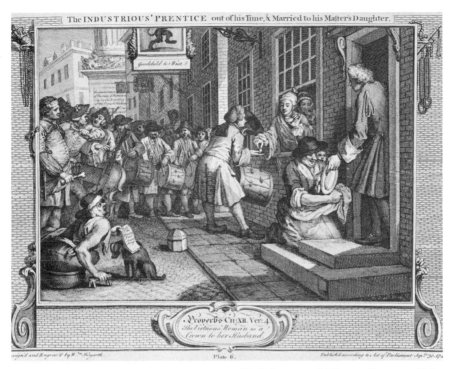

86. Industry and Idleness (6); 10 x 13¼ in.

Vertue's comments suggest additional motives for the series: an endeavor to capture the cheap-copy market as well as the deluxe, and a way to save on engraving costs. Perhaps because of such innuendoes, Hogarth saw fit to defend his style when he was composing his commentary on this series; these prints, he wrote, were

> calculated for the use & Instruction of youth wherein every thing necessary to be known was to be made as inteligible as possible. and as fine engraving was not necessary to the main design provided that which is infinitely more material viz that characters and Expressions were well preserved, the purchase of them became within the reach of those for whom they [were] cheifly intended.

Twelve plates, coincidentally the number Highmore issued of his *Pamela,* was in fact the usual number in the popular Italian and continental print cycles. The verses printed under the *Rake's Progress* had been an experiment that was not repeated; now he placed naively explicit titles (reminiscent of those on the cheap reprints of the *Har-*

lot) over each design and Bible verses underneath, surrounding his figures with frames containing symbolic cornucopias and skeletons, coronets with maces and whips with fetters. The simple yet extraordinarily expressive style of the engraving was patently removed from the French style of *Marriage à la Mode,* and proclaimed the absence of preliminary paintings.

By introducing two protagonists, each representing a distinct pattern of behavior, Hogarth made the reader choose in a much more

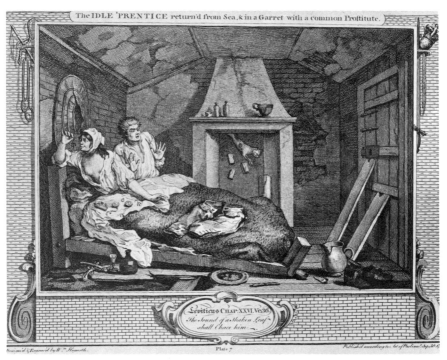

87. Industry and Idleness (7); 10⅛ x 13⁷⁄₁₆ in.

active and "popular" sense than in *Marriage à la Mode.* If the earlier prints offered the audience a choice that was often problematical, here it is ostensibly an easy one. One might almost define the popular prints, beginning with *Simon Lord Lovat,* as designs in which the choice is obvious. There is no doubt about the choice between *Beer Street* and *Gin Lane,* or between the good boy and the bad in the first plate of *The Four Stages of Cruelty,* or between England and France in the *Invasion* prints of 1756. Beginning with *Industry and Idleness,*

the contrast is starkly depicted and strengthened by the blacks and whites of the design. The folly is much the same as the Harlot's, but now it is called idleness; and, in the manner of a morality play, its opposite—industry—is also presented. To Hogarth, the essence of a popular print was apparently simpler forms and choices, fewer allusions, and less "reading." Having acknowledged the primary effect of *Industry and Idleness* as the reader's active participation in a morality, condemning the idle and admiring the industrious and presuma-

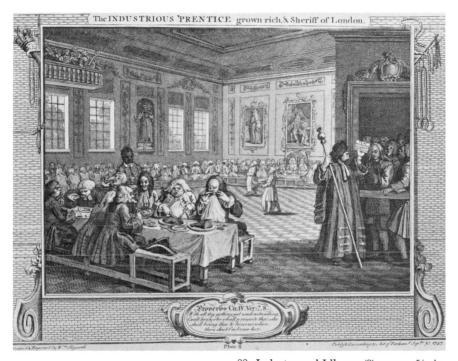

88. Industry and Idleness (8); 10 x 13⁵⁄₁₆ in.

bly learning from their examples, one may pause to admire its simple and strikingly monumental forms. Using the excuse of his popular mode, Hogarth simplified forms, reactions, emotions, characters into a kind of heroic opposition that is closer to sublime history painting, where gods or saints opposed devils, than to the complex world of his comic histories. In a real sense, these prints beginning with the story of Idle and Goodchild and ending with the death of Tom Nero are Hogarth's most bold, original, and powerful modern equivalents to history.

Hogarth exploits the popular print and the expectations of the readers of pious tracts, drawing much of his strength from this simple but powerful source. However, one must not lose sight of his tendency, since the late 1730s, to move to the juxtaposition of contrasting values: the pious vs. the profane in the first two plates of *The Four Times of the Day* (church vs. tavern, pious lady vs. wenches) and the resigned vs. the rebellious (heat vs. fire) in the last two plates. In *Strolling Actresses* he simply opposed contrasting values: the costumes

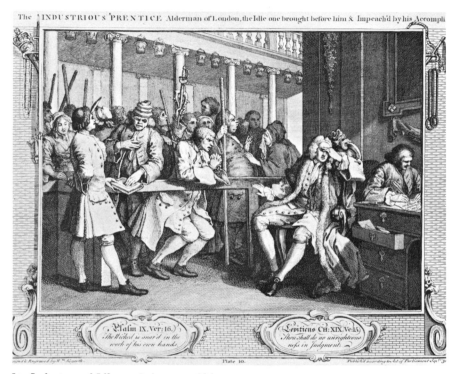

89. Industry and Idleness (10); 10 x 13¼ in.

vs. the girls themselves, the role of Diana vs. the pretty, beer-drinking girl *en déshabillé* who plays her. This sheer contrast, engendering a kind of comic acceptance, is not altogether absent from *Industry and Idleness* and explains the uneasy feeling one may have about those plates. The good and the bad in Plate 1, for example, are so well documented, each with its own broadside ballad, *Prentice's Guide,* loom, and so on, that neither can be accepted with entire seriousness, and they are finally reduced to opposing ways of life; the moral contrast

becomes a comic contrast. The series, one recalls, concerns not a good
and a bad apprentice but an industrious and an idle one. Industry vs.
Idleness, with all the consequences attendant on each, is the subject.

At exactly what level Hogarth intends the parallel (as opposed to
the contrast) to be grasped is difficult to determine. The apprentices
are not as far apart as Hilaire Belloc's young Jim, who slips away from
his nurse and is devoured by a lion, and Charles Augustus Fortesque,
who dutifully eats up all his mutton fat and does the other things a
good child should do and so ends with great riches "To show what

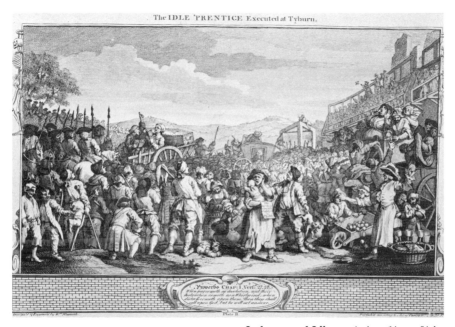

90. Industry and Idleness (11); 10⅛ x 15¾ in.

Everybody might / Become by SIMPLY DOING RIGHT." The ef-
fect of Hogarth's series is somewhere between a pun and an ambigu-
ity. The popular prints exploit the punning that is perhaps central to
all his art. Throughout his career he has used objects which prove to
be two different things, from the purely emblematic *Royalty, Epis-*
copacy, and Law, where a coin is also a king's head, to the *Harlot's*
Progress, where a curtain knot is also a face, and *Marriage à la Mode,*
where a picture on a wall is also a witness to the proceedings under it.
On the simplest level, *Industry and Idleness* constitutes an indictment

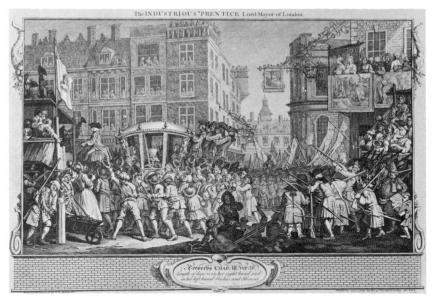

91. Industry and Idleness (12); 10⅚₁₆ x 15¾ in.

of its idle villain, and on a more sophisticated level (probably to some
extent in the popular mind as well), it attacks the unscrupulous peo-
ple around him; but one does not cancel out the other. It hails the
industrious hero but casts doubts upon the value of his reward, and
perhaps even on his kind of success. The punning art of these prints
can be taken either as a sophisticated manipulation of popular forms
and sources or as part of Hogarth's very nature, which transforms his
materials accordingly. In *Industry and Idleness,* Hogarth portrays a
hero for the first time in his comic oeuvre; and permits this hero to
rise triumphantly from climax to climax, producing a daydream
which is immediately qualified by juxtaposition with its opposite.

It takes little imagination to perceive the obvious parallel between
the industrious apprentice and Hogarth, who married his master's
daughter and took over his business, carrying on the art academy, his-
tory painting, and defending Thornhill's name. It is the face of Tom
Idle, however, that resembles Hogarth's, while Goodchild's is ideal-
ized almost to the point of caricature, and the strange muffled shape
of Idle's mother (repeated from print to print) bears a disconcerting
resemblance—hooded and in mourning attire—to the single portrait
Hogarth painted of his own widowed mother (pl. 51).

From 1746 to 1748 had been busy years for Hogarth, and in July 1748 he must have decided that he needed a rest. Though his first trip left him with good memories of France, he hated French artists in England, and certain aspects of the French style appalled him; their houses, he remarked in an oft-quoted phrase, were "all gilt and be-shit." And this second trip, in 1748, coupled with the Seven Years' War, seemed to intensify his notorious hatred of things French. Once the preliminaries for peace negotiations had been agreed upon and the passage from Dover to Calais was free, Hogarth joined with some of the artists who had previously shared in the Foundling project (they were also St. Martin's Lane Academy people): Hayman, the sculptor Henry Cheere, Hudson, and the drapery painter (at that time shared by Hudson and Ramsay) Vanhacken. In the words of Vertue, who chronicles the episode, they "resolved and agreed to go to Paris." From Paris the majority traveled north to Flanders and Holland; but Hogarth and Hayman returned to Calais.

There Hogarth took out his sketchbook and drew some views of the drawbridge to the Calais gate—the old English tower fortifications. Walpole's account, written the following December, which sounds as though it was had from Hogarth himself, says he was taking a sketch of the drawbridge. Vertue's account has both Hogarth and Hayman drawing. Hogarth, according to his own and Walpole's accounts, "was seized and carried to the Governor"—as a spy. "I conceild none of the memorandum I had privately taken and they being found to be only those of a painter for [my] own use it was Judged necessary only to confine me to my lodging till the wind changed for our coming away to England." In Walpole's account "he was forced to prove his voca-tion by producing several caricatures of the French; particularly a scene of the shore with an immense piece of beef landing for the Lion d'Argent, the English inn at Calais, and several hungry friars follow-ing it. They were much diverted with his drawing, and dismissed him."

Whether Hogarth saw France before this experience as he saw it after we shall never know. His memory of it was grim:

The first time any one goes from hence to france by way of Calais he cannot avoid being struck with the Extreem different face things ap-pear with at so little a distance as from Dover: a farcical pomp of war, parade of religion, and Bustle with little with very little bussiness in short poverty slavery and Insolence with an affectation of politeness

give you even here the first specimen of the whole country nor are the
figure less opposited to those of dover than the two shores. Fish wemen
have faces of leather and soldiers raged and lean.

As soon as he arrived back in England he "set about the Picture"—it is
not clear whether he means the one he was sketching when inter-
rupted, although this is Walpole's interpretation. To this "I intro-
duced a poor highlander fled thither on account of the Rebelion year
before brozing on scanty french fare; in sight a sirloin of beef a pres-
ent from England which is opposed to the kettle of soup meager; my
own figure in the corner with the soldier's hand upon my shoulder is
said to be tolerably like."

The painting (pl. 92) was done with speed but is a meticulous per-
formance, as careful and finished as *Marriage à la Mode*. When it was
cleaned in 1966, the warm colors disappeared and cool grays and blues
and off-reds emerged: though as detailed as a miniature, its style be-
gins to suggest the broad, almost poster-like handling of the *Election*
series of a few years later. The engraving, partly done by Charles
Mosley, was published in early March 1748/9:

> *This Day is publish'd, Price 5s.*
> A Print design'd and engrav'd by Mr. HOGARTH, representing a
> PRODIGY which lately appear'd before the Gate of CALAIS.
> O the Roast-Beef of Old England, &c.
> To be had at the Golden Head in Leicester-Square, and at the Print
> Shops.

Vertue, noting the appearance of the print, observes that the title is
"a prodigious Blunder of his—for he has represented a Man carrying
a peice of (Raw beef) instead of Roasted—as it appears colour'd only
red & yellow in the Middle of the print." Unless he had seen a colored
version of the print, Vertue must be thinking of the painting, which
no doubt was displayed next to the print in Hogarth's house. He adds
that the "print of him and his dog" (*Gulielmus Hogarth*, pl. 128) was
out, selling for 3s 6d.

Vertue's comments also indicate that with these two prints Hogarth
was further publicizing himself; anyone who had not heard the story
of his adventure in Calais by word of mouth would "read" it in his
print. If there is any doubt, however, that Hogarth saw himself dis-
passionately in this episode it is dispelled by the blatantly stage-like
structure of *The Gate of Calais*—perhaps more obvious than in any

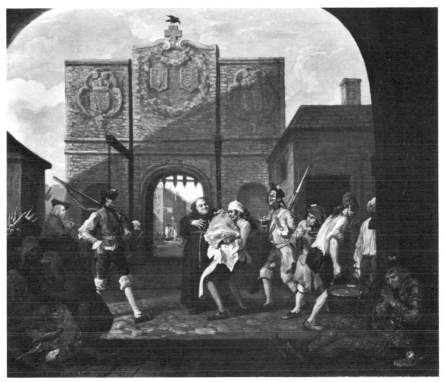

92. The Gate of Calais, or O! the Roast Beef of Old England; 1748; 31 x 37¼ in. (Tate Gallery)

picture since *The Beggar's Opera*. Hogarth's self-comment is that this was a small comedy played out with a motley cast of characters. Nevertheless, here and perhaps in *Industry and Idleness* too (for those who saw the deeper import of the success story of the industrious apprentice), he was in a dangerous sense making himself his subject.

In September 1749 Hogarth took the final step of buying a villa in the country. The Hogarths had lived in Leicester Fields now fifteen years, growing more prosperous and better known; a country house was clearly called for. Chiswick, the location they chose, was one of the loveliest of the Thames-side towns. It derived its name from Old English *cese* or *ciese* and *wic,* the cheese farm, and a cheese fair was supposed to have been held there within Hogarth's lifetime. The house he settled in, assessed at £10 and rated 5s, was a very modest version

of Thornhill Hall. A brick structure, it is of an irregular, almost wedge-like shape; its bare back wall is continued in a high wall that surrounds the whole garden and cuts it off completely from the outside world. Except for a couple of small windows in the servants' quarters, all the windows look inward to the garden. The house is largely as it was, the sole alteration being the demolition of his stable and studio and the addition of a room, possibly where the studio once was. The inside was described by John Ireland in the 1780s, when it was still unchanged. None of Hogarth's own prints was on the walls, but there were engravings of Thornhill's St. Paul paintings around the parlor, and the Houbraken heads of Shakespeare, Spenser, and Dryden. In the garden, over the gate, was "a cast of George the Second's mask, in lead," and in one corner "a rude and shapeless stone, placed upright against the wall," the marker for a pet bullfinch:

> ALAS, POOR DICK!
> OB. 1760
> AGED ELEVEN.

Underneath were two bird crossbones surmounted by a heart and a death's head scratched with a nail, and at the bottom were Hogarth's initials.

Very little is known about Hogarth's private life during these middle years, aside from minutiae such as the fact Samuel Ireland discloses, that he could not distinguish fresh from salt butter till he had taken a bit of cheese at breakfast. And there are anecdotes about his forgetfulness or absentmindedness, traits often attributed to artists, but in his case perhaps a byproduct of his remarkable visual memory. By this time he had set himself up with an equipage and was very conscious—as the self-portrait too might indicate—of his dress. Benjamin West recollected him as "a strutting, consequential little man"; James Barry saw him strolling about in a sky-blue coat, and others remembered "his hat cocked and stuck on one side, much in the manner of the great Frederick of Prussia." John Ireland noted that he always wore his hat in such a way as to show off the deep scar in his forehead, which Ireland says he received as a child, and which also appears prominently in the self-portrait with Trump.

Hogarth's early life had been one of intense relationships, with his family and with Thornhill, indicating an obvious personal need for security and for models. Once he was married, however, with his

father, mother, and Thornhill dead, and the success and security he desired a reality, the remaining relationships are more difficult to assess as to importance and purpose. The majority were either convivial or professional, that is public, associations. For example, it is very difficult to document the personal relationship between Hogarth and Fielding, though much can be said about the public one. It is discernible in terms of their works, not of themselves: Fielding refers to "my friend Hogarth" in *Tom Jones*. And the Rev. James Townley, who assisted Hogarth with verses for his *Stages of Cruelty* and was to help correct *The Analysis of Beauty*, wrote him (28 February 1750): "I wish I were as intimate with you . . . as your Friend Fielding." There are signs of affection but no very clear indication of what kind of friendship it was or what Hogarth put into it or got out of it.

Closer to home, his sister Anne and he remained in the same house for over twenty years, but nothing is known of their relationship save that she served him well and faithfully. His business situation was changing in the 1740s, most notably with the addition of his trade with the Continent and the increasing sale of bound volumes of his prints. The sisters, who were living close to William by 1736, appear as ratable tenants in Cranbourn Passage from 1739 to 1742. Mary died in 1741 and was buried three days later near her mother in the churchyard of St. Anne, Soho. Anne remained in Cranbourn Passage into 1742; but by the end of that year she had given up the shop and moved in with William in Leicester Fields, and thereafter her signature begins to appear on receipts, bills, and the like, and she remained with her brother's family until her death in 1771. William may even have put money into Anne's shop before she came to live with him; certainly he supported her thereafter. In his will he left her £80 a year for life out of the profits of his engravings; and if Jane had remarried, the *Harlot*, the *Rake*, and *Marriage à la Mode*, evidently the most popular of the prints, would have gone to Anne.

As to Jane, more can be said about the origin of their relationship, and what it meant in 1729, than about its later development. The only letter that has survived was written to her on 6 June 1749. He sends some money but makes no comment on business or on the project that engages his attention at the moment. He gossips about their close friend Garrick, who was about to marry. The tone of Hogarth's letter combines good-natured gallantry with affection, how much real and how much an automatic gesture it is impossible to say.

I have found no record of any children of the Hogarths, either in the parish registers or in the family Bible. One might leave the matter at that, were it not for Hogarth's apparently free-and-easy social habits, the difference between his origins and his wife's, and certain rumbling sounds from the early anecdotists. Responding to a typically ungenerous and vague description by Steevens of Hogarth's childless marriage, Thomas Morell, who knew the Hogarths well, wrote to Nichols that he had not seen much fondling between *Jenny* and *Billy* (the common appellation of each other); but had been witness of sufficient endearments to conclude them a happy couple.

Although the popular prints are obviously concerned more with morality and society than with art and the artist, their underlying subject matter should be understood in relation to the prints that began with *The Distressed Poet* and ran from *Marriage à la Mode*, with its indirect emphasis on the artist, to the self-portrait with Trump and even *Garrick as Richard III* (to the extent that Hogarth uses Garrick as an analogue for himself as artist). *The Gate of Calais*, of course, includes Hogarth himself in the act of sketching the gate, and *Industry and Idleness* is in its way as much about Hogarth as this or as the self-portrait. Two contrary aspects emerge: the respectable and the unrespectable, the astute businessman and the naïf, the orderly and the disorderly, and, not least important, the admired and the suspect. In short, in these years of his middle age Hogarth was beginning to look back, take account, study himself, and wonder where to go from here: he was attempting new forms, vacillating from sublime history to a "comic history" of high life to the most popular blockprint sort of broadsides—which, moreover, were increasingly focused on himself or (what amounted to almost the same thing) his art.

The great synthetic work of this period, before he settles down to art as his subject on the one hand and purely popular prints on the other, is *The March to Finchley* (pl. 93), and here, though Hogarth does not appear as one of the dramatis personae, there is a direct confrontation of opposites: order, in the lines of troops marching to defend England against the Pretender, is juxtaposed with disorder in the muddle of soldiers getting ready to leave their wives or mistresses, the foragers and deserters, the camp followers, all the idle apprentices in and out of uniform, and all the natural instincts that operate against regimentation, duty, and prudence—a confrontation that seems almost to be between art and nature.

A contemporary would have taken *The March to Finchley*, with its dedication to the King of Prussia and its moiling confused troops, as a commentary on the Mutiny Bill being violently and spectacularly debated in Commons in 1749–50, and continuing in 1751. Then again, one could take the reference to the King of Prussia as "An En-

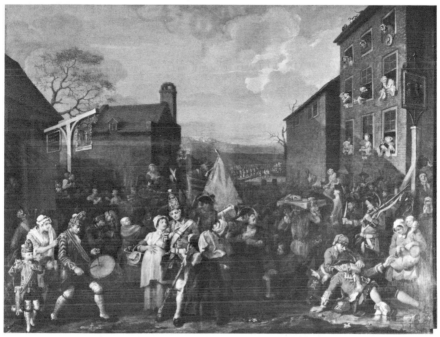

93. The March to Finchley; 1749–50; 40 x 52½ in. (The Thomas Coram Foundation for Children)

courager of Arts and Sciences!" as an ironic allusion to George II's notorious indifference to the arts. The references are there, though neither obtrusive nor partisan, and with an ambiguity similar to that of the *Industry and Idleness* plates. In any case, the subject of art and nature is central.

Published only a year after *Tom Jones*, *The March to Finchley* is Hogarth's response to Fielding's masterpiece: here is the "comic history painting" on its largest scale, with an epic scope but, unlike Fielding's novel, Hogarth's painting takes no sides, only illustrating the relationships. If there is a choice, it is once again, as in the histories of the late 1730s, left up to the viewer. It is probably no coincidence, however, that Hogarth chose to illustrate the same historic struggle that hovers

in the background of *Tom Jones,* where it acts as a correlative to the sundered families, confused loyalties, and egregious misunderstandings of the main plot. Termed more accurately than his other works a "history" painting, *The March to Finchley* portrays a particular historical moment in early December 1745 from the perspective of 1750. Like Fielding's novel (and the presence of the *Jacobite's Journal* alludes to Fielding), its context is not the patriotism of 1745–46 but the later discontent in an unhappy England ruled by an unpopular foreign family and swarming with dissident elements; and more immediately, the Treaty of Aix-la-Chapelle (1748), from which England had gained little or nothing, and the current attempt by the victor of Culloden to bring the British army up to a German standard of order and precision.

Hogarth could not have made such a painting within a shorter time of the events it portrays because the forces of patriotism might have seen it as Jacobite (as Wilkes attempted to do, in retrospect, in *North Briton* No. 17). The only gap in his work schedule when he could have undertaken such an ambitious painting was late in 1749. It must have been nearing completion in the spring of 1750 when events made it an even more appropriate image of the times. On the night of 8 February London suffered an earth tremor, and a second more violent one followed exactly one month later. Charles Wesley and the Bishop of London issued a sermon and a pastoral letter respectively admonishing the nation to repentance, which alone could avert the just chastisement of God. A Lifeguardsman ran around London prophesying a third earthquake that would swallow the city on 4 April, one lunar month from the second earthquake. Panic set in, and in three days 730 coaches were counted passing Hyde Park Corner "with whole parties removing to the country"—in effect, another "march to Finchley." The *General Advertiser* of 13 April viewed the affair, logically enough, in terms of a satire by Hogarth:

> Not a Fribble, Bully, Wicked, or Damn'd-Clever Fellow was left in Town on Wednesday last Week.—The First Class own'd their Fright, and pleaded their Nerves. The Second sneak'd out. The Third and the Last swore furiously, on their Return, that they never flinch'd an Inch.—We hear that a True List of these Demi-men will be soon published.—If Mr. Hogarth were to oblige the Town with a Print of these woeful Wretches in their Fright and Flight, it could not be disagreeable.

Already on 16 March, in the same paper, Hogarth had published an advertisement announcing just such a project:

Mr. HOGARTH *Proposes to publish by* SUBSCRIPTION,
A PRINT representing the March to Finchley in the Year 1746,
engraved on a Copper-Plate 22 Inches by 17, Price 7s. 6d. . . .

As a painting, *The March to Finchley* shows that Hogarth had not yet given up the attempt at painting a comic history begun in *Marriage à la Mode*. The size of the canvas (40 by 52½ inches) is indicative, serving to narrow the usual Hogarthian separation between print and painting until both can legitimately be called monumental. The originality of the composition as well as the subject becomes evident if one tries to find a precedent. A suggestive resemblance may be observed in Rembrandt's great "militia piece," *The Night Watch,* which Hoogstraten commended for its avoidance of the domino-like rows of figures usual in such large military compositions. Though the size of the figures in relation to the picture space is different, one cannot fail to notice the similar treatment of subject and composition: in the use of lighting, which on the face of it is rather odd in the broad daylight of *Finchley;* the interrelation of the three lighted groups at right, left, and center; the same unfurled flag rising near the center background; and, above all, the s-shaped movement, forward and back, of the various groups of figures. To draw any valid conclusions about inspiration or influence, one would have to establish whether Hogarth had access to either the original or a copy. But the analogy at least points to the essentially Rembrandtesque solution employed by Hogarth. If such a connection is not fanciful, it would be neither the first nor the last time that Hogarth turned to Rembrandt.

The *General Advertiser* for 23 April added further information on the subscription: it would end on the thirtieth and, as to the painting: "In the Subscription-Book are the Particulars of a Proposal whereby each Subscriber of 3s. over and above the said 7s. 6d. for the Print, will, in consideration thereof, be entitled to a Chance of having the original Picture, which shall be deliver'd to the winning Subscriber as soon as the Engraving is finish'd." A few days later Hogarth announced that on Monday, 30 April, at 2 P.M. the box would be opened and the drawing made. The *London Evening Post* for 28 April to 1 May reported:

Yesterday Mr. Hogarth's Subscription was closed, 1843 Chances being subscribed for. The remaining Numbers from 1843 to 2000 were given by Mr. Hogarth to the Hospital for the Maintenance and Education of exposed and deserted young Children. At Two o'Clock the Box was open'd, in the Presence of a great Number of Persons of Distinction, and the fortunate Chance was drawn, No. 1941, which belongs to the said Hospital; and the same Night Mr. Hogarth deliver'd the Picture to the Governors. His Grace the Duke of Ancaster offer'd them 200 l. for it before it was taken away, but it was refus'd.

To judge by this report, Hogarth, though he had originally announced that he would keep the picture till the print was finished, evidently changed his mind—no doubt to take advantage of the publicity while the picture was still in the public mind and to get it up where it could be seen. This gesture could not, of course, stimulate subscribers, but it could advertise his comic history painting and lure people who had not subscribed to buy the print once it was out. Hogarth himself explained later that it was "disposd of by lot (the only way a living Painter has any probability of being tolerably paid for his time)"; he remembered it as bringing him £300. The whole subscription must have earned him £920 and, counting only the 3s addendum for the lottery, the painting alone brought £276.

That summer or fall Rouquet wrote his account of *The March to Finchley* as an addendum to his *Lettres de M. * **. This seven-page pamphlet, which was bound in with the *Lettres,* can be dated only roughly: it obviously postdates February 1749 when *Tom Jones* was published, because it makes reference to that novel, and antedates January 1750/1, because Rouquet apologizes for describing the painting before the print was made, using his correspondent's impatience as his excuse. More probably, he had to leave for France himself.

Hogarth had Luke Sullivan, a talented young engraver who may have worked his way up in Hogarth's shop, make a carefully detailed drawing—and I think it likely that he himself drew the heads (as usual, for expression). The painting presumably remained with Hogarth, however, until Sullivan was finished. Finally, in the *London Evening Post* of 29 December–1 January 1750/1 the print was announced as ready for subscribers on 3 January.

Something of the effect Hogarth wished to achieve with his "popular" prints can be seen in Fielding's efforts in the same direction. *In-*

dustry and Idleness appeared in October 1747, and on 28 March 1748 Fielding opened a puppet theater in Panton Street, just a block from Leicester Fields, which operated with great popular success until he closed it in June. Fielding had expressed in the *True Patriot* of 11–18 February 1746 his desire for a return from sophisticated modern plays to the vigor of the ancient Punch and Judy show (specifically, he adds, as a vehicle for satire).

In 1747–48 Fielding edited a pro-Pelham periodical, the *Jacobite's Journal,* for which Hogarth is said to have designed the headpiece. Then in the winter of 1748–49 he became a Westminster magistrate. *Tom Jones,* which he was still writing as he took up his puppet theater and his police duties, came out at the end of the year, with its quota of Hogarth references. But Fielding was now devoting himself wholeheartedly to the business of presiding over the Bow Street police court and his efforts to reform the community. His last novel, *Amelia,* reflects this experience; in the meantime he was writing tracts urging practical solutions to the problem of crime in London.

Fielding faced criminals day after day in his courtroom. Hogarth's personal contact with the encroachments of poverty, crime, and violence in the metropolis was less direct. He lived in a respectable and elegant square. Some idea of the state of crime in Leicester Fields can be gained from the *London Evening Post* for 25–28 May 1751. The preceding Friday, 24 May, between 11 and 12 midnight,

> Mr. Howard, an eminent Peruke-maker, in Castle-Street, Leicester-Fields, was knock'd down near his own Door by a Ruffian; . . . Mr. Howard was desperately wounded in the fore Part of his Head by the Violence of the Blow.

Hogarth, no doubt, would have shared the reporter's indignation, and in general Londoners saw these vagabonds as threats to their welfare rather than unfortunates to be helped and corrected. They were put away in workhouses with madmen or in prisons and forgotten.

In May 1749 Fielding, in his first year as magistrate, was chosen chairman of the Quarter Sessions of the Peace, and so delivered the annual charge which had been made famous by Justice Gonson; he delivered his first on 29 June and it was published three weeks later. Full of precedents and legal references, it was as much a charge to the citizens of Middlesex as to the law enforcement officers; trying to anticipate crime at its source he spent much time on minor offenses, and,

like Gonson, found its roots in the brothels and the dance halls, "where idle persons of both sexes meet in a very disorderly manner, often at improper hours, and sometimes in disguised habits."

It is difficult to say whether Fielding had any influence on *Industry and Idleness*, produced back in 1747 before he was a magistrate. The influence of Hogarth's prints, in their emphasis on "idle persons" and idleness as a source of crime, and even in some of their images, may, however, be felt in Fielding's writings. There was certainly no coincidence in the appearance, with almost synchronized precision, of major attacks in January and February 1750/1 by both Fielding and Hogarth.

Fielding's *Enquiry into the Causes of the Late Increase of Robbers* appeared in mid-January. Its main theme is a remarkable restatement of the ideas of his early fiction and Hogarth's early progresses. In his *Charge to the Grand Jury* he had, unlike Gonson, distinguished between the poor and the rich. Practically speaking, Fielding has turned his attention on "the lower order of people," but the *Enquiry* does not imply that the rich are without vice. Its point is that they can afford their vices, unlike those who are ruined through emulating them—and there is legally nothing to be done about it. "Let the great therefore answer for the employment of their time to themselves," says Fielding, "or to their spiritual governors." If I read its irony properly, the *Enquiry* says that the real evil is in the false ideal offered by the great, but the subject is the poor fool who copies it and inhabits the middle area that is called, in the preface to *Joseph Andrews*, affectation. His object, Fielding says in his preface, is "to rouse the civil power from its present lethargic state"; this is achieved partly through irony that implicates the great, but primarily by focusing on practical measures that might conceivably alleviate the problem of crime among the poor.

Fielding's first chapter is on emulation; his second is on the poor's own escape from the status quo, one within reach of the lowest—gin. He agrees with Isaac Maddox, the Bishop of Worcester, whose sermon on Easter Monday, 1750, laid all the prevalent crimes in England at the door of gin. Delivered before the Lord Mayor and the magistrates of London, it was entitled "The Expediency of Preventive Wisdom," and was later widely distributed. The worst vice which has attended the idleness and emulation he has described, Fielding says, is a "new kind of drunkenness . . . which, if not put a stop to, will infallibly de-

stroy a great part of the inferior people"—that is, gin-drinking, which he has "great reason to think is the principal sustenance (if it may be so called) of more than a hundred thousand people in this metropolis."

As *The March to Finchley* was being engraved by Sullivan, Hogarth must have been working on his equivalent to Fielding's *Enquiry*. In the *London Evening Post* of 14–16 February he announced:

This Day are publish'd, Price 1 s. each.
Two large Prints, design'd and etch'd by Mr. Hogarth, call'd
BEER-STREET and GIN-LANE

A Number will be printed in a better Manner for the Curious, at 1s. 6d. each.

And on Thursday following will be publish'd four Prints on the Subject of Cruelty, Price and Size the same.

N.B. As the Subjects of these Prints are calculated to reform some reigning Vices peculiar to the lower Class of People, in hopes to render them of more extensive use, the Author has publish'd them in the cheapest Manner possible.

To be had at the Golden Head in Leicester-Fields, Where may be had all his other Works.

It is well to remember that Hogarth (like Fielding) is portraying vices "peculiar to the lower Class of People," but that while he has "publish'd them in the cheapest Manner possible," he has also had a number "printed in a better Manner for the Curious" at 6d more. The "cheapest Manner" must have referred to the light paper and the broad execution: relatively few lines were used. He had gone so far as to employ John Bell to make woodcuts of two of the *Stages of Cruelty,* but the project had to be abandoned because it proved more expensive than copper engraving.

Choice is clear and unambiguous in *Beer Street* and *Gin Lane* (pls. 94, 95). Hogarth draws on a tradition going back at least as far as Defoe's *Augusta Triumphans* (1728), in which beer is opposed to gin as good to evil and, of course, industry to idleness. There is almost no ambiguity about the contrast here between order and chaos. The crowd that was getting a bit too disorderly and dangerous in *The March to Finchley* has here been divided: the lusty folk of *The Four Times of the Day* and *The Enraged Musician,* accompanied by their pretty girl, are in *Beer Street;* the drunks, thieves, and sharpers of *Finchley* (those Fielding called "the thoughtless and tasteless rabble") are now iso-

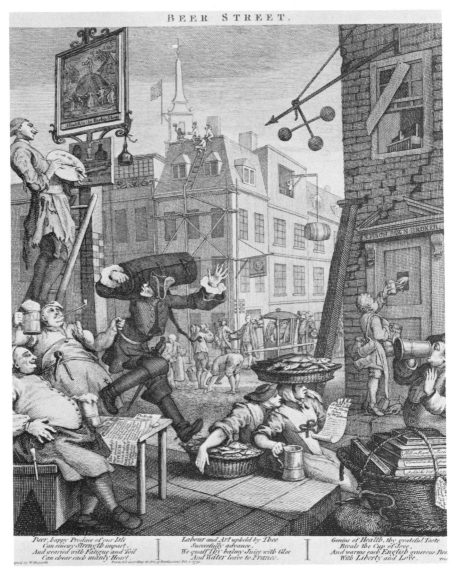

BEER STREET.

Beer, happy Produce of our Isle
Can sinewy Strength impart.
And wearied with Fatigue and Toil
Can cheer each manly Heart.

Labour and Art upheld by Thee
Successfully advance.
We quaff Thy balmy Juice with Glee
And Water leave to France.

Genius of Health, thy grateful Taste
Rivals the Cup of Jove,
And warms each English generous Breast
With Liberty and Love.

94. Beer Street; Feb. 1750/1; 14⅛ x 11¹⁵⁄₁₆ in. (BM)

lated in *Gin Lane*. They are totally out of control, destructive and self-destructive; particularly horrible, besides the collapse of buildings and the rather melodramatic skewering of a baby, is the perversion of the pretty girl, the stereotype of mother and child, in the grim figure slouched in the middle of the picture. The contrast is between

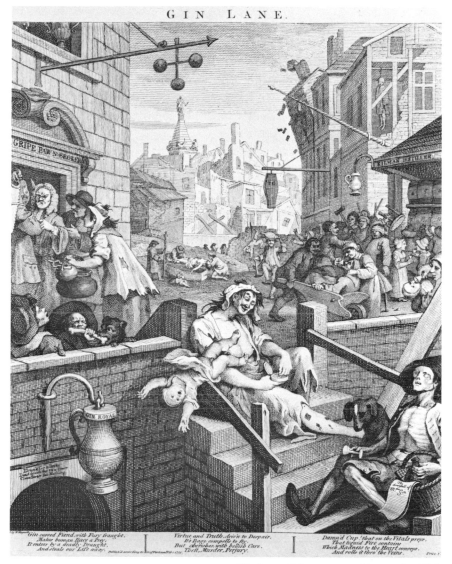

95. Gin Lane; Feb. 1750/1; 14¾₆ x 12 in. (BM)

life, love, eating, and growth, and death, apathy, starvation, and de-
cay: a suspended beer barrel in the one becomes a coffin in the other,
a church steeple celebrating the birthday of George II in the one be-
comes the remote spire of St. George Bloomsbury in the other, and the
bankrupt pawnbroker becomes the successful ruler of Gin Lane.

In *The Four Stages of Cruelty* Hogarth is concerned with a broad subject, the brutality and callousness of the times, which, like Fielding, he links to criminal behavior. The boy torturing a dog or a cat will grow up to be the thief and murderer. But in eighteenth-century London cruelty was much more than a source of criminal behavior; it was a way of life. The dog–bull fight Hogarth depicts in Plate 96 was an everyday event, with occasional notes in the paper that an onlooker had been gored to death.

The *Stages of Cruelty* are Hogarth's most shocking, most purely expressive prints; they were clearly intended both to horrify ("to

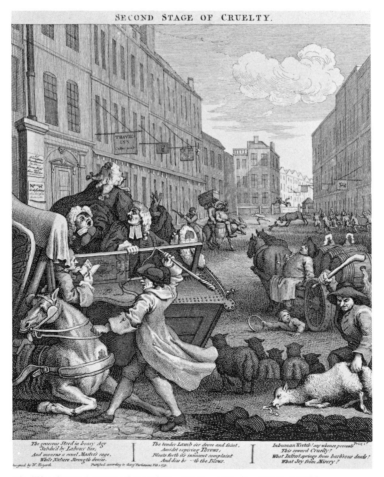

96. The Second Stage of Cruelty; 13⅞ x 11¹⁵⁄₁₆ in. (W. S. Lewis)

rouse," as Fielding had put it) his usual customers and to appeal to a lower, more general audience. They move from Tom Nero torturing a dog and being restrained by a respectable-looking boy of the upper classes, to Nero beating his horse to death, with a respectable young man taking down his number to report his cruelty. And this second plate includes other examples of cruelty, extending from the man beating a sheep to the drayman asleep and unaware that he is running over a child, to the respectable lawyers who have crowded so many into Tom Nero's cab to save fares (the sign "Thavies Inn" shows that they are taking the longest possible shilling fare to Westminster Hall, where they work) that the horse has collapsed under their weight, leading to Nero's brutal assault. By the time the reader has reached the last plate he has perhaps begun to sense the complexity in Hogarth's picture of cruelty, but he is not prepared for the turning of the tables—certainly one of the most powerful graphic images of Hogarth's career—in which the respectable viewer himself becomes the agent of cruelty (pl. 97). The criminal, however evil, seems no worse than the powerful social elements, like the cold unfeeling surgeons, who surround him: they are as cruel in their way as the cutthroats who are tried and condemned and the public that enjoys the exhibition. The last plate of *Industry and Idleness* showed how much the populace enjoyed executions, which offered more excitement than the pugilists or bear-baiters. Dissections of malefactors following execution were also often public and were included as part of the sentence imposed on the prisoner.

The climax of the *Stages of Cruelty* implies that the great can get away with behavior that is in its way no different from that of the poor —in a sense, that the poor suffer for the enjoyment of the rich. This is how Hogarth's so-called popular prints operate. It is impossible to fix his own opinion somewhere along the spiral of reading deep into the prints, but one suspects that he was darkly amused at the case of the jail fever carried up by prisoners from their noisome cells to the court house of the Old Bailey in May 1750. The disease infected and killed the Lord Mayor, an alderman, a baron of the exchequer, a judge of the Court of Common Pleas, the under sheriff, most of the Middlesex jury, and some of the spectators.

Whatever ultimately disruptive elements may lurk in these prints, Hogarth liked to maintain publicly the simple pose of the moralist. A Mr. Sewell, bookseller in Cornhill, used to go to the Golden Head

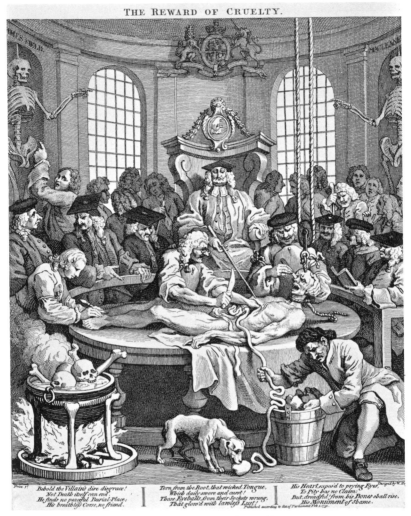

97. The Reward of Cruelty; 14 x 11¾ in. (W. S. Lewis)

for subscription prints, and once he told Hogarth it must have given him great pleasure to see his works so generally admired. "Sir," replied Hogarth,

> it gratifies me very highly, and there is no part of my works of which I am so proud, and in which I now feel so happy, as in the series of the Four Stages of Cruelty, because I believe the publication of them has checked the diabolical spirit of barbarity to the brute creation, which, I am sorry to say, was once so prevalent in this country.

If this was his aim it was, in a minimal way, rewarded. A new gin law was passed in 1751 reducing the number of gin shops, more than doubling the tax, increasing the police authority, and offering rewards to informers. However, the stories of the reform accomplished by Fielding and Hogarth are exaggerated. They both probably served as useful propagandists, but the old accounts that presented Fielding as a powerful influence for progressive reform on the Ministry and the Parliamentary Committee that was appointed in 1751 to investigate the problem of poverty, and as the probable author of the subsequent legislation, are unfounded. From the little evidence that exists, it appears that, being Bow Street Magistrate, he was doubtless consulted, and that his *Enquiry* was simply his independent publication outlining the views he had offered.

Hogarth's own statement in his manuscript notes, written about the time of his interview with Mr. Sewell, was that he would rather have been the author of the *Stages of Cruelty* than the Raphael Cartoons, "unless I lived in a roman Catholic country"; and when he repeats the statement on another page he says he speaks as a man, not as an artist. What he means, of course, is that his kind of Protestant country calls for a different kind of "history painting"—one without superstition, which must be based on the public's benevolence, charity, and the virtue of works. These prints must be regarded as another phase of his search for a kind of contemporary history, this time toward popular, almost folkloristic roots, and toward a stark simplicity and monumentality that none of the earlier prints achieved.

To understand the intention behind the "popular" prints, one must see them as part of Hogarth's reaction against the ultimate in complex reading structures, *Marriage à la Mode*. A sort of crisis, we have seen, followed that elaborate work, and he produced a series of pure oil sketches: which, as sketches, express formal structures not yet completely represented or finished, not yet clothed in meaning. These sketches did not lead into engravings. However, on the engraving front, with *Industry and Idleness* and the prints that followed, the reading structure itself is radically simplified; while inscriptions are lengthened, the meaning is conveyed less through words or objects than through relationships of form. The juxtaposition of large shapes with the Idle 'Prentice, of crowds with isolation, of inside with outside—these represent another aspect of Hogarth's attempt to move away from verbal or emblematic structures toward a more expressive,

more purely visual form, which reaches its climax in the powerful last plate of the *Stages of Cruelty*.

The popular prints were also, in fact if not in Hogarth's recollections, related to his preoccupation with the subject of art, theory and practice, around 1750. In the earlier works, and continuing as late as *The Election*, he imitated the tradition of late baroque in order to identify it with the corruption of the institutions he presented: in the climactic image, *Chairing the Member* (see pl. 106), subject and method are indeed one, in a decadent, overripe way. But beginning with *Industry and Idleness*, and most notably in the brutal prints of 1750/1, he produced "popular" prints in which the forms and subject matter were equally brutal, and the intention was at least partly an assault on the tender sensibilities of taste-hardened art fanciers. To this segment of Hogarth's audience these plates revealed a known area of life not generally portrayed in art (at least outside the popular print) except under the stylized guise of a saint's martyrdom. *The Reward of Cruelty*, for instance, is strongly reminiscent of Poussin's *Martyrdom of St. Erasmus* with the long rope of intestine being drawn out. In the *Stages of Cruelty*, Hogarth was countering the tyranny of taste with apparent tastelessness. The subject, the method, underlined by the brutal woodcut effect, constituted an attack on the institution of art analogous to the attack on academic art theory in *The Analysis of Beauty* a few years later. The advocacy of expressive form also stressed in the *Analysis* was the other prong of Hogarth's argument.

ART AS SUBJECT

From the beginning, Hogarth's prints, with their overtones of aesthetic argument, incorporated a unique appeal beyond the tyranny of aristocratic taste to the general public. His subscription tickets implied as much. In his autobiographical notes he was explicit:

> As my notions of Painting differ from those Bigots who have taken theirs from books, or upon trust, I am under some kind of necessity as an apology for works to submit mine to the public, but not with [the] least hopes of bringing over either those Interests [which] are [*word illegible*] or such as love to deceive and delight in antiquity and the marvelous and what they do not understand, but I own I have hope of succeeding a little with such as dare think for themselves and can believe their own Eyes.

Only in the 1750s did this aim, hitherto secondary, become primary and deadly serious. The prints, in effect, became weapons in a war with the connoisseurs and critics.

Art as a subject had, of course, been a preoccupation of Hogarth's since his *Beggar's Opera* paintings, which play off the illusion of art against the reality of the audience and the actors themselves. Then in the late 1730s, facing the competition of foreign artists for history and for portraits, he began to focus more intently on this theme, producing the poet–painter–musician prints and the self-portrait with pug and palette. Though the comic histories of the 1740s (even, in a sense, *The March to Finchley*) present a story and a moral, their style, the furniture and pictures of their rooms, make a statement about art. If art is a vehicle for the metaphor of this series, in the 1750s art usurps the subject matter as well: Hogarth begins to think first about art, second about morality. One of his interesting parallels with Daumier is that both artists were preoccupied with social and moral subjects but devoted a curiously large part of their oeuvre not to the human condition as such but to artists, collectors and art dealers.

There is a story (which must refer to 1749) about the caricature Hogarth produced on the death of his friend Vanhacken (who had accompanied him on his last trip to the continent the year before). This design, which has not survived, is said to have shown Vanhacken's funeral procession, "composed of all the portrait painters of the metropolis as mourners, and overwhelmed with the deepest distress." His death deprived at least Hudson and Ramsay of the skilled craftsman who supplied all but the heads and general compositions of their portraits.

The most celebrated of the art satires in which Hogarth took part was in progress at this very time, and led directly into his next large publishing venture. The whole collecting business had perked up after the peace of Aix-la-Chapelle; the rage for Italian objects began to gain ground when the threat of the Pretender diminished after 1745 and his younger son become a priest. Englishmen began to return to Rome in droves and to collect antiquities on a large scale. It is interesting therefore that the particular rage that caught the attention of Hogarth and his circle came from the north: Rembrandt etchings were already eagerly sought after in the 1730s, and the demand for his etchings had grown to large proportions by 1750.

With the rage for collecting anything that resembled Rembrandt, one may consider Hogarth's friend Benjamin Wilson, one of the St. Martin's Lane artists. Wilson, reminiscing some years later, recalled that he had been an enthusiastic admirer of Rembrandt's works and a successful student of his style and manner. At a sale he bid up to £10 for a Rembrandt drawing, which however went to Thomas Hudson, who afterward exhibited great anger with Wilson for having forced him to pay more than he had intended: he "expressed himself *very uncourteously*." Wilson restrained his resentment but determined on a retaliation which stemmed from his knowledge that Hudson maintained that no one could etch like Rembrandt, and that he could always discover an imitation of Rembrandt as soon as he saw it. Thus, Wilson began by copying a rare etching called "Companion to the Coach," then attributed to Rembrandt but now to De Koninck or some other. He claimed to have copied it from memory, as the pirates did Hogarth's *Rake's Progress;* he spent a great deal of labor on duplicating the India paper used by Rembrandt, which he discovered was made by pasting together and pressing more than one sheet. He struck off a print from his etching, wrote in Dutch upon it "The Companion to the Coach," and sent it in a portfolio with a number of genuine Rembrandts, via a Dutchman, to Mr. Hudson for sale. Hudson immediately purchased it for 6s and told Mr. Herring, nephew to the Archbishop of Canterbury, and others, that it was "the best piece of perspective," and "the finest light and shade that he had ever seen by Rembrandt." Wilson communicated the success of his scheme to his friend Hogarth, who persuaded him to repeat the experiment and try its effect with Harding, the famous printseller, who had the reputation of being a connoisseur.

This sounds like Hogarth, shifting the satire from a painter to a dealer. Wilson then etched an old man's head, which he dispatched by the same Dutchman to Harding. After a short examination, Harding paid the two guineas and threw in a bottle of wine, urging the Dutchman if he came upon any more to let him have first choice. The two conspirators took a few others into their confidence, who gulled particular parties in whom they were interested, including Lord Duncannon (afterward Lord Bessborough and a Hogarth collector), Arthur Pond, and Dr. Chauncey, all supposed connoisseurs of Rembrandt's works. Wilson spent the money he had obtained by his fraud on a supper to which he invited, without telling anyone what he

meant to do, twenty-three artists including Hogarth, Scott, Lambert, Kirby, and of course Hudson, telling them it was to be an "English roast." Hogarth sat on his right, Hudson on his left. The chief dish at table was a large sirloin of beef covered all over with the same kind of prints Hudson had sold. He would not at first believe he had been taken in; but Wilson produced his portfolio full of the engravings in various stages of progress. It had been expected that Hudson would see the joke and join the crowd, but he took serious offense, and again expressed himself "*uncourteously*." Wilson responded by telling him that he was therefore determined to publish the prints and publicize the folly of both Hudson and Harding. Indeed the *General Advertiser* for 7 May carried Wilson's advertisement:

> *On Saturday next* [i.e. 11 May] *will be published,*
> TWO PRINTS, in Imitation of Rembrandt, designed and etched by B. Wilson, which were purchased by two very great Connoisseurs, as curious and genuine Prints of that Master, and at a considerable Price.
> Soon will be published some others, taken from Mr. Wilson's own Paintings, and etched in the same manner.
> ☞ Those Gentlemen who are curious, and would be glad of Variations, and upon India Paper, may have them by applying to Mr. Wilson, at his House in Great Queen-street, near Lincoln's-Inn-Fields.

The landscape sold for 6*d* and the head for a shilling, and "so great was the demand that both plates were almost entirely worn away by frequent printing."

Hogarth had evidently taken stock, and used this as an opportunity to make his own statement on the subject of the Dutch style, the rage for dark prints, and at the same time usher in the publication of his own history paintings of the last few years—seen by many Londoners and, he calculated, as worth taking home in an engraved copy as paintings in Rome. (One should not lose sight of the fact that in February, only four months before, he had published *Beer Street, Gin Lane,* and the *Stages of Cruelty*.) He must have planned this as soon as the hoax began, because only two days after Wilson's advertisement, on 9 May, his appeared in the same paper:

> MR. HOGARTH proposes to publish by Subscription, Two Large PRINTS, One representing *Moses* brought to *Pharoah's Daughter;* the other, *Paul* before *Felix;* engraved after the Pictures of his Paint-

ing, which are now hung up in the Foundling-Hospital and Lincoln's Inn Hall. Five Shillings to be paid at the Time of Subscribing, and five more on the Delivery of the said Prints.

Then he adds, alluding to all that has gone before:

> For the first Payment a Receipt will be given, which Receipt will contain a new Print (in the true Dutch Taste) of *Paul* before *Felix*.
>
> *N.B.* The above two Prints will be 7s. 6d. each after the Subscription is over, and the Receipt Print will be sold at a very extraordinary Price.

He is referring to his splendid Rembrandt imitation (pl. 98), a print that brought in many subscriptions. It was, indeed, so popular that by 1 June he changed the wording to "will not be sold for less than One Guinea each." As his patrons recognized, here was something of a higher order than the serious engravings that were in progress. He goes far beyond Wilson's careful imitations to a general burlesque of the Rembrandt style—the dark mezzotinting of some of the late etchings, a wonderfully scratchy effect, and then the portrayal itself of a blowsy Justice and Felix defecating in terror.

Hogarth perpetuates the contemporary criticisms of Rembrandt's naturalism, producing at the same time a very funny print. He seems to have been especially anxious at this time to avoid the realistic and grotesque elements that had been prominent in his own St. Bartholomew paintings: the dogs and dwarfs and the anecdotal details.

In the 1730s he had been drawn to exactly the sort of consciously anti-academic painting Rembrandt produced in the earlier part of his career, and he was leaving parts of his canvas "unfinished" and applying his paint in the "broken" manner associated with Rembrandt. Two decades later he was satirizing Rembrandt for demeaning serious history subjects and simultaneously experimenting to find how Rembrandt might be useful to a history painter; at the same moment he denies and acknowledges him. In spite of his precautions, he was soon to be accused by Joseph Warton of the irreverent use of a dog in a sublime history; to prove his own literacy, he began to write an art treatise, arguing that an artist should be guided by nature, not rules, which would evoke gibes of illiteracy from unsympathetic critics. One of the more illuminating asides in his autobiographical notes is the remark that his portraits had "met with the like approbation Rembrandt's did, they were said at the same time by some Nature itself

98. Paul before Felix Burlesqued (without receipt); May 1751; 9⅞ x 13½ in. (BM)

and by others execrable." His next self-portrait, *Hogarth Painting the Comic Muse* (1758, pl. 117), inevitably if vaguely recalls Rembrandt. But the true imitation of a Rembrandt self-portrait, of the sort Reynolds would be making in years to come, was reserved for the portrait of his old friend John Pine (pl. 113), as if Hogarth did not quite dare assume the mantle himself. This interesting displacement reflects the ambivalence of his lifelong attitude toward his great precursor.

It is possible that another reason for the particular timing of the engraving of *Moses Brought to Pharaoh's Daughter* was the death of Captain Coram on 29 March 1751. Times were changing and some things were coming to an end. The great burst of the popular histories was over, and the period of the sublime histories was being memorialized in engraved copies. Now the paintings of the last and most ambitious of comic histories were to be sold. The announcement of the subscription for *Moses* and *Paul* had a last paragraph which, beginning with the cutoff date of the subscription, went on to announce a new auction:

> Subscriptions will be taken till the 6th of June next, and no longer, at the Golden Head in Leicester-fields, where the Drawings may be seen, as likewise the Author's six Pictures of *Marriage A-la-Mode,* which are to be disposed of within the said Time, by a new Method, to the best Bidder.

During the last half-dozen years the fate of the *Marriage à la Mode* paintings had been shrouded in silence. At the time of the first auction of paintings, Hogarth had said he would sell the series as soon as he had finished with the engravings. But no buyer seems to have materialized. His friend Christopher Cock exhibited it in his auction rooms for some time—perhaps up to the time of his death on 10 December 1748.

It is clear that Hogarth had some difficulty disposing of what he no doubt considered his masterpiece "in this way," and was feeling defensive about it, blaming the situation once again on the connoisseurs, auctioneers, and old masters. In the *Daily Advertiser* for 28 May he elaborated on his plan of sale:

> That each Bidder sign a Note, with the Sum he intends to give.
> That such Notes be deposited in the Drawers of a Cabinet, which Cabinet shall be constantly kept lock'd by the said William Hogarth.
> . . .
> That each Bidder may, by a fresh Note, advance a further Sum, if he is out-bid, of which Notice shall be sent him.
> That the Sum so advanced shall not be less than three Guineas each time.
> That the Time of Bidding shall continue 'till Twelve o'clock the 6th Instant, and no longer [i.e. 6 June].
> That on Friday the 7th Instant, the Notes shall be taken out of the Drawers, . . .
> That no Dealer in Pictures will be admitted a Bidder. . . . Mr. Hogarth, by way of Precaution, not Puff, begs Leave to urge, that, probably, this [i.e. *Marriage à la Mode*] will be the last Suite or Series of Pictures he may ever exhibit, because of the Difficulty of vending such a Number at once to any tolerable Advantage; and that the whole Number he has already exhibited of this historical or humorous kind, does not exceed fifty, of which the three Sets, call'd, *the Harlot's Progress, the Rake's Progress,* and that now to be sold, make twenty; so that whoever has a Taste of his own to rely on, not too squeamish for the Production of a Modern, and Courage enough to avow it, by daring to give them a Place in his Collection (till Time, the suppos'd

> Finisher, but real Destroyer of Paintings, has render'd them fit for
> those more sacred Repositories, where Schools, Names, Hands, Mas-
> ters, &c. attain their last Stage of Preferment), may from hence be con-
> vinced, that Multiplicity at least of his (Mr. Hogarth's) Pieces, will be
> no Diminution of their Value.

This manifesto, repeated once in whole and later in part, sets the
stage for the fiasco that took place on 6 June. Vertue's account of the
day starts off with the generalization that Hogarth "is often projecting
scheems to promote his business in some extraordinary manner":

> but alass when the time came—to open this mighty secret he found
> himself neglected. for instead of 500. or 600 pounds he expected. there
> was but one person had got to bid. without any advance. the only sum
> of 120 pounds. by which he saw the publick regard they had for his
> works—but this so mortified his high spirits & ambition that threw him
> into a rage cursd and damned the publick. and swore that they had all
> combind together to oppose him—
>
> at the same time he carried on a subscription for two prints from
> paintings of his. however he therein got a good subscription.
>
> by this his haughty carriage or contempt of other artists may now be
> his mortification—<and that day following in a pet. he took down the
> Golden head that staid over his door—. . .>

Vertue paints a vivid picture of Hogarth's disappointment, his rage at
the public, and his taking down his sign, the Van Dyck's Head. His six
paintings did indeed sell for £21 apiece, from which the cost of "ele-
gant Carlo Maratt frames" at four guineas each must be deducted.
John Lane of Hillingdon, the purchaser, wrote an account of the
affair and speculated on what had gone wrong with Hogarth's
"scheem," as Vertue called it: "This *nouvelle* method of sale probably
disobliged the Town; and there seemed to be at that time a combina-
tion against poor Hogarth, who, perhaps from the extraordinary and
frequent approbation of his Works, might have imbibed some degree
of vanity, which the Town in general, friends and foes, seemed deter-
mined to mortify." He may, of course, have been echoing Hogarth's
own view. Another account, an anonymous letter to the *St. James
Chronicle* in 1781, recalling the advertisement that forbade picture
dealers from bidding, adds that Hogarth also "called on his friends,
requesting them not to appear at the sale, as his house was small and
the room might be overcrowded. They obeyed the injunction. Early
on this mortifying day he dressed himself, put on his tye-wig, strutted

away one hour, and fretted away two more"—and no bidder appeared. About 11 A.M. Mr. Lane dropped in, "when, to his great surprise, expecting (what he had been a witness to in 1745, when Hogarth disposed of many of his Pictures) to have found his Painting-room full of noble and great personages, he only found the Painter and his ingenious friend Dr. Parson, Secretary to the Royal Society. These gentlemen sat in the Painting-room, talking together, expecting a number of spectators at least, if not of bidders."

When Hogarth opened the box, he found only one bid, for £120. Since nobody else came in, about ten minutes before twelve by the decisive clock in the room, Lane told Hogarth he would raise the bidder's pounds to guineas. The clock struck twelve; and Hogarth wished Lane joy of his purchase, hoping it was an agreeable one. He then asked Lane to promise him he would not dispose of the pictures or have them cleaned without first giving him notice.

A day or two later a gentleman approached Lane at a coffeehouse and offered him £200 and more for the paintings, and, he reported that a gentleman in public life once offered him three hundred guineas for them, but whenever he and Hogarth met, Lane always told him he intended to keep them as long as he lived.

An event that seems to have disturbed Hogarth in the period before the publication of *The Analysis of Beauty* was the test case for the Engravers' Act. The first prosecution under the statute did not occur until 24 July 1750, fifteen years after enactment; this case was successfully concluded for the plaintiff, but the next one, three years later, exposed a loophole in the act. Thomas Jefferys, a printseller specializing in maps and charts at the corner of St. Martin's Lane, brought suit against Richard Baldwin, a bookseller of St. Paul's Churchyard, who had copied "A View of the British Fishery off the Sᵒ Coast of Shetland" for the *London Magazine*. The print had originally been made for Jefferys, who paid the artist and "took an assignment of the right to the property in it accruing to the Artist by the Act of Parliament." John Hawkins, who tells the story, was at the hearing before Lord Hardwicke on 22 March 1753 in the Court of Chancery—presumably in the hall of Lincoln's Inn, where the business of the Court of Chancery was frequently transacted, and where Hogarth's *Paul before Felix* hung, looking accusingly down on the proceedings. Lord Hardwicke, pointing out that no assignee claiming under an assignment from the

original inventor could take any benefit from the print, found for Baldwin. Although this affected only printsellers and in no way interfered with the artist's own interest, Hogarth expressed his displeasure to Hawkins afterward.

Hogarth apparently thought Hardwicke's decision a great enough setback to circulate among his friends a caricature of the chancellor as a spider in the center of a tangled web spotted with his victims. Although the only source for this story is Wilkes (*North Briton* No. 17), a decade later when he was using any weapon at his disposal to attack Hogarth, it seems likely that it is distorted only in underplaying the very private nature of Hogarth's outburst. If the story has any truth, it must be connected with Henry Fox's speech of 29 May 1753 attacking the Clandestine Marriage Act and its chief advocate Lord Hardwicke, comparing his Court of Chancery and its proceedings to a great spider. The dates are so close it seems quite likely that Hogarth did pick up Fox's simile; perhaps the drawing was made for Fox himself— a year later he was the first subscriber to the *Election* prints. Nevertheless, only a year after Hardwicke's decision, Hogarth brought out his print celebrating the success of the Engravers' Act as subscription ticket for his *Election* prints.

Hogarth still regarded the act as his own responsibility. He saw himself, and was seen by many, as the guardian of English art, the symbol of the English artist. By the 1750s his name was almost proverbial for a kind of comic-moral picture and for a common-sense, nationalistic attitude toward art. His profile in tricorn hat, busily sketching, was copied from *The Gate of Calais* onto numerous printsellers' shopcards and signboards. Comic prints of all kinds were being sold at John Smith's "Hogarth's Head" in Cheapside, and Ryall and Withy's "Hogarth's Head and Dial" in Fleet Street. His own folio of prints was a standard item in the libraries of all classes who could afford it, and individual prints decorated the walls of private and public houses throughout the land. A merchant named Purce left Hogarth a legacy of £100 as an acknowledgment for the pleasure and information the testator had received from his works. This particular fame was not to be shaken by subsequent events.

HOGARTH'S CRITICS AND THE ACADEMY

Just two years after the engraving of *The Gate of Calais* appeared, Tobias Smollett published his second novel, *The Adventures of Pere-*

grine Pickle (February 1751), well seasoned with recognizable carica-
tures of his current enemies. George Lyttleton as Gosling Scrag and
Hogarth's friend Fielding as Mr. Spondy were only the most scurril-
ous, because most personal, of a rogues' gallery that also included
Quin, Chesterfield, and Garrick. With the possible exception of Ches-
terfield, these were all part of the Fielding–Hogarth circle of ac-
quaintance. The physician-poet whom Peregrine meets in Paris in the
Palais Royal (Chapter 46) was recognized as Mark Akenside.

In 1751 Smollett was a peppery young Scot of barely thirty who had
come up to London in 1739 to make his way in the literary world,
and had been thwarted (he felt) by the theatrical coteries. Quick to
respond to an affront, real or fancied, Smollett had replied to the the-
atrical folk in *Roderick Random* (1747), and to the literary in *Pere-
grine Pickle*. In general he aimed his satire at his seniors, the famous
and accepted leaders of the London literary establishment. Fielding
had made a great splash with *Tom Jones,* Garrick was the foremost
actor of the age, and Mark Akenside, though exactly Smollett's age,
was already famous as the author of *The Pleasures of the Imagination*
(1744), though perhaps his particular offense was a reference in his
Ode to the Earl of Huntingdon (1748) to "the barbarous Host" of
Scotsmen.

The physician-poet's (Akenside's) companion in Paris is a painter
named Pallet. While the Doctor is a young man, a lover of the an-
cients dressed in sober black, Pallet is a modern who, "though seem-
ingly turned of fifty, strutted in a gay summer dress of the Parisian
cut, with a bag to his own grey hair, and a red feather in his hat." He
is "a painter from London, who had stole a fortnight from his occu-
pation, in order to visit the remarkable paintings of France and
Flanders." He is "extremely talkative," he "pronounce[s] judgment
upon every picture in the palace" (the Palais Royal), and reveals with
every word his pomposity as well as his ignorance of art, French, and
Latin.

Hogarth was by far the most famous artist in London at this time,
and he had "just turned fifty" in 1747. He was, as I have noted, well
known for his jaunty dress; and Vertue and others have recorded how
he loved to hold forth, belittling "all other professors of Painting."
By this time he had begun to talk about his "Line of Beauty" and
other theoretical matters concerned with art. The anecdotes illustrat-

ing Hogarth's ignorance of foreign or learned languages surfaced a few years later when he published *The Analysis of Beauty,* but others probably existed earlier, and he no doubt encouraged them: he saw himself, after all, as that common-sense pug. His friendships with medical men were well known. The name Pallet would support the identification. In 1749, if not earlier, he had issued his engraved self-portrait, pretentiously entitled *Gulielmus Hogarth,* which showed him with his dog Trump and a large, prominently displayed palette inscribed with the intentionally tantalizing Line of Beauty. An artist's palette was already a Hogarth trademark, appearing as his seal affixed to the subscription tickets for his engravings.

As an immediate source for his parody, Smollett made use of Hogarth's recent abortive trip to France and the print publicizing it. Smollett recalls the unhappy affair by giving Pallet an analogous fiasco in Chapters 49 and 50: he is imprisoned in the Bastille as a result of disguising himself as a woman (another case of mistaken identity), and later released on the condition that he and Peregrine leave Paris in three days. The story of Hogarth's getting into trouble through his sketching appears in Chapter 67, where Pallet sketches an old Capuchin preaching in Antwerp Cathedral and is nearly mobbed by the congregation.

The caricature of Hogarth in *Peregrine Pickle* can be attributed in part to guilt by association and in part to the fact of Hogarth's prominence. His friendship with Fielding and Garrick had been manifested in painting and print (Richard III was a role censured by Smollett in the novel); worse, he was a close personal friend of both. Smollett does not, however, bring Pallet together with Spondy, and while his treatment of Fielding is grossly personal, he shows Hogarth in his public image, expressing his public views; the only private incidents alluded to are ones that Hogarth himself publicized (and he was, judging by Vertue, regarded by some of his contemporaries as a self-publicist). His career in general was extraordinarily public: from his proposals for his progresses, to his advocacy of the Engravers' Act, to his defenses of his art and his attacks on the art of rivals. He was not only the best-known English artist of the period, but also potentially the best comic butt; Smollett was one of the first to utilize this potential, in print at least. But already Smollett differentiates, as would most of Hogarth's later attackers, between the great comic

moralist and the poor, pretentious, silly painter and aesthetician who attempted abortive flights toward the sublime. Pallet is presented as a history painter, a creator of only the most serious works.

Like almost every novelist of the time, Smollett often invokes Hogarth's work as a metaphor to stress the comedy of a given scene. In *Roderick Random* he notes that "It would require the pencil of Hogarth to express . . ." (Chapter 47), and in *Peregrine Pickle* itself: "It would be a difficult task for the inimitable Hogarth himself to exhibit the ludicrous expression of the commodore's countenance . . ." (Chapter 14). It is the enthusiast for "the sublime parts of painting" who appears in *Peregrine Pickle,* the Hogarth of *Moses Brought to Pharaoh's Daughter* and *Paul before Felix*—paintings that roughly correspond to the efforts of which Pallet is so proud. *Moses Brought to Pharaoh's Daughter,* on display in the Foundling since 1747, may be recalled in Pallet's work-in-progress, another Egyptian subject, "Cleopatra"; an unkind critic might have seen Cleopatra in the sensuous lounging figure of Pharaoh's daughter, which clearly draws attention away from the young Moses. Pallet's "Judgment of Solomon" (Chapter 46) might also be a parody of Moses' choice between his two mothers, but I suppose Smollett is alluding to *Paul before Felix,* with Felix choosing between Paul and Tertullus, which was by this time on display in Lincoln's Inn.

Smollett is the first person to publicly attack Hogarth's attempts at sublime history, and to draw the unkind inference that by using Raphaelesque motifs he is trying to outdo the Italian. Pallet's "Judgment of Solomon" may, indeed, refer more specifically to the burlesque "Judgment of Solomon" that hangs on the wall of the bagnio in the fifth plate of *Marriage à la Mode.* Perhaps Smollett is suggesting that Hogarth's history painting cannot in fact be distinguished from his burlesques of the genre.

The final characteristic of Hogarth remarked by Smollett, and by Vertue as well, was his business sense. When Pallet reappears in London (Chapter 96), spouting disdain for the connoisseurs, he has arranged a picture lottery for "Cleopatra," with subscription and proposals, and he offers to sell Peregrine a chance for "such a trifle as half a guinea." Hogarth's dislike for connoisseurs, his picture auctions, his published proposals for them, and the eccentric way in which he carried them out, were well known. Smollett, however, recalls here the

more recent lottery for the painting of *A March to Finchley*, 30 April 1750, which coincides with Pallet's down to the detail of the price, half a guinea. Vertue, who describes this lottery, might not have agreed with Peregrine's opinion that it was "a begging shift to dispose of a paultry piece, that he could not otherwise have sold for twenty shillings," but he does conclude that "such fortunate successes are the effect of cunning artfull contrivances."

Thus Smollett's satire contains all the assumptions on which later attacks were based: from the superiority of Italian art to the particular flaws noted in the painter, contrasted with the talent of the comic moralist and the implication that he was just another comedian who wanted to play Hamlet. Perhaps because the time was not yet ripe, contemporaries appear not to have played up Hogarth's portrait in Pallet. The nickname that caught on in the 1750s, though taken from the same print, was not Pallet but Painter Pugg.

There is no real point in time when the hostility toward Hogarth shown in Smollett's caricature can be said to have originated; it may have been latent among his artist contemporaries, who agreed with his defense of English art but regarded it as self-praise, to some extent at least. Most obviously, as I have indicated, it followed his efforts to paint and engrave sublime histories. But it may also have been given an impetus in the late 1740s by the changing ideas in France, where the impatience with mythological subjects in history painting that Hogarth had shown in the 1730s came to the surface, launched by La Font de Saint-Yenne in his *Réflexions sur quelques causes de l'état présent de la peinture en France* (1747). Saint-Yenne, and many others after him, attacked the rococo of Boucher and his followers, the erotic scenes and pretty little portraits. But unlike Hogarth, they unequivocally demanded a return to the dignity of true history painting—to noble themes and compositions in the grand manner. Naturally the attack fell upon small genre scenes and landscapes as well; works with no higher aim than imitation of nature were considered trivial and tending to undermine the taste for serious historical subjects.

The alternative of moral scenes by a Greuze had not yet been raised by Diderot; and Hogarth's solution to the problem of decadent mythological painting had been modern moral subjects in an essentially rococo style. Therefore, the demand for seriousness of subject, classical and historical in tone, must have touched him at a sensitive point.

As usual, he at once reacted against such demands and felt their influence; he had, in fact, anticipated them in the simplified forms of *Garrick as Richard III* and *Moses*.

The Abbé Jean-Bernard Le Blanc was one of the originators of the movement back to seriousness with his *Lettre sur l'exposition des ouvrages de peinture* (1747), but it was his *Letters on the English and French Nations*, translated and published in England in the same year, that left its mark on English artists and connoisseurs. Letter XXIII, entitled "On the State of Painting and Sculpture in England," is based on a visit to England in the late 1730s. The gist of the argument is that while English connoisseurs strip the continent of its greatest art treasures, England itself produces no painters of its own. Although the reverberations of this statement were to be profound in England, the more immediately galling assertions concern native history painters. Thornhill, the only Englishman who had attempted this high genre, is scornfully dismissed; all the rest have aspired no higher than portraits—and then for money rather than reputation. Kneller, the Abbé says, launching into his attack on English portraiture, could have made his reputation only among the English. He makes the conventional distinction "in painting, as in poetry," between the two extremes, the sublime and burlesque.

The letter ends with Le Blanc's remarks on Hogarth himself, which seem to have had some effect in the years that followed:

To conclude, those of them who have the talent to paint nature in burlesque, ennoble it by the use they make of it: they employ it to give a disrelish to vice.

The Luxembourg gallery by Rubens, or the battles of Alexander by Le Brun never had a greater run in our country, than a set of prints actually have in England, engraved lately from pictures of a man of genius in this way, but who is as bad a painter, as he is a good subject. They have made the graver's fortune who sells them; and the whole nation has been infected by them, as one of the most happy productions of the age. I have not seen a house of note without these moral prints, which represent in a grotesque manner the Rake's Progress in all the scenes of ridicule and disgrace, which vice draws after it; sometimes even in those circumstances, the reality of which, if tolerably expressed, raises horror: and the English genius spares nothing that can inspire it. Thus the ancients were of opinion, that nothing could give such an aversion for intemperance, as the very sight of a person

labouring under the effects of it. I verily believe that such pictures make a deeper impression on a people like this, who delight in strong representations, than the most sensible reflections, or the most pathetic discourses. What do I say? The human kind are the same every where: whatever end is proposed, it is surer and easier to make an impression on the senses, than to convince the understanding.

This passage contains almost all the assumptions about Hogarth that held until long after his death, until in effect the exhibits of his paintings in the early nineteenth century. He is, whatever he may say himself, a burlesque painter, "a man of genius in this way," but as bad a painter as he is a good moralist. He remains something of a sport, and yet quintessentially English, in his limited and provincial emphasis on the grotesque.

The decade of the 1750s thus opened for Hogarth on a new and unresolved note. In this decade Hogarth chose to devote himself to his own peculiar, rather insular thoughts on the artist, in fact turning from the brush to the pen and producing a treatise on aesthetics. He also published his history paintings in engravings, produced satires against continental art, and when other artists began to agitate for a national academy, found himself resolutely swimming against the tide. The center of his alienation was, ironically, the St. Martin's Lane Academy. He had created it and brought about the developments that opened new outlets for artists—the general public, the pleasure gardens, the hospitals, and the new public buildings. These effectively offered alternatives to personal patronage, increasing both the artist's independence and his status. One reaction, which Hogarth shared with the rest of the St. Martin's group, was expanded criticism of aristocratic patrons and silly connoisseurs. A second reaction, less strongly shared, was a growing agitation for a state academy.

Behind much of the theory of art in the eighteenth century was the example of France. In 1737 a daily paper, copied by the *Gentleman's Magazine* (VII, 1737), had commented: "About two hundred paintings, and other prize pieces, of the Academy of Painters at Paris, are daily visited by the curious of all nations at the Louvre. What a discouragement . . . is it to the ingenious Men of *Great Britain* that we have no yearly Prizes to reward their Pains and Application!"

In 1747 the Abbé Le Blanc's criticism had appeared, and Hogarth's friend Dr. Parsons in his treatise on physiognomy promptly replied, pointing to the great works in St. Paul's, St. Bartholomew's, the

Foundling, and Greenwich Hospital. But he admits that there is little encouragement in England for anything but little portraits.

Partly to answer Le Blanc, John Gwynn published two years later (1749) *An Essay on Design: Including Proposals for Erecting a Public Academy to be Supported by Voluntary Subscription (Till a Royal Foundation can be obtain'd) For Educating the British Youth in Drawing, and the several Arts depending thereon.* Beginning with Le Blanc's assertion that the English, while a wise people, lack taste: "Tho' in our Writings we abound with good Matter," Gwynn writes, "we know not, according to him, how to make a good Book: That is, we are deficient in Rule, Judgment, and Method." Thus what is needed is an academy. English artists "have wanted, while young, the Assistance of an *Academy,* which should lead them on from the first Principles of Geometry and Perspective, thro' all the Rules of correct Drawing, and make them conceive a true Standard of Excellence before they attempt to excell."

Academies were in the air. In July 1749, Vertue records a conversation with Frederick, Prince of Wales, in which the latter "spoke much concerning the settlement of an Accademy for drawing & painting." This may have been the time when Vertue drew up his own plans for an academy; clearly many were doing so. An academy, going back to the Renaissance concept, was a place where old and young could meet to draw the works that formed somebody's collection: the essentials were the works themselves and the desire to copy them. In contrast to the apprenticeship format, older and younger artists practiced together. This was essentially the academy as Hogarth carried it on, with Thornhill's "collection" of casts, in St. Martin's Lane.

The academies that led to the French Academy began with the rise of mannerism; these emphasized precise laws as to procedure and the election of an elaborate system of functionaries. Young artists who wished to become members had to submit "reception pieces," and amateurs could be elected to membership. The formality probably followed from the initial aim of most artists in founding an academy: to raise the artist above the level of a craft guild to the rank of a scientist or scholar. Although the artists saw the academy in terms of social status, royal favor, annual exhibitions, and the like, contemporaries thought of it as a school of art: "to train students—and to train them in one particular style of drawing and modelling, the style of the King and the Court"—as Hogarth implied when he wrote that "Lewis

the 14 got more hon^r by establishing a pompous parading [academy] at paris than the academician." And, Hogarth adds, citing Voltaire as his authority, "after that establishment no work of genius appeard for says he they all became imitators and mannerists."

The essence of Hogarth's academy was its informal and democratic structure, but this was being undermined from within and without in the late 1740s. The artists' committee at the Foundling Hospital had brought them into the public eye as never before, and had also evidently led to factions. Rouquet's account of the difficulty the artists had gaining recognition and their attempt to prove their importance at the Foundling is juxtaposed, perhaps significantly, with his remark, "And indeed, the artists themselves have contributed to this injustice, by running one another down, as they usually do." The next paragraph turns to Hogarth's "new kind of pictures." The implication, I think, is that the Foundling artists attacked each others' pictures, then and later, and that Hogarth came in for this kind of abuse.

It was clear, however, that no support was going to come from George II, that notoriously uncultivated king. Since Hogarth's dedication of *The March to Finchley* to the King of Prussia as a "Patron of the Arts" is attacked in at least one of Sandby's satires (*The Painter's March to Finchley*), it seems likely (in view of Gwynn's emblematic image of George II) that Hogarth was referring ironically to some artists' attempts to get support from the king. But in 1751, with the death of Prince Frederick, people became aware of their king's age; and the new Prince of Wales, who was born and educated in England, suddenly seemed much more promising than his father. The artists began to look toward the next reign. Hogarth's own comment on how the project got started was that "His present majesty's inclination to those arts set those that now belong to it a maddning," which led to the meeting at the Turk's Head. Considering that Hogarth wrote this around 1760, it seems quite likely that he was referring to George III as "his present majesty," and the attention Hogarth himself paid to the prince—putting him into the *First Stage of Cruelty* in 1751 and later into Plate 2 of the *Analysis of Beauty*—suggests that he was perhaps showing some interest in the arts.

Hogarth's opposition derived from both public and private sources. Before him was the example of the French Academy, which was to prove prophetic of the English: from the search for official standards on which to organize art down to the "conférences" held by Le Brun,

which set the precedent for Reynolds' discourses. He would also have remembered the endless arguments between the colorists and the linear proponents, which the academy finally neutralized by presuming that all had been solved and having Louis Testelin draw up synoptic tables of Rules for Great Art (*Table de Préceptes,* published in 1675). Then another compilation followed, by De Piles, of tables allotting comparative marks to the great artists on the basis of 20 marks for perfection: thus Titian got 18 for color but only 6 for expression and 12 for composition; Michelangelo got 17 for drawing but only 4 for color and 8 for expression and composition. Hogarth's thinking on the founding of an academy was very modern: he recognized, as historians do today looking at the Royal Academy, that a national academy of art is a contradiction in terms. His opinion of course presupposes an organic and changing conception of art that was counter to his times and to the feeling that the best in style could be fixed and passed on as a tradition.

There were no doubt personal reasons as well—his own success story being one. "I know of no such thing as genius," Hogarth said to Gilbert Cooper; "genius is nothing but labour and diligence." Something like this must have been a favorite saying of his in the 1750s (it crops up in his Society of Arts notes), but stressing the image of the self-made man, it missed the point that few others could have come out on top with his own lax training.

Hurt pride was undoubtedly another reason, for he must have regarded the St. Martin's Lane Academy with the fondness of a father. This organization had belonged to him and his father-in-law, and he insists repeatedly that for thirty years it had functioned efficiently and accomplished as much as any state academy could, while avoiding its inherent dangers and inequalities. This would have been one motive apparent to his colleagues who heard his arguments against an academy, but they do not bring it up in their attacks. They emphasize rather his pride and fear that in a state academy, not of his own running, he would lose prestige. And they also see him as a dog in the manger: for, although he opened the way for other artists at the Foundling, the only subsequent commissions for history painting were his own. No one could approach him in the sale of prints; Robert Strange, Vertue, and others could carry on with greater safety and profits in the reproductive line, but their profits were not comparable to Hogarth's. Pye was close to the truth, at least as seen by Hogarth's

colleagues, when he wrote that he "stood alone, the sole occupant of the field of patronage created by his own genius, and dependent upon the million." The author of *The Conduct of the Royal Academicians* (1771) says that the artists were brought together by the St. Martin's Lane Academy, but they still remained to a large extent "the property of picture-dealers, (at that time their chief employers) and held by them, in somewhat the same kind of vassallage and dependance, that many authors are by booksellers at this day" (meaning in 1771). Several meetings were devoted to discussion of "those difficulties and impediments, under which they laboured," and "the method most generally offered and approved, was the establishment of a public academy, as the most likely means to attract the notice of the public, and facilitate improvement."

Subscribers to the St. Martin's Lane Academy met at 7 P.M., Saturday 24 March 1753, at the Turk's Head Tavern in Greek Street "in order to settle the Accounts of the present Year, and to pay their first Subscriptions for the ensuing." Nothing more was recorded on the academy until the fall when, with or without previous discussion within, some of the members, including Hayman, took academy funds and printed a circular:

> Academy of Painting, Sculpture, &c.,
> St. Martin's Lane.
> October 23, 1753.
>
> There is a scheme on foot for creating a public academy for improvement of painting, sculpture, and architecture; and it is thought necessary to have a certain number of professors, with proper authority, in order to make regulations, taking subscriptions, &c., erecting a building, instructing the students, and concerting all such measures as shall be afterwards thought necessary.
>
> Your company is desired at the Turk's Head, in Gerard Street, Soho, on the 13th of November, at five in the evening, to proceed to the election of thirteen painters, three sculptors, one chaser, two engravers, and two architects, in all twenty-one, for the purposes aforesaid.
>
> Francis Milner Newton,
> Secretary
>
> P.S. Please to bring the inclosed list, marked with a cross before the names of thirteen painters, three sculptors, one chaser, two engravers, and two architects, as shall appear to you the most able artists in their several professions, and in all other respects the most proper for conducting the design. If you cannot attend, it is expected that you will

send your list sealed and inclosed in a cover directed to me at the
Turk's Head, Gerard Street, Soho; and that you will write your name
on the cover, without which no regard will be paid to it. The list, in
that case, will be immediately taken out of the cover and mixed with
the other lists, so that it shall not be known from whom it came,—all
imaginable methods being concerted for carrying on this election with-
out any favour or partiality. If you know of any artist of sufficient
merit to be elected as a professor, and who has been overlooked in
drawing out the inclosed list, be pleased to write his name according
to his place in the alphabet, with a cross before it.

Hayman is supposed to have chaired this meeting. It was an odd one,
presaging many more in which the real business was enacted by a gov-
erning committee, with the general meeting merely sanctioning their
action. The meeting was not called to discuss the merits of the pro-
jected academy or of abandoning the old one, or to argue over the
question of aristocratic patronage; presumably these points had been
argued out before or were regarded as unimportant. The purpose of
the meeting was apparently to secure the subscriptions of the general
group of artists in order to get the proposed establishment running,
and to give them an opportunity to choose officers from the slate that
was drawn up for them by the governing committee. It is not known
whether the elected slate was the same as the list that emerged in the
letter to the Dilettanti somewhat later; or whether Hogarth refused to
act with them, or went to the Turk's Head and debated with them—
probably not the latter, since they evidently had nothing to debate.

What exactly did Hogarth do at this time to rouse the ire of some
of his former colleagues? At the end of November the *Analysis of
Beauty* appeared, and this bore the brunt of the attack because in
some ways it was vulnerable. But the artists must have thought it sig-
nificant that this treatise should have been published at just this mo-
ment—the first sustained anti-academic treatise in the history of aes-
thetics, as it has been called. It opposed not only copying and training
students in particular styles, those mainstays of academies, but also the
whole system of categories (invention, expression, disposition, draw-
ing, etc.) and of rigid superimpositions on reality. In particular and
in general it attacked everything that the continental academy, upon
which the plan was based, stood for.

Hogarth's remarks on the events are confusing, but they could
mean that he had simply refused to assist in the promotion of the

scheme. Perhaps one may assume that Hogarth's former colleagues tried to set up a new academy on lines he disapproved of, that it threatened to destroy his and Thornhill's academy, and that Hogarth retaliated by refusing to let them have—or perhaps even removing— the studio equipment that was rightfully his. Thomas Jones, writing of the years 1764–65, refers to "that *unique* Anatomical figure and the other Effects which were the joint property of the general Sub- scribers to the old Academy in St. Martin's Lane"; they were still in existence then, and they later became the nucleus of the drawing school at the Royal Academy, but by Jones' time they were regarded as "joint property," not as Hogarth's own.

From Hogarth's remarks it is clear that the undemocratic organiza- tion was what he most disliked about the proposal. They were, he notes, in favor of "having salary as in france for telling as they do there the younger ones when a leg or an arm was too long or too short." His own academy at this time supported "with great order, and even with success to their pupils," as Rouquet put it a few years later in *State of the Arts,* "a model of each sex, by the annual and voluntary subscrip- tion of those who come there to learn." His testimonial might have been inspired by Hogarth himself: "This institution is admirably adapted to the genius of the English: each man pays alike; each is his own master; there is no dependance; even the youngest pupils with reluctance pay a regard to the lessons of the masters of the art, who assist there continually with an amazing assiduity."

Some of the members, according to Rouquet's account, "with a view of rendering the arts more respectable, and at the same time of establishing a public free school," began to seek out ways of incorpo- rating themselves into an academy. It was to discredit Hogarth, and forestall a pamphlet about the proposed academy which he evidently threatened to write as a sequel to his *Analysis,* that Paul Sandby pro- duced his eight etchings in quick succession beginning in December. In the late 1740s, Sandby, a young man of just over thirty, joined his brother Thomas (who had connections with the Duke of Cumber- land) in sketching the work being done at Windsor Great Park. He had been with Thomas and the duke in Scotland; in 1746, on the strength of this connection and the sketches, he was appointed drafts- man to the survey of the Highlands made after the suppression of the rebellion. He had only quitted this service in 1751, and thereafter he sold his etchings of Scottish landscapes, twenty-six plates altogether.

On 6 December 1753 he published "Eight Perspective Views of Cities, Castles and Forts, in North Britain." These were the topographical watercolors from which Gainsborough dissociated himself and of which Constable was thinking when he called Sandby "the only man of genius" who painted "real views from Nature in this country." Sandby's pictures were carefully observed scenes and reactions against the picturesque arrangements of nature à la Claude or Gaspar Poussin; in this sense they resembled Hogarth's. He was doubtless amused by the generalizations and formalizations of Hogarth's treatise, and his satiric response is remarkably close to Hogarth's own to Kent and Burlington in the 1720s. As Hogarth's luck would have it, Sandby was after himself the most talented graphic satirist of the mid-century.

Sandby's distrust of Hogarth probably began with the academy. It is not known whether he ever attended it, but he and his brother were holding sketching classes of their own in their house in Poultney Street in early 1753. He must have came into contact with Hogarth in some way, and his vision of Hogarth's studio in *Burlesque sur le Burlesque* (pl. 99) may carry some authority. The appearance of Dutch prints on Hogarth's easel may mean (as was probable) that he had many, or merely that he plagiarized motifs from them; but the "students" shown at work are clearly imaginary, since Hogarth did not take students during these years. On the other hand, *The Gate of Calais* would have hung on his wall as shown, as yet unsold, and someone may have told Sandby that Hogarth had some such arrangement of blinds on his studio windows. As a portrait, the Hogarth of *Burlesque sur le Burlesque* relies entirely on the hat type shown in *The Gate of Calais* and perpetuated already in copies of the head on shop bills and watch papers. The gross-featured figures at the top (in the lantern) and the bottom, however, are also meant for Hogarth, and in the subsequent prints the face became more individualized: drooping eyelids, pouchy-eyed, heavyset, with noticeable jowls. The body is humped, slouching, and aging, but in motion it struts with a comical military gait.

The objects of attack in Sandby's other satires are easily formulated, the principal one being Hogarth's self-conceit. He sees himself as a great painter of sublime history, which turns out in *Burlesque sur le Burlesque* to be "A history piece, suitable to the painter's capacity, from a Dutch manuscript"—Abraham sacrificing Isaac by pointing a blunderbuss at his head, with an angel preventing him by urinating

99. Paul Sandby, Burlesque sur le Burlesque; Dec. 1753 (BM)

on the firing pan of the weapon. (This joke, referring to a nonexistent Dutch original, had been current for half a century, going back to the time of William and Mary.) Another is Hogarth's attempt at theorizing in *The Analysis of Beauty*. The attack on the *Analysis* falls into three parts: its folly, its plagiarism, and the assistance Hogarth received in its writing from his friends. The theory itself is most effectively satirized by showing all sorts of grotesque or ugly shapes that adhere to the so-called Line of Beauty—a parody of Hogarth's own use of humble if not vulgar objects as his examples.

Related to Hogarth's opposition to the public academy are allusions to Hogarth's substitute plan, the Foundling Hospital, and the possibilities he apparently said this offered artists. Much is also made of his disposal of the *March to Finchley* painting by lottery to the Foundling, presumably to suggest that he was interested in the Foundling for purely personal reasons. With *The Mountebank Painter, The Author Run Mad,* and *The Painter's March from Finchley,* Sandby begins alluding derisively to the new subscription for *An Election Entertainment,* which began in March 1754.

At his most effective, Sandby burlesques Hogarth, who is presented as constantly accompanied by his pug and, in some instances, as himself half man and half dog (referred to as Pugg or *Doguin*)—again taken at his own evaluation. He is a hawker and mountebank (reference to his self-advertisements), a megalomaniac surrounded by disciples, a man gone mad with delusions of grandeur, and a merchant who thinks up schemes like lotteries and auctions to get 'rid of his paintings. He is also, as Sandby sinks into miscellaneous private innuendoes, a henpecked husband: he is horned and pursued by a shrewish wife in *The Painter's March from Finchley.*

When Sandby's attack began, Kirby, Benjamin Wilson, and some other artists rallied to Hogarth. One surviving print defending him appeared very early in 1754, and showed a group of connoisseurs sitting around a table, one trampling the *Analysis* underfoot (and Milton and Shakespeare with it) and all of them examining with pleasure the *Burlesque sur le Burlesque.* Against the wall can be seen "A List of Professors Public Academy Buckhorse Prof——," Buckhorse being a contemporary pugilist. William Kent's designs and Sandby's *Views of Scotland* are also in evidence, as well as volumes inscribed "Defense of Atheism" and "Romains Philosophy" (to which Hogarth was to allude in *Credulity, Superstition, and Fanaticism*). Not a very striking

piece of work, it was soon followed by a second equally weak defense called *A Club of Artists,* which was answered by Sandby's *Painter's March from Finchley.*

The last-named print was sold on 1 April, by which time the "frontispiece" *The New Dunciad* was also on sale, and all eight prints were out and available in sets, entitled *The New Dunciad, done with a view of fixing the fluctuating ideas of taste: dedicated to his friend Beauty's Analyser.* Though hasty and careless Sandby was a talented caricaturist and emblematic satirist, and a worthy antagonist.

The Analysis of Beauty

The careful reproductive engraving of the two prints after his history paintings must have taken much of Hogarth's time during the latter part of 1751. At the end of February 1751/2, he announced their completion, and on 24 March he inserted a notice in his friend Fielding's current periodical, the *Covent-Garden Journal:*

Mr. HOGARTH *Proposes to Publish, by* SUBSCRIPTION,
A short Tract in Quarto, called THE ANALYSIS OF BEAUTY. Wherein Objects are considered in a new Light, both as to Colour and Form.
(Written with a View to fix the fluctuating Ideas of Taste)
To which will be added
Two Explanatory Prints, serious and comical engraved on large Copper-Plates, fit to frame for Furniture.
Five Shillings to be paid at the Time of Subscribing, and five Shillings more on the Delivery of the Book and Prints. The Price will be raised after the Subscription is over.
Subscriptions are taken at his House in Leicester-Fields, where may be had all his other Works bound or otherways.
N.B. The Two Prints, one Moses brought to Pharoah's Daughter, the other Paul before Felix, are ready to be delivered to the Subscribers.

Proposed in March 1752, the book and plates were not completed and delivered until the end of 1753, twenty-one months later. Hogarth would surely not have been so bold as to announce the treatise without a draft of some sort that had been seen by his friends. But considering the length of time he took to finish it, and the drafts that have survived, it appears that at best he had only his rough draft, which outlined the main ideas developed and elaborated in the later drafts.

Hogarth's Line of Beauty, of course, first appeared on the palette in his self-portrait of 1745 (pl. 74), to be seen hanging in his studio until about 1749, and thereafter in the engraving, *Gulielmus Hogarth* (pl. 128) as well. A remark of Vertue's indicates that in 1745 the Line of Beauty was a frequent topic of Hogarth's conversation (perhaps stimulated by the painting). The painter Giles Hussey, he notices, had developed a theory of triangles for producing true proportions in figure drawing, which, as he records with gentle irony, shows that all the ancients wrought in error. "Hogarth," he writes, "(in opposition to Hussey. scheem of Triangles.) much comments on the inimitable curve or beauty of the S undulating motion line, admired and inimitable in the antient great Sculptors & painters." The triangle plays an important part in Hogarth's theory too, and his reaction to Hussey's assertions may have been less "opposition" than modification by drawing attention to the Line.

In the preface to the *Analysis*, Hogarth explains that his treatise evolved out of arguments about the Line of Beauty. He says he intended the enigmatic s-curve as a "bait," and "The bait soon took." But then arguments and jokes followed. The general attitude of his friends, apparently amusement at an amiable crotchet, is evident as early as July 1746 in Garrick's remark, among reminiscences of a happy visit with Hogarth at Old Alresford: "I have been lately allarm'd with some Encroachments of my Belly upon the Line of Grace & Beauty, in short I am growing very fat." One can visualize Hogarth during the years 1745–53 walking around London, observing as always expressions and movements, how light plays on a surface, what form shadows take as he walks beside a wall; but now looking more selectively and tendentiously, seeking examples to fit his thesis. He mentions the "ordinary undulating motion of the body in common walking (as may be plainly seen by the waving line, which the shadow a man's head makes against a wall as he is walking between it and the afternoon sun)." He began to pore over Cheselden's *Osteographia* with a more intense interest and delve into Montfaucon's *L'Antiquité* with a more specialized attention than before. It is a great pleasure, in reading the *Analysis*, to come across Hogarth's descriptions of contemporary life, verbal equivalents of the details that fill his prints; he must have taken pleasure in writing them. He provides acute commentary on physiognomy and curious speculation on epidermal structure, even advice on how to keep one's child from bashfully lowering

his chin and thus forcing his body into an ugly line. He was a close observer, he had a naturally inquiring mind, and he loved to generalize. It is difficult to imagine him not passing on his discoveries about form to his friends and colleagues.

Hogarth's colleagues at the St. Martin's Lane Academy (and perhaps Slaughter's, which amounted to the same thing) badgered him about his Line. Argument grew, "the torrent was against" him, he "ever had the worst on it" and got the reputation of being obstinate; at the same time, he asserts that "several of my opponents [who] had turn'd my arguments into ridicule, yet were daily availing themselves of their use, and venting them even to my face as their own." He seems to have been particularly piqued to think other artists were ridiculing his theory while unconsciously practicing its principles.

The subscription ticket for *The Analysis of Beauty,* issued in March 1752 at the time of Hogarth's advertisement, illustrated his situation with the story of Columbus and the egg. Everyone had laughed at Columbus' theory, but when he returned from his discovery of the new world (i.e. the Line of Beauty), jealous courtiers insisted that anybody could have done it. Columbus tested their assertion by asking who among them could stand an egg on end, and when none could, he simply smashed the end of the egg and stood it up: clearly, the ticket implies that it takes a Columbus—or a Hogarth—to demonstrate the obvious for the less observant masses.

From Hogarth's account and his subscription ticket, it appears that the *Analysis* originated as an attempt to explain himself. Much of his career from this point on would be devoted to such explanation, although in one sense it began with his early *Hudibras* frontispiece and *Boys Peeping at Nature.* He may have felt it necessary, following the engraving of his sublime histories, to demonstrate that his painting was not a mere recording or imitating of nature, that there was a system behind it unperceived by such critics as Smollett when they equated him with the Dutch literalists.

Self-justification is an important part, but only a part, of Hogarth's reason for writing a treatise on aesthetics. He had commented on art in his early prints, but with reference to genres and modes, to the doctrine of art treatises, rather than the wider problem of beauty. His bent was naturally toward generalizing, toward instructing others, and perhaps, following his father, toward creating theories. One can see in the additional emphasis on art as subject in the late 1740s a tend-

ency to pass from specific concepts like "comic history painting" to general aesthetic concepts; certainly the first plate he made for the *Analysis* is of a piece with *Taste à la Mode* and the first and fourth plates of *Marriage à la Mode*. His reason for settling down to write out his thoughts as well as materialize them in images, however, may have been quite simply that he wanted to carry out something his father had failed to do: *The Analysis* represented the scholarly work Richard Hogarth never got into print because of the booksellers. (The shocking reaction from some quarters after publication of the *Analysis* was to have, accordingly, a greater effect on Hogarth than it might otherwise have had.) He insists that he wanted someone else to write it for him, and after this experience he used mouthpieces like Rouquet and Bonnell Thornton to convey his thoughts into print, but he still continued to write, even if his fear of a repetition of the *Analysis* attacks prevented him from publishing.

Hogarth evidently knew how his contemporaries felt about his new venture: having challenged Raphael with *Paul before Felix,* he was now going to challenge Alberti, Lomazzo, Shaftesbury, Richardson, and the rest on their own ground. And, of course, it was less to prove himself a Renaissance Man than to correct what he took to be the critics' stultifying effect on contemporary art. Throughout his career he had carried on a dialogue with them, adjusting all his movements to their doctrines, modifying here and subverting there but never stepping outside their frame of reference. Now he did so with a vengeance, and it must have afforded him a pleasant sense of release.

His literary friends provided another sort of impetus. Fielding had encouraged his theorizing about art but evidently played no part in the *Analysis;* a sick man, he was devoting the last ounce of his energy to the war against crime in London. Benjamin Hoadly and James Ralph, old friends, the one a physician and amateur playwright and scholar, the other a journalistic jack-of-all-trades, did offer him advice and a sympathetic sounding board for his ideas, as did many others such as the Reverends Thomas Morell and James Townley.

Joshua Kirby, though he did not assist Hogarth with the *Analysis,* was working along the same theoretical lines; and communication with him may have had an effect on Hogarth (Kirby appears among the other "disciples" in Sandby's satires). Nineteen years Hogarth's junior, Kirby had been apprenticed as a youth to a widow in Ipswich as a house and sign painter, setting up his own business around 1738.

By the late 1740s Kirby was Hogarth's agent in Ipswich for selling his prints—a sideline to his painting business. By 1748, he was also publishing views of ruins and churches in Suffolk; four years later he was deep in theoretical problems of perspective and had secured a promise from Hogarth for a frontispiece to the book he was writing, *Dr. Brook Taylor's Method of Perspective Made Easy* . . . (1754), dedicated to Hogarth. The drawing was *False Perspective* (engraved by Sullivan, pl. 100), characteristically both a satire on careless perspective and an example of Hogarth's own practice of punning with false perspective, as when the young man's sword *seems* to be stabbing the cuckolded Jew (*Harlot*, Plate 2) or the cow's horns *seem* to be sprouting from the unhappy husband's head (*Evening*). This little print is a nice example of the "love of pursuit" advocated in the *Analysis* and elaborately illustrated in its two plates.

Although not mentioned by Hogarth, or by Nichols or Ireland, one other name should be added to the list of those who in one way or another influenced the conception of the *Analysis*. This was Benjamin Wilson, a young man (born in 1721) who was as interested in science as in painting. He communicated his experiments with electricity to Martin Folkes and others at the Royal Society, Folkes characteristically advising him on both his experiments and his paintings. By 1750 Wilson was a friend of Hogarth's, and in 1751 the two of them perpetrated the Rembrandt hoax on Hudson. Wilson, with his broad scientific interests, his connections with the Royal Society (to which Hogarth sent a copy of the *Analysis,* possibly in hopes of being himself elected a member), and his inquiring mind, may have supplied the most powerful stimulus of all Hogarth's friends toward the formulating of his ideas in abstract terms. He may also be responsible for the spurious scientific precision that Hogarth sometimes injects into his argument.

Manuscripts of the first three drafts of the *Analysis* have survived largely because, after the attacks following publication, Hogarth wanted to make sure there was no doubt as to what he himself had written. If the first accusation made against him was that he stole his idea from Lomazzo, the second was that his treatise was written by his literary friends. The manuscripts prove that he was the sole author: only with the third draft, transcribed by an amanuensis, does Morell's hand become evident in corrections of style, though never of sense.

According to the early drafts of his preface, Hogarth approached

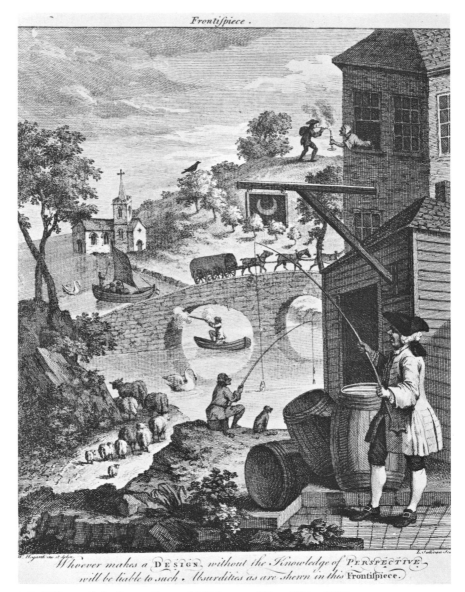

100. Satire on False Perspective; publ. Feb. 1754; 8¾₁₆ x 6¾ in. (BM)

one friend, apparently Hoadly, and discussed the project: should he verbally communicate his theory to Hoadly, who then would write it down? No ready answer provided itself—indeed, considering the complex of intentions involved, there was none—so Hogarth determined

to write it himself. Once he set to work, his method of composition seems to have roughly paralleled that of his paintings. He started with a conceptualized idea; then, with his imagination activated, illustrations, elaboration, and further ideas tumbled out, filling the margins and backs of pages, and covering additional scraps of paper. The difference was that in the discursive medium of the *Analysis* he never found a really satisfactory line of argument, equivalent to the narrative line of his progresses, on which to arrange his ideas; he came closest in the two prints which accompanied his text. Passages are constantly being moved about from one place to another. The theory of comedy, for example, is not in the first draft at all. It began with a marginal comment beside the words "Quantity add Greatness to Grace": "When Improper or Incompatible excesses meet they generally excite our laughter especially when the forms of those excesses are Inelegant that is when they are composed of unvaried lines." This set him thinking, and ideas flowed, mostly illustrations, until he had filled the margin and the opposite blank page. In the second draft the thought developed into a thorough "analysis of the ridiculous" parallel to the "analysis of beauty."

Of the finished manuscript, Hoadly evidently corrected a third (up to Chapter 9) for the press—this would be the lost fourth draft—but was prevented by illness from continuing. Hogarth then turned to Ralph, but by the time they had finished one sheet they were so at odds that they could not continue, though the incident did not affect their friendship. Hogarth's third recruit was Morell, who corrected the rest, except for the preface, which was corrected by Townley. The last fact may explain why certain absurdities that appear nowhere else in the treatise were allowed to remain in the preface.

The first draft of the preface is a sharper, more illuminating document in many ways than the final published version. Perhaps it made the polemical, even satiric intention of the treatise too emphatic—the sense in which its prose as well as its plates were an extension of the comic histories. In the published treatise a long and elaborately realized metaphor of the road is reduced to the bald statement that the "ingenious gentlemen who have lately published treatises" upon beauty, unable to discover the principle of the Line of Beauty, "have been bewilder'd in their accounts of [beauty], and obliged so suddenly to turn into the broad, and more beaten path of moral beauty."

The authors of art treatises, while not ignoring concrete paintings

and sculpture, omitted consideration of all else. Hogarth's witty account of authors, connoisseurs, and gentlemen of the grand tour is reduced in the published preface to the writers who "amuse their readers with amazing (but often misapplied) encomiums on deceased painters and their performances; wherein they are continually discoursing of effects instead of developing causes." These writers, for whom beauty is merely a system of rules, remain most cogently in the "je ne sais quoi" Hogarth disdainfully dismisses as their way of accounting for anything that cannot be explained in terms of their rules.

Hogarth had of late shown impatience with pretentious and misleading art treatises. In 1751 in *Beer Street* (pl. 94) he consigned to waste paper George Turnbull's *Treatise on Ancient Painting* (1740), which solemnly draws parallels between each Greek and each Italian painter (Appelles = Raphael, and so on), though Turnbull had seen no works by the former. As painter, Hogarth may have learned from Turnbull, but as critic he must have found preposterous Turnbull's attempt to uncover a whole new sphere of old masters.

In his preface Hogarth claims, perhaps somewhat disingenuously, to have read none of the basic art treatises—Lomazzo, Du Fresnoy, De Piles—before evolving his theory, which was based strictly on observasion. He shows elsewhere, however, that he was aware of the tenor of such treatises, perhaps originally encountered at the academy, and kept up with the treatises appearing in his time. It is quite possible, for example, that while he is perfectly truthful when he writes that Dr. Kennedy drew his attention for the first time to Lomazzo's passage on the serpentine line, he may have read it years before in John Elsum's *The Art of Painting after the Italian Manner* (1703) and forgotten about it but retained the germ of the idea. It is evident that after getting his "idea" he did read other treatises, whose appalling wrongheadedness prompted him to write his *Analysis* and cast it in the form he did, which was a modification if not contradiction of the whole approach to art perpetrated by the classic treatises and carried on by most of the recent authors. As he suggests in the preface, the art treatises showed how to paint or judge a picture, regarding the total painting as a moral and intellectual, indeed a literary, construct, and the divisions were invariably based on the terms Invention, Disposition, Proportion, Color, and Light, and thence progressed to the listing of the hierarchy of genres (history, portraiture, landscape, etc.)

found in the *artes poeticae* running from Horace to Boileau. "Beauty" was determined by a long series of abstract categories illustrated from works of the High Renaissance, at once prescriptive and restrictive.

Although he entitles his treatise *The Analysis of Beauty,* his actual subject is how the artist should express beauty in a painted picture. His break with tradition is evident at once in the absence of any mention of genres and in the chapter headings: Fitness, Variety, Uniformity, Simplicity, Intricacy, Quantity, Lines. Only toward the end, when these principles are firmly established, does he get around to the traditional categories of Proportion, Color and Light, Attitude and Action, which are viewed from his own unorthodox standpoint.

The second crucial dogma of earlier treatises which Hogarth utterly rejects is the importance of copying. Hogarth not only does not recommend copying, he is unconcerned with it. It does not figure in his study of formal beauty. His object, he says, is to show "what the principles are *in nature,* by which we are directed to call the forms of some bodies beautiful, others ugly" (italics added). Previous art treatises had only encumbered the mind with artists' manners and histories and ignored "the ideas . . . of the objects themselves in nature." Artists must look at nature, not at pictures: he is constantly urging us "to see objects truly," "to *see with our own eyes.*" He talks much about "the surprising alterations objects seemingly undergo through the prepossessions and prejudices contracted by the mind." Of course he was in fact oversimplifying; he was as influenced by schemata as any other artist, especially as his paintings moved from sketch to finished representation. But to the extent that he urges the artist to break away from old schemata, inappropriate to his time, he is performing a useful service—though his advice was little heeded.

His conviction that artists should turn from paintings to nature explains why he is concerned with form rather than morality in the *Analysis.* The whole tradition of the art treatises was platonic, based on the assumption that moral good was beautiful, evil ugly; and thus making a strong case for idealized history painting, for the picture–poem analogy, and so on. Hogarth says that *nature* is beautiful; morality has no place in his argument, or in his oppositions of nature to the unnatural, beauty to ugliness, variety to conformity and rigidity.

The tradition of the art treatises was also platonic in that it defined beauty as unity. Hogarth rejects the idea that mathematical propor-

tion, let alone unity, is a cause of beauty. As he wrote in his notes, "the Mathematical road is quite out of the way of this Enquiry." His key term, "variety," is hardly mathematical; though it occurs in the art treatises, Hogarth uses it in his own way. As one of the basic concepts of classical aesthetics, variety referred to the composition of various parts within a unified harmony of proportions. It is rather "an exigency of the eye which will not tolerate being 'fixed at a single point' any more than the ear will suffer being struck by a single note continuously." Hogarth argues for an emphasis on variety and irregularity, and a respect for nature's potential design.

Variety is symbolized in the *Analysis* by the wavy line in two dimensions and the serpentine in three, as opposed to unvarying geometrical shapes like straight lines and circles. The serpentine line which Lomazzo had noted in art was, Hogarth triumphantly demonstrates, everywhere in nature: in "elegant" movements on the stage or in the ballroom, in boxing and horse-racing, in cooking and interior decoration, in the bones, muscles, and skin of the human body, and in the forms of flowers and plants.

The principles Hogarth applied to domestic and state buildings and paintings run parallel to those Addison applied to gardening in the *Spectator*. "Our British Gardens," he wrote in No. 414,

> instead of humouring Nature, love to deviate from it as much as possible. Our Trees rise in Cones, Globes, and Pyramids. We see the Marks of Scissors upon every Plant and Bush. I do not know whether I am singular in my opinion, but for my own part, I would rather look upon a Tree in all its Luxuriancy and Diffusion of Boughs and Branches, than when it is thus cut and trimmed into a Mathematical Figure. . . .

Hogarth illustrated this thesis in his prints, going back at least to *Taste à la Mode,* and even seeming to echo Addison in the second plate of *The Times.* In the *Analysis,* he continues to oppose nature and the artificial, the human figure and the finest work of sculpture or painting, much as Addison holds up nature to art throughout the "Pleasures of the Imagination."

The *Analysis* is in part a continuation of the "modern moral subjects," a tract aimed not only at the artist and connoisseur but at the public of the *Spectator* and of Hogarth's own prints. This was the point he stressed in his next advertisement, at the end of June in the *London Evening Post:*

MR. HOGARTH, having proposed to publish by Subscription a Tract, call'd, The ANALYSIS of BEAUTY, together with two explanatory Prints, thinks it expedient to add, that the Subjects of the said Prints will be, a Country Dance, and a Statuary's Yard; that these will be accompanied with a great Variety of Figures, tending to illustrate the new System contain'd therein: and that he has endeavour'd to render it useful and interesting to the Curious and Polite of both Sexes, by laying down the Principles of personal Beauty and Deportment, as also of Taste in general, in the plainest, most familiar, and entertaining Manner.

One plate depicts the town and fashionable man-made artifacts, and the other the country and people dancing in a country house with paintings and statues around them. The artificial and the human (natural) are persistently played off against each other: Addison, it will be remembered, saw a pleasure of the imagination in this reciprocity.

The setting for the first plate (pl. 101), in which art dominates, is Henry Cheere's statuary yard at Hyde Park Corner, an allusion to Clito's statuary yard in Xenophon's *Memorabilia* where Socrates wan-

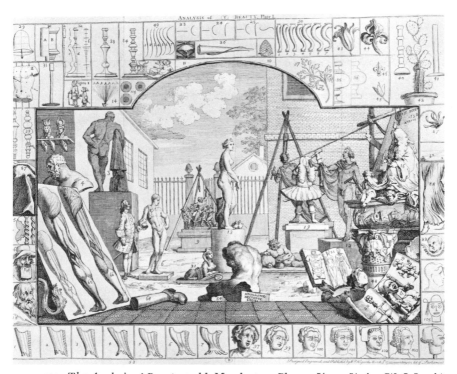

101. *The Analysis of Beauty*, publ. March 1753; Pl. 1; 14⅝ x 19⅝₁₆ in. (W. S. Lewis)

dered about discussing beauty and illustrating his argument with the
statues. A series of statuary yards ran from Park Lane to Half Moon
Street, each producing objects of lead and stone, mostly for gardens:
ornamental vases and dolphin fountains, statues of shepherds and
shepherdesses, marble funerary monuments, and above all copies of
classical statues. Being a friend of Cheere, Hogarth can have intended
no reflection on his yard as such, only a series of aesthetic juxtaposi-
tions. These statues, even when they are individually examples of
beauty, are examples of "*un*fitness" in their setting, in the same way
that Palladian houses are out of place in the Indies or in Lapland.

Only two persons appear in the yard: one holds a book of anatomies
reduced to geometric figures while gazing up at the *Venus de Medici*,
in which art and nature join; the other is a posturing dancing master
correcting the stance of an *Antinous* that appears much more natural
than he, and the contrast is between nature rendered artificial and art
that is natural. The casts themselves, placed and manipulated by off-
stage attendants of the yard, engage in acts of indecorum; the effect is
like that of the art works displayed in *Marriage à la Mode*. As a paint-
ing, Caravaggio's *Medusa* is a dead object, but in the context of the
Squanderfields' house, she becomes a horrified observer of catastro-
phe, more sensible than the humans. In this *Analysis* plate, art is simi-
larly activated; beyond the dancing master tableau, a figure of Caesar
tilts over as if falling, a statue of a "Roman general dressed by a mod-
ern tailor and peruke-maker" lifts his hand (clutching a roll of parch-
ment) in a gesture that in its contiguity to Caesar appears to be a
death blow, and the *Apollo Belvedere* seems to be avenging Caesar by
knocking his assassin on the head. A judge sits by unconcerned and
the *Hercules Farnese* turns his back on the scene. In fact, Caesar is
tilted by a rope, but the rope, around his neck like a hangman's noose,
hangs from a gibbet-like structure above the funerary monument of
the judge. The judge has a weeping putto at his feet holding a square
symbolic of his rectitude which also resembles a gibbet: as though
Caesar were hanged by his decree. The putto weeps both for the de-
ceased judge and for the wretches he has hanged. The Apollo, if re-
garded in the context of the Venus rather than the assassination of
Caesar, seems to give the goddess a friendly wave, and this relationship
is confirmed by the two mating doves at her feet.

Each tableau engenders a sense of order or incongruity, and these
unique variations are extended in a more schematic form in the frame

that surrounds the statuary yard: corsets, jacks, candlesticks, table legs, flowers, and human faces that represent varying degrees of beauty and fitness, nature and geometry. The old treatises used the *Venus de Medici* and the *Apollo Belvedere* as their illustrations, as did of course the academies of drawing; Hogarth plays off their beauty and fitness against the flawed human figures and other statues, as well as the surrounding objects, curious and commonplace alike.

The judge, although ironically depicted (with a flame on his head to show that, like the apostles, he is filled with the Holy Ghost), is an important part of the print: the *Analysis* focuses on seeing and judging.

The second of the illustrative plates (pl. 102) moves art into the background and presents a group of people dancing in a country house. The most abstract and artificial elements here are stylized medallions of heads on the wall; beneath them, pictures and statues of historical personages by Holbein, Van Dyck, and Kneller; then the dancers, two graceful and the rest less so; and the non-dancers who are

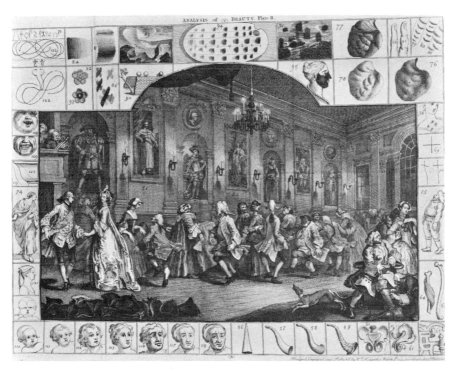

102. *The Analysis of Beauty*, Pl. 2; 14⁹⁄₁₆ x 19⅝ in. (W. S. Lewis)

providing music or getting ready to leave the party. Implicit, since this
is itself so clearly a picture, are the real people and movements of
whom these are copies: how they reached the page as beautiful or ugly
forms is the subject of the treatise. The dancers' attitudes are, of
course, rendered ridiculous partly because the action is suspended;
the beauty is in the movement itself, which cannot be caught by the
best artist. The statuary yard naturally illustrates attitudes, the dance
transitions. The rustics, however, dance in attitudes, as the dancing
master assumed an attitude next to a statue portrayed by its artist in
transition from one attitude to another. The one graceful dancing
couple is similarly in transition; its supple movement is balanced by
the jumbled knot of non-dancers at the opposite side of the plate, and
from these the eye descends to the inanimate heap of hats at the bot-
tom left. Finally, the quality of these people and objects is reflected
in the figures in the diagrams around the border, ranging from a copy
of Coypel's Sancho Panza to heads of different degrees of abstraction
to purely abstract forms, diagrams, and areas of shading and pure tex-
ture.

It should not seem strange, considering his development, that at
this point in his career Hogarth produced a treatise that seeks aes-
thetic rather than moral judgments. Indeed, his "analysis of the ridic-
ulous," which complements the beautiful, is largely based on formal
considerations. His is one of the earliest statements of the incongruity
theory of comedy: "When improper, or incompatible excesses meet,
they always cause laughter. . . . the ideas of youth and age are jumbled
together. . . . [the] joining of opposite ideas. . . ." He goes on to point
out that the joke is only funny when told in such a way that two dif-
ferent strains of association are brought into conjunction suddenly
and surprisingly. Laughter therefore results from the inappropriate
juxtaposition of different shapes, such as the ugly and the beautiful.

Hogarth's particular understanding of juxtaposition is based again
on a combination of experience and the *Spectator*. It seems quite
likely that he took note of Addison's distinction (*Spectator* No. 62)
between true wit as a congruous comparison of ideas (and hence in
Hogarth's terms beauty) and false wit, an incongruous comparison,
and therefore more comical. Of course, as his discussion and examples
show, the mere juxtaposition of different forms, while it may support
comedy, cannot create it. Laughter lies in the ideas behind the shapes
—the idea of an old man's head attached to a baby's body, for example.

As Hogarth says near the end of the *Analysis,* "when the form of the body is divested of its serpentine lines it becomes ridiculous as a human figure." Here, if not throughout, the ridiculousness derives specifically from the dehumanizing effect. The "inelegant," stiff, mechanical, repetitive movements of "low and odd characters," ultimately of a man-made machine like Vaucanson's famous duck, are opposed to the "graceful acting" and the elegant movements that define the s-curve; which thus becomes, and largely remains in Hogarth's graphic works, a symbol of what Bergson called the *élan vital.*

The *Analysis* is in general a tendentious document; it supports one set of aesthetic concepts that advocates the natural, epitomized by the Line of Beauty, and opposes another set that advocates the artificial, in the sense of copy, pose, mask, geometry, fashion, and rigidity. The satiric thrust is, however, carefully aesthetic: lines with too shallow a curve are described as "mean and poor" and lines with too generous a curve are "gross and clumsy," expressing an aesthetic judgment that stops just short of the moral. There is no way of exactly demarcating the aesthetic meaning of art and nature from the moral. But Hogarth clearly approaches the more purely aesthetic position in his prints (e.g. *The Distressed Poet, The Enraged Musician*), as the beautiful girl becomes part of a little story of her own involving a crowd of commonplace people using the commonplace objects Hogarth depicted in the *Analysis;* opposing them is an artist who tries to order nature according to art treatises or old master paintings (or musical harmonies or rhyming dictionaries). The girl's role in those works is summed up in the famous passage in the *Analysis,* "Who but a bigot, even to the antiques, will say that he has not seen faces and necks, hands and arms in living women, that even the Grecian Venus doth but coarsely imitate?"

The *Analysis* should be understood as an aesthetic continuation of those prints, beginning with the fables of the artist and ending with *The March to Finchley,* in which questions of the natural and unnatural, the disorderly and the orderly, tend to omit the evil consequences and other signs of a moral contrast. Probably Hogarth continued to regard the natural as good, the unnatural as evil, and so in some sense the beautiful as good. But the unavoidably moral subject of his earlier works was replaced by one that did not require a moral judgment, indeed made the judgment itself problematical by a refusal to take an unequivocal side.

His chapter "Of Intricacy" is about the "reader" of the work of art. "Pursuing is the business of our lives; and even abstracted from any other view, gives pleasure." In short, the eye's movement, accompanied by the intellect's, over the surface and into the crannies of the *Marriage à la Mode* paintings or the *Industry and Idleness* prints is pleasing even when divorced from the lesson or the moral. The undulating shape of the figure is paralleled by the viewer's searching and pursuing mind, just as the great object is paralleled by (or elicits) the viewer's feeling of sublimity.

I wonder if Hogarth did not to some extent associate "intricacy," and perhaps his intermediate genre as well, with the "uncommon," Addison's curious category between the great and the beautiful which he characterized as follows: "it fills the Soul with an agreeable Surprise, gratifies its Curiosity, and gives it an Idea of which it was not before possest." If the principle of intricacy is connected with Hogarth's attack on secondhand forms and experience in the *Analysis,* one may formulate the subject of the "comic history painting": "the surprising alterations objects seemingly undergo through the prepossessions and prejudices contracted by the mind.—Fallacies and prejudices strongly to be guarded against by such as would learn to see objects truly!" This is one of the pleasures intricacy produces: the ability to see objects truly. Perhaps in the works leading up to 1754 the question of the viewer's choice, which grew ever more complicated and ever more his own, in fact became the question of seeing objects truly.

What this means to the artist may be determined by examining an apparent paradox that runs through the *Analysis:* nature is the truest beauty, but a mere slavish copying of nature will lack all beauty. Hogarth attacks both those artists who try to improve upon nature and those who merely copy it. What these artists lack, he says, is an awareness of the visual equivalent for the human being's vitality, which must be lost in a mere imitation of nature, let alone a copy of other artists' manners. This is where the emphasis on using one's own eyes and looking carefully at the world enters into his search for beauty. The Line of Beauty is the formal principle that will allow nature's beauty to be transmitted in art: one can learn from ancient statues (as opposed to slavishly copying them) not because they are more than coarse imitations of the living woman's beauty, but because the ancient sculptors recognized nature's principle: that is, according to Ho-

garth, they had "perfect knowledge" of "the use of the precise ser-
pentine-line." The s-curve, then, was rediscovered by Michelangelo
(from whom Raphael learned it), and was unearthed once more in the
1740s by Hogarth. Thus nature is beautiful, but only with a knowl-
edge of the principle behind this beauty can an artist transmit it and
ordinary people draw out the maximum beauty in themselves, their
actions, and their surroundings.

Earlier it was suggested that the plates illustrating the *Analysis* were
of a piece with those of *Marriage à la Mode*. They represent a striking
example of seeing objects truly, of pursuing intricacy to new revela-
tions; more clearly than the text they extend beauty to deportment
and manners, but they also touch upon moral issues that are excluded
from the *Analysis* itself. Plate 1 remains almost purely a series of aes-
thetic judgments because its contents consist of art objects, but even
there the muffling robes and wig of the judge, which illustrate "quan-
tity" in the text, in his own context may disguise cruelty as well as
stupidity. A world of brutality, murder, and harsh judgment from the
popular prints exists just beneath the surface.

Plate 2, however, is about people, and although it exemplifies aes-
thetic points in the text, it has its own moral point which (character-
istically) runs against the grain of the aesthetic thesis. The formally
chaotic knot of people at the right contains one graceful figure, the
young wife who does not want to leave off dancing and go home. The
simple juxtaposition of this woman with her old husband who does
want to go home is comic, but it turns satiric with the addition of a
third figure, a lover behind the wife's back, passing her a note about a
future assignation. An aesthetic contrast, by this detail, has become a
moral epitome. The awkward lines of the husband suggest folly, but
the beautiful curves of his wife do not in the context imply virtue, any
more than does the s-curve of the barking dog.

Beyond its conventional form as an illustrative plate (many art
treatises included composite designs, sometimes with symbolic scenes)
and its aesthetic rubric, Plate 2 is a complicated study of morals and
manners. Here a knowledge of the principle of beauty, the serpentine
line, causes some people to dance or gesture with grace, but no hint is
supplied about the moral life that lies beneath; ignorance of the prin-
ciple causes others, despite the natural beauty of their dance move-
ments, to look ridiculous. People's shapes are determined by a

number of external controls. Good deportment is represented by a nobleman wearing an order across his chest and his lady, bad deportment by bumpkins of the lower classes.

Most of the assumptions that underlie the *Analysis* operate in Hogarth's graphic works too, but unlike those works the *Analysis* tries to make a positive statement about the nature of beauty. It begins by advocating nature, not art, as the model of beauty for the artist, and then sets out to examine the prime quality of natural beauty—variety.

> All the senses delight in it, and equally are averse to sameness. The ear is as much offended with one even continued note, as the eye is with being fix'd to a point, or to the view of a dead wall.
>
> Yet when the eye is glutted with a succession of variety, it finds relief in a certain degree of sameness; and even plain space becomes agreeable, and properly introduced, and contrasted with variety, adds to it more variety.
>
> I mean here, and every where indeed, a composed variety; for variety uncomposed, and without design, is confusion and deformity.

Thus Hogarth starts with variety and then creates a tension, or what the eighteenth century would have called a *concordia discors.*

A whole series of such tensions follows. A typical conclusion finds that "Simplicity, without variety, is wholly insipid, and at best does only not displease; but when variety is join'd to it, then it pleases, because it enhances the pleasure of variety, by giving the eye the power of enjoying it with ease." So too in the chapter on intricacy Hogarth defines "the beauty of a composed intricacy of form"; and in the chapter on quantity he stresses that only "with simplicity" does quantity contribute to the beauty of an object, for in excess it "will become clumsy, heavy, or ridiculous." Too much variety in dress is tawdry, and so "simplicity is call'd in to restrain its superfluities."

Hogarth's language is the language of Pope's *Essay on Man:* "The lights and shades, whose well accorded strife / Gives all the strength and colour of our life." But this is only a sign of its basis in tradition, for *concordia discors* was a permeating concept of the century. Philosophers and politicians as well as poets saw it everywhere. Samuel Johnson, not long before Hogarth began to write the *Analysis,* defined a perfect marriage as a *"concordia discors,* that suitable disagreement which is always necessary to intellectual harmony" (in *Rambler* No. 167).

In Hogarth's earliest graphic work, one may see signs of an Augus-

tan principle of order. However, Hogarth's was not a Hutchesonian "Uniformity amidst Variety" (a varied uniformity) but a "composed variety." In Hogarth's works leading up to the *Analysis* one always feels that, although architectural forms exercise control within the picture space, variety remains the operative term. In that pivotal work, *The March to Finchley*, the crowd is outdoors and the buildings on either side, by no means containing the people, only suggest vague limits. In the *Analysis* plates, and more in the text, Hogarth pushes the theoretical concept of variety further than anyone before him: lines should be varied "as much as possible, with propriety. . . . In a word, it may be said, the art of composing well is the art of varying well."

Up to the composition of the *Analysis*, Hogarth employed two kinds of cognitive (or "reading") structures in his art. At one extreme were the almost verbal structures of his engraved "histories," while at the other were the studies in almost pure form, texture, and color. The first he treated in the *Analysis* under "intricacy" and "this love of pursuit," in a way that might make one equate it with the rococo; the second he treated both in terms of rococo form and of larger, simpler and more self-expressive forms that, without abandoning the s-curve, historically were a reaction against rococo.

Both of course are expressive in certain ways, and both lend themselves to certain kinds of readable structures. However, the principles of intricacy, variety, and the rest, while in themselves expressive (e.g. of chaos or energy or "nature"), serve primarily for Hogarth as a wonderful vehicle for preventing the viewer's eye from coming to rest; they force the eye to move about, prying and poking and discovering new denotations, allusions, and relationships. But if they force the viewer to "read," they may (Hogarth makes clear in the *Analysis*) give him a purely aesthetic pleasure as well. Even those simple head-and-shoulder portraits, which lacked accessories to make them full-fledged Hogarthian subjects, are illuminated by the passage extolling the special variety of the human face, the one part of the body not covered by clothing: "vast variety of changing circumstances keeps the eye and the mind in constant play, in following the numberless turns of expression it is capable of. (As the lily when it is stylized into a *fleur de lys* loses variety, becoming a meaner shape, so the face is reduced by the caricaturist.)" Hogarth was no more unique in his formalism than in the general movement from unity to variety.

But he shows that he is also aware of another, different formalism, quite apart from the readable structure of his prints or the pure rococo of his paintings. He shows his awareness of this style in *Garrick as Richard III,* in *Moses Brought to Pharaoh's Daughter,* and above all in some of the popular prints. In the *Analysis,* discussing the use of light and shade in composing a picture (Chapter 13), he enunciates principles of opposition, breadth of shade, and simplicity which verbalize this last phase of his art, leading directly into the final portraits and history paintings. He contrasts a figure that is "better distinguish'd by its breadth or quantity of shade, and view'd with more ease and pleasure at any distance," from another, "which hath many, and these but narrow shades between the folds." What he suggests as an alternative to the rococo profusion of his earlier work is a composition of "large, strong, and smart oppositions." With great acuteness—and more effectively than he was to express it in his own art—he points to the distinction between readable, narrative-descriptive works such as his progresses and works whose emotional effect is generated by large, expressive shapes.

Though not officially published until the early part of December 1753, *The Analysis of Beauty* was in print by 25 November when Hogarth sent a copy to Thomas Birch for the Royal Society's library. There is no way of knowing for certain how well Hogarth's subscription went: his enemies portrayed him with innumerable unsold copies on his hands, and others being used as liners for pie pans and the like; we do not know how large an edition he published, but it was not exhausted for twenty years. He was, of course, publishing a book this time, even though it included two plates and an illustrated subscription ticket, and it is possible that he miscalculated the size of his learned audience; it was certainly not the same as the audience that bought one of his progresses, let alone one of his etchings like *Lord Lovat.* But we must also discount the images of Sandby, who was, after all, using all the weapons of the satirist.

The strange thing about the affair of the *Analysis* is that its supporters were plainly in the majority: all the published reviews were favorable, the learned appreciated it, and its fame quickly spread abroad. But at home Hogarth found himself suddenly the object of ridicule in his own medium, the broadside cartoon—attacked by a fellow artist and hawked about the streets to be seen by his own great audience, who knew nothing about the *Analysis* or the more personal

issues at stake. More visible than the reviews were the satiric poems
and squibs, often merely exploiting the *Analysis* as an occasion for
humor.

Hogarth's own feeling about the reaction to the *Analysis* was re-
corded a few years later, as he attempted to write his account of the
arts in England:

> it is a trite observation that as life is checquer'd every success or ad-
> vantage in this world is attended with a reverse of one kind or other.
> So this work however well receiv'd both at home and abroad by the
> generality yet I sufferd more uneasiness from the abuse it occasions me
> than satisfaction from its success altho it was nothing less than I ex-
> pected as may be seen by my preface to that work.

5

The Final Decade
1754—1764

THE *Election:* ART AND POLITICS

The last decade of Hogarth's life began with the publication of *The Analysis of Beauty*, immediately followed by the completion of the *Election* paintings, in some ways his climactic, certainly his most ambitious comic history. But the former trailed off into acrimonious bickering, the latter into four long years of engraving problems, delays, and growing national crisis before the prints were all published. Once past the original conception of the *Election*, his work during this final decade was a series of discontinuities if not anticlimaxes, starts and stops with no clear line of development toward an aesthetic climax as in the earlier decades. The progression was rather a psychological one and, punctuated by a few bursts of imaginative energy, revealed a gradual tapering off from painting to writing, personal gesture, self-justification, and involvement in politics—Hogarth no longer saw himself as the cool observer of folly, but rather as the beleaguered agent of virtue. The subject of his works changed accordingly. Instead of the fool surrounded by knaves or the contrast between art and nature, he would depict a crowd of knaves filling the canvas, implicitly taking over the world, opposed only by one or two virtuous men; or alternatively, one virtuous man or woman alone, whether in *Sigismunda* or in the portraits of personal (and sometimes controversial) friends.

The decade began propitiously with the subscription in March 1754, only three months after the *Analysis* was published, for a new plate called *An Election Entertainment*. The painting was on display in Leicester Fields; by this time, its three pendants were probably painted as well (pls. 103–06).

These paintings, large and elaborate as they are, represent a continuation of Hogarth's stylistic development from *Garrick as Richard*

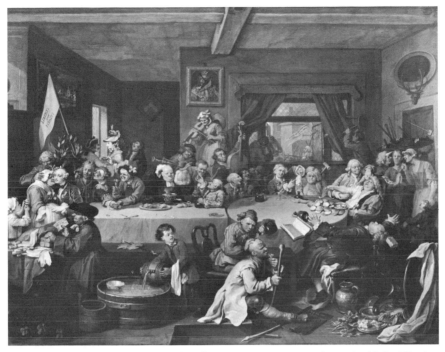

103. An Election: Four Pictures; painted 1753–54; appx. 40 x 50 in. each; (1) An Election
Entertainment (Sir John Soane's Museum)

III and his remarks on expressive form in the *Analysis*. The simplic-
ity of articulation amid a great complexity of detail is realized in both
large pattern and small, in both composition and application of paint,
by a kind of stylized compartmentalization. Better than any previous
work, the *Election* series shows how architecture in relatively undis-
torted perspective gives coherence of "reading" to the packed and
complicated baroque design. In Plate 2, for example, the two men at
the table are set off in a unit of their own by the table and the anchor-
ing "Portobello" tavern; the mob behind them is contained by the
verticals and horizontals of the Excise Office; the central trio (the
Choice of Hercules again) by the intersecting lines of the Excise Office
and the Punch signboard; and the next trio (candidate, petitioner,
and peddler) by the signboard and post and the bow window. The two
men at dinner are simply framed in the bow window, as the two
women above are by a balcony, a door, and a window, and the last pair
(landlady and grenadier) by the door of the inn. But within these

frames the individual figures assume larger composite forms, as in the
serpentine line formed by the sweep of the crowd around the tables in
Plate 1.

In Plate 4, to illustrate the release of the chaos that is implicit but
restrained in 1 and 2, Hogarth simply spreads out the architectural
verticals and horizontals and shows a crowd flowing in all directions.
If the composition suggests barely restrained disorder, the painting
style is a distinct departure from the shifting focus and evanescent

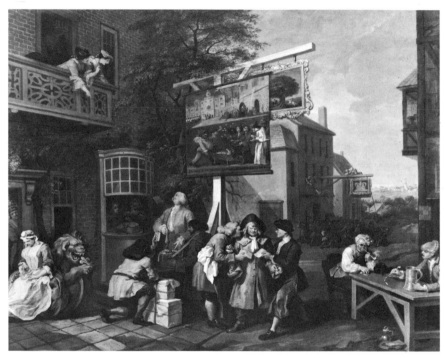

104. (2) Canvassing for Votes

shapes, sometimes the wonderful sketchiness, of paintings as recent as
The March to Finchley; the brush quite apparently imposes order on
human flux. In a way, this style, with its large, bold patches of color, is
a freer version of the brushwork in *Marriage à la Mode.* But on a
larger scale the poster-like effect, the compartmentalization of areas,
the broad application of paint, and the heavy outlines recall on the
one hand the surface of a cartoon (in particular the Raphael Cartoons,
which resemble these paintings in size and color as well as in the ap-

plication of paint), and on the other the most popular of all English paintings: signboards—like the one in Plate 2.

To place these works in Hogarth's development is to recognize them as a painted equivalent of the popular prints of 1751; in simplification and stylization, they suggest the blockprint effect sought in *The Four Stages of Cruelty* (and carried out in Bell's woodcuts). The primary equivalent of such prints was the signboard, a form in which Hogarth always showed a great deal of interest. Indications of this

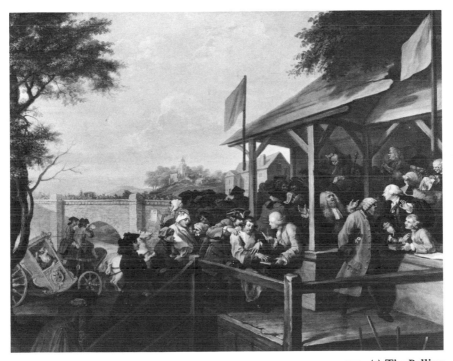

105. (3) The Polling

stylized, somewhat flattened application of paint can be found as early as 1747 in a sketch of *The Stage Coach* (Ashmolean Museum), in 1748 in *The Gate of Calais* (pl. 92), and around the same time in a small sketch of a tavern scene (Mellon Coll.); it appears later in the sketch for *The Bench*. The *Election*, with its much larger scale, is the central work. This brushwork and the date of its advent might give rise to speculation on the influence of Canaletto's handling of paint in his English landscapes, painted in the late 1740s. It seems quite possible

that Hogarth met Canaletto during his visits, begun in May 1746, since his friend Samuel Scott was the most notable English perpetuator of the Canaletto mode and style.

Whatever the influence of Canaletto, or perhaps of Scott, these paintings are essentially a direct link with the conception of the popular prints and represent Hogarth's attempt to utilize sign paintings as he had blockprint broadsides. He must have realized how effective some of the latter were as images. His own attempts to engrave *An*

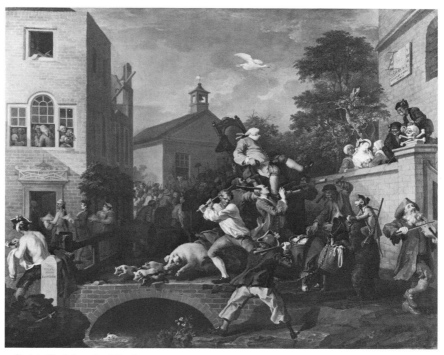

106. (4) Chairing the Member

Election Entertainment, involving numerous trial proofs, and his ultimate recourse to another engraver, indicate the difficulties he encountered when he tried to convey the impact of the paintings through the print. In the end, all trace of the signboard style was lost; rather, the prints pursue the late baroque implications of the *Election*'s compositions.

Hogarth's subscription ledger, dated 19 March 1754 on its binding, is inscribed on the title page 28 March. Both subscription book and

advertisements explained that the *Election Entertainment* could be subscribed for at 5s down, 5s on delivery, until the last day of April.

Paul Sandby had provided a rough sketch of the *Election Entertainment* in *The Author Run Mad,* and implied that this was another money-making scheme like *A March to Finchley.* It is true; the announcement of the subscription was shrewdly timed to draw upon interest in the general election that was going to be held in April.

To Hogarth the election must have been significant as the first in years that focused on the Whig–Tory opposition. This had happened (and rapidly reached its greatest intensity in Oxfordshire) as a result of the innocuous "Jew Bill" which, naturalizing the Jews then resident in England, was passed by the Pelham administration in the spring of 1753. The City merchants began the opposition largely through fear of the Jewish merchants as rivals, and the old Tories, by the 1740s and 1750s little more than defenders of the Anglican Church, woke to find in the Jew Bill one of the very few issues around which they could rally. As early as August 1753 the story was printed of a Jewish peddler's unsuccessful attempt (in another county) to cheat some young ladies. Hogarth picked up this story with its "mob," which would be ubiquitous during the election, and introduced it in Plate 2, which shows the peddler and a candidate using his wares to win two young ladies. His procedure is to juxtapose pointless or outdated issues (one of the latter is the excise bill of 1733, still a vestigial piece of Tory propaganda, causing a riot in Plate 2) with the mob in action; the empty party slogans of "No Jews; Christianity and the Constitution" and "No Jews, No Naturalization Bill, Old England and Christianity for ever" with the reality of the politicians accepting the Jews as part of their crowd. In short, Hogarth was still devising comic effects by means of juxtaposition, an ideal technique for illustrating the folly of elections; and (while perhaps preferring the Whigs to the Tories, whose slogans he ridicules) he was not taking sides between equally absurd parties. At least, this was his position at the time he conceived and undertook the series, when the *Analysis* was still fresh in his mind. However, what the affair of the Jew Bill in particular, and the election in general, represented to sober Englishmen was the dismaying power of popular pressures, which could in a few months force a British Parliament to repeal an act it had just passed.

The triumphal candidate in the final plate is falling because, while the Tories won initially in Oxford, they lost when the issue was re-

ferred to the Whig House of Commons: he appears to be winning but is headed for a fall. More specifically, in the context of the series, he is falling because he cannot control the mob he has loosed, and so reveals connections with the Harlot, the Rake, and the falling figures in *Southwark Fair*.

By the time the whole series of prints was published in January 1758, four years later, they were deeply scored with the momentous political events that filled the intervening years. But even without these events, and the revisions (such as the removal of the British Lion's teeth in 2) that followed the publication of each plate, the designs were marked by a sardonic quality lacking in Hogarth's earlier works. Plate 1 includes an ironic rendition of *The Last Supper*, and Plate 4 of triumphal processions and conventional battle pieces as in Rubens' *Battle of the Amazons* (Alte Pinakothek, Munich), whose arching bridge is reduced to a sewer and routed cavalry to a herd of fleeing pigs. Plate 2 has a "Choice of Hercules" in which both Virtue *and* Pleasure offer the voter bribes. The subject of the series as a whole is, in fact, Hogarth's familiar choice, here equated with English politics. But choosing now has become an end in itself, hence frivolous and, in Plate 3 where preoccupation with choice causes Englishmen to ignore the predicament of Britannia's coach, a dangerous pastime. The choices have been reduced to a simple minimum, the two parties, but the choosers (the electors) have become multitudinous and chaotic. From the early prints in which one person chooses, Hogarth moved first to a simple presentation of the alternatives, with the choosing left to the reader, and here to designs in which the choosers cover the stage and one must look very carefully to isolate two choices, which prove to be practically indistinguishable. The idea of choice is only an excuse for releasing all the restless, undirected forces in people. In a limited sense, Hogarth is simply saying that there is no legitimate choice here: candidates are the same and the choice is made by bribe. But more generally, he is getting at the impossibility of choice as a symptom of his society's discontent.

The threatening nature of the mob, indeed the whole darkening view of the *Four Prints of an Election*, must have owed something to Hogarth's shock at the response of some artists, perhaps some friends, to the *Analysis* and to himself as defender of the old St. Martin's Lane Academy. But the public events of the ensuing years, as he worked on the *Election* engravings, cannot have eased his feelings about the mob.

In November 1755, for example, after the war with France had begun, an entertainment called *The Chinese Festival,* produced by Garrick, was thought by the "town" to contain some French dancers; on the sixth night, although the king himself was present, a riot broke out, the theater was wrecked, and Garrick's own house was threatened and damaged. The heat of the election was becoming generalized.

After flirting with politics in the late 1720s, and establishing rapport with his large public in the 1730s, Hogarth maintained a pose of generality and uncommittedness. Though often extremely topical, he was never political in his allusions—a stance which supported the universality of his appeal, the generality of his audience, and perhaps also the doctrine of general (vs. particular) satire advocated by Addison and Steele in their influential essays on the subject. A first sign of a subtle intrusion of political bias might be detected in *The March to Finchley,* with its triangle of implicit referents—the Prince of Wales, the Duke of Cumberland, and the king.

Much that is obscure in the *Election* series and also in Hogarth's subsequent actions leading up to the political prints of 1762–63 would be clearer if one could assume that he had imbibed the popular ideas of Bolingbroke's *Letters on the Spirit of Patriotism and on the Idea of a Patriot King* (published together in 1749). As Bolingbroke said, "*party* is a political evil, and *faction* is the worst of all parties." The subject of the *Election* is parties and factions and the chaos they produce. Bolingbroke's thesis constituted, in one respect, a radical departure from the view of politics Hogarth would appear to have held formerly. Parties, especially for the old Tories like Swift, were necessary for a "mixed government" held in a *concordia discors* by its king (it was the Whigs' belief that Parliament should be the main factor and that balanced political powers destroy each other). Bolingbroke now posited a ruler who would not reconcile but rise above such well-accorded strife in a partyless golden age. Hogarth's apparent acceptance of this idea in the mid-1750s suggests a sudden desertion of the ideal of "composed varieties" expressed in the *Analysis* for a stark opposition of good against evil, which in turn must lead to a series of disillusionments as one "Patriot King" or great man after another proves a disappointment.

Politics in another form continued to demand Hogarth's attention at the same time that he was painting and engraving the *Election.* He and his party seem to have retained momentary control of the St.

Martin's Lane Academy in the winter of 1753–54. He had doubtless engineered the invitation to Kirby to deliver three lectures from his *Dr. Brook Taylor's Perspective,* after which Kirby was unanimously applauded and elected a member. As the caricatures reveal, Kirby was known as Hogarth's man, and when the treatise itself appeared on 9 February the first book was dedicated "To Mr. HOGARTH" and the second book, as significantly, "To the Academy of painting, Sculpture, Architecture, &c."

The idea of a state academy had been temporarily put aside but was by no means dead. Doubtless the artists' committee, with Hayman at its head, had continued to plan all along. By January or early February 1755 a fifteen-page pamphlet was published called *The Plan of an Academy for the Better Cultivation, Improvement and Encouragement of Painting, Sculpture, Architecture, and the Arts of Design in General,* which contained a polemical introduction followed by the abstract of a royal charter "as propos'd for establishing the same." Included were the usual clauses concerning professors, presentation of admission pieces, medals awarded to students, and the chance for the students to travel to Rome. The introduction, written in the ponderous words and balanced sentences of the *Rambler* style (and so sometimes attributed to Reynolds or Johnson), takes a very high-flown and un-Hogarthian approach to the question of why art should be supported—echoing only a few of the old ideas about connoisseurs and foreign art that Hogarth favored. In the course of this introduction, after stressing that his "Undertaking is of a public Nature," the author alludes to "one distinguish'd Set of Noblemen and Gentlemen, long ago convinced of the Necessity of such a Plan," who had set aside a sum of money for a similar project. Taking no chance that the inference would be missed, Francis Newton, still the secretary of the enterprise, sent a copy of the *Plan* to this "Set of Noblemen and Gentlemen," the Dilettanti Society. The pamphlet was delivered to the Dilettanti on 2 February 1755 by Colonel Gray, a sympathetic member of the society, and read.

The Society of Dilettanti was founded in 1734 by some gentlemen who had made the tour of Italy and were "desirous of encouraging at home a taste for those objects which had contributed so much to their entertainment abroad." Composed of such men as Simon (afterward Earl) Harcourt, Sir Francis Dashwood, Richard Grenville (later Earl Temple), and Sir Charles Hanbury Williams—as well as a few of the

learned like Joseph Spence, and an artist to paint their portraits, George Knapton—it was essentially a drinking club. The president wore a scarlet Roman toga, the secretary dressed as Machiavelli, the archmaster wore "a long Crimson Taffeta Robe full pleated with a rich Hungarian cap and a long Spanish Toledo." These rich young men sat around drinking and making up elaborate bylaws, first deciding what the president must wear (designed for his discomfort as much as his pomp), and then the secretary, and so on. Hogarth's only contact with the group at this time would have been through Lord Boyne, who was apparently a typical member: his commissions to Hogarth were for scenes of himself and his friends in compromising rakish postures.

It was this unlikely society, whose very name suggested everything that Hogarth distrusted, that in 1748/9 had entertained the plan of Robert Dingley and other members for support of an academy and drawing school for English artists. Communications were exchanged and some hopes entertained by the artists until the end of the year. By then it was apparent that the Dilettanti wanted more in return for their support than the artists were prepared to give. From document to document the artists' signatures dwindle until the collapse of negotiations is all too apparent.

Hogarth may be said to have won, or at any rate to have been proven right, but he had lost the pace-setting role he played in the 1730s and 1740s. He may even have withdrawn, or at least absented himself more frequently, from the St. Martin's Lane Academy in these years: he makes no mention of it, nor do accounts of its functions mention him. It would have been like him to withdraw: the pattern had been the same with Coram and the Foundling Hospital and would be repeated with Shipley and the Society of Arts. Certainly he was now outside the activist group of artists, and the figure who rose to replace him as teacher and administrator in the academy after 1755, the one most symbolically the antagonist (though Hogarth never mentions his name), was Joshua Reynolds, a young man in his early thirties.

Reynolds was born in Devonshire in 1723, like Hogarth the son of a schoolmaster who taught him privately. Richardson's theory of portraiture as a rival of history painting, in which the sitter is made into a history subject, was successfully put into practice by Reynolds. He was a bookish man, and never deviated from the ideal of a gentleman

artist laid down by Richardson. In 1740, at the age of seventeen, he traveled up to London and was apprenticed to Hudson, but before three of the four years of his indenture were up he had returned to Devonshire to paint portraits on his own. He apparently left with no ill feelings. By December 1744 he was back in London. He was in and out of London between 1745 and '49, but in the latter year he set off for Italy.

The three and a half years he spent in Italy gave Reynolds the key to his aesthetic frame of reference. Others had made the trip before, but without his power of assimilation and acute sense of the times and the English aristocracy. One may smile at some of his confections, with such provocative titles as *Lady Sarah Bunbury Sacrificing to the Graces* or *Lady Blake as Juno Receiving the Girdle from Venus*, but he produced the first successful English adaptation of the Renaissance style of heroic painting and portraiture, managing to transform these rather dumpy and (as the Italian sculptors complained) horse-faced English men and women into the graceful shapes of gods and heroes.

Reynolds arrived back in London in October 1752, and after a short visit to Devonshire settled the following year in a London flat at 104 St. Martin's Lane; later in 1753 he moved to Great Newport Street. Although one cannot discount the possibility of coincidence, it is noteworthy that in May 1752, the month he set out for London, the English Academy in Rome had been founded—he may well have contributed to its inception. And no sooner had he arrived in St. Martin's Lane, infused with the spirit of Italy and the English Academy, than agitation and revolt broke out in the nearby academy—the first recorded in its twenty years of existence. In short, he was probably involved in, if not an instigator of, the disturbance in the fall of 1753, and certainly participated in the 1755 plan to join the Dilettanti (his name is on the list).

Reynolds was another of those short English artists Vertue mentions, 5 feet 6 inches (not much taller than Hogarth), with blunt features and a florid complexion, cheeks scarred by smallpox and upper lip disfigured by a fall from a horse while on his trip to Italy. Although to his sister (and housekeeper) Frances he was "a gloomy tyrant" and to his assistants a hard taskmaster, to society he was charming. The comments on his "suavity of disposition" (Fanny Burney's phrase) and the like apply to the old man, the president of the academy and paterfamilias of English portraiture if not art. But something

of the "inoffensiveness" Johnson remarked depended on a careful avoidance of dispute, the preservation of a bland exterior, like the ironic mask of his *Idler* essays, which veiled his very decided opinions and a powerful ambition.

Reynolds and Hogarth were just enough alike to make them, through their differences, utterly incompatible. It is impossible to imagine Hogarth relaxed and friendly with Reynolds as he was with Hayman or Ramsay. Both Reynolds and Hogarth were terribly self-conscious, ambitious, ruthless, and self-centered; but Hogarth, perhaps, seems a somewhat more sympathetic figure. At best Reynolds was something of a prig; Hogarth was a blustery, buffoonish type, but aboveboard, almost ludicrously honorable in his actions even when obviously self-interested, and quite able, if not willing, to make a fool of himself. It is significant that no one seems to have disliked him for this until he had to be discredited for other reasons; but then there was a plentiful store of ammunition: the former friends—Wilkes is the best example—dredged up all the little follies that had been amusing and tolerated at the time. Reynolds, on the other hand, never played the fool; he worked behind the scenes, through other people; he was an individualist like Hogarth, but preferred to express himself through committees and organizations rather than isolated acts of his own, open to misinterpretation. Class was also a consideration: partly by his manner, partly by his satires, Hogarth alienated the aristocracy, while Reynolds' charm and manners drew members of all classes together around his table.

Reynolds' success as a portraitist was phenomenal. His prices soon matched those of his master Hudson—12 guineas a head, 24 for a half-length, and 48 for a full-length. Already in 1753–54 he was painting aristocratic sitters. In 1755, the year of his first surviving "pocket-book," he had 120 sitters; 150 in 1758 was the largest number in a single year. Here then was a man who met the fashionable world on equal terms and favored artists' incorporation with rather than isolation from each other, not as a solution to their economic problems but as an aspiration toward the continental ideal of an academy and what he felt to be a viable English tradition of painting. Emerging as the most prestigious artist of his time, he would clearly attract the support of others: those who believed that the artists' economic future and prestige lay not below (as Hogarth felt), but above; not with the naturalistic approach Hogarth favored, but with the conventional man-

ner espoused by Reynolds. The academy, to them, seemed a potential bridge between the artist and his aristocratic market.

Hogarth, meanwhile, had been momentarily proven right and, perhaps feeling ill at ease with his old friends, refrained from publishing a treatise on the academy, as he had threatened. It seems quite probable that at this time his views on the academy, as well as on art in general, were incorporated in the magnum opus of his friend and disciple André Rouquet, *L'État des arts en Angleterre* (*The State of the Arts in England*), which was published in French at the end of 1754 (though dated 1755 on the title page); his own English translation appeared in October 1755. In the same year, perhaps already in desperate condition, he returned to Paris and—exactly when is not clear—became insane and was removed to Charenton, where he died in 1758 or 1759.

The driving force in *The State of the Arts in England* is the assumption—already influencing Hogarth in the *Election* series—that as a commercial people, the English have no interest in art aside from portraiture, with perhaps some fashionable paintings from the continent purchased as tokens of social status. Rouquet says he is going to correct French misinterpretations of the English, alluding in particular to those of the Abbé Le Blanc, but what he does is simply shift from Le Blanc's emphasis on bad art to the bad conditions for creating art, pointing out how remarkable the art produced has been considering the obstacles.

It is characteristic of the book that while Rouquet covers almost all aspects of English creative endeavor, including cooking, the only ones that are treated in detail, and reflect great knowledge of the issues, are those that interested Hogarth: history painting and portrait painting, and of course the artist's economic situation. All of Hogarth's themes and crotchets, his victories and defeats, are the centers of interest here. Except for a favorable opinion of the French Academy, of which Rouquet was a member, the views are exactly Hogarth's, and whenever Rouquet turns to subjects in which Hogarth was obviously not interested, he becomes very general and perfunctory. The writing style, on the other hand, is light and bantering, totally unlike Hogarth's. Hogarth's ideas are reiterated: that history painting cannot flourish in England because of its religion; that dealers help to keep the market continental; that portrait painters are the only ones who can earn a living in England, and that they are essentially manufac-

turers. Though in many ways a brilliant performance, Rouquet's little book was not well received in England: the *Monthly Review* contemptuously dismissed it, partly missing its point and partly outraged by its strictures on the English (as opposed to English artists).

Hogarth seems to have recognized the necessity of producing some kind of an alternative to the proposed state academy. In December 1755, just as negotiations with the Dilettanti were collapsing, he became a member of the Society of Arts, another project for benefiting English art which must have appeared to him at first as more promising than the proposals for an academy because it offered a substitute for noble patronage. The Society of Arts was the conception of William Shipley, a drawing master who came to London from Northampton in the 1740s to study art. Back in Northampton, he practiced painting until about 1753, when he returned to London and founded a drawing school for the young. Unlike the St. Martin's Lane Academy, the training was directed toward industrial design and the decorative arts. Although the drawing school was to some extent the nucleus of the Society of Arts, Shipley remembered that he got the idea of using prizes to stimulate English industry from the Northampton horse fair. The first premiums were offered for the discovery of cobalt and madder in England (for use in dyes) and, reflecting Shipley's own interest, for young artists of promise. Not much came of the search for cobalt and madder, but thirty-six boys and girls submitted drawings, and the society used "the most Eminent Masters of Drawing . . . to assist in determining ye Merit of the Drawings"—Henry Cheere, Robert Strange, Richard Dalton, and Israel Bonneau. The decisions were announced at a meeting at Peel's Coffee House in Fleet Street on 15 January 1755. Perhaps not surprisingly, all five premiums were won by students of Shipley's school.

Hogarth always wanted to be where the action was: this is the simplest way to explain his election on 31 December 1755 to the Society of Arts, and the subscription of his two guineas. At the same meeting he was appointed to the year's committee of judges for drawings by boys and girls; the other members were Cheere, Hodgson, Dalton, Hayman, Strange, and Pond. (At this time only Cheere, Dalton, and Hogarth were members.)

Hogarth took his membership seriously. At the meeting on 28 January, having observed the functioning of the society for a month and in particular the procedure for awarding drawing prizes, he made a

formal address setting forth some recommendations which the society apparently considered important. Knowing Hogarth, and looking ahead to the later campaign by other artists to reform the premium-giving, one may infer that he proposed that the premiums be awarded to more mature artists and that the drawings be made not under Shipley's eyes in his studio and from his casts but anywhere the candidates desired. No more is heard of Hogarth's paper, and his proposals were apparently tabled or rejected, but in a later speech he seems to have been genuinely appalled by the merchants who dominated the society and their callous references to the poor: he cites the "cruel speech" of one member arguing that it was useful to have a great number of poor because they represented cheap labor in the coal mines. He felt the premiums would delude children about the rewards of art; the premiums for "improvement in kettles etc." made more sense than those for drawing. Those in need of encouragement are the professional artists, who have all too few illusions about their futures.

One of the more intriguing aspects of Hogarth's association with the Society of Arts is his leave-taking: his name is violently struck out in the subscription book—the gesture can only have been his own. One has the distinct impression—perhaps in light of his refusal to re-subscribe for 1757 and the crossed-out name—that he saw the society as a hope, attempted to reform it, then withdrew in despair; one can imagine him chafing at the dull concern with cobalt, saltpeter, and the rest.

It appears that at least some of his reforms were carried out by other artists not long after his departure. The age limit was extended to twenty-four and the range of places where drawings could be executed was extended to include the St. Martin's Lane Academy, the Duke of Richmond's gallery, and even the competitor's own chambers if he could produce a witness to swear that he had received no assistance. In short, the rules were considerably relaxed, and at the same time categories were multiplied to include drawings after a human figure and landscapes after nature. With this reform Shipley's direct connection with the premium competition came to an end. But by then Hogarth had moved on to other concerns.

The *Election Entertainment* had been announced as ready for subscribers on 24 February 1755, and Hogarth began a new subscription on the same day for the other three prints. It was by no means so suc-

cessful as the first subscription: time was passing, immediacy lacking, and Hogarth himself inordinately slow. In the *London Evening Post* of 9–11 March 1756 he had remarked that the last three prints would have been delivered by now "if the most able Engravers had not been pre-engaged with other Works."

Early in 1756 the Seven Years' War with France had begun, and, with rumors of invasion everywhere, in March Hogarth ceased his regular work long enough to etch two simple and popular plates called *The Invasion* (pls. 107, 108). They are, however, symptomatic of his ambivalence in matters political—as if, having emerged slightly from his shell, he was using these two "popular" prints to regain his former uncommitted status. The sign of the Duke of Cumberland on the tavern in Plate 2 juxtaposes the duke's name with "Roast & Boil'd every day." Supporters of the duke might infer from this that their great hero, after whom so many taverns had been named following Cul-

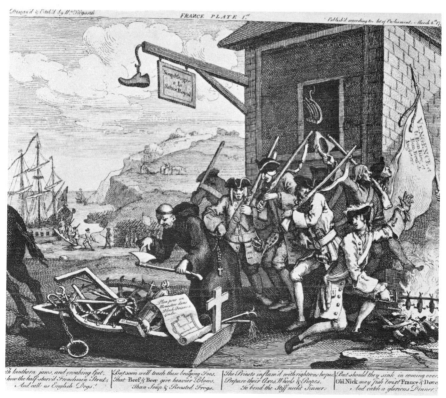

107. The Invasion, Pl. 1: France; March 1756; 11½ x 14⅞ in. (BM)

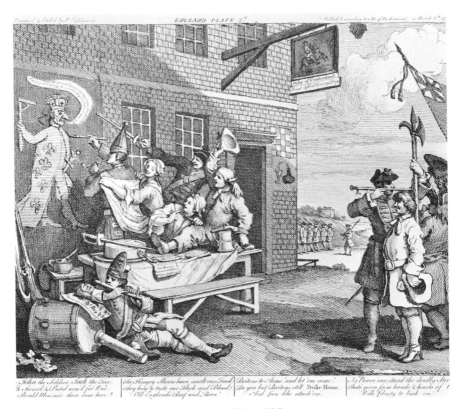

108. The Invasion, Pl. 2: England; 11⅝ x 14¾ in. (BM)

loden, was now wantonly attacked whenever his name arose. But ene-
mies of the "Butcher" would consider that fate a right and proper one
for good Englishmen (like the ones shown in the print) to wish upon
the duke. Again, the portrayal of the French coming with their tools
of torture and religion is at once a clarion call to Englishmen to rise
and prepare and a gloomy forecast, not without foundation. As popu-
lar prints they were immensely successful; no sales figures are availa-
ble, but judging by the copies used for recruiting posters and the like,
they produced images that passed into the contemporary vocabulary.

The second *Election* plate, finished a year later, bears out a pessi-
mistic reading of *The Invasion* and reflects the temper of early 1757.
That spring was the time of catharsis for the outrage felt by the Lon-
don public at the English defeats of the preceding year: Admiral
Byng, who permitted the fall of Minorca to the French, was executed
in March as a scapegoat. The large painted signboard in the middle

of the scene is an expansive elaboration on such political prints as *Punch's Opera with the Humours of Little Ben the Sailor,* published in October 1756 (BM Sat. 3394), which shows Fox as Punch and the Duke of Newcastle as "Punches Wife Joan," a hunched figure wearing a dress, shawl, and apron. The signboard characterizes the government, the late Newcastle regime under which Byng's disaster took place, as one whose major interest is election bribery of the sort illustrated in the scene unfolding around it.

The *Election,* with its emphasis on the evils of faction and the mob, could have been taken as a tract for the Leicester House party which was consciously shaping itself on the maxims of *The Patriot King,* advocating the destruction of the party system and the initiation of less corrupt methods of government. Whatever his intention, the *Election* prints to a remarkable extent express Pitt's point of view at the time: that the country was draining away its resources in factions, party politics, personalities, and corruption. The series may not have begun with this idea, but as Hogarth worked through 1755, '56, and most of '57 the *Election* became for him the symbol of England in those dark years—politics had usurped her warlike might, her traditional naval strength, and all her moral values.

Only in 1758, after the last *Election* print was published, did the gloom begin to lift; optimism returned only in 1759, with the conquest of Canada. Hogarth's prints express the same tone of pessimism regarding politics, the age, and mankind in general that appears in many journals and pamphlets of the time; but with Hogarth the pessimism, equating decline in art and society, remained, deepening, until his death.

THE LAST HISTORIES

At the end of May 1755, as he worked on the last three *Election* plates, Hogarth received his largest commission for a sublime history painting—and the only one from the Church of England. The vestry of St. Mary Redcliffe, Bristol, met on 28 May to discuss the replacing of their old altarpiece, painted by a member of the London Painter-Stainers' Company named John Holmes, back in 1710 when the church had last been remodeled. Hogarth's name may simply have been the logical one to be proposed; it was known to the provinces through his publicly displayed histories and the widely disseminated engravings of these works. This circulation had been part of his orig-

inal plan when he engraved them; he no doubt remembered that the success of the Burlingtonians in architecture had been due largely to the availability of their plans to provincial architects.

With the offer before him, Hogarth presumably traveled to Bristol that summer, and saw Holmes' painting hanging on a curtain over the high altar, which in the remodeling of 1709–10 had been moved back one bay east into the ambulatory and smack against the Lady Chapel screen. Alterations were intended to modernize the church according to the prevailing taste: the open area above the screen and below the gothic-arched stained glass window had been bricked in, and the window itself covered by the curtain. Not only the screen but the walls on either side as well were draped with curtains edged with gilt fringe and tassels, and this enormous area was to be filled by Hogarth. A gothic structure had been clumsily restructured into a space suitable for a baroque design: precisely what Hogarth attempted to produce.

A fee of £525 was agreed upon, and he returned to London. He must have worked out the composition in detail back in London, making pencil studies and oil sketches, and painted the panels *in situ* inside the church. Tradition locates him for some time in the Bath–Bristol area, and with so large an undertaking this seems probable. He drops out of sight in London from 28 April 1756 until 14 August, when he accepted his payment of £525 for the finished altarpiece. This payment was only for his own work; separate payments were made to the frame-makers (joiner, carver, and gilder) and to the drapers who supplied the curtains that went behind the panels. Hogarth furnished only the canvas.

He may have employed an assistant. John Simmons, a well-known sign painter and church decorator of the area, received payment from the church for gilding the frame and for painting four niches on the walls under the pictures. According to an old story, he also assisted Hogarth on the canvases themselves—being in that case paid from Hogarth's own pocket. This seems likely with such a large composition. There are great open spaces which somebody other than Hogarth must have mechanically filled in; and many of the accessories—the rocks and palm trees, even some of the flowing robes—called for someone of Simmons' accomplishments.

Hogarth's altarpiece (pls. 109–11) consisted of three panels, the whole being 17 feet high and 51 across. Raphael's *Transfiguration* seems to have influenced the *Ascension* with its mysteriously active

109. The Ascension; 1756; in all, 17 x 51 ft.; (1) The Sealing of the Sepulchre (St. Mary Redcliffe, Bristol)

disciples along the bottom and a rising Christ so high up (inside the arch at the top) that he seems to have nothing to do with these earthlings. What sometimes happened when Thornhill's delicate sketches were blown up into murals appears to have happened here. The figures are too far apart from each other, with great empty spaces yawning awkwardly between, and their features are grotesquely large. The two wings, representing (left) the sealing of the tomb and (right) the

110. (2) The Ascension

three Marys visiting the open tomb, suffer the same spatial troubles.
The former takes on a certain liveliness because it shows the villain-
ous Romans and a Hebrew priest sealing the tomb, and adds a Ho-
garthian touch in the application of sealing wax to establish whether
the tomb has been tampered with by disciples. The right panel, how-

111. (3) The Three Marys Visiting the Sepulchre

ever, with its gaping tomb, consists of loosely connected figures painted according to the sentimental tradition of religious females. The whole conception is unimaginative, and both painting and drawing, if one may judge by the extensive restoration that has been done, are extremely uneven. Only the color represents Hogarth at his best: the three panels are held together by the color scheme rather than by the composition.

This conventionality probably pleased the St. Mary's vestry; the figures and their surroundings are suitably baroque, or imitation baroque. But the total effect cannot have been happy. Considering St. Mary Redcliffe's reputation as one of the most beautiful Gothic churches in England, the plan for Hogarth's altarpiece was most appallingly ill-conceived. The vestry minutes leave no doubt that Hogarth was asked to follow the plan already in existence. It does not seem possible that, even if he wanted to, he could have persuaded the

vestry to remodel the whole area—and to what end? In a Gothic set-
ting, a different artist would have been called for. The fact remains,
however, that he acquiesced in the plan, perhaps a challenge to one
who had always been interested in relating conflicting styles. The re-
sult shows that his taste was still in many respects that of his time, but
also, I suspect, that a strong desire to get some paintings into a church
made him accept the commission whatever the terms, and that weari-
ness or indifference kept him from working out a solution of any orig-
inality in the paintings themselves. In the St. Bartholomew's Hospital
paintings, the nearest equivalent in his earlier work, he came to terms
with an uncongenial subject by approaching it from the direction of
the hospital itself and its patients. Here his intellectual construction
seems perfunctory.

A further quixotic aspect of the project was the fact that while the
Ascension was visible from the door of the church, the side panels had
to be flat against the walls and so were virtually invisible except from
a few places in the choir. Now displayed in the Bristol Art Gallery,
they can be seen to better advantage (except for the problematic qual-
ity injected by the restoration) than at any time since they were
painted. The restoration is most vexing in the drawing itself and the
application of paint, making it difficult to say to what extent the in-
adequacies are due to Hogarth's failing hand, to the enormous scale,
and to the restorer. But even imagining the brushwork as Hogarth at
his best, the result can only be regarded as the effort of a tired, aging,
and perhaps ailing man.

While still to some extent supervising the engraving of the *Election*
plates, within six months of completing the altarpiece he had retired
to another line of painting. In his advertisement in February 1757
announcing a further delay in the *Election,* Hogarth expressed his
disgust at the difficulties he was having with his engravers, adding that
he will produce no more comic histories but "intends to employ the
rest of his Time in Portrait Painting chiefly." Whether the advertise-
ment is viewed as mere statement of fact or as an invitation, however
tentatively offered, for portrait commissions, it seems clear that one or
more portraits were under way. He complained to his friend Benja-
min Wilson that Garrick was remiss in his visits, perhaps implying
something about Garrick and the aristocratic friends whose houses he
frequented, and Wilson passed the complaint on to Garrick, who evi-

dently did visit Hogarth. One result was the commission for a double portrait of Garrick and his wife Eva Maria (pl. 112).

The portrait was not, however, finished. Another of Hogarth's problems in these last years seems to have been the inability to finish a picture—he himself describes how long he spent on *Sigismunda*. In the picture's present state the eyes are finished, and by Hogarth's hand, but

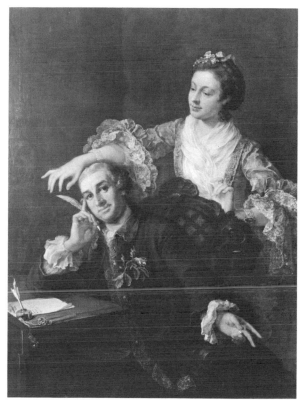

112. David Garrick and His Wife; 1757; 50¼ x 39¼ in. (Royal Coll., copyright reserved)

there are some signs of revision in the left eye. Perhaps made uneasy by Garrick's doubts about it, he kept the picture in his studio and tinkered with it. The fingers of Garrick's right hand and his pen have been altered, as well as the area around Mrs. Garrick's head and right arm and hand. The background was never finished: above Garrick's head was a candle on a curved sconce, on which rested a little snuffer from which

rose a wisp of smoke. On the wall beyond was a bookcase and beyond that a small looking glass, some prints, and paintings. From X rays it appears that only the bookcase and candle were finished.

The smaller portraits of the mid-to-late 1750s were—depending on how one looks at them—experimental or playful. Hogarth painted Mary Cholmondeley (née Woffington, sister of the actress) in ruff and mobcap, wearing a cross and resembling Mary Queen of Scots; and Mary Lewis, Mrs. Hogarth's cousin, was similarly "disguised" (Art Gallery, Aberdeen). These partake of the current vogue for portraits in fancy (usually Van Dyck) dress. But the most interesting of the portraits is that of his old friend, the engraver John Pine (who died in 1756); this was painted in the impasto manner and costume of Rembrandt's late self-portraits (pl. 113), and Hogarth thought enough of it to have McArdell reproduce it in mezzotint.

With the Pine portrait Hogarth taps a vein that will be mined by Reynolds; most obviously in his Rembrandtian self-portraits but also in his employment of a wide range of known styles for expressive effects. The example usually cited is his *Garrick between Comedy and Tragedy,* in which the Comic Muse is painted in the style of Correggio, the Tragic in the more severe style of the Bolognese School. Associationism was, of course, at the bottom of Hogarth's art from the beginning, though usually limited to his engravings. Only with the portrait of Archbishop Herring, and perhaps a few other sketches in the pastel style of La Tour (ca. 1745), did he begin to apply the principle of formal association—or extension of expressive possibilities through style—to his paintings. He used a kind of associative form in the *Election* paintings and certainly in the portraits that followed.

In the same category is the copy in oils of Van Dyck's drawing of Inigo Jones (Greenwich, Queen's House), which Sir Edward Littleton commissioned around 1756; here, Hogarth roughly approximated Van Dyck's style. This picture also gives some indication of Hogarth's mode of fulfilling commissions: he was rather casual, apparently, and not terribly concerned about either completion or payment.

Further information about Hogarth's portrait-painting comes from Benjamin Wilson, who in 1756 had just returned from France. He reported that Hogarth, who was not so successful as Reynolds, proposed a partnership in portrait painting to Wilson in order to secure what he considered a just proportion of portrait commissions. Ho-

113. John Pine; ca. 1755; 28 x 24½ in., oval (Beaverbrook Art Gallery, Fredericton, New Brunswick)

garth was so anxious for this partnership that he asked Garrick to persuade Wilson to accept the proposal. Nothing came of it, however, and Wilson concluded his account with the remark that he declined it "for good reasons."

The great portrait group of the 1750s is *Hogarth's Servants* (pl. 114), six simple heads on a canvas. Recently cleaned, the painting

114. Hogarth's Servants; mid-1750s; 24½ x 29¼ in. (Tate Gallery)

looks just as it did when it stood on Hogarth's easel: the cool colors
are as fresh as when they were painted. Applied all at once, perhaps in
a single sitting, the paint had no time to dry or harden, and there were
no glazes to crack. Laid on his usual gray-green ground, the work also
demonstrates his wide use of body color mixed with white lead, which
in medium is practically as strong and permanent as any pigment.
These faces were done either for the sheer love of painting, to hang in
his showroom as a sample of a variety of likenesses for prospective sit-
ters (who might then compare them with their originals), to demon-
strate his status, or simply to preserve the likenesses of six people who
were very close to him. Probably all of these considerations entered in.

The number of servants portrayed does not advertise an unusual
prosperity. The minimal needs of a country squire in the later eight-
eenth century were set by Hogarth's commentator, the Rev. John

Trusler, at five servants. Thus it is possible to reconstruct Hogarth's little household: in 1757, besides Hogarth and Jane, sister Anne and mother-in-law Lady Thornhill, there were the six servants, and Jane's cousin Mary Lewis, a young girl in her twenties who served as Jane's companion. Jane's mother, Lady Thornhill, from a portrait Hogarth painted about this time (Nostell Priory Coll.), was by now grim and aging. It is the only Hogarth portrait that has the bleached white face of a Reynolds. Was Lady Thornhill pasty-faced, or was Hogarth experimenting (as with the portrait of Pine), this time with one of Reynolds' own formulae? Mary Lewis, young and pretty, he had painted in a ruff.

The other great portrait that, though undatable, may be of this time is *The Shrimp Girl* (pl. 115). This splendid sketch is difficult to explain except as a jeu d'esprit, perhaps a portrait of a familiar fishmonger. Its scale is too large for it to have been part of a conversation,

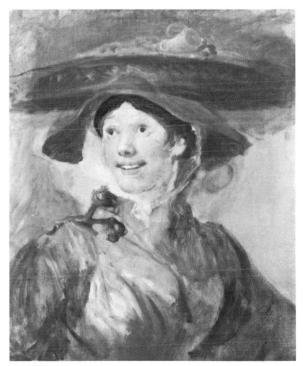

115. The Shrimp Girl; mid-1750s?; 25 x 20¾ in. (National Gallery, London)

though it seems to have been cut down; it is difficult to dissociate it from the earlier pictures of pretty, lively girls standing among masses of moiling humanity. A head and shoulders only, with a smile that is more alive than any of those full-length girls, she seems to constitute Hogarth's last loving treatment of this familiar figure. Like the *Servants,* she is an exercise in pure painting, based on the simplest and boldest forms in a style even freer and more joyous than those portraits. If the Bristol altarpiece showed signs of decline, there is none in these perhaps more congenial subjects of about the same time.

On 16 May 1757 the Duke of Devonshire became Lord Chamberlain on the death of the Duke of Grafton, who had held the position all these years since Hogarth's rebuff in the Chapel Royal at St. James' Palace in 1733. This was the period between the fall of Pitt's first ministry (the Pitt–Devonshire ministry) and the rise of the great Pitt–Newcastle ministry. Negotiations of all sorts were afoot, Pitt making exorbitant demands, Newcastle trying to gather nerve to lead a ministry without Pitt, and Fox watching and advising from the wings. In the midst of all this, on 6 June, Devonshire appointed Hogarth Serjeant Painter to the King. Thus Hogarth was able to realize to a considerable extent his ideal of emulating Sir James Thornhill. If Devonshire, Fox, and the Leicester House party, or some combination of these, had not wanted to reward Hogarth in some way, he would not have received the position. Wilkes' later innuendos, though chronologically wrong, suggest that something political lay behind the appointment. Despite Wilkes' and Hogarth's own deprecating remarks about "pannel painting," the position was financially a plum, and just what Hogarth seems to have been looking for in his last decade: a good source of income that would allow him to save money without exerting very much energy.

The Serjeant Painter is listed in the *Court & City Register* under both Ministry of Works and Lord Chamberlain, neither of which places Hogarth in what he would have considered exalted company. He must have found it comic to appear in the Lord Chamberlain's Officers list with Stephen Slaughter, who was "Surveyor of the Pictures" (£200 a year); John Shackleton, who was "Principal Painter" (£200); and John Gower, Rat-killer to the King (£48 3s 4d). His own salary was £10. In the Board of Works, where his actual profits lay, he was "Serjeant Painter of all his Majesty's Works," appearing among

the Master Bricklayers, Master Carver, Master Glazier, Joiner, Plasterer, Wine Worker, and the Serjeant Plumber. If the job were taken at face value, he would merely have been a house painter. Hogarth must have seen through the honor since he drew up a parody of the patent for himself.

One might wish for the same mock-heroic irony in his engraved self-portrait of the next year, showing himself painting the comic muse, with under his name the pompous title, "Wm Hogarth, Serjeant Painter to His Majesty." In March 1758 he published the engraving, intended to replace *Gulielmus Hogarth* as frontispiece to the bound folios of his prints. Why call himself Serjeant Painter on the frontispiece to his collected prints? Although some interesting painters had served in the post, no artist had who was considered preeminent, let alone great, except—for Hogarth at least—Thornhill. It was presumably the continuity with Thornhill (and most especially as a history painter), and the relationship to the king implied by the title, that made him inscribe it beneath the engraved self-portrait. While a court sinecure, the paintership was a relatively lucrative one that could not be judged by the paltry £10 per annum of salary. Hogarth may have secured a few more portrait commissions from the title and the contacts it brought with it, but its principal benefit was to provide a monopoly on the painting and gilding of all the royal palaces and conveyances, including banners and tents for royal troops and ships.

One lucrative sort of painting about which little has been said, because the dating is so questionable, is the "special commission." This poor cousin of the comic history painting lies somewhere between the quasi-Dutch portrait group of *Graham in His Cabin* and a comic history like *Midnight Modern Conversation* which probably includes portraits, though they are subordinated to the satiric purpose. One such commission was Thomson's for *Before* and *After*, at the beginning of Hogarth's career, when one aspect of his reputation was already being exploited by randy and rakish young Englishmen. The old man who claimed he was buying his own progress when he bid on the *Rake* exemplifies another attitude toward Hogarth's works; and it is quite possible that Beckford bought the *Harlot* and the *Rake* to have stag pictures around. From the blue picture to the pious exordium, such special commissions were filled from time to time throughout Hogarth's career. Even *Taste à la Mode* fits into this category.

The largest number, however, are associated with the Dashwood–Sandwich circle, which originally included Gustavus Hamilton, Viscount Boyne. Boyne seems to have been the earliest such commissioner, and it may have been through him that Hogarth became involved with Sir Francis Dashwood. It was reasonable that a painter famous for catching likenesses and depicting vice should have been approached in this way. After he had painted Boyne's portrait, probably in the mid-1730s, he was commissioned to put Boyne and friends into a genre scene: the result shows a night brawl outside a tavern, a coach with link boys, one trying to steal a gold-laced hat from Boyne's prone companion (Viscount Boyne Coll.). Into this scene, Hogarth has injected portraits: Lord Boyne's is essentially the same as in the full-length portrait, probably drawn from the portrait or from the *ad vivum* sketch.

A more ambitious piece, commonly called *Charity in the Cellar* (private coll.), shows Sir Philip Hoby in the center, surrounded by Lord Sandwich, Mr. de Grey, and Lord John Cavendish, with Lord Galway lying prostrate in the shadows on the left with wine dripping from a barrel into his open mouth. The center group echoes the composition of a statue of charity at the right—her breasts are turned into ale bottles. Another inanimate object is utilized grotesquely in the vial held between Hoby's legs to resemble a penis. Like the later version of *Before* and *After,* the low message of this painting is suggested through symbols and parallels rather than being depicted outright. The men portrayed, if they are correctly identified, were all members of the Dilettanti Society.

Sir Francis Dashwood, another Dilettanti, may in fact have been responsible for this commission. His connection with Hogarth can be traced to the satiric poet Paul Whitehead, who was one of Dashwood's closest confidants by the 1750s. Dashwood was a great lover of hoaxes, of dressing up, and of founding and conducting clubs. After 1751 and the death of his patron Frederick, Prince of Wales, Dashwood turned his attention from London to Buckinghamshire. In the next two years he rented Medmenham Abbey, near Marlowe, a low, rambling, red-stained house. Supervised by Nicholas Revett, in the greatest secrecy, workmen were brought down from London and returned at twilight, and servants were sworn to silence: he added at the southeast corner a ruined tower, and beneath it, somewhat better preserved, cloisters, and over the low square door at the east of the house he painted the Rabelaisian motto, "Fay ce que voudras." Outside, the grounds were

full of suggestive caves, cascades from under overhanging foliage, and upright columns; there were urns dedicated to Potiphar's wife and the Ephesian widow.

Among the Medmenhamites there were two orders of so-called friars, a superior and an inferior, twelve of each; the superiors were known as the apostles, and this was the real brotherhood. The inferior order was composed of visiting friends and neighbors—and if Hogarth did ride over to attend any meetings during his summers in Chiswick, it would have been as one of this group. Each of the brotherhood (the superior order at least) had his own cell, with a bed for his repose: "each is to do whatever he pleases in his own cell, into which they may carry women."

Dashwood's biographer sees the Medmenhamites as Gothic romantics, in the manner of the Beckford of Fonthill Abbey and *Vathek* and the Walpole of Strawberry Hill and *The Castle of Otranto*. Another writer (following the author of *Nocturnal Revels*) sees them, not inaccurately, as the tag end of Augustan satirists and hoaxers, employing a parody of Catholic ritual but also, probably, in the 1750s, of Wesleyan enthusiasm, ghost visions, and the like. All the books on the Medmenham brotherhood list Hogarth as one of the members, but none gives a satisfactory source other than the painting of Dashwood in his monk's robes. This, together with his friendship with Whitehead and his general susceptibility to such clubs, is the only evidence for his connection. In the late 1750s he must have painted Dashwood as St. Francis at his devotions (pl. 116). This large painting, in its way as ambitious as *Garrick and His Wife,* shows Dashwood, in habit, adoring in place of a crucifix a naked Venus, with various other sybaritic accouterments around. By no means Hogarth's best work, it nevertheless contains characteristic passages: the pink Venus, the beautifully painted still life of the fruit, and the dominant greens and browns.

One final picture of a special sort in the 1750s should be mentioned. This commission was for the Schutz family of Gillingham Hall, Suffolk. George Schutz, mentioned in Ministry of Works records of the 1750s, had been connected with Prince Frederick's household, and there were other members of the family in the royal service. Frank Matthew Schutz had married in 1755, and the inscription on the back of the painting claims that Mrs. Schutz commissioned Hogarth to paint a temperance lecture for her husband. Hogarth shows him leaning over the side of his bed vomiting into a basin. On the wall by the

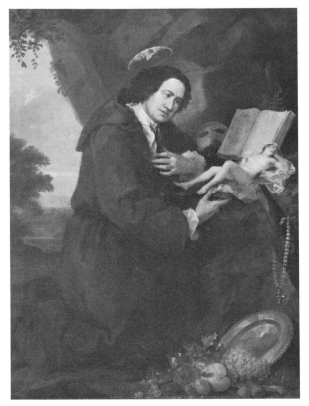

116. Sir Francis Dashwood at His Devotions; mid-1750s; 48
x 35 in. (the Right Hon. the Viscount Boyne)

bed is an inscription from Horace: "Vixi puellis nuper idoneus, &c"
(not long ago I kept in shape for the girls [Bk. III, Ode 26]); the "&c"
refers to the lyre hanging beneath the inscription (Horace's speaker
has hung up his weapons and his lyre). The handling of the paint is
very free and graceful, the colors almost pastel: salmon pink bed cur-
tains, green bedspread, olive green background, pale green behind the
bed, and a darker red in the window curtains and chair seat. Unfortu-
nately, a descendant of Schutz had the basin painted out, and now he
leans out of bed reading a newspaper, still with a very sick look on his
face (John Todhunter, Esq.).

The face in the self-portrait of 1758 (pl. 117) shows that Hogarth
was no longer, in either appearance or spirit, the Hogarth of the self-

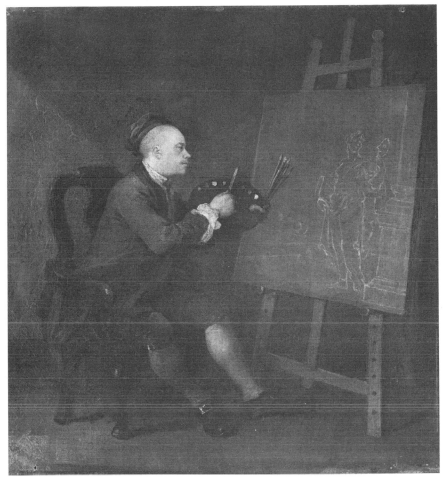

117. Hogarth Painting the Comic Muse; ca. 1758; 15½ x 14¾ in. (National Portrait Gallery, London)

portrait with Trump. The painting is only a modello, a much smaller and less precise one than *Gulielmus Hogarth* (pls. 74, 128). Hogarth's face is small, monkey-like, and intensely focused on the canvas before it—not as important as the symbolic objects around it. In the engraving, however, Hogarth dutifully engraved the face himself, a fact which he carefully registered in the publication line.

The self-portrait is primarily, of course, a portrait of the artist, and its composition is as important as that of *Gulielmus Hogarth*. Hogarth draws on a tradition of artists painting their muses: Vermeer's artist

paints Clio, the muse of history, and Metsu's paints Erato, the muse of lyric poetry. The point, however, is that he shows himself in the act of painting. This self-portrait is a complete reversal of *Gulielmus Hogarth*, where he makes himself the art object, with the real world contained in the symbols of his moral and aesthetic endeavor that surround his portrait. It gives an idea of how Hogarth's attitudes had changed since the completion of *Marriage à la Mode* and *Gulielmus Hogarth*. He shows himself in the pose which he apparently saw as characteristic at this moment; but the quality of this work, as well as the return to portrait painting, is perhaps a further sign of diminishing energies in the mid-1750s.

Two letters written by Hogarth to his old friend William Huggins survive from the fall of 1758, showing him at his most relaxed and intimate.

Huggins wrote Hogarth in November 1758 asking him to paint his portrait as a companion to the portrait of his father (done in the early 1740s). Hogarth wrote back on the ninth: "how could you doubt I would refuse anything Mʳ Huggins would ask of me. was the request to be no favour done to me you may and ought to command me at all time upon many accounts too tedious to mention. As to the size you woud have that picture you need only to bring to town with you the length and breadth of its companion together with just the Size of the face." In the late fall of 1758, then, Huggins, Jr., simply measured the canvas and his father's face and sat to Hogarth in London.

These paintings are the last of Hogarth's great parent–child portraits (The Hyde Collection). They are painted in different styles: John in hard, dry brushstrokes, emphasizing the harsh, craggy face, is clearly a tough, mean, and grasping old man. William is done in broad strokes that emphasize his soft, flabby, good-natured face. Kindly and slightly fatuous, he is another of the inheritors like Horace Walpole and John Hoadly, shown with a bust of Ariosto and a plaque referring to his other literary endeavor, his translation of Dante.

Hogarth's reply to Huggins' letter of November 1758, which asked him to consider making illustrations for his Dante translation, tells a great deal about Hogarth's state of mind: for the sake of tranquillity he is willing to limit himself to trifles. The old dichotomy of his studies and his pleasures has now broken down; he cannot "muster up spirits" to do serious work, but he can still "enjoy and love this world

as much as ever." One wonders if he is concealing the first signs of the illness that would plague him on and off for the rest of his life. Just turning sixty may have been a depressing experience, but that alone would not have slowed him down, stopped his plans and ideas and ambitions.

In spite of his low spirits, by the fall of 1758 he had undertaken two ambitious projects. One was for Lord Charlemont, the other for Sir Richard Grosvenor, about which he concludes (ironically, considering the sequel) that "one should not conceal the names of such as behave so nobly." James Caulfeild, Lord Charlemont, was the attractive and promising young scion of a prominent Anglo-Irish family; he bore a great reputation in Ireland. In 1746, at the age of eighteen, he had set out on his grand tour, studying at the Royal Academy in Turin, spending a year in Rome and Naples, and in 1749 traveling from Leghorn to Greece and Constantinople—a trip whose pleasures and dangers he afterward described wittily. He returned to London for good in January 1755. When he first came into contact with Hogarth is not known. A close personal friend of the Duke of Devonshire, earlier Lord Lieutenant of Ireland, now Lord Chamberlain, Charlemont may have met Hogarth through him. It looks as though he bought a folio of Hogarth's prints (personally chosen by the artist, as he later claimed, which meant only that Hogarth picked out especially clear impressions for him). He does not seem to have been any more interested in Hogarth's prints than in his sublime histories, but he wanted to own one of his comic history paintings. Perhaps reading Hogarth's advertisement of February 1757 in which he announced that he would paint no more of these subjects, Charlemont persuaded Hogarth to make one more for him. It was the sort of picture in fact, if a spade may be called a spade, more like the "special commissions" for Boyne and Dashwood than the sublime history of *Sigismunda* later acquired by Grosvenor, that Charlemont commissioned from Hogarth in 1757 or '58. Charlemont urged him, he remembered, before he "entirely quitted the pencil to paint him a picture leaving the subject to me and any price I asked." For Charlemont he painted *The Lady's Last Stake* (Albright-Knox Art Gallery, Buffalo; sometimes called *Picquet*). The subject, he says, was "a virtuous married lady that had lost all at cards to a young officer, wavering at his suit whether she should part with her honor or no to regain the loss which was offered to her."

While Hogarth was painting the picture, they were seeing each other socially, and Hogarth was instructing Charlemont in the danger of a "virtuoso landscape" and such pictures "decorated by a long Dutch name." In late November 1758, Charlemont bought an *Old Man's Head* attributed to Rubens and, as he recalled, "shew'd it to my Friend Hogarth, who under the Influence of Good Breeding, and perhaps of Friendship, seemed to approve of it. The next Day however, conscious of having acted with some Degree of Hypocrisy, and unable to long conceal his real Sentiments," Hogarth wrote him a letter:

Novbr 26 1758

My Lord

I endeavour'd in vain last night to get the Tragidy I promis'd to send or bring your [lord]ship this morning however I will try for the Authors consent to bring it. and I do not absolutely despair of success. I do not think there is any kind of ill nature in Enjoying such a mans follies. by the way my Lord I have Something upon my conscience to disburthen if that head I saw yesterday is not done as follows I am mistaken, Recipe an old bit of coarse cloth and Portray an old bearded Beggars head upon it with the features much in shaddow make the eye red and row some slurrs of the Pencill by way of freedom in the beard and band clap a vast splash of light upon the forehead from which gradate [sic] by degrees from the Blacking pot, varnish it well, and it will do for Langford or Prestage. I scarce ever knew a fizmonger who did not succeed in one of these masterpieces. one old Peters famous for Old Picture making, use[d] to say, even in contempt of those easiest parts of Rubens productions that he could sh–t old mens Heads with ease consider my lord he was a dutchman.

I am my Lord your most
obd humble Svt W$^:$ Hogarth.

This was the relationship Hogarth enjoyed, and one can imagine the complicity of the two friends in the developing painting of *The Lady's Last Stake:* where the lapdog came from, what the picture on the wall meant, and what the furniture signified.

Another young man, Sir Richard Grosvenor, heard about the picture (perhaps from Charlemont) and saw it in Hogarth's studio in 1758. Taken by it, and learning the curious details of the commission, he made Hogarth the same proposition. "Seeing this picture," Hogarth recalled, "being infinitely rich, [he] pressed me with more vehe-

mence to do what subject I would, upon the same terms, much against my inclination." And so Hogarth "began on a subject I once wished to paint." These statements were written in his autobiographical notes. The subject he had wished to paint—Sigismunda weeping over the heart of her dead lover Guiscardo—stemmed from the enormous price of £400 paid for a similar painting in May 1758 at Sir Luke Schaub's sale.

Hogarth's growing pessimism about England was implemented in the art world by the auctions of Henry Furnese's and Sir Luke Schaub's collections, both of which, as Walpole commented, brought much more than they deserved.

On the first day of the sale, *Sigismunda Weeping over the Heart of Guiscardo,* attributed to Correggio (No. 29), was sold for £404 5s, the highest price of the day, since there were virtually no Correggios to be had in England. Thus there were few Correggios with which to compare it (pl. 118); Hogarth, after seeing it, was convinced that it was not a Correggio at all. It was, in fact, the work of Francesco Furini, a seventeenth-century Florentine painter.

Sir Richard Grosvenor was very much in evidence at the sale. He was indeed "infinitely rich," the heir to the Grosvenor estates in Cheshire and Westminster. Originally Cheshire gentry of good but moderate estate, his ancestors had married into the Davies family and secured possession of the land stretching from Oxford Street to the Thames at Vauxhall and Chelsea, which at length became the streets and squares around Grosvenor Square and Park Lane, and the districts of Victoria and Pimlico.

It is possible to imagine the comedy of Sir Richard telling Hogarth to paint just what he liked and name his own price, hoping for something like *The Lady's Last Stake,* a cross between Teniers and Boucher, and ending up with the lugubrious *Sigismunda* and a bill for 400 guineas. Hogarth pointed out in his reminiscences on the affair that he thought this a reasonable sum—he had "spent more time and anxiety" upon this picture "than would have got me double the money in any of my other way & not half what a common face painter got in the time." It is a careful if not labored performance, and he might have worked on it as long as a year before showing it to Grosvenor; then he would spend many hours on the canvas before it was considered finished, with further changes to follow.

The *Sigismunda* (pl. 119) was indeed a wonderfully perverse under-

taking. Hogarth selected a subject and composition least suitable to
his talents—a female mourning her lost lover, with only her upper
body and a table depicted—no interaction of characters. Then he
offered the work to the least likely candidate for it, in circumstances
suggestive of false pretenses. Nevertheless, the *Sigismunda* is an inter-
esting painting which deserves consideration: Hogarth was trying to
paint in a particular tradition without sacrificing his individuality.

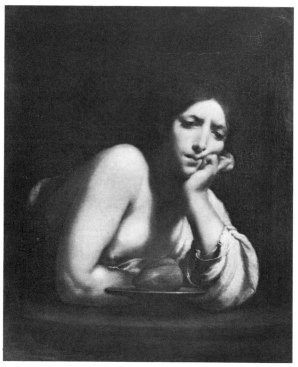

118. Francesco Furini, Sigismunda; ca. 1640 (Duke of New-
castle)

The composition takes another step beyond the simple two figures
of *The Lady's Last Stake* to a single figure spreading languorously
across the picture space. This is a painting which continues the gen-
eralizing tendencies of *Moses* and *Paul,* with a touch of the French
elegance from *The Lady's Last Stake* in such details as Sigismunda's
outstretched, curved fingers pressed to her bosom and the elegant
s-curves of the table and her billowing garments. The brushwork it-

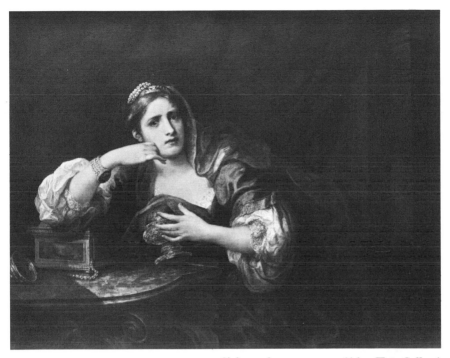

119. Sigismunda; 1759; 39 x 49½ in. (Tate Gallery)

self is smoothed until the face and hands are hardly recognizable as
Hogarth's, and his flair takes effect only in the goblet and accessories.
A tension exists between the simple composition and the careful,
crowded iconography. Hogarth has made the best of his few symbolic
objects. The heart of the lover in the goblet is balanced against Sigis-
munda's bracelet bearing the head of a king, clearly her father, who
killed her lover. Even the landscape on the side panel of the box de-
tails a church or castle on the left and a Palladian villa with a dome
(resembling Chiswick House) on the right.

Despite its classicized elements, the painting was founded in the
technique of realism, if the stories about the posing of Jane Hogarth
and a human heart are true. Much of Hogarth's sensitivity about this
picture may be traced to the reports that he modeled Sigismunda on
Jane as she mourned the death of her mother. Wilkes noted unkindly
that it was Jane "in an agony of passion, but of what passion no con-
noisseur could guess," and a housemaid of the Hogarths at Chiswick
recalled that it was Jane grieving for her dead mother.

At the time Sir Richard saw the painting there was blood on Sigis-
munda's fingers from the heart she was handling. This realistic touch
cannot have charmed him, and it offended so many others that Ho-
garth later repainted the hands. The main problem with *Sigismunda*
was all the advice proffered to Hogarth during its composition, which
in this case apparently influenced the usually self-confident artist and
caused repeated repainting. So it ends as an exercise in painting; an
intellectual exercise, and a fairly interesting painting, but not one to
kindle much enthusiasm in Grosvenor. On seeing the finished picture
in June 1759, Sir Richard must have been taken aback by this most
un-Hogarthian of works, and he responded with polite surprise or dis-
belief. (Charlemont had not yet received his picture; next to *Sigis-
munda* in Hogarth's showroom, it must have made a striking con-
trast.) Hogarth was offended by Grosvenor's evasiveness. He tinkered
with the picture a while longer, and on 13 June he wrote to Sir Rich-
ard (a draft of this letter is the first of a series of documents he pre-
served and pasted into the subscription book when he attempted to
have *Sigismunda* engraved):

> I have done all I can to the Picture of Sigismunda, you may remember
> you was pleased to say you would give me what price I should think
> fit to set upon any Subject I would Paint for you, and at the same time
> you made this generous offer, I, in return, made it my request, that
> you would use no ceremony of refusing the Picture, when done, if you
> should not be thoroughly satisfied with it. This you promis'd should
> be as I pleased which I beg now you will comply with without the least
> hesitation, if you think four hundred guineas too much money for it.
> One more favour I have to beg, which is, that you will determine on
> this matter as soon as you can conveniently, that I may resolve whether
> I shall go about another Picture for M^r Hoar the banker on the same
> Conditions or stop here.

Sir Richard replied on the seventeenth:

> Sir
> I shou'd sooner have answer'd yours of y^e 13th Ins^t but have been
> mostly out of Town. I understand by it that you have a Commission
> from M^r Hoare for a Picture. If he shou'd have taken a fancy to the
> Sigismunda, I have no sort of objection to your letting him have it; for
> I really think the Performance so striking, & inimitable, that the con-

stantly having it before one's Eyes, wou'd be too often occasioning melancholy ideas to arise in ones mind: which a Curtain's being drawn before it wou'd not diminish in the least.

I am, Sir,

your most obedient servant,

Richard Grosvenor.

This letter, poised between compliment and irony, must have infuriated Hogarth. Grosvenor has purposely misread Hogarth's remark (admittedly a tactical error in itself) about Hoare and used it as a graceful way out. Partly for self-laceration, partly to let Grosvenor know that he was not intimidated, Hogarth wrote to him again:

Sᴿ Richard

As your obliging answer to my Letter in regard to the Picture of Sigismunda, did not seem to be quite positive, I beg leave to conclude you intend to comply with my Request, if I do not hear from you within a week.

Sir Richard took no further notice of the affair, though his interest in Hogarth's "drolls" continued, and some years later he bought the original of *The Distressed Poet*.

The sequel was Hogarth's obsessive concern with this picture, and his refusal to sell it for less than the "Correggio" had brought at Schaub's sale. Anecdotes of his love of flattery generally refer to *Sigismunda* rather than to those works about which he felt more secure.

Also in August, Hogarth finally finished Charlemont's painting and, perhaps still chafing from Grosvenor's response to *his* picture, asked him to name his own price. Charlemont, who was sitting for his portrait to Hogarth at this time, confessed with much flattery that he was very hard up and leaving immediately for Dublin. In January, with more flattery about the unworthiness of the price for such an inestimable picture, Charlemont sent Hogarth £100.

At first it is puzzling that Hogarth should have been so enthusiastic over Charlemont, who seems to have paid him more in words than in hard cash—and whose explanation of why he paid so little is remarkably similar to Grosvenor's explanation for paying him nothing at all. Perhaps Hogarth was so hungry for praise that he accepted these kind words from a well-known connoisseur and politician, scion of an old and noble family; perhaps they meant more to him than the money—

certainly they offered a striking contrast to Grosvenor. Perhaps he knew that Charlemont was in fact hard up, while Grosvenor was immensely wealthy.

The Lady's Last Stake hung in a bedchamber in Charlemont House in Dublin. The portrait (Smith College), for one reason or another, was never finished. On an ocher ground only a bluish-gray background is indicated, and a bit of red at the collar. Otherwise Hogarth finished only the face, a metaphor, in effect, for his relationship with Charlemont: the lips are too red, the smile too artificial, the face too idealized. The earl bought another Hogarth painting, *The Gate of Calais,* presumably after the Society of Artists' exhibition in 1761 when it was shown.

One other painting, *Satan, Sin, and Death* (Tate), still in his studio, must have been on Hogarth's mind. Edmund Burke's *Philosophical Enquiry into . . . the Sublime and Beautiful* had been published at the end of April 1757. Hogarth undoubtedly read this treatise as soon as word reached him of the subject (he and his *Analysis* were treated in the second edition of 1759); he found in it unacknowledged signs of his influence, as well as much with which he disagreed.

Hogarth had opened virtually every possible form of history painting to his fellow English artists. A few, like Hayman, had pursued the historical illustration branch with some success. Hayman, indeed, is usually described in contemporary accounts as the paramount English history painter, presumably for his large pictures at Vauxhall, which continued to appear regularly through the 1750s, and in 1760 were capped with his four huge scenes from the Seven Years' War hung in the "new music room" adjoining the Rotunda. Hogarth had opened up the Foundling Hospital and kept the tradition going himself, however slightly, through all the lean years. When he stopped he was on the verge of the great age (in terms of quantity) of English history painting. In 1758 Gavin Hamilton's *Andromache Mourning the Dead Hector* was commissioned, demonstrating another way of securing patronage for this kind of painting. Working in Rome, Hamilton realized that "only at Rome, under the influence of the temporary enthusiasm for Antiquity produced by the Grand Tour, would the traveling British patron be likely to commission the sort of picture he wanted to paint." He furthered this idea by making package deals with English connoisseurs who were buying antiquities from him: in-

cluded in the bargain would be one of his history paintings. The new
age of English history painting really dates from Hamilton, though to
some extent it stemmed from Hogarth's Foundling Hospital and Lin-
coln's Inn Fields pictures.

In February 1759 the Society of Arts Committee on Premiums re-
ported a premium of 100 guineas for the best history painting "con-
taining not less than three human Figures as big as Life" and 50
guineas for second best. After Hogarth, the deluge.

The Lady's Last Stake was Hogarth's last comic history painting;
and the ill-fated *Sigismunda* was his last attempt at sublimity in that
genre. After they were completed, he lived up to his word and made
only prints and painted portraits—and few of those. In December 1759
he published one of his best engraved histories, *The Cockpit* (pl. 120),
which once again used the tradition of history painting as a context

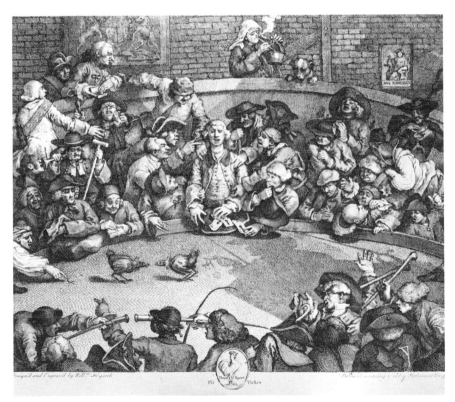

120. The Cockpit; Nov. 1759; 11¹¹⁄₁₆ x 14¹¹⁄₁₆ in. (BM)

for modern behavior: this time patterned after Leonardo's *Last Supper*. The figure of Christ—or Anti-Christ—is a nobleman, blind but intensely concentrated, who gambles furiously among a crowd of moiling and equally obsessed plebeians. It is a terrifying picture, with more true *terribilità* than *Satan, Sin, and Death,* free of complex readable patterns but producing an image of desire that appears almost satanic in its savagery—the nobleman's desire imparts a kind of wicked sanction to all the others, with the implicit inscription "The Blind leading the Blind." At least two other noblemen appear in the gambling crowd, and even the man suspended in a basket (for failure to pay his debts) desperately tries to stay in the game. The etching is free and fluent, in Hogarth's most mature style, as close as he ever came on copperplate to duplicating the freedom of his oil sketches. But even here one senses in the juxtaposition of noblemen and mob the impact of his feelings about the experiences of the last year.

A year earlier Hogarth had received sheets of Huggins' translation of Dante's *Inferno* and promised to read it. Although he gently refused to furnish Huggins with illustrations, he sighed that a few years before he might have undertaken such an ambitious project. If he was not illustrating books for Huggins, the influence of Dante's *Inferno* is nevertheless evident in all his work from *The Cockpit* onward. On the simplest level, this work can be said to convey a stronger sense of damnation than any done previously: these people appear to be condemned to futile and repetitive actions. Even the circular structure—something required of a cockpit but not evident in any other work by Hogarth—may owe its inspiration to Dante's circles of Hell. *Enthusiasm Delineated* (engraved sometime in 1760 or 1761) is definitely reminiscent of the *Inferno,* down to the Dantesque observer watching these damned souls with fascinated attention through a window.

Once again literature has influenced Hogarth. But now it is no longer a *Beggar's Opera* that inspires him. What followed Hogarth's encounter with Dante's Hell was a series of prints that return to the emblematic mode of his earliest efforts and in some sense portray hell —whether it be a Methodist congregation or a London street, or the symbol of England in a Bedlam he had created thirty years before. Perhaps it would be more accurate to say that Huggins' Dante confirmed both his feelings at the time and the images (such as the crowd)

he had already selected to express them, and provided a religious context, even one of apocalypse, heretofore absent in his work.

ILLNESS, WITHDRAWAL, WRITINGS

After the completion of *Sigismunda* in 1759 Hogarth subsided into virtual silence as an artist. One or two projects were begun and abandoned, but no further attempt at a major painting was made; only a few portraits can be dated with any certainty from the last six years of his life. In the late 1750s, before the vigorous return to printmaking in 1761, the prints themselves dwindled into writing, and Hogarth became a man of words rather than images. What little art survives from this period was apparently undertaken by chance—a faint echo of the powerful pattern of challenge and response which produced the histories and portraits of the 1730s.

Hogarth describes his failing health after the Grosvenor fiasco. The exertions 'which attended this affair coming at a time when perhaps nature rather wants a more quiet life and something to cheer it as well as exercise after long sedentary proceeding for many years brought on an Illness which continued a year which a horse cheifly when I got well enough to ride recovered me of"; 1760 was probably the year he refers to. After *The Cockpit* of December 1759, nothing else came from Hogarth's studio until the spring of 1761, when the frontispiece and tailpiece to the catalogue of the Society of Artists' exhibition appeared, and Hogarth, himself active in the whole project, was reported in good health by Horace Walpole. In the interim only three prints appeared: two were based on sketches he must have made in March and December for Laurence Sterne's *Tristram Shandy,* and the other was based on a drawing made sometime before July for Joshua Kirby's *Perspective of Architecture.* He attended the Foundling Hospital's annual meeting on 14 May, and again the meeting of 20 December. But he does not appear in the list, dated 7 December, of artists who agreed to appear at the next (1761) annual dinner in clothing made by the foundlings in the Ackworth establishment in Yorkshire.

Whatever the immediate effect of his illness, he had already in the mid-1750s moved strongly in the direction of document as form and his own craft as subject. *Sigismunda* itself was produced as an illustration of his aesthetic theories. In September 1758 his meditation on his art, and the attacks made on him, led him to publish *The Bench*

(pl. 121), a curious combination of illustration and text, not unlike a page from *The Analysis.* The oil sketch (Fitzwilliam Museum) might date back to the *Election* paintings; it is very small and slight, though nicely finished. The print, however, is notable because the design engraved from the oil sketch is little more than an illustration for a long paragraph of prose beneath it. This is the only piece of writing Hogarth published under his own name after the *Analysis,* and it may have been worked up from one of the rejected passages (it refers to Chapter 6).

That the thin, long-nosed judge is taken from the judge on the funerary monument in *Analysis,* Plate 1 (which would have appeared only half-a-dozen pages earlier in the volume of his collected works), suggests that Hogarth wishes to emphasize the connection. There the judge was an epitome of false sagacity, robes attempting to conceal stupidity or cruelty, and a metonymy for the bad judges of art. Here the judges, dominating the picture with their heavy, pompous shapes and stupid, inattentive, or malicious faces, appear to be not only examples of character but, as judges, themselves caricatures of judgment. (Visible above their heads is the inscription "SEMPER EADEM"— always the same.) I suspect that on some level the Bench represented to Hogarth those self-styled critics who sat in judgment on his *Analysis* and caricatured it, surprising him "with any sort of Similitude in objects absolutely remote in their kind" (as he defines caricature in *The Bench*). At the least, they are the obtuse judges who cannot tell character from caricature.

The Bench was presented, however, and accepted as a new verbal pronouncement by the author of the *Analysis.* As *Characters and Caricaturas* was inspired by Arthur Pond's importation and reproduction of Ghezzi's caricatures, this work was a reaction against a new kind of caricature—Colonel George Townshend's sketches of political figures. Hogarth dedicated the print to Townshend, who was one of the attackers of *The Analysis of Beauty.* More recently, he had instigated the Militia Bill, aimed against the Duke of Cumberland, at which Hogarth made a swipe in the *Election,* Plate 3. Townshend had served for a time as the duke's aide-de-camp, and they came to heartily dislike each other. Accordingly, when Newcastle appointed Fox, Cumberland's chief supporter, secretary of state and leader of the House, Townshend broke with Newcastle and became a supporter of Pitt.

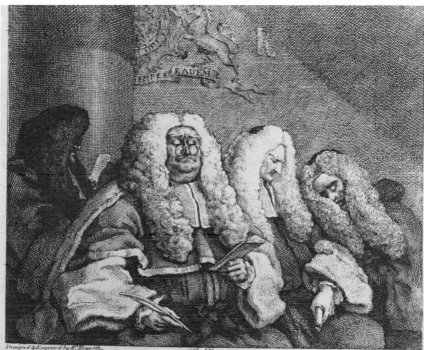

The BENCH.

Of the different meaning of the Words Character, Caracatura and Outrè in Painting and Drawing. — Addrefs'd to the Hon.ble Coll: T.....d.

There are hardly any two things more efsentially different than Character *and* Caracatura *nevertheless they are usually confounded and mistaken for each other: on which account this Explanation is attempted It has ever been allow'd that, when a* Character *is strongly mark'd in the living Face, it may be consider'd as an Index of the mind, we express which with any degree of justness in Painting, requires the utmost Efforts of a great Master: Now that which has of late Years, got the name of* Caracatura, *is, or ought to be totally divested of every Stroke that hath a tendancy to good Drawing: it may be said to be a Species of Lines that are produc'd rather by the hand of chance than of Skill; for the early Scrawlings of a Child which do but barely hint an Idea of an Humane Face, will always be found to be like some Person or other, and will often form such a Comical Resemblance as in all probability the most eminent* Caracaturers *of these times will not be able to equal with Design, because their Ideas of Objects are so much more perfect than Childrens, that they will unavoidably introduce some kind of Drawing; for all the humourous Effects of the fashionable manner of* Caracaturing *chiefly depend on the surprize we are under at finding our selves caught with any sort of Similitude in objects absolutely remote in their kind. Let it be observ'd the more remote in their Nature the greater is the Excellence of those Pieces, as a proof of this I remember a famous* Caracatura *of a certain Italian Singer, that Struck at first sight, which consisted only of a Streight perpendicular Stroke with a Dot over it As to the French word* Outrè *it is different from the foregoing, and signifies nothing more than the exagerated outlines of a Figure, all the parts of which may be in other respects a perfect and true Picture of Nature. A Giant may be call'd a common Man* Outrè. *So any part as a Nose, or a Leg, made bigger than it ought to be, is that part* Outrè. † *which is all that is to be understood by this word so injudiciously us'd to the prejudice of* Character. ———*

† See Excess Analysis of Beauty. Chap. 6.

121. The Bench; Sept. 1758 (Townshend's name removed); 6½ x 7¾ in., caption plate 4⅝ x 8⅜ in. (BM)

The Militia Bill he sponsored was both his way of attacking the duke and a method of resuming a military life outside the duke's domain. Townshend moved for the bill on 8 December 1755, and in the following months, as the bill was pending, he adorned "the shutters, walls, and napkins of every tavern in Pall Mall with caricatures of the duke and Sir George Lyttleton, the Duke of Newcastle and Mr. Fox." He also published a series of these on cards—a new kind of manufacture. The bill failed that session, but was reintroduced in January 1757, and on 28 June received the royal assent.

A few years later, Hogarth alluded to Townshend again in *The Times, Plate 1* (pl. 126), as a militarist, a regimenter of men; but more than that, the sign bearing his initials seems to sanction the unregimented, chaotic mob below. The serious riots that followed the Militia Act helped to impress on Hogarth's mind in the late 1750s a sense of the danger of popular agitation and a fear of oncoming chaos. Caricature, to Hogarth, was another form of that chaos.

Someone signing himself "B" published a letter in the *Monthly Review,* dated 20 September, claiming that Hogarth's distinctions were all wrong. This writer notices that the text is indeed the primary part of Hogarth's print, "intended for the instruction of the ignorant world," and the print itself rather insignificant. His first point is that despite Hogarth's claim, the distinction between character and caricature is very well known and hardly needs further explanation. Second, he hits upon the one point of originality in the inscription, in which Hogarth backs up the critics' position on the crudity of caricature (Félibien, for one, defines caricature as a likeness done in a few strokes), by pointing out that it encourages poor drawing. Caricature, "B" argues, is as valuable a thing in its way as character. Exemplifying "character" by the works of Clarendon, Shakespeare, and Hogarth himself, "B" simply argues that "caricature" can involve as skillful drawing and as much genius as its more elevated opposite.

Hogarth responded to "B" with a letter explaining why he published *The Bench* and trailing off into fragmentary comments on "Mr B." Hogarth's opinions were by no means all self-defensive; they were both practical and theoretical, and were expanded in letters and in conversation as well as in his private manuscripts.

In his next document of self-justification Hogarth once again supplemented images with words, adding long inscriptions on the plates of *Paul before Felix* and *Moses Brought to Pharaoh's Daughter,* and

explaining his action in the advertisement of 1–4 December 1759 for *The Cockpit*. Announcing the new print, he says he is also republishing these two old ones, "with the Rev. Mr. JOSEPH WARTON's curious Remarks on the Author's Manner of treating serious Subjects." Warton's *Essay upon the Genius and Writings of Pope* had been published in 1756. Garrick had a copy and wrote Warton on 15 June to thank him for his flattering comments. Hogarth must have seen it soon after and was less happy than Garrick with what he read. Warton's argument was that a writer or artist cannot do well in more than one line. Shakespeare and Garrick are his two exceptions, equally good at comedy and tragedy. Pope, of course, is Warton's chief witness, and Pope's kind of poetry is demoted from the first rank, now the Sublime and Pathetic, to the second, Ethical Poetry. Hogarth came into favor in the tradition of Swift and Pope, but unlike them he outlived it; by the mid-1750s Warton was in the mainstream of educated English thought when he emphasized the limitations of didacticism, and even more of satire. He applies Pope's line "One science only will one genius fit" to the poet himself and proceeds to a list of examples which concludes with Hogarth and his attempts at sublime history:

> some nicer virtuosi have remarked, that in the serious pieces, into which Hogarth has deviated from the natural bias of his genius, there are some strokes of the Ridiculous discernible, which suit not with the dignity of his subject. In his PREACHING of St. PAUL, a dog snarling at a cat; and in his PHARAOH'S DAUGHTER, the figure of the infant Moses, who expresses rather archness than timidity, are alleged as instances, that this artist, unrivalled in his own walk, could not resist the impulse of his imagination towards drollery. His picture, however, of Richard III. is pure and unmixed with any ridiculous circumstances, and strongly impresses terror and amazement.

If Hogarth was disturbed by the judgment on his art, he was doubly irritated by Warton's egregious error, which showed that he had not looked closely at the painting in question. While both *The Pool of Bethesda* and *The Good Samaritan* contain dogs—the *Pool* has one leaning over the architectural parapet, the *Samaritan* has one licking a wound it probably received defending the injured man from the thieves, and the bas-relief has a dog barking to awaken the sleeping monk Rahere—there is none in *Paul*. Warton may have been right as to the background spirit of *Moses* and *Paul*, but he was wrong as to

the letter, perhaps having vaguely in mind the burlesque subscription ticket. No personal relations between the two men are on record. It is possible that they had met, but they were no more than friends of friends; the conflict was carried out through intermediaries; 1756, when the book appeared, was a relatively calm time for Hogarth, and the matter did not become public.

Apparently Warton sent Hogarth a draft of his emendation for the second edition. But the second edition did not appear until 1762, and by 1759 Hogarth had painted his *Sigismunda* as a sublime history painting and been rebuffed; and with his reputation threatened (he feared) by Grosvenor's stories, his impatience got the better of him. He was also at this time in close communication with William Huggins, who may have added to his suspicions of the Wartons. Huggins would have convinced him of the stupidity of Joseph's brother Thomas, whose *Observations on the Faerie Queene of Spenser* (1754) he attacked in *The Observer Observed* (1756). One can imagine Hogarth and Huggins getting together to ridicule the error-prone Wartons, by 1759 no doubt impugning Joseph's motives for delaying publication of his retraction; and at the end of that year Hogarth engraved Warton's erroneous passages prominently on both *Paul* and *Moses* and reissued them with the clear advertisement of his intention. His feelings were so strong that he felt compelled to ruin the aesthetic effect of the prints (temporarily at least) in order to express them.

Warton's second edition did finally appear at the beginning of 1762, and on page 119 all but the complimentary reference to Hogarth's *Garrick as Richard III* is omitted, and a footnote is added:

> The author gladly lays hold of the opportunity of this SECOND EDITION of his work, to confess a mistake he had committed with respect to two admirable paintings of Mr. Hogarth, his PAUL PREACHING, and his INFANT MOSES; . . .

Besides the weight of the *Sigismunda* affair, another contribution to Hogarth's unfortunate inscriptions on *Paul* and *Moses* may have been the *Idlers* by Joshua Reynolds, published only a few months after the rejection of *Sigismunda*, just when they would have galled him most. Reynolds had earlier drafted some "Observations on Hogarth," which, beginning with "Sir," sound as if they were originally composed as a letter to some periodical. They appear to have been

prompted by the academy dispute. This draft, however, never saw print; the cautious Reynolds decided to use the less direct but perhaps more damaging approach of having a connoisseur just returned from Italy praise Hogarth's Line of Beauty. The result was published in *The Idler* No. 76, 29 September 1759, by his friend Samuel Johnson. Visiting Hogarth's beloved Raphael Cartoons, the connoisseur pauses before *Paul Preaching at Athens* (recognized by contemporaries as an inspiration for *Paul before Felix*):

> 'This,' says he, 'is esteemed the most excellent of all the Cartoons: what nobleness, what dignity there is in that figure of St. Paul! and yet what an addition to that nobleness could Raffaelle have given, had the art of Contrast been known in his time; but above all, the flowing line, which constitutes Grace and Beauty! You would not then have seen an upright figure standing equally on both legs, and both hands stretched forward in the same direction, and his drapery, to all appearance, without the least art of disposition.'

In one blow Reynolds has caught Hogarth's theories of "Contrast" and the Line of Beauty, as well as their application in *Paul before Felix*. The connoisseur goes on to praise Hogarth's pyramidal principle and the benefits of an academy education, denied, alas, to Raphael.

Two more essays followed: No. 79, 20 October, was on the "Grand Style of Painting," and No. 82, 10 November, on "The True Idea of Beauty." Hogarth would have found none of this reassuring, but No. 79 must have been particularly disturbing. This essay begins with a clear statement of the nature of great painting which Hogarth would not have argued with: it involves not mere mechanical imitation, in the manner of the Dutch genre painters, but the transformation of nature by the imagination in the Italian manner (poeticized, Reynolds would say; moralized or made meaningful, Hogarth would say). But again Hogarth is Reynolds' quarry, and he pointedly excludes the Hogarthian experiment: "To desire to see the excellencies of each style united, to mingle the Dutch with the Italian School, is to join contrarieties which cannot subsist together, and which destroy the efficacy of each other." This describes Hogarth's original genre, the comic history painting, but it can also be taken as an unsympathetic view of his sublime paintings, like that of Warton. Reynolds sees too much of the Dutch school (and the Venetian, "which may be said to

be the Dutch part of the Italian Genius") in contemporary painting.
Like Warton he calls for more sublimity—or, as he designates it in
Idler No. 79, "enthusiasm."

If Hogarth's response to Reynolds' *Idlers* was the inscriptions he
added to *Paul* and *Moses* to prove that Warton was wrong about the
"Dutch part" of these paintings, a much more important one was his
launching into the single major engraving of this relatively barren
period, *Enthusiasm Delineated* (pl. 122), in which he replied to Reyn-
olds' taunt. He attempts to show that, Reynolds to the contrary, it is
not "very difficult to determine the exact degree of enthusiasm that
the arts of Painting and Poetry may admit," and he includes a ther-
mometer for this purpose.

There is no way to date precisely this remarkable print, though it
was extensively revised in February 1762. Its inception, however,
clearly occurred in the fall of 1759. Two impressions of a complete
engraving with the inscription sketched in by Hogarth have survived,
and the handwriting is very shaky, perhaps suggesting the sickness that
seems to have overtaken him in 1760. The conception is nevertheless
vigorous and Dantesque, transforming the "enthusiasm" of the old
masters into religious images that mingle with the physical "enthusi-
asm" of religious fanatics. "The Intention of this print," he wrote
underneath the design, "is to give a lineal representation of the
strange Effects of litteral and low conceptions of Sacred Beings as also
of the Idolatrous Tendency of Pictures in Churches and prints in Re-
ligious books &c." His examples, clear enough in the design but enu-
merated beneath anyway, are those Reynolds listed at the end of *Idler*
No. 76 as the highest examples of "the majesty of heroic Poetry":
Raphael's ancient God supported by two angels, Rubens' muscular
Devil holding a gridiron, and Rembrandt's roly-poly St. Peter. (He
identifies only these three, but the puppet-like Adam and Eve prob-
ably allude to Dürer.) The print is dedicated to the Archbishop of
Canterbury (at this time Thomas Secker), the patron of ecclesiastical
art in England—reminiscent of the ironic dedication of *The March to
Finchley*.

Through the dedication to Secker, who though Archbishop of
Canterbury had Methodist leanings, Hogarth is perhaps making a
connection between the art of the old masters and the worship of con-
temporary enthusiasts. Different religions are crowded into one
church—all sects that could be called enthusiastic: Roman Catholics

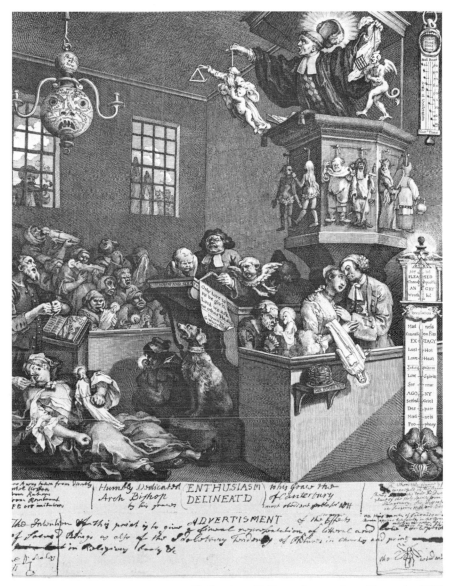

122. Enthusiasm Delineated; ca. 1760; 12⅝ x 14 in. (BM)

eating small figures in the shape of Christ, a Jew going into ecstasy over a picture of Abraham sacrificing Isaac, and a Methodist preaching a fiery sermon. Only the Moslem, outside the window, is quietly watching, like one of those foreign observers popular in satires of the

time. The room itself is a meeting house, strongly resembling White-
field's tabernacle on Tottenham Court Road.

Either Hogarth's illness or, as tradition has it, a friend, prevented
him from entrusting *Enthusiasm Delineated* to the writing engraver
and publishing it. The friend, apparently John Hoadly, may have
persuaded him that his intention would be misunderstood—that he
appeared to be drawing ugly parallels between the Anglican and Ro-
man churches. In the revision, the Catholics and Anglicans are meta-
morphosed into Methodists, a safer target. The Devil remains dan-
gling from the preacher's left hand, but from his right hangs a witch,
associating him with the Hutchinsonians; and the religious images
around the pulpit are replaced by puppets of ghosts: Wesley's credo
included belief in spirits. All the images of Christ are replaced by the
Cock Lane Ghost—a much better point, suggesting that these Meth-
odists (like their preacher) are merely Catholics in disguise, and their
Cock Lane Ghost another image of Christ; the Jew is still present, pre-
sumably to show Methodism's connection with Judaism as well as
Catholicism. Enthusiasm has become superstition; the ghosts are ac-
companied by demonologies and various hoaxes like the Boy of Bil-
ston who spewed nails and Mary Toft who gave birth to rabbits.

The parallels between Hogarth and Reynolds, as the *Idlers* show,
extend as far as their turning at times to writing to supplement their
art. In this respect as in others, Hogarth seems to be the precursor, but
again the differences are instructive. The major difference can be seen
in Hogarth's indiscretion: he used his name, advertised his writing,
and openly thanked his friends who helped him write *The Analysis*.
Reynolds carefully kept his name from his essays, though it was known
that he was the author, and so continued the tradition of the gentle-
man who would not stoop to put his name to his writings. He never
admitted to any assistance from Samuel Johnson with style, let alone
content, going so far in his *Discourses* as to cancel references to any
line Johnson may have added or helped him with; and thus leading
modern scholars to question the origins of large sections of this work.

Another concern common to Hogarth and Reynolds was the fact
that the latter was flourishing. In 1759 he raised his prices to 20 guin-
eas a head, 50 for a half-length, and 100 for a whole length. In 1758–60
he painted the Duke of Cumberland, the Duke of York, and the
Prince of Wales, as well as Garrick, Sterne, Lord Ligonier, and many
others. In July 1760 he bought a house on the west side of Leicester

Fields, across the square from Hogarth's; he had paid for it by September, and had it decorated in a style influenced by the chinoiserie of William Chambers. By this time his earnings totaled £6000 a year; soon he was riding about in a splendid coach with allegories of the seasons painted on its panels and its wheels decorated with carved foliage and gilding. While one does not ordinarily think of Reynolds as specifically challenging Hogarth, his Leicester Square house, his painted coach, his writing (especially the *Idlers*) and his sponsorship of the academy might well be viewed in that light. After the failure of the Dilettanti project, in which he was deeply involved, he turned to another Hogarthian endeavor and in 1757 presented his full-length portrait of Lord Dartmouth to the Foundling Hospital. He thus joined the artists who met every year on Guy Fawkes Day, and moved to the center of this convivial and promising group.

The first two volumes of *Tristram Shandy* were published in 1759, and Laurence Sterne visited London in the spring of 1760 to reap the rewards and to set his second edition in the right context: he wanted a dedication to William Pitt and illustrations by Hogarth, and he got both. Sterne was himself an amateur painter, whose ideal was Hogarth, and he includes complimentary references to Hogarth's Line of Beauty in the first two volumes of *Tristram Shandy*.

In London, Sterne became acquainted with the elegant equerry, Richard Berenger (shortly to be George III's Gentleman of the Horse), a member of the Murphy–Foote circle, and an acquaintance of Hogarth's. The author of books on horsemanship, Berenger was praised by his contemporaries for his high spirits ("the joyous Berenger"), his charm, and his witty anecdotes. He was "a particular friend" of Garrick, and through him may have been introduced to Hogarth, as later to Sterne. On 8 March Sterne wrote Berenger (at least two drafts were necessary to get the letter right) asking him to approach Hogarth about an illustration, preferably of the Trim passage, for the second edition, which was expected in another month. Between them, Berenger and *Tristram Shandy* charmed Hogarth, and he contributed an illustration for the passage, showing Trim reading the sermon on conscience, and throwing in Dr. Slop as well: a graceful shape and a comic, caricatured one. The drawing (pl. 123) and Ravenet's engraving were finished by 2 April, when the second edition appeared: "*Dedicated to the Right Honourable Mr. PITTT* [sic], / With a

Frontispiece by Mr. HOGARTH." Hogarth followed this up by sub-
scribing to Sterne's *Sermons of Mr. Yorick*—one of the 661 subscribers
along with Garrick, Reynolds, Wilkes, and the nobility, clergy, and
world of fashion. One wonders if Hogarth was merely joining the
Sterne bandwagon, or whether he realized how symbolic was his asso-
ciation with *Tristram Shandy*.

123. Frontispiece, *Tristram Shandy,* vol. I (draw-
ing); 1759; 5⅜ x 3¼ in. (New York Public Li-
brary, Henry W. and Albert A. Berg Coll.)

To mirror the tone of Sterne's novel, he exaggerated more than
usual, producing a close anticipation of the style of Rowlandson. He
may nevertheless have realized, as he drew the picture or as he read
Tristram Shandy, how indebted Sterne was throughout to his prints
and to the *Analysis*. Many of Hogarth's doctrines—of contrast, of va-
riety, and above all of intricacy—inform Sterne's novel, whose radical

intention was to convey both the chronological sense of a novel and the simultaneity of a painting. Of course, *Tristram Shandy*'s pictorialism is readily apparent in the importance of the typography, the marbling or blackening of pages, and the like, as well as in the emphasis placed on the appearance and gestures of the characters. But Sterne's narrative method constitutes an attempt to make a temporal form into a spatial one; the reader is meant to "read" and chase about in his book as he does in a Hogarth painting (leading "the eye a wanton kind of chace"). Tristram (the "author") is constantly instructing his reader "not to be in a hurry"; he orders a lady reader to go back and read a chapter again, which, he says, is "to rebuke a vicious taste . . . of reading straight forwards, more in quest of the adventures, than of the deep erudition and knowledge" which is the author's real content. This is, of course, exactly how a Hogarth print was to be read.

The Line of Beauty is the symbol of this spatial and, at the same time, natural and vital ideal in *Tristram Shandy*. The reader is repeatedly asked or forced to deviate "from a straight line." "He will have views and prospects to himself perpetually solliciting his eye, which he can no more help standing still to look at than he can fly." For example, in the chapter on lines at the end of volume vi, Tristram shows how he has progressed thus far in wildly erratic lines and promises that he will now proceed in a straight line; volume vii then turns out to be one long digression, which, however, is thematically the center of the novel.

Sterne, though producing something less immediately recognizable as Hogarthian than Fielding's works, is revealed as the inheritor of Hogarth's method as well as his theory. The closest Fielding comes to the Hogarth of the *Analysis* and the "chase" through his prints is his chapter on contrast in *Tom Jones*. Fielding and Hogarth share the presentation of shifting characters within an architectural solidity of plot; Sterne's point of departure is the *Analysis,* and he produces an aesthetic for Hogarth's prints through the Line of Beauty and the doctrine of Intricacy that sums up Hogarth's achievement at the end of his career as neatly as Fielding did at the beginning. It is ironic that, as Sterne produced a rationale for Hogarth's art, Hogarth himself was retiring further and further into the world of the written word, the very world that he had taught Sterne to vacate.

Although Hogarth appeared there infrequently now, the Foundling Hospital was still London's center of public art, the one unifying

and rallying ground for its artists after the dissension over the St. Martin's Lane Academy. The artists had now fixed a pantheon of English painters in which each could be exalted for his particular excellence. The grounds of the Foundling were by this time one of the most popular strolling places in London, and as early as 1752 the General Committee had ordered "That all Persons of Fashion be admitted into the Garden at all reasonable hours, except on Sundays" (for admission on Sundays a special written order of a governor was necessary). By 1756 a letter to John Fielding and Saunders Welch, justices of the peace for Westminster, asked for constables "to search for and apprehend all Persons selling Fruit, Spirituous Liquors, gaming, or begging on Sundays, within the Fields belonging to this Hospital."

The size of the contributions to the charity boxes and the popularity of the paintings permanently on display in the public rooms of the hospital must have suggested to the artists the idea of annual exhibitions of their works. More cynically, the author of *The Conduct of the Royal Academicians* (1771) notes that the accessibility of the donated works of art "made those artists more generally known than others; and this circumstance it was, that first suggested an exhibition; which was no sooner proposed, than approved." For the artists, exhibitions were a means both of keeping the general public abreast of their work and of collecting money for various purposes—and, of course, a first step toward a royal academy. Another lesson of the Foundling experience was that the visitors to such an exhibition must be restricted in some way in order to keep out the mob.

Annual exhibitions were connected in the minds of English artists with the French Academy of Painting and Sculpture, established in the seventeenth century, which held regular annual salons from 1737 to 1751 (skipping 1744), and after 1751 biennial salons. The English artists were attracted by the association of exhibitions and academies, but they were also developing another of the concepts Hogarth had demonstrated. Having failed with the Dilettanti Society, they decided to "appeal from the tribunal of criticism to that of the people." The phrase is Goldsmith's. His *Enquiry into the Present State of Polite Learning in Europe* had appeared in April 1759, filled with the Hogarthian view of the critic as a villain who overshadows and ruins the poet as the connoisseur does the artist. The public had been the object of Hogarth's appeals all along, and probably the only reason he

did not suggest annual exhibitions was their association with a national academy—the aspect that drew the other artists. They lacked royal patronage, but they had an organization of artists, and if they secured public support, patronage might follow. When the suggestion came it was an adjunct to the founding of a "Society of Artists," as they called themselves.

However, annual exhibitions (as one commentator has observed, speaking of the French) tended to create a public which had contact with art for a few hours every year or two and formed its standards from that casual contact. A second consequence was the creation of the professional art critic, only a slight improvement on the connoisseur.

Hogarth did not participate directly in the planning that now began—certainly he was not on the committee that governed the artists at this time. The agitation apparently commenced in early 1759. The Society of Arts, of which some of the artists were members, had held exhibits of its premium pictures, framed and mounted at the society's expense. In March 1759 Robert Pine proposed to the society that it hire a room for exhibitions of the works of "the present painters and sculptors," but there was no room available. The Foundling artists bided their time until the Society of Arts had moved into its new quarters in the Strand across from Beaufort Buildings. Then at their annual dinner on 5 November 1759, Hayman, one of the members of both societies, proposed "a public receptacle to contain the work of artists for the general advantage and glory of the nation and satisfaction of foreigners." His proposal was received with applause.

On the ninth a notice appeared in the *Public Advertiser:*

> Foundling Hospital, November 5, 1759.
> At a Meeting of the ARTISTS.
> Resolved, That a General Meeting of all Artists in the several Branches of Painting, Sculpture, Architecture, Engraving, Chasing, Seal-cutting, and Medalling, be held at the Turk's Head Tavern in Gerrard-street, Soho, on Monday the 12th instant, at Six in the Evening, to consider of a Proposal for the Honour and Advancement of the Arts, and that it be advertised in the Public and Daily Advertisers.
> JOHN WILKES, President
> FRA. MILNER NEWTON, Sec.

Wilkes, listed here as president, was now treasurer of the Foundling; he was also at this time on drinking and card-playing terms with both

Reynolds and Hogarth, and doubtless kept both informed about the other's activities.

Pleasant, easygoing Hayman was the logical choice for chairman; such a peacemaker was needed among the unruly artists. Moreover, Hayman had roots in the St. Martin's Lane Academy almost as deep as Hogarth's (and seems to have remained on good terms with him), was a member of the contributing artists to the Foundling (and so a governor) and the Society of Arts, and had chaired the earlier attempts of the St. Martin's Lane group to establish a state academy. It was he who made the proposal and conducted the meeting that took place at the Turk's Head a week later. The "President" or convener, however, was Wilkes, whose particular friendship with Reynolds went back to the latter's apprentice days in Hudson's studio, and whose name appears more frequently than any other in Reynolds' early pocket-books, his record of social engagements. It appears quite probable that Reynolds was the moving force behind both Hayman and Wilkes. Perhaps even those *Idlers* on art, coming out in September, October, and November, were intended to lay the way for his moral leadership: attacking Hogarth, taking sides on important issues like history painting, connoisseurship, and aesthetics, but remaining anonymous.

On 12 November the artists met at the Turk's Head as planned, and agreed to hold an annual exhibition the second week of April, at which "every Painter, Sculptor, Architect, Engraver, Chaser, Seal-cutter, and Medallist may exhibit their several Performances." The purposes of the exhibition were: first, to "encourage Artists whose Abilities and Attainments may justly raise them to Distinction who otherwise might languish in Obscurity and that their several Abilitys may be brought to Public View"; and second, to form a provident fund for the support of infirm and aged artists and their widows. For this purpose, a shilling entrance fee was to be charged. A committee of sixteen artists representing the various arts was elected to carry out the plan. These were the senior artists—Reynolds leading the list of painters, with Hayman, Richard Wilson, Samuel Wale, Richard Dalton, and Francis Newton—who thereafter governed the Society of Artists with an iron hand, creating an academy in miniature. The committee controlled the younger artists many of whom had been their pupils, as Thomas Jones recalled, "monopolizing those powers and privileges which the rest ought to have had a chance in sharing," including that of hanging their pictures in the best places in the exhibi-

tions. Considering that when he did join the artists he was elected to
this group, it seems likely that Hogarth did not attend the meeting, or
if he did, spoke against the plan.

The governing committee approached the Society of Arts early the
next year, and in March their proposal was accepted. The society
agreed to bear all costs and receive nothing in return, but (like the
Dilettanti) they did intend to control the exhibit and make it theirs,
not the artists': there would be no charge for admission, a committee
appointed by the Society of Arts would settle all questions of hanging
if the artists disagreed, and the date proposed by the artists was ad-
vanced by two weeks. If Hogarth, with his previous experience of the
Society of Arts, had not already withdrawn, no doubt he did so at this
point; the other artists accepted the rejection of their entrance fee,
but circumvented the loss by charging 6d for a catalogue.

The first specially organized art exhibition in England opened on
21 April, and was a great popular success. There was no picture ex-
hibited by Hogarth. But as he must have grasped, even from the side-
lines, the exhibition raised Reynolds to the highest eminence, in the
eyes of the other painters as well as the public. Reynolds was careful
to select four pictures illustrating the variety of his talents: a pair of
unpretentious busts, supplemented by a pair of full-length portraits
in his grandest manner.

The aftermath of the exhibition apparently roused Hogarth to ac-
tion, at least momentarily. At the governing committee meeting of
15 May, with Reynolds, Chambers, and the rest present, it was decided
that, contrary to the original plan to donate the profits (around £165)
to superannuated artists, they should "be apply'd to the advancement
of the Academy." A motion was then made, perhaps by a Hogarthian
representative, "That all Future Committees should be open"; it
failed to pass. The general sense of the meeting was clearly in favor of
an academy. But Hogarth saw their action as confirmation of his worst
suspicions: these artists were not concerned with their less fortunate
brethren but with their own advancement and glorifications in their
chimerical academy. (The funds were put into stocks to mature until
they should reach £500.)

On 25 October the old king died and the hopes of all the artists,
including Hogarth, rose with the accession of George III. This event
in fact further divided the artists: some hoped that he would support
native talent, that he would sponsor an academy, while others felt any

support would amount to interference. They had become so disturbed
by disagreements among themselves that the first rift, the break with
the Society of Arts, was virtually inevitable.

Hogarth, as well as the other artists and many politicians, had put
great faith in the young Prince of Wales. He had introduced him as
a boy into one print; and in the late 1750s, perhaps on his coming of
age, he revised the graceful dancer in *The Analysis,* Plate 2, to resem-
ble him. When he later portrayed the new king as the fountain of the
arts on the catalogue of the 1761 artists' exhibition, he was not merely
fulfilling the instructions of the artists' committee; it is clear from his
notes on the proposed academy that he regarded the whole movement
as stemming from hope in the new reign. Once George III became
king, projects abounded again to approach him and his parliament
about a royal academy.

The only trace that has survived of the Society of Artists' activity at
this time is the formal address made to the throne on George III's acces-
sion. It was published on the first page of the *London Gazette,* 6–10
January 1761, composed in Samuel Johnson's rolling periods. It says,
in effect, that they hope for some royal assistance now that George III
is king. While nothing said in the whole address was at variance with
Hogarth's views, as expressed in the frontispiece to the artists' cata-
logue later that spring, it showed that the group, separate at this time
from Hogarth, was approaching the king—and that other more specific
petitions were probably pending.

It must have been at this time that Hogarth drafted his letter to a
nobleman, mentioning that he has already made notes toward his own
views on the academy question. This curious, hesitant, revealing letter
apparently remained in the same rough form as the notes among
which it was found. But, surprisingly full of information, it shows
what Hogarth was trying to do. There are two names mentioned in
the draft: Samuel Martin and Allan Ramsay. The nobleman is un-
named, but in the context of these two names it has to be Lord Bute
himself, the new king's favorite. Hogarth is approaching him through
his lieutenant Samuel Martin, secretary of the Treasury and head of
the English civil service—a man Hogarth may have met as Serjeant
Painter, since Martin was responsible for disbursements; he was a
close friend whose portrait Hogarth painted for his own pleasure, and
left him in his will. Hogarth evidently made contact with Bute
through Martin and then drafted this letter asking for a private audi-

ence in which he could clarify a few points before finishing his formal proposal.

No subsequent draft of this letter is known, and the undeveloped state of the surrounding notes supports the conclusion that Hogarth's health, or his circumspection, prevented him from carrying on—or that the artists' "scheme" subsided, or that (perhaps most likely) he was persuaded to join them when they broke away from the Society of Arts. Nevertheless, it appears that Hogarth received some sort of satisfaction, or at least was not alienated by Bute, since not long after he came out in active support of his ministry.

Hogarth at this point was spending much of his time writing the notes on academics and on the Society of Arts, one of the series of manuscript notes that have survived. He does not really get beyond the history of English academies, which he takes as far as the negotiations with the Dilettanti Society, but his own idea of a democratic and decentralized academy is quite clear by implication. The historical evidence is employed to suggest that the present plan has already been attempted with disastrous results in France and in pre-Hogarthian academies of short duration in London. These were all based on hierarchy and regimentation, and failed.

But the notes are also about the teaching of young artists and broach certain questions crucial to Hogarth and his idea of an academy: whether or not they should travel to the continent to copy old masters, what they can expect from the English mercantile-minded buyers, and what sort of persons should be encouraged to take up art in the first place. After one of his attacks on the society for trying to multiply the number of painters, his mind apparently turned again to the advances made to the king, and he suggests what he considers a preferable alternative to a royal academy: the prince, he says, should "set the example and furnish any part of his palace with a Picture of each of his most eminent subjects' work."

He began writing on uniform sheets, probably with a single subject in mind, but before long he was using any size that came to hand, odds and ends—writing very rapidly, and not usually reading back over what he had written, filling in very little punctuation, omitting plurals, crossing out either more or less than he intended. He evidently discussed whatever subject came to his mind. On a typical page, now separated from the main body of the manuscript in the British Museum, he paused to record what he had learned about varnishes. As

they survive, these manuscripts were never intended to be read by anyone but Hogarth; perhaps for that reason, though they often verge on the undecipherable, they have the bite of his conversation. One can almost hear him speaking across a table, throwing out bitterly pointed opinions. They are pugnacious and dogmatic and disillusioned: the qualities that dominate the prints he produced in the last decade of his life.

These notes, and others written on and off until his death, moving from topic to topic, gradually incorporating all the different subjects that mattered to him, provide the closest approximation of the workings of his mind. One page will suffice to show how he starts with a particular item and is carried away by his emotions and most pressing thoughts. The first paragraph runs straight on without any punctuation (I have inserted stops in brackets; pointed brackets are Hogarth's insertions).

All profession berogue one another say locket in the Beggars Opera ["who has not found that" follows, only the last four words crossed out] [.] <men> of same profession are rivals especially when they are put in competition[.] what racer wishd his oponent might out run him or boxer that chose to be beat in complesance to his antagonist[.] the artist who pretends to be most pleased when he sees himself [outdone?] by his competitor must be a lyer and an hipocrite[.] the most he can do is to be polite and civil but if he is so polite as to confess one he thinks his inferior he is a fool[.] if he has temper enough to say nothing it is sufficient but this I have seldom met with even among the most polite and liberal set of men The Faculty themselves[.] . . .

Then, slipping unconsciously into another line of thought:

had rubens or even Raphael lived at this <this time in England> all there perfections <and superior talents> the[y] would have found men of very middling parts <excellent> face painters and who if they happen'd to be in vogue that would with ease get a 1000 a year by the assistance of a <journeyman> still life painter called a dresser or Drapery painter <whilst [they] might scarce have found employ­ment>

Speed and carelessness are invariably typical of Hogarth, as in the *Analysis* manuscript when he was not under any emotional strain (though he undoubtedly was around 1760). What the evidence really points to is physical illness, no doubt accompanied by mental unease;

but the interesting fact is not his poor syntax—a common flaw in the rough drafts of more educated and calmer men than Hogarth—but the fact that he was never able to revise and finish them and yet could not discard them either.

In any case, as Hogarth grew older he increasingly found graphic images inadequate for the expression of his ideas, and turned to words. At the same time, his subject—in both graphic and written works—underwent a gradual transition from life and the problems of living to art; his focus shifted from the outside world to within himself, his own worries and self-justifications. His writings represented an attempt to conceptualize and defend his practice of the 1730s and 1740s, rather than press ahead to new forms and ideas in the graphic arts.

This was partly the result of the pressure of the times on a sensitive, basically insecure mind, partly the example of Fielding and the power of the word among the Augustans. Hogarth began as the Augustan who applied the literary mode to graphic images, and ended as another word-weaver. Also instrumental, of course, was the decreasing flow of artistic inspiration as he grew older. He was not painting any longer, except for small portraits or likenesses; during the spring of 1761 when the second annual exhibition was being set up, and a number of his own paintings (all old) were exhibited, he was writing and thinking.

THE EXHIBITIONS OF 1761 AND '62

The 1760 exhibition had satisfied the Society of Arts more than it had the artists. The absence of an entrance fee had allowed all and sundry to gather. The rule said that anybody "with an order from any member of this society or from any known artist" would be admitted, and this led to the presence of many undesirables. Before long it was necessary to give officers of the society discretionary power "to exclude all persons whom they shall think improper to be admitted, such as livery servants, foot soldiers, porters, women with children, etc., and to prevent all disorders in the Room, such as smoking, drinking, etc., by turning the disorderly persons out."

The second and more vexing ground for the artists' displeasure was the mingling of their paintings with the premium pictures, those paintings submitted by amateurs in various categories (boys under twenty-one, sons or daughters of peers, and so on), which hung re-

splendent with prizes. Seeing his bare picture next to these made the artist feel (in Dr. Johnson's phrase) "the disgrace of having lost that which he never sought."

In the governing committee meeting of 8 December 1760, approving the request for an exhibition hall in 1761, the artists insisted that the exhibition be postponed until June to avoid rubbing shoulders with the society's prizewinners, and that the purchase of a shilling catalogue be the condition of admission. All their requests were rejected.

The artists' response was to delegate Reynolds and the architect James Paine to find a suitable place of their own in which to exhibit. By 4 March Cock's auction room in Spring Gardens, Charing Cross, had been rented for £40, the advertisement was drafted, and the deadline for pictures set at 27 April (later postponed until 2 May).

All this time, the artists continued their academy in St. Martin's Lane. Through one group or another, overtures were made to Hogarth; or he, hearing about the break with the Society of Arts, let it be known that he would exhibit with the artists this year. I take the first sign that he was interested (or wished to be solicited) to be his etching, *Time Smoking a Picture* (pl. 124), which he distributed around the first of March as a subscription ticket for a projected engraving of *Sigismunda*. The satire, glancing back at such works as the Correggio-Furini *Sigismunda,* was aimed at the notion that old pictures improved with the mellow tints of age and varnish—a view that even a contemporary painter like Reynolds sometimes took so literally as to mix varnish-brown with his paints. The idea of Time the Destroyer had long been in Hogarth's mind; now it received definitive form in this etching from his own hand, a strikingly simple image reminiscent of the *Stages of Cruelty* and the other popular prints, which showed that his eye was as acute as ever though his hand not quite so steady.

When the general meeting ("to which all Artists in Painting, Sculpture and Architecture are invited") was held on the night of Tuesday 7 April, Hogarth was among the sixty-seven present. He rose and made a proposal, which is recorded in the minutes. In typical rhetoric, Hogarth offered a motif for that year's exhibition, which, like *Time Smoking,* was to be a statement against such as the Dilettanti and their representatives in the Society of Arts. It was not just secession, it was war, and clearly Hogarth returned with the intention of declaring it and formulating its strategy. The name itself did not turn out to be his proposed "Free Professors of Painting, Sculpture & Architecture,"

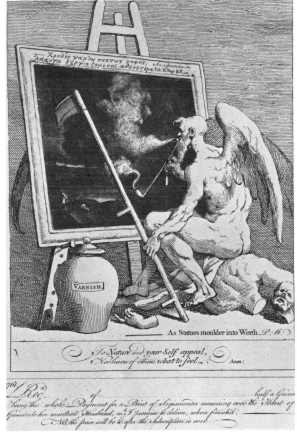

124. Time Smoking a Picture; March 1761 (ticket removed);
8 x 6¹¹⁄₁₆ in. (BM)

but an even more pointed one, the Society of Artists (as opposed to
Arts).

The two satiric designs he contributed to the exhibition catalogue
were essential to his plan of giving the artists the initiative. The *Fron-
tispiece* represents the hopes the artists placed in the new king as a
fountain that nourishes the arts. The *Tailpiece* shows the fate of art-
ists who are dependent on monkey-like connoisseurs, whose only in-
terest is in the dead art of the past—the paintings smoked, the busts
fragmented, by time.

The designs were finished, and engraved by Grignion, by 21 April
when the governing committee met and the notice for the advertise-

ment was read. It ended, "Catalogues at one Shilling each with two Prints designed by Mr Hogarth may be had at the Door." That Hogarth donated the design, and Grignion was paid for his engraving, can be seen in the list of the society's disbursements following the exhibition. But Hogarth's contribution, his return to prominence, did not go unnoticed. At the next meeting of the governing committee someone raised the question of why Hogarth should be singled out in the advertisements—presumably because none of the other exhibiting artists was. It was decided that one artist's name should not be mentioned at the expense of the others: it was "Resolved. That it is the Opinion of the Committee that Mr Hogarth's Name should be omitted in the Advertisement but to remain as at present if Mr Hogarth chooses it." This resolution reflects the prickly tone of relations between Hogarth and some of the members of the governing committee. It meant, for one thing, that someone's pride overruled the commercial common-sense view (borne out by events) that a catalogue containing Hogarth prints would sell better than one without, and should be advertised as such. Since in fact Hogarth's name was omitted from the published advertisement, one must assume that he went along with the proposal.

The pictures Hogarth chose to show at the exhibition were carefully representative: three comic histories, *The Gate of Calais, An Election Entertainment,* and *The Lady's Last Stake;* a sublime history, *Sigismunda;* and three portraits, only a head of Benjamin Hoadly being identified. But more striking than his selection is the fact that he was showing only old pictures. In short, Hogarth was engaged in writing and perhaps recovering his health, when the young Hogarth might have been expected to exploit the situation, rise to the challenge, and display a bright bouquet of new paintings. His total absence the year before may have testified to his condition: perhaps he refused on the grounds that he had no paintings that year. But in 1761 he still had no significantly new pictures, aside from his two drawings for the catalogue; evidently, at this stage of his career, he viewed the exhibition as a place to show the best available, not the newest, work. Like the writing he was doing around this time, it provided an opportunity for a retrospective defense of his career, as opposed to a look forward. His role in the exhibition was that of propagandist—publicizing his own earlier pictures and works by English artists in general.

It was to advertise the engraving of *Sigismunda* that Hogarth etched *Time Smoking a Picture,* and it was to advertise the painting, and vindicate his faith in it, that he projected his subscription for the engraving. Below his subscription list he wrote, sometime around 16 April: "M^r Ravenet the Engraver having undertook to Engrave the picture of Sigismunda, a Subscription for the Print was begun March 2^d 1761, but some time afterwards, on finding that M^r Ravenet was under articles not to work for any Body but for M^r Boydell the Print-seller for three years then to come, the Subscription was put a Stop to, and the Money return'd to the Subscribers, there being no other Engraver at the time capable of doing it as it should be done." The names in the book are duly crossed out and marked "Money Return'd"—and only John Salusbury refused his money.

The painting remained in his studio until, a month later, he exhibited it with hardly less misfortune at the Society of Artists' exhibition. Anecdotes have collected around this picture and the exhibition. Horace Walpole, in his copy of the catalogue, notes that on 19 or 20 May, that is ten days after the exhibition opened, Hogarth withdrew *Sigismunda* and replaced it with another of the *Election* paintings, *Chairing the Member.* Thomas Birch refers in a letter to Hogarth's "humiliation" over *Sigismunda* at this exhibit, but all that has survived is the story told nearly thirty years later, that Hogarth posted a man nearby to write down all the objections made to it. Enough criticism was collected by Hogarth, always sensitive but extremely so about this particular picture, that he withdrew *Sigismunda* for revision. His withdrawal, of course, only added more fuel to the adverse stories and did nothing to enhance the picture's reputation.

Hogarth's state of mind that spring is vividly illustrated in an episode described by Horace Walpole. On 5 May, just a few days before the exhibition opened, with *Sigismunda* still on the easel, Walpole visited his studio. Walpole was so struck by the interview that he wrote down part of it in a letter to his friend George Montagu (5 May 1761). Unfortunately, his transcription does not make clear whether Hogarth's behavior was unusual, or whether this occasion served as an excuse to amuse his friend with the artist's eccentricities. I quote from the scene for it is the only direct representation of Hogarth, written within a short time of the event, that has survived.

As background, one should note that George Vertue had died in 1756 and in the summer of 1758 Walpole bought from his widow

some forty of his manuscript notebooks, full of invaluable data on English art, including remarks indicating how Hogarth appeared to one contemporary. Walpole had known Vertue well and paid his widow £100 for these jottings, which would have been worthless to anyone else. Hogarth of course got wind of this, and he also knew that Walpole had begun to use these notes as the basis for a history of English artists. Walpole had, in fact, begun his *Anecdotes of Painting in England* on 1 January 1760 and had finished the first volume by August, the second by the end of October. These were finally printed early in 1762 but did not carry the story to that point. So on 3 May he visited Hogarth's studio, where the artist was working on his portrait of Henry Fox, with the painting of *Sigismunda* displayed nearby.

. . . As I was going, Hogarth put on a very grave face, and said, 'Mr. Walpole, I want to speak to you'; I sat down, and said, I was ready to receive his commands. For shortness, I will mark this wonderful dialogue by initial letters.

H. I am told you are going to entertain the town with something in our way. W. Not very soon, Mr Hogarth. H. I wish you would let me have it, to correct; I should be sorry to have you expose yourself to censure. We painters must know more of those things than other people. W. Do you think nobody understands painting but painters? H. Oh! so far from it, there's Reynolds, who certainly has genius; why, but t'other day he offered £100 for a picture that I would not hang in my cellar; and indeed, to say truth, I have generally found that persons who had studied painting least, were the best judges of it—but what I particularly wanted to say to you was about Sir James Thornhill (you know he married Sir James's daughter) I would not have you say anything against him; there was a book published some time ago, abusing him, and it gave great offence— he was the first that attempted history in England, and I assure you some Germans have said he was a very great painter. W. My work will go no lower than the year 1700, and I really have not considered whether Sir J. Thornhill will come within my plan or not; if he does, I fear you and I shall not agree upon his merits. H. I wish you would let me correct it—besides, I am writing something of the same kind myself, I should be sorry we should clash. W. I believe it is not much known what my work is; very few persons have seen it. H. Why, it is a critical history of painting, is not it? W. No, it is an antiquarian history of it in England; I bought Mr Vertue's MSS, and I believe the work will not give much offence. Besides, if it does, I cannot help it: when I publish anything, I give it to the

world to think of it as they please. H. Oh! if it is an antiquarian work, we shall not clash. Mine is a critical work; I don't know whether I shall ever publish it—it is rather an apology for painters—I think it owing to the good sense of the English, that they have not painted better. W. My dear Mr Hogarth, I must take my leave of you, you now grow too wild—and I left him—if I had stayed, there remained nothing but for him to bite me. I give you my honour this conversation is literal, and perhaps, as long as you have known Englishmen and painters, you never met with anything so distracted. I had consecrated a line to his genius (I mean for wit) in my preface; I shall not erase it, but I hope nobody will ask me if he was not mad.

If it did not exist, this confrontation could have been invented by an author of "imaginary conversations." Were it not seen through Walpole's eyes, it would be comic—two incompatibles talking at each other like characters out of *Tristram Shandy*. Walpole the raconteur emerges more cruel and supercilious, perhaps for Montagu's benefit, and Hogarth more of a fool, than was actually the case. Walpole's behavior must have confirmed Hogarth's dark image of an incomprehensible world: "you now grow too wild," Walpole says, leaving Hogarth in mid-sentence—no doubt to turn in choked anger to the scraps of paper he was covering with notes about the state of the arts in England.

The "Apology for Painters," which Walpole records Hogarth as mentioning, sounds ambitious enough to be connected with the pages of outline he wrote in an attempt to tie together all his notes up to this point. This table of topics was probably superimposed on what he had already written, with the addition of some others covering what he intended to write or fill in. A title page has also survived, perhaps of about the same time:

<div align="center">

on the arts of Painting and Sculpture
particularly in England
To which is added Some observations
A Short [Account—s.t.] <explanation> of <all> M^r
Hogarth's [prints—s.t.] <Works?>
written by himself

</div>

As a dedication, expressing his point of view in the work, he drafted the following lines, which may hark back to the drawings of "Somebody" and "Nobody" he added to the *Peregrination* manuscript in 1732:

The no Dedication

Not Dedicated to any Prince in Christendom for <fear> it might be thought an Idle peice of Arrogance

Not Dedicated to any man of quality [because–s.t.] <for fear> it might be thought too assuming

Not Dedicated to any learned body of Men as either of <the> universitys or the Royal Society [because–s.t.] <for fear> it might <be> thought an uncommon peice of vanity.

Not Dedicated to any <one> particular Friend [because it may be thought a Blunder–s.t.] for fear of offending another.

Therefore Dedicated to nobody

But if [nobody–s.t.] for once we may suppose nobody to be every body as Every body is often said to be nobody then is this work Dedicated to every Body.

by their most hum^ble
and devoted—

All the notes, however, revolve around three general subjects, two of which were evident in the conversation with Walpole: the lack of patronage for English artists due to the mercantile preoccupations of their countrymen and the ease with which pictures could be obtained from abroad (what Hogarth meant when he spoke of English "good sense" to Walpole); the problem of judging a work of art; and the error of studying art through the literal copying of works of art or even nature.

Hogarth's satiric frontispiece and tailpiece helped to sell the exhibition catalogues, which went so fast that they had to be engraved over again by Grignion; 13,000 were sold at 1s each (as opposed to 6582 the previous year), earning the artists some £650. Hogarth's attitude, as set forth in these plates and in *Time Smoking a Picture,* was by no means idiosyncratic. Samuel Foote's *Taste,* for example, presenting a connoisseur buying dilapidated antiquities, had played on and off from 1751 to 1757 and was revived in April 1761. That Foote and Hogarth were not exaggerating very much can be shown by the catalogue of the Oxford and Somers sales, 30 March, 1 April 1762, which included "No. 71. A bust of Antinous (without a head)."

But the journal that carried and developed these hints in Hogarth's designs, showing most interest in the artists' exhibition, and specifically in Hogarth's position, was the *St. James' Chronicle,* a newly

founded paper controlled by Garrick, Bonnell Thornton, and George Colman. Like his old friend Hogarth, Garrick had felt in the 1750s a reaction from the adulation of the previous decade and had come in for his share of criticism. In his case one feels that his success tended to make him a scapegoat for the theater public. Himself sensitive to criticism, he doubtless understood and sympathized with Hogarth's sensitivity. On 14 March 1761 Charles Churchill's *Rosciad* was published, and this attack on virtually all the actors, writers, and managers except Garrick brought about the alignment of Churchill, Garrick, Colman, Lloyd, and Thornton. Their "allies" included Hogarth. In fact, the group seems to have regarded Hogarth, his reputation and ideas, as a parallel phenomenon to Garrick, and to have defended him in the same way.

The artists' exhibition, duly announced in the *St. James' Chronicle*, opened on 9 May. But as early as the issue of 23–25 April a letter to Henry Baldwin (the printer) from "John Oakly" (i.e. a stout-hearted, no-nonsense Englishman) was published, which, were it not for the extravagant praise given Hogarth, could have been written by the artist himself. At least some of the letters signed "Oakly" were by Garrick, but Thornton's hand is detectable, and behind both of these Hogarth's.

Oakly begins with all the old Hogarthian generalizations about "the Tribe of Auctioneers, Connoisseurs, Picture-Brokers, Dealers, Menders, Cleaners, &c. &c. &c.," who control the trade in art, exerting their influence on the great patrons and the uninformed public. The English painter therefore labors "for a small Pittance," many "are absolutely starving," and only the portrait painters are decently rewarded. Having made a number of unfavorable comments on the Englishman's love of "Looking Glasses," Oakly turns to the prime example of English genius: Hogarth.

> It is universally confessed by Foreigners, and even by our selves, for we are not the most quick sighted to the Merits of our Countrymen and Co-temporaries, that we have now living as great a genius as any Time or Nation has produced. He stands by himself, as the great Original of Dramatic Painting, if I may be allowed the Expression. He has invented Characters, Fable, Incidents, &c. and has put them together in such a masterly Manner, and with such Variety, that a Writer of Comedy might paint almost exactly after him, and furnish great Entertainment for the Stage from his exquisite comic Paintings.

In a Word, their Merit, Force, and Effect, are universally allowed; and yet, to our Shame be it spoken, one of his first-rate Productions [i.e. *Marriage à la Mode*] was sold by Auction for a Price, the Mention of which would dishonour our Country, while the Drawings of Rembrandt, the Pictures of Teniers, and the scarce-visible Productions of some antiquated Dauber, have been bought up with a Kind of religious Enthusiasm.

Hogarth's argument with the connoisseurs and picture dealers had never been so cogently and vehemently stated before. Hogarth could only imply the personal damage he had suffered for lack of an appreciative audience; Oakly could be perfectly explicit about it. Now at last, says Oakly, the situation may be righted by the quarrel between the Society of Arts and the Society of Artists, "which, in all Probability, will bring about a Change and Advantage to our English Geniuses, that was so much to be wished, but so little expected." Now, he concludes, he can assure us

that the long-wished for Union among the Artists is now happily brought about, and that all little private Parties, Caballings, Suspicions, and Animosities, are laid aside for more general and generous Considerations; . . . for what may we not expect . . . in this free Country, under such a Government, and protected by such a King?

Here then is a clear statement of Hogarth's view of the artists and their search for an academy. The letter was reprinted in the *Chronicle* of 5–7 May, which advertised the opening of the exhibit, because, a headnote explains, it has "been a Subject of much Conversation (in Consequence of which the Paper has been lost out of several Coffeehouses)."

The next issue (7–9 May) announced the publication of a pamphlet supporting the artists:

A Call to the Connoisseurs, or Decisions of Sense, with Respect to the Present State of Painting and Sculpture, and their several Professors in these Kingdoms; together with a Review of, and the Examination into their comparative Merits and Excellencies. Intended to vindicate the Genius and Abilities of the Artists of our own Country, from the Malevolence of pretended Connoisseurs or interested Dealers, recommended to the Perusal of every true Judge and impartial Critic in Great Britain, previous to a View of the present Exhibitions of the modern Artists. By T. B. Esq. . . .

The following issue (9–12 May) carried quotations from this pamphlet, describing the leading English artists—all in rather fulsome rhetoric.

Meanwhile, something less to Hogarth's liking had appeared. The *London Chronicle* for 12–14 May reprinted Reynolds' three *Idler* essays on art and Hogarth as a single "Letter on Painting"; the author was still unidentified, but everyone must have known who it was by now. The young connoisseur returning from Italy to praise Hogarth's Line of Beauty may have inspired Oakly's piece in the *St. James' Chronicle* of 14–16 May. It certainly inspired the letter from "Admirer, but, thank God, no Encourager of the Polite Arts" printed in the *St. James' Chronicle* of 23–26 May, which also clearly focuses the battle between the artists and the connoisseurs on the rivalry of the artists and the Society of Arts. The attacks were directed at the Society of Arts and the connoisseurship and dilettantism it stood for, with its premiums and patronizing attitude toward the artists. Those who had stayed and exhibited at the Society of Arts' rooms were not mentioned, or were, indeed, lumped with the artists in Spring Gardens against the connoisseurs.

A close observer of the artists' movements, Samuel Johnson may have had all of these contretemps in mind, as well as his own indifference to painting, when he wrote Baretti (10 June 1761), after the exhibition, that it had "filled the heads of the Artists and lovers of art. Surely life, if it be not long, is tedious, since we are forced to call in the assistance of so many trifles to rid us of our time, of that time which never can return." (Reynolds, he comments in the same letter, "is without a rival.")

The same issue of the *St. James' Chronicle* (23–26 May) that carried Admirer's letter about the Society of Arts connoisseurs observed on the back page, under "LONDON" news, that

> The projected Exhibition of the BROKERS and SIGN-PAINTERS of *Knaves-Acre, Harp-Alley*, &c. &c. &c. is only postponed, till a Room spacious enough can be provided, as the Collection will be very numerous. In the mean Time the Several ARTISTS (Natives of Great-Britain) are invited to send to the Printer of this Paper, a List of those Capital Pieces, which they intend to submit to the public Judgement. N.B. No Foreigners, and *Dutchmen* in particular, will be allowed a Place in the Exhibition.

This good-humored sally, criticizing the exhibitors' emphasis on their Englishness, may have been Thornton's first thought for advertising the exhibit that did materialize the next year. Thornton had originated the idea of a sign-painting exhibit in an essay he wrote for the *Adventurer* in 1752 (No. 9, 2 December). His idea probably came from Hogarth's *Beer Street* (pl. 94), of the year before, in which an ethereal-looking artist is decorating a tavern signboard as if it were a history painting. While the idea of sign painters, as it developed in Thornton's and Hogarth's minds, was a satiric joke, it also pointed up one of the popular sources of Hogarth's art and its appeal. The signboard was the archetypal visual image as far as eighteenth-century Englishmen were concerned. Hogarth is sometimes said to have painted signboards early in his career—as in the 1750s his own head illustrated the signs of at least two printshops.

A sign was an emblematic representation often compartmentalized in the manner of Hogarth's prints, and invariably conveying its message by the same devices he used—subtly in his comic histories, more obviously in the symbolic pictures of his last years. For example, there was the cockney custom of punning on the name, so common on signboards (and noticed by Thornton), whose precedents can be traced back to Roman shop decorations. This format produced "Two Cocks" for Cox, or the "Brace Tavern" for two brothers named Partridge; or, going on to rebuses, a hare and a bottle stood for Harebottle, and a hat and tun for Hatton. Hogarth's prints are often built around such visual puns. More important, however, were the symbolic representations: the implement of a trade (a measuring rule for a surveyor, a cupping glass or a urinal and a goldheaded cane for a physician), the source of the product (grape arbor for a pub), or the part for the whole (Van Dyck's head for an artist, the Hogarth head for a printseller, a knife for a cutter, a hand for a glover, a stocking for a hosier). This then was one of the genuinely popular arts of the time, and the equivalent of some of Hogarth's simpler, more emblematic prints. Every shop had its signboard, at this time still perpendicular to the buildings, jostling each other over the pedestrian's head. "Our streets," wrote Addison in *Spectator* No. 28, "are filled with blue Boars, black Swans and red Lions; not to mention flying Pigs, and Hogs in Armour, with many other Creatures more extraordinary than any in the Desarts of *Africk*." Harp Alley, from Shoe Lane to Farrington Street,

was the center of the sign-painting trade. The exhibition is announced in the *St. James' Chronicle* (26–28 May) for the beginning of the next month. Then in the next issue, 28–30 May, "Theo. Coverley," another correspondent, writes to Oakly that he thinks the party of the Modern Painters

are as likely to carry their Admiration to their co-temporary Countrymen to as ridiculous an Extreme as ever was done by the Connoisseurs in favor of the ancient Foreigners. I have surveyed the two Exhibitions with some Attention, and I am sure, with great Impartiality; and I am sorry to declare, that, throughout the whole, for one good Picture there are at least ten bad ones. I shall not affront any of the Exhibiters by pointing out those which are most conspicuously bad; but really there are several amongst them, which are very little above Sign-daubing. As to Portrait Painting, I can hardly allow them to be called Painters. The only Talent they require is an accurate Eye; their whole Art consists in copying, and therefore Genius or Invention are entirely out of the Question. Now if from the Exhibition in Spring Gardens we subtract the Portraits, and Cassali's Works from that in the Strand, what have we remaining in either of them worth the Attention of Men of real Taste and Judgment?

This interesting document, while offering exactly the same argument about portraitists that appears in Hogarth's notes, suggests that Hogarth's paintings resemble signboards. Although this is not entirely farfetched if one considers the *Election* paintings on display, it was not meant as a compliment. The *St. James' Chronicle* always tends to balance one opinion with a contrary one, probably written by its own editors, and Garrick complained that his own paper criticized his acting from time to time. This letter sounds like a commentary on the sign-painters' exhibit, and a notice that followed in the same issue effectively killed the possibility of such an exhibit in 1761.

By 2–4 June the exhibitions of both Society of Artists and Society of Arts were over, and the *Chronicle* printed a letter from a supporter of either side, both insipid. Interest had apparently died out because no more appeared for some time. Nevertheless, one wonders whether the letter from "Theo. Coverley" did not put the sign-painters' exhibition in a light that was not intended by its original projectors, leading them to drop the idea for the present.

The project is supposed to have started in Thornton's "Nonsense

Club," and while there is no evidence that Hogarth was a member of the club, he was clearly involved with Thornton in the project, at least as it evolved the next year: he is named by all the sources, and he appears in the contemporary cartoons and squibs on the subject. The important fact about his connection was that he did not exhibit that year with the Society of Artists—but instead with the sign painters.

Whether because of the machinations and the increasingly undemocratic nature of the committee and society, or for other reasons (he would have had no new pictures to show), Hogarth did not exhibit with the Society of Artists after 1761. The artists' exhibits continued to be monetarily successful—£525 in 1762, £560 in 1763, and £762 in 1764. At a general meeting on 24 January 1764, with Hogarth now completely withdrawn and virtually retired, the artists resolved to solicit His Majesty to incorporate the society by royal charter. The charter was granted on 26 January 1765, and the group was called "The Incorporated Society of Artists of Great Britain," but by this time Hogarth was dead. And much politicking was yet to be done before in 1768 Reynolds and Chambers emerged with the Royal Academy. As a last sign of the times, they left Hogarth's old friend Kirby high and dry as president of the moribund Incorporated Society of Artists.

The early months of 1762 were busy ones for Hogarth. His illness seems to have been over by the spring of 1761, when he appeared in public and was seen by Walpole painting a portrait. In November he etched his ironic celebration of the coronation, *The Five Orders of Periwigs,* and at the end of this year or the beginning of 1762 he produced the three drawings commemorating three friendships: portraits of Morell, Fielding, and Garrick acting in *The Farmer's Return.* On 26 April, after the sign-painters' exhibit had opened, his portrait of Henry Fielding was published as frontispiece to Arthur Murphy's edition of Fielding's *Works.*

Hogarth's last picture of Garrick was a frontispiece to *The Farmer's Return,* and the play was, in turn, dedicated to Hogarth. Sometime after April, when John Courtney reported seeing the *Election* paintings in Hogarth's studio, Garrick bought that series. According to Farington's *Diary* (entry of 7 March 1802), Garrick told Benjamin West that Hogarth proposed to sell them for 200 guineas, to be raised by a raffle at two guineas each. "Garrick called on him & subscribed,

but on leaving his House, reflected on what He had done as unworthy to so great an artist, went back, gave him a draft for 200 guineas & took away the pictures, thus relieving Hogarth from further trouble abt. them."

In the spring of 1762 the sign-painters' exhibit that had not materialized in 1761 was arranged, probably hastened by the effect of certain ordinances. In September 1761 Paris had been cleared by law of its signboards, thereafter to be fixed against the walls and not to protrude into the street. In London, an act for paving, cleaning, and lighting the squares, streets, and lanes of Westminster was passed during the spring of 1762 and signed into law on 2 June. While mainly concerned with the removal of nuisances in the streets, this act soon generated bills for other districts, which began to affect the signs. They were coming down at least as early as November 1762, and the possibility may have been evident earlier.

The *St. James' Chronicle* for 18–20 March announced:

GRAND EXHIBITION.

The Society of SIGN PAINTERS beg Leave to give Notice, that their GRAND EXHIBITION will be some Time next Month. A large commodious Room is provided for that Purpose, and their Collection is already very numerous. In the mean Time they shall be obliged to any Gentleman who will communicate to them where any curious Sign is to be met with in Town or Country, or any Hint or Design for a Sign, suitable to their Exhibition. Letters will be received by the Printer of this Paper.

From this notice, and from later reports, it appears that no paintings were created especially for the occasion; Thornton and his friends collected signs from London and the adjacent countryside, then labeled them appropriately. Hogarth "gave a few touches of chalk where effect could be added by it." The announcement for 23–25 March was more extravagant, juxtaposing the sign-painters' exhibit with that of the Society of Arts.

The exhibit opened as announced on 20 April "at the large Rooms in Bow-street, Covent-Garden, nearly opposite to the Play-house Passage"—Thornton's chambers, open from 9 A.M. until 4 P.M., admission 1s. Prefixed to the tickets was a catalogue containing the names of the signboard painters, who turned out to be the journeymen printers in Baldwin's office, where it was printed. One name, "Hagarty," was a

transparent variation on "Hogarth," and he was credited with the following works:

No. 5. The Light Heart. A Sign for a Vintner. This, as one of the descriptive acounts explained, showed "A Feather weighing down a Heart in a pair of Scales."

No. 16. A Man. This showed nine tailors at work, alluding to the saying that it takes nine tailors to make a man.

No. 19. Nobody, alias Somebody. A Character. And *No. 20. Somebody, alias Nobody. A Caricature. Its Companion.* The former was a man all legs, the latter a man all belly, with a constable's staff.

No. 27. The Spirit of Contradiction. A Conversation. This showed two brewers carrying a cask, pulling in different directions.

No. 28. The Logger-Heads. Ditto. "Underwritten, the old Joke of We are three. Shakespeare plainly alludes to this sign in his Twelfth Night, where the Fool comes between Sir Toby Belch and Sir Andrew Aguecheek, and, taking each by the Hand, says, 'How now, my Hearts, did you never see the Picture of We Three?' "

No. 30. The Dancing Bears. A Sign for N. Dukes, or A. Hart, or any other Dancing-Master to Crown Gentlemen. This showed "Bears in Men's cloathes, learning to dance, a great one amongst them, with a gold Chain around his Neck; the Dancing Master a Monkey, holding a Kitten on his Breast with one hand, and pinching its tail with the other."

No. 40. Welcome Cuckolds to Horn Fair. "Being a Picture of Horn-Fair containing various Figures of Cuckholds in different Characters; some with large staring Bulls, Goats'-Horns, &c., others with their Horns just budding. . . ."

No. 64. View of the Road to Paddington, with a Presentation of the Deadly Never-Green that bears Fruit all the Year round. The Fruit at full length. This showed Tyburn with three felons hanging from it.

No. 67. Death and the Doctor; in Distemper.

No. 76. The Constitution; Alderman Pitt's Entire. This showed a tall grenadier and a short sailor, perhaps a reference to Pitt and Beckford.

Hogarth's shadow hung over the whole exhibit: No. 1 in the Grand Room was a "Portrait of a justly celebrated Painter, though an Englishman and a Modern," described by one observer as "Mr. Hogarth,

or a wretched Figure done for him drawing his five orders of Peri-wigs." This is followed by No. 2, "A Crooked Billet, formed exactly in the Line of Beauty," a companion piece to No. 1. The "Harlot Blubbering over a Bullock's Heart," which according to a later story was displayed and offended Hogarth by its ridicule of *Sigismunda,* does not appear in the catalogue, and, I suspect, is only a memory of the anti-Hogarth caricature *A Brush for the Sign-Painters* (BM).

From the accounts of visitors, it appears that most, if not all, the works were in fact signs, whose humor came from their placement: "The Three Apothecaries' Gallipots" as a companion to "The Three Coffins," or "King Charles in the Oak" to "The Owl in the Ivy Bush." Others were touched up and juxtaposed, as in the ones Hogarth is said to have worked on: Nos. 53 and 54, "An original Portrait of the present Emperor of Russia" and "Ditto of the Empress Queen of Hungary, its Antagonist" (Maria Theresa). These were two old signs of the Saracen's Head and Queen Anne. Under the first Hogarth wrote "The Zarr," and under the second "Empress Quean," and he touched them up somewhat, lolling their tongues and turning their eyes at each other. Over their heads was a wooden label, "The Present State of Europe." All in all, not an untimely comment from the Ho-garth who was to compose *The Times, Plate 1* four months later. Some of the signs were so elaborate that they must have undergone considerable repainting. Besides signs, the exhibit included carved figures and wig blocks, also touched up, labeled, and comically juxta-posed.

The first public reactions are difficult to gauge: if the outrage ex-pressed at having old signboards foisted on the public and tickets with detachable catalogues (so that the buyer had to have a new one for every visit to the exhibit) was real, it was also exploited by the *St. James' Chronicle* as advertising and surrounded with ironic com-mentary. The *London Register,* with some of the same publishers as the *Chronicle,* printed a laudatory account, which was then reprinted in the *Chronicle* (29 April–1 May). It singles out Hogarth and Thorn-ton as the prime movers.

The satiric prints as well as all the letters and poems that attacked the exhibition are evidence of the exhibition's success. Following criticism of the catalogue policy, a notice was published in the *Public Advertiser* (5 May): "It is hoped that Ladies and Gentlemen do not take it ill, that no Person can be admitted with the same Catalogue

twice; as otherwise it would be impossible to accommodate the Company." They were drawing crowds, perhaps away from the other exhibition.

The Society of Arts exhibition ended on 17 May; on the same day the Society of Artists of Great Britain opened their exhibition at Spring Gardens. The sign-painters' exhibition ended at the same time and the *St. James' Chronicle,* as if to clarify their position, published a complimentary essay on the Society of Artists' exhibition.

Letters and poems continued to appear; the most significant fact about them, of course, was the extensive explanation of motives the writers thought necessary. While the display's primary purpose remains ambiguous, it was partly a reaction against the extravagant praise English artists were bestowing on each other; partly an indication of where Hogarth believed the true roots of English art were to be found (vs. the continental tradition); and so partly a continuation of Hogarth's attack on the art establishment, begun in his "popular" prints of the late 1740s and early '50s. Appropriately, this subversive exhibition was Hogarth's last important gesture purely as an artist.

The Times

In the autumn of 1761 a pamphleteer attacking the Ministry, and in particular the Duke of Newcastle, wrote that he would recommend "Mr. Hogarth" to try his fertile imagination in a drawing for a political print on this subject. He then, perhaps with the *Election* prints in mind, proceeded to describe such a drawing, presumably for Hogarth's benefit. There was no immediate response.

Two plates of the next year, however—*Credulity, Superstition, and Fanaticism* and *The Times, Plate 1*—indicate Hogarth's increasing political involvement. Writing in the fall of 1763, he recalled that, with his illness and recovery, "the loss of so much time and the inattention to Prints occationd by the wars . . . abroad and contentions at home made it necessary to do some timed thing that [would] stop a gap in my income"—and thus he produced *The Times.* In light of the probable period of his illness, another "timed thing" was perhaps his revision of *Enthusiasm Delineated,* published as *Credulity, Superstition, and Fanaticism* (pls. 122, 125) in April 1762, profiting by the notoriety of the Cock Lane Ghost. This project, involving relatively little work, and not proving so traumatic as *The Times,* may not have occurred to him at the time he was writing. But *Credulity* and *The*

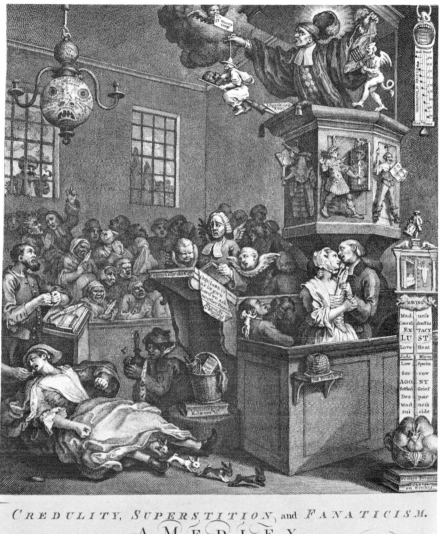

125. Credulity, Superstition, and Fanaticism; publ. April 1762; 14½ x 12⅝ in. (BM)

Times, though different in scale and artistic importance, are closely related. The one serves as prelude to the other.

Enthusiasm Delineated (pl. 122), undertaken in late 1759 or 1760, had been put aside by illness or dissatisfaction or on the advice of

friends. This original version, though including some Methodists, is about art—"the strange Effects of litteral and low conceptions of Sacred Beings as also of the idolotrous Tendency of Pictures in churches and prints in Religious books &c." Nevertheless, the crowd of fanatics —the "strange Effects"—fills the plate. The art is represented, but the chaotic crowd it works upon becomes the important element. In the revision, the subject of art is dropped altogether.

One Richard Parsons, back in 1759, had rented rooms in his house in Cock Lane to a William Kent and the sister of his recently deceased wife, Miss Fanny Lynes. Parsons, who was officiating clerk of St. Sepulchre's, Newgate Street, borrowed £12 from Kent, failed to repay it, and was at length sued for repayment. Meanwhile, Kent and Miss Fanny had moved to other lodgings nearby, and on 2 February 1760 she died of smallpox and was buried in the vault of St. John's, Clerkenwell. In January 1762 Parsons began to hear knockings and scratchings in his house, apparently centered in the bedroom of his eldest daughter, a child of eleven. The knockings were studied; the "ghost" was interrogated and its replies interpreted, and word spread that it was the ghost of Miss Fanny trying to make contact with the world through Parsons' daughter in order to condemn Kent as her murderer. The story attracted the attention of the Methodists.

"The methodists," as Horace Walpole uncharitably put it in his *Memoirs of the Reign of King George III,* "had endeavored to establish in Warwickshire, not only the belief, but the actual existence of ghosts. Being detected, they struck a bold stroke, and attempted to erect their system in the metropolis itself." The Parsons family, with whose child the ghost communicated, was Methodist; out of desire for revenge and Methodist enthusiasm, then, Parsons fostered the delusion of the ghost and started the accusations of murder against Kent. Some sense of Hogarth's feeling about the Methodists is communicated both in the fury of the print and in Walpole's violence as he describes the Cock Lane affair, perhaps inflating the aesthetic importance of Hogarth's design.

It was true that the Methodists exploited the Cock Lane Ghost. Some prominent members were involved: the Rev. John Moore, lecturer at St. Sepulchre's, was Parsons' confidant from the start of the affair; the Rev. Thomas Broughton, lecturer at St. Helen's, Bishopsgate Within, and All Hallows, Lombard Street, constantly attended the Parsons girl with Moore; and among the nobility who showed in-

terest was William Legge, Earl of Dartmouth, a Methodist sympathizer. All of which, as Walpole observed, "affected to cast an air of the most serious import on the whole transaction."

The story was first introduced in the early days of January into the *Public Ledger* by Parsons, Moore, and the others; and once the Parsons house had become crowded with noblemen anxious to hear the tapping ghost, other newspapers followed, first copying the *Public Ledger* and then producing their own reports. The *London Chronicle* and the *St. James' Chronicle* first referred to the ghost in their issues of 16–19 January, *Lloyd's Evening Post* in that of 18–20 January. Crowds from all quarters of the town flocked to Cock Lane, stopping the narrow way with coaches and pestering anyone who had firsthand information to give. By 21 February, the child had been caught with blocks of wood concealed under the covers, and the Methodists were naturally accused of complicity. After the ghost was exposed, she was popularly connected with the other great female impostors of the century, Mary Toft and Elizabeth Canning. For Hogarth, she was another instance of the delusion he had first exposed in his print of Toft, who appears in *Credulity* in much the same pose as in *Cunicularii* (pl. 14). On 23 February Goldsmith's pamphlet *The Mystery Revealed* was published, containing many details incorporated into Hogarth's print—King James' *Demonology*, Glanville's *Sadducismus Triumphatus*, and Richard Hathaway, the Boy of Bilston, who "vomited in public crooked pins, which he had previously swallowed in private."

On about 5 April, Hogarth's print was published. This work, which half a century later disturbed Keats' dreams, was Hogarth's last venture in modern history: he never attempted such scale or monumentality again. Its mode, like that of *Gin Lane* and most of the prints since, was the corruption or degeneration of an ideal paradigm (as the *Election Entertainment* and *The Cockpit* were corruptions of the paradigm of Leonardo's *Last Supper*, and *Election*, Plate 4, of paintings of triumphal processions like Le Brun's *Alexander the Great*). The corruption in *Credulity* is the corruption of an institution, the church, and the same kind of degeneration is traced in *The Times* plates and the prints that followed. The unruly crowd was only one aspect of the general perversion of normative values.

In the summer of 1762, still under the influence of this powerful image, Hogarth set about a rather elaborate, though small, design in the popular style of *Industry and Idleness* but conceived in the em-

blematic tradition of his very earliest prints. This was *The Times,
Plate 1* (pl. 126), which marked his excursion from religion into poli-
tics, from the relatively safe ground of Methodist fanaticism mani-
fested in an exposed hoax to the very uncertain ground of contempo-
rary political controversy.

The crazy, frenzied Methodists of *Credulity* have become here the
mob of City officials, merchants, and bruisers (clanging their bones
and cleavers together) who are worshiping an idol symbolizing Pitt,
War, and Trade at the expense of King and Peace. In the foreground,
among the wretched inhabitants of his ruined country, an equally
crazy Frederick the Great contentedly plays his fiddle. The less de-
mented people in the picture are craftily impeding the efforts of the
single fire fighter, the Earl of Bute, who tries to direct his hose at the
nearest burning house. High above him in garret windows, shooting
water at him from clyster pipes, are two figures (one in clerical bands)

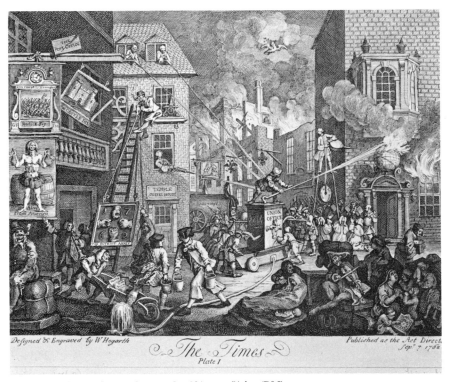

126. The Times, Plate 1; Sept. 1762; 8⁹⁄₁₆ x 11⅝ in. (BM)

who would have been recognized by contemporaries as Charles Churchill and John Wilkes, whose *North Briton* was indeed impeding the Minister in his efforts to secure peace.

The print shows a city (Europe) being consumed by the fire of war, its refugees huddled with their few belongings in the foreground. The three relatively unharmed houses represent England, or different segments of it. The one on the left is the government: the fanatically and divisively clenched fists of the "Patriot Armes" (Pitt's administration) are being lowered to be replaced by the clasped hands of Bute's insignia, the "Union Office." Indeed, the small group of fire fighters unites English- and Scotsmen in the only sign of order in the chaotic scene. The "patriots" have withdrawn to the "Temple Coffee House" next door; Temple, the faceless man in the lower window, was Pitt's colorless brother-in-law, the only cabinet member to follow him in his abrupt resignation of October 1761. Up in Temple's garret are Churchill and Wilkes, his propagandists in the Pittite cause of continued war. The third house, with the flaming world over its door and fire breaking through a window, would appear to be the residence of the English citizenry; the open door and the proximity of the kneeling City officials around Pitt suggest that they are worshiping the very man who is fanning the fire in their house.

This print, like others of both sides, was a public statement, but it was the work of an artist who had made himself well known to most Englishmen. The conjunction of print and artist could not help bringing the Pittites, the many sincere admirers of the great minister, and his talented propagandists down upon Hogarth's back. For a public print, moreover, it featured distinctly personal traces. Obviously, Hogarth was a friend of both Churchill and Wilkes. Most telling, and most private of all, the house that is burning has one distinct architectural mark, the bow window above its front door. This is almost precisely the bow window on Hogarth's house in Chiswick. It is not only the house of Englishmen but of one beleaguered Englishman in particular.

The crowd itself, of course, carried personal connotations for Hogarth. It had always been an ambiguous element in his prints, representing at best nature as it is vs. the superimposition of some false and constricting order. But in these prints Hogarth's emphasis is also shifting from the deviant individual, the man who has made the wrong choice, to the uncontrolled passions in a group of people. The only

outbreak of crowd violence in his earlier years had been the Spital-
fields Riot of July 1736 against the Irish, a destructive but not bloody
affair. The action of *Industry and Idleness* begins in Spitalfields, and
the ugly crowd is always close to the subject of the plate. But it was the
Common Council of the City of London that often gave the lead to
riots in eighteenth-century England. The Council had generally been
Tory in sympathy during the Walpole and Pelham years, until in the
mid-1750s it adopted William Pitt as its champion, helped him into
office, and supported him even more fervently after his resignation. It
was the City mob that cheered Pitt in the royal procession to the Lord
Mayor's Dinner, slighted the new king, and booed and pelted the new
prime minister, the Earl of Bute.

In the *Election* the crowd was the electorate itself, and though set
in outlying areas like Oxford, it hinted at Hogarth's attitude toward
the City. This strain becomes more urgent in *The Times, Plate 1,*
where he is specifically attacking the City interest. There emerges,
however, an apparent paradox: he is appealing to the City as his audi-
ence but portraying it as a disorderly and dangerous mob. Wilkes was
very much aware of this difficulty, noting in his attack on Hogarth in
North Briton No. 17 that "the public never had the least share of his
regard, or even good will." It is true that this group was an important
part of the public on which he founded his prosperity.

One way of looking at the paradox is to distinguish Hogarth's aris-
tocratic yearnings from his solid business sense: his pride in his friend-
ship with Lord Charlemont, in being treated in some sense as his
equal; his evident pleasure in friendships with politicians like Fox,
Hanbury Williams, Sir Edward Walpole, and George Hay, and with
people near, not only to Bute but also to the Prince of Wales and even
the king himself.

But whether one accepts the public or private motive of the artist,
the important thing to note is that *The Times, Plate 1,* finally aligned
Hogarth with the court and the West End against the City; it repre-
sented a final choice, though he did try to modify and certainly (as
was by this time habitual with him) to explain it. All his life he had
vacillated between one group and the other: refusing to take his free-
dom of the Merchant Taylors' Company, turning from engraving to
painting, from his great public of print buyers to the royal family for
portraits, being rebuffed and returning to his prints, turning to the
church but always returning to his faithful public of the middle class

and his love–hate relationship with them. By the late 1750s his choice was clear in his angry comments on the mercantile bias in England that prevented artists from surviving, and on the Society of Arts that wanted to deceive and delude young artists with hopes that he knew would never be fulfilled.

Hogarth's stated purpose in making *The Times, Plate 1,* as he wrote in the fall of 1763, besides "stopping a gap" in his income, was to urge "peace and unanimity," and so he "put the opposers of this humane purpose in a light which gave offence to the fomenters of destruction." The pro-Pitt crowd of City merchants was his main object of attack: their infatuation with the idol Pitt, analogous to the Methodists with their spirits and the Catholics with their graven images, originated in their own ignoble goals. Thus a print for the peace was also a print for Bute and for the small minority of Scotsmen around him. It was a print against the immensely popular and successful (but now dismissed) minister, Pitt.

Politically, Hogarth may have been from the outset a Tory like Smollett, or a Leicester House Tory. It could be argued that he had always supported, spiritually at least, the Leicester House party. Consciously or not, his prints had all been drawn from an assumption that political factionalism was bad, a view inculcated in the young prince by his mother and tutors; and the *Election* prints, as noted, might have been a Leicester House tract on the value of a Patriot King. In this case he could have supported Pitt, and even the City interest, during the war in the hope that they would bind the country together in a partyless, seamless fabric, breaking the back of the old Whig oligarchy, those noblemen he associated with the Dilettanti and the dark masters. But once Pitt broke with his king, and himself became part of a faction, Hogarth would have found himself on the other side.

Hogarth's action should also, however, be seen in the narrower context of his personal friendships in the years leading up to his plunge into politics, and in those crucial years of 1762–64. He was part of a loosely connected group consisting of (besides the old friends, Morell, Townley, and Garrick), Garrick's friends Colman, Thornton, Wilkes, and Churchill, and—still more loosely connected—Hay and Martin. They were drinking, talking, plotting, practical-joking, and propagandizing companions, whose basic stance was irreverence—a group analogous to the Medmenham Brotherhood in this as in their splintering on the rock of the peace negotiations. Hogarth's political

friends may even have included Henry Fox, who actually appears in both *Times* plates, in the first as a fox emerging from his kennel (his lucrative post of paymaster of the armed forces), in the second as a heroic (if perhaps misguided) gardener. After his years as paymaster he had become one of the most unpopular politicians in England; but he was emerging now to guide the peace settlement through Parliament.

It was with such men as Hay, Martin, and Fox—at the head of their professions as technicians, but of suspicious repute politically, and all presenting a strong contrast to the courageous and dedicated Pitt—that Hogarth was personally associated. Their friendship enabled him to extend one side of his character, but in the peculiar context of the times this led to an evident confusion between idealism and self-interest, involvement and detachment.

Two other friends of Hogarth in the years and months immediately preceding the publication of *The Times* were no more spotless but perhaps more amusing. One was John Wilkes, the son of a well-to-do malt distiller of Clerkenwell, who lived in the square behind St. John's Gate where Hogarth had spent a few years of his childhood.

Hogarth's association in the later 1750s with Thornton and perhaps also Colman, with Garrick as a common friend, brought him into touch with the other, Charles Churchill, around 1758. That autumn, Churchill returned to London to be curate of St. John the Evangelist's, Millbank, and took up with his Westminster classmates, Thornton, Lloyd, and Colman. It was also about this time that the strong Wilkes–Churchill friendship began. There was an overlap among these political friends, Hay for one being a friend of both Hogarth and Wilkes.

Despite Wilkes' later protestations against Hogarth's negative satire, it is obvious that this was what drew him, and doubtless Churchill as well, to Hogarth; both were skillful satirists, who admired Hogarth's work and also his lively talk. However, it seems evident that Wilkes originally admired Hogarth as the lover of freedom and "variety," revealed in his prints and in certain aspects of the *Analysis:* for Wilkes, unlike Hogarth, Thornton, and the rest, seems to have been a genuine radical. To Hogarth and Thornton, the sign-painters' exhibit was first a device for exposing some contemporary ideas about artists, and second (perhaps equally important for Hogarth) an expression of positive feelings about lower-class art. For Wilkes both

these aspects would have applied, but he would have carried the exposure much further. He probably read his own radicalism into Hogarth's attacks on the aristocratic patrons of art and the Whig aristocracy. He was naturally shocked when he learned that Hogarth—who doubtless had ridiculed his serjeant paintership as panel-painting in his presence—announced himself as a true placeman and a supporter of the government.

An expensive parliamentary contest in 1754, the cultivation of an interest at Aylesbury, and the wild London life he enjoyed in the late 1750s had brought Wilkes to the brink of financial ruin. He had hitched his star to Pitt in Commons, and Pitt's resignation in October 1761 cut off one possible path of political advancement and financial retrenchment. By 1762 he was deep in debt, and it was at this point that he turned to journalism—though hardly for money alone—with Earl Temple's fortune behind him, and the hope that his writing, wherein (as he perhaps realized) lay his talent, would win him both Pitt's approval and a place in the next Pitt administration: which seemed as inevitable as Bute's fall. He miscalculated Pitt, of course; his journalism brought him notoriety, which satisfied one side of him, but negated any future with the cold and proper Pitt.

Churchill too had been overwhelmed by his debts in 1760–61, was forced into bankruptcy, and saved from debtors' prison only by the intercession of Lloyd's father. At about the same time, probably a symptom of the same collapse, he separated from his wife and left her and his children. While he wanted none of her, devoting himself to prostitutes who repaid him with serious venereal infections, he was apparently conscientious about the financial support of his children, and he eventually repaid Dr. Lloyd and his creditors. A more brilliant but much less stable person than Wilkes, he accepted Wilkes' invitation in June to join him in writing the *North Briton*. This periodical was saturated, as Walpole has said, "with an acrimony, a spirit, and a licentiousness unheard of before in this country." Its reputation was never particularly savory, and it was frowned upon by the respectable, but its effect was powerful.

Wilkes begins his account of *The Times* with the remark that he and Churchill had "for several years lived on terms of friendship and intimacy" with Hogarth. Wilkes, a colonel of his regiment in the Buckinghamshire Militia, was stationed that summer in Winchester, guarding some French prisoners, sitting on courts-martial, and drink-

ing with other officers, and in his spare time writing the *North Briton,*
making quick trips to London, and urging Churchill in letters and in
person to meet his deadlines. An unnamed friend wrote him that Ho-
garth was soon to publish a political print called *The Times,* "in
which Mr. Pitt, Lord Temple, Mr. Churchill, and himself, were held
out to the public as objects of ridicule. Mr. Wilkes on this notice," as
Wilkes told the story, "remonstrated by two of their common friends
to Mr. Hogarth, that such a proceeding would not only be unfriendly
in the highest degree, but extremely injudicious; for such a pencil
ought to be universal and moral, to speak to all ages, and to all na-
tions, not to be dipt in the dirt of the faction of a day, or an insignifi-
cant part of the country, when it might command the admiration of
the whole." The last, much emphasized in *North Briton* No. 17, was
no doubt the sugar that sweetened the warning: the print would be
"injudicious" both because Wilkes and Churchill were dangerous
men to cross and because Hogarth would be confining his natural
talent.

Hogarth, according to Wilkes, replied that neither he nor Church-
ill was attacked in the print, though Temple and Pitt were, and that
the print would soon appear. Although he was keeping letters he con-
sidered significant during these years, Hogarth did not keep this one,
and its message may have been conveyed by word of mouth. If the im-
portant point, to which Wilkes returns later, that Hogarth did not
keep his word about depicting him and Churchill, is true, one must
assume that Hogarth was being disingenuous about the two figures
shown leaning out of the garret windows. The matter of identity both-
ered him. He originally disguised Pitt himself as Henry VIII, but be-
fore publication changed the shape to Pitt's—both versions reached
early buyers.

If Hogarth had been hesitating, he was forced into immediate pub-
lication by the appearance of a print called *John Bull's House Sett in
Flames* (Paul Sandby?), dated 2 September and first advertised on the
sixth. His own print, dated 7 September, was advertised on the ninth;
he could not have made such a complex and carefully executed plate
in five days. *John Bull's House* was evidently based on the same rough
description of Hogarth's design that reached Wilkes sometime before
publication; the Pitt camp naturally sought to anticipate Hogarth and
make his print appear the copy—a point that Wilkes elaborates in
North Briton No. 17. There would have been no reason to introduce

a portrait of Churchill (or, for that matter, Smollett ["Smallwit"]) if the subject of Temple's Coffee House had not first been raised in Hogarth's print. The metaphor of Europe on fire, logical in terms of Hogarth's conception, is turned around in *John Bull's House:* Britain itself is on fire, with fire fighters and perpetrators reversed.

Wilkes criticizes Hogarth both for plagiarism and for the poverty of the fire conceit. While this sort of simple emblematic representation was not Hogarth's forte, he presumably employed it in hopes of reaching the broadest possible public.

As soon as *John Bull's House Sett in Flames* appeared, Hogarth began to advertise his own print, and it reached the public on Thursday the ninth. Wilkes on that day was in London, staying in his town house in Great George Street, Westminster, and trying to see Churchill, who was ill; he returned to Winchester on Saturday the twelfth. First report of the print was from Hogarth's acquaintance Thomas Birch, confidant of Lord Hardwicke, who described it in his letter to Hardwicke for 11 September. At this stage, Hogarth was evidently still concerned to prevent a break with Wilkes and, being at Salisbury on the sixteenth, he called upon him, but Wilkes was away, and they did not meet again. On the other hand, on Saturday the thirteenth, according to Reynolds' pocket-book for the year, he and Wilkes dined together at the Beefsteak Club (Reynolds, not a member, was Wilkes' guest), and Hogarth avoided Wilkes on that occasion.

Hogarth's life at this point can be defined by neither his art nor his actions, but only by the responses of his friends, enemies, and anonymous journalists. Wilkes' reply, according to his warning to Hogarth, was to be out the following Saturday. It did not in fact appear until 25 September, by which time other attacks had already been launched by Earl Temple's propagandists. Paul Sandby produced the earliest and the wittiest, as he had a decade before; he was enlisted, or volunteered, to reproduce again his old caricature of Hogarth—if anything more puffy and blear-eyed than in 1753–54. As the Pittites must have realized, Sandby was a genuinely gifted political satirist; *John Bull's House Sett in Flames* looks like his work, as does another unsigned, untitled print (BM Sat. 3910) which presents the whole dramatis personae of the Bute–Pitt conflict, including Hogarth carrying a Scotsman on his back. Not long after, an elaborate but very crude parody of *The Times, Plate 1,* called *The Times, Plate 2* appeared with the central group of the fire fighters replaced by Hogarth himself standing

in the pillory for libeling (a motif he picked up, replacing himself with Wilkes, in his own *Times, Plate 2*).

Garrick, though as close as ever to Hogarth, was very involved with Churchill and Colman at this time. It may have been he who served as the mutual friend between Hogarth and Wilkes prior to the publication of *The Times*. His relations with Churchill were always a little uneasy: Churchill had attacked all the actors except Garrick in *The Rosciad* (1761), but in *The Apology*, out in April of the same year, he had made some gestures toward chastising Garrick too. Garrick gratified him with an anxiously protesting letter sent through Lloyd, which established a balanced relationship between the two men. Churchill liked to brandish warnings of his retaliatory strength. Writing shortly after the appearance of *The Times*, Churchill concluded ominously:

> I have seen Hogarth's print, sure it is much unequal to the former productions of that Master of Humour. I am happy to find that he hath at last declar'd himself, for there is no credit to be got by breaking flies upon a wheel. But Hogarths are Subjects worthy of an Englishman's pen.
>
> <div align="center">Speedily to be published,
An Epistle to W. Hogarth by C. Churchill</div>

One notices throughout the Churchill correspondence, especially with Wilkes, the sense of game, play, irresponsibility, and pride in power for its own sake that is so unlike the utterances of Pope, and distinguishes Churchill's very personal approach from that of his Augustan predecessors. His norm is not society, but his own genius. It was his custom to announce a title before he had written a line, and in this case it was nearly a year before his threat was fulfilled. As to his quarrel with Hogarth, it sprang presumably from his support of Wilkes and the *North Briton*, and the pleasure of demonstrating his power, although there is another story that it began in the parlor of the Bedford Arms in Covent Garden, over a rubber of shilling whist. There may have been some such incident, but it seems significant that Churchill could not muster up enough indignation to compose an attack on Hogarth at this time.

Wilkes, however, was true to his word, and on the twenty-fifth he published a *North Briton* devoted to Hogarth. Setting the tone and vocabulary for the attacks to follow, he evokes essentially the same

Hogarth Smollett depicted a decade earlier, adding another dimension: the moralist who betrays his sacred trust by descending to scurrilous particulars. Here is the Hogarth who "possesses the rare talent of gibbeting in colours, and in most of his works has been a very good moral satirist," but who deviates from his true forte into sublime history painting (much is made of the unfortunate *Sigismunda*), self-interested attacks on the old masters, and now politics. Hogarth can only portray the dark side of things—a *Marriage à la Mode* but not a *Happy Marriage;* he cannot even celebrate a Pitt, but must scrutinize all through his distorting glass.

Wilkes makes much of Hogarth's personal vanity and jealousy of other artists; of the "rapid decline" of his powers in *The Times.* It is implied that Hogarth's health and mind are deteriorating. Throughout, the piece would have read much more gallingly to Hogarth than to most outsiders: there are many touches to the quick, some true, some expansions of partial truths, and perhaps some outright falsehoods. In particular he would have been hurt by the long passage on *Sigismunda,* which Wilkes knew he was sensitive about to begin with, and which includes a personal reference to Jane Hogarth. Wilkes goes on to reveal those "tiresome discourses" Hogarth delivered "day after day" about *Sigismunda*'s merit vis-à-vis the old masters. He must have known that these revelations would be exceedingly painful to someone who, while always in a sense a public figure, nevertheless carefully guarded his private life. Even worse, he seeks to destroy Hogarth's public image of himself: "The public never had the least share of his regard," he writes; "or even his goodwill. Gain and vanity have steered his light bark quite thro' life. He has never been consistent, but to those two principles." Like the personal revelations, these words were just close enough to the truth to be disturbing.

The reaction of the *St. James' Chronicle* to the squabbling is instructive. A pro-Pitt paper run by Wilkes' and Churchill's friend Thornton, it usually printed excerpts from the *North Briton,* as well as the *Briton,* the *Monitor,* and the *Auditor* each week. No excerpt, however, was printed from *North Briton* No. 17, and no sanction was given to Wilkes' attack on Hogarth—though as time passed, and the Hogarth–Churchill contest developed, this neutrality seemed to dissolve. This was, of course, a paper Garrick had stock in, and one that had closely echoed Hogarth's views on the arts. It is easy to see how his advocacy of the Bute Ministry may have appeared to the *St. James'*

Chronicle group as apostasy, and how Garrick may have felt some responsibility for his friends and allies as they turned on Hogarth. His control, or Thornton's friendship, may have held the paper in line on Hogarth as on the general issues of the time.

Hogarth's own account of *The Times* in his manuscript notes remarks only that one of "the most notorious" opposers of the peace had been "till now rather my friend"—and observes that "a flatterer" attacked him in the *North Briton*. He makes no mention of any preliminary negotiating, but adds that this person (he often omits names when he feels strongly) attacked him "in so infamous a manner that he himself when pushed by even his best friends [who] would not stand [for] it, (wonderful) . . . was driven to so poor an excuse as to say he was drunk when he wrote." The attack hit Hogarth the harder because his health had again seriously deteriorated during September.

The title of *The Times, Plate 1,* called for a sequel, and although Plate 2 was never published, it was nearly completed (pl. 127). The matter of Hogarth's health makes it difficult to say how early it was

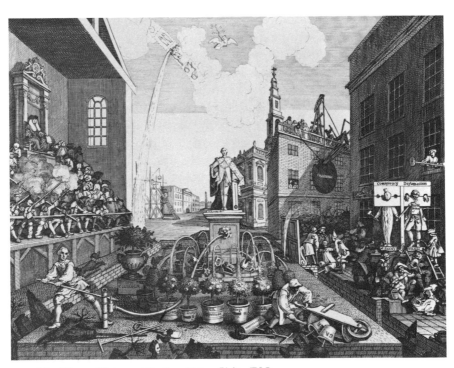

127. The Times, Plate 2; 1762–63; 9⅛ x 11⅞ in. (BM)

begun. It must, however, be datable between December, when the
peace preliminaries were passed and Fox began purging the old place-
men and replacing them with new, and Bute's resignation on the next
7 April. In fact, Bute's resignation was probably the definitive reason
for leaving the print unfinished. There is no reason to think that
Hogarth was afraid to publish it, but he may have sensed the opaque
and ambiguous quality of his symbols, reflecting the ambivalence of
his own feelings. He began a written explanation, suggesting that he
planned to include this in his bound volumes of prints. The plate
shows Fox, Bute's parliamentary manager for passing the peace treaty,
as a gardener replacing the old plants and shrubs (the Whig placemen
of the previous reign) with rose trees (the Tory "friends of the King,"
who, Hogarth suggests, were merely old Jacobites replacing "James"
with "George"). The general setting alludes to the so-called Butifying
of London that was in progress from 1762 onward. This had begun
with the act (2 George III, cap. 21) to clean, lighten and widen the
streets of Westminster, signed into law on 2 June 1762, and followed
by acts pertaining to other parts of London as well as provincial cities.
Hogarth shows some sort of "improvement" going on in the street,
with a very wide panorama of the Strand stretching west to Kew Gar-
dens. The water may refer to the water being brought to the West
End, into the canal behind the queen's palace, through pipes from the
Chelsea River.

The West End panorama may be intended to complement the City
view in Plate 1. Certainly the water refers back to the water that was
being used to fight the fire in Plate 1. The general point is that the fire
fighters of Plate 1 are trying to turn their attention to peaceful pur-
suits—gardening and rebuilding and improving London; the water is
turned from fighting a fire to cultivating a garden. Plate 1 represents
the agitation before the peace treaty was drawn up, Plate 2 the strug-
gle while it was in Parliament being ratified. Thus in 1 Pitt is out in
the streets of the City with his mob, in 2 he is within the House of
Commons shooting at the peace dove that flies overhead (it was also
overhead in the first plate).

In this plate, however, the gardeners are regarded with more am-
bivalence than were the fire fighters. They (or the system of patronage
through which they must work) are pointedly not watering the Duke
of Cumberland's plant, but rather the Scottish-Jacobite supporters of
George III, who might well desire the isolation of the victor of Cullo-

den. Fox's efforts are being hindered by a £100,000 note, which may refer to the war debt, to his own profiteering as paymaster general, or to the large bribes he was supposedly offering to secure ratification of the treaty. In any case, the allusion is open to uncomplimentary as well as complimentary interpretations. Hogarth's attitude toward the Butifying of London is even more ambivalent. The Dutch topiary garden is being replaced by a French parterre with potted bushes. At the center, the new king is delineated entirely in straight lines by his unofficial court painter, Ramsay (this portrait, engraved by Ryland, had been published in 1762). The attached rule is a pun: certainly the straight lines suggest the rigidity of rules criticism (Ramsay distrusted Shakespeare, for example, because he neglected the rules) and perhaps also Ramsay's mechanical style: both his copies of the royal portraits and his own works adhered too closely to "the rules." Something of this rigidity inevitably attaches itself to the subject, George III. The whole matter of the Butifying of London would appear to show Hogarth's disillusionment with George III as patron of English art.

What he intended to accomplish and exactly on whose side he meant to be is not clear. Nobody comes off well: neither the squabbling members of Parliament nor even the royal gardeners; only perhads the little group of irate citizens around Wilkes in the pillory. If he had published the print, Hogarth must have realized, he would have been accused of turning his coat and attacking Bute, perhaps even the king himself. In fact, he seems to have changed his mind and recognized that, as his friend Hay no doubt argued, Bute was neither better nor worse than Pitt. Everything in the London scene was changing for the worse: for this reason, because he was dissatisfied with the symbols he had chosen, because his own indecision was reflected in the confusion of the print, because Bute's resignation rendered the print meaningless, because of declining health, or a combination of these, he left the plate unfinished. He made some sepia changes on a drawn proof of the plate (Exeter Coll.), but these were never transferred to the plate. His attitude remained ambivalent.

About one thing, however, he was morally certain. In *The Times, Plate 2*, he had shown Wilkes standing in the pillory with Miss Fanny, the Cock Lane Ghost—a prophecy of a demagogue's fate based on *North Briton* No. 17 (the number is punningly represented by the fold in the paper around his neck). The prophecy was realized, and Wilkes' *North Briton* came to an abrupt halt with No. 45, published

on 23 April 1763, which attacked the king's speech closing Parliament and praising the peace; it refused to make the conventional distinction between the king and his ministers who wrote the speech, casting aspersions on the monarch himself. A general warrant was issued on 29–30 April to arrest the "authors, printers, and publishers" of the paper, and Wilkes was taken into custody and lodged in the Tower. On 3 May he was brought to the Court of Common Pleas and remanded to the Tower until 6 May, when he was returned to Westminster. On that day Hogarth was in Westminster Hall to see and record Wilkes for posterity.

From the drawing (BM), it appears that Hogarth made a sketch on the spot with a porte-crayon and later marked it with pen and brown ink, then incised it to transfer it to the copperplate. Hogarth was not a well man: the drawing, and even more the print, are the work of a shaky hand, perhaps partially paralyzed. Despite the manifest signs of physical infirmity, the print *John Wilkes* was a masterful and damaging piece of propaganda—the most effective of the whole campaign on either side. Announced for publication on 21 May, the portrait of Wilkes was designed to hang alongside that of the traitor Lord Lovat. *John Wilkes* was evidently to be seen by 17 May when it was first advertised. Already by the eighteenth the *Public Advertiser* was running a letter from one N. O. (ironically posing as a supporter of Hogarth) who argues that *Wilkes* cannot be by Hogarth but must be an imposition to ruin his reputation. Naturally it elicited many reactions, from attempts to beautify Wilkes to imitations putting Hogarth in Wilkes' place. Everyone expected Churchill to reply to Hogarth. In *The Author* (1763) he had attacked all the literary Buteites, including Murphy, Smollett, and Samuel Johnson, assailing them as "vile pensioners of State." In March 1762, before the political controversy had begun, he had ridiculed Johnson as a self-appointed literary dictator, and then, when Johnson came out for Bute, in October 1762, his eloquence overflowed.

Both Wilkes and Churchill were astute enough psychologists to understand Hogarth's sensitivity—especially the increased vulnerability that accompanied ill health—and had certainly taken advantage of it, first in the form of threats and, when this failed, as a source of revenge. Churchill's continued announcements of his *Epistle* before it was written were probably intended to harass Hogarth, throw him off balance, punish him for *John Wilkes,* and silence him.

Churchill had written to Wilkes on 16 March that he planned a poem on Hogarth. "I shall get him on Paper, not so much to please the Public, not so much for the sake of Justice, as for my own ease—a motive ever powerful with indolent minds." But in the same letter Churchill wrote that he feared he was suffering from gonorrhea, and by mid-May his indisposition was preventing him from completing his answer to Hogarth.

Churchill's *Epistle* continued to be announced, however—again on 28 May, to be published on 29 June—undoubtedly to some extent as psychological warfare, to increase Hogarth's apprehension; he must have shown some signs of concern.

When the *Epistle to William Hogarth* did finally appear at the very end of June, it was something of an anticlimax. Morell, who was the first to carry a copy of the *Epistle* to Hogarth, and read it to him, told Nichols that "he seemed quite insensible to the most sarcastical parts of it. He was so thoroughly wounded before by the North Briton, that he lay no where open to a fresh stroke." This accords with Hogarth's own account. There were, of course, really no new charges in Churchill's poem, whose most eloquent passages amounted to strong praise of Hogarth's now moribund talent. Moreover, it lacked bite and was, compared to some of his earlier efforts such as *The Prophecy of Famine,* dull. He did not even get to Hogarth until line 309, by which time Hogarth may well have concluded that many readers would have turned away. Only envy and decrepitude are criticized. Finally, Hogarth the artist is so complimented that he may have considered how much worse he might have come off; on the balance, he might even have been flattered by it, thinking that it is a better thing to be a great artist than a good-natured man.

The *Epistle,* "the reduction to nothing of Hogarth's once effective talent," is, in fact, a characteristic Churchillian satire. Images that suggest the sterility, uselessness, decrepitude, even nonexistence of the object of attack are opposed to some form of greatness or superiority, usually associated with Churchill himself; but the reviews of Churchill's poem began to sound weary of the whole personal affair. *An Epistle to C. Churchill* had been announced for publication on the twentieth, and the *Chronicle* of 24–26 July published this or another such poetic epistle dated Brighton, 9 July. The lines also survive in manuscript in a letter addressed to Hogarth, which he preserved and

perhaps himself inserted in the *Chronicle*. Hogarth's defender puts the case for Churchill's ineffectiveness nicely:

> Epistles; Pho! they're tedious Things
> Their very Length disarms their Stings!
> They ask, before they reach the Head,
> The Task, the Labour to be read.
> And Readers may mistake the Matter,
> Who have not Sense to find the Satire.

Garrick read the *Epistle* with dismay and on 10 July wrote to George Colman from Chatsworth (where he was visiting the Duke of Devonshire):

> Pray write to me, & let me know how y^e Town speaks of our Friend Churchill's Epistle—it is y^e most bloody performance that has been publish'd in my time—I am very desirous to know the opinion of People, for I am really much, very much hurt at it— his description of his Age & infirmities is surely too shocking & barbarous— is Hogarth really ill, or does he meditate revenge?— Every article of news about these matters will be most agreeable to me— pray write me a heap of stuff for I cannot be Easy till I know all about Churchill, Hogarth, & c—

Colman's reply has not survived, but his own feelings seem to have been mixed. Hogarth's health was at best doubtful. In the *St. James Chronicle* of 2–5 July a news item reported: "We hear that Mr. Hogarth is much indisposed with a Paralytic Disorder, at his House in Leicester-Fields." If this was not a manufactured news item, placed to coincide with the *Epistle*'s claims that Hogarth was dying, it shows that Hogarth was having a relapse and that the *St. James' Chronicle* (the only paper to report it) still maintained some personal connection with him.

He was, however, well enough later in the same month to "meditate revenge" and respond with an anti-Churchill plate. This was not a revenge that took much meditation. From a sympathetic pamphlet called *Pug's Reply to Parson Bruin,* published on 9 July, he took the image of Churchill as a bear in clerical bands, opposed by a small Hogarthian pug. The pug in the pamphlet represents not Hogarth but his pug, or the pugnacious, earthy part of his character. Taking these two symbols, Hogarth turned to the old plate of *Gulielmus Hogarth* (pl. 128) which already contained one of them, the pug; he

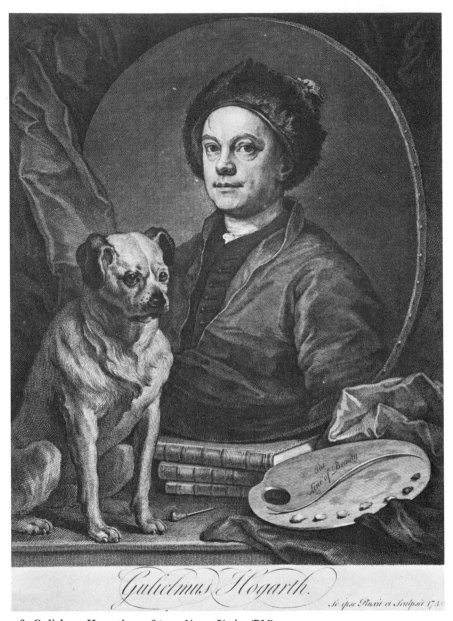

128. Gulielmus Hogarth; 1748/9; 13½ x 10⁵⁄₁₆ in. (BM)

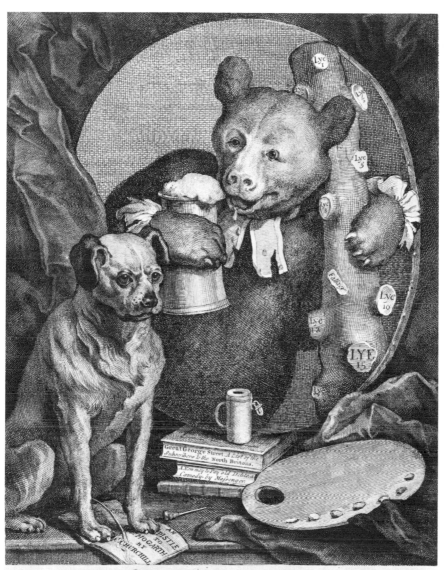

129. The Bruiser; Aug. 1763 (BM)

obliterated his own face and replaced it with the leering, beer-swilling bear, shown holding a Hercules club. He also erased the Line of Beauty from his palette (pl. 129). It did not take a great deal of work, and was published by 6 August. Hogarth's own explanation is distinctly ironic: "Having an old plate by me with some parts ready such as the background and a dog, I thought how I could turn so much work laid aside to account, so patched up a print of M^r Churchill in the character of a Bear." His tone serves both to devalue Churchill— he is not worth the trouble of a new plate—and to reflect his current cynicism: to make the print he obliterated his own face and trademark, the Line of Beauty.

Wilkes had also attacked Hogarth's friend Samuel Martin, the secretary of the Treasury in February 1763; and Martin, not having Hogarth's recourse to the burin, practised with pistols during the summer. In November he challenged Wilkes to a duel: their first shots missed, and Wilkes' second missed but Martin's struck Wilkes in the groin. Wilkes told Martin to flee to the continent to escape prosecution, and he did. Even Wilkes' enemies noted the restraint with which Martin controlled his temper all those months between the insult and his revenge; the careful wording of his note of challenge by which he deprived Wilkes of his privilege of choosing weapons; and the target practice during the summer. Martin's reputation seems to have suffered, but Churchill's inevitable response, *The Duellist,* published in January 1764, spent its attack on Bishop Warburton, and was treated with less sympathy by the critics than the *Epistle to William Hogarth:* they were getting tired of his personal attacks on respected people. The duel did not alienate Hogarth, who kept Martin's portrait at hand, continued to see him after his return from abroad in 1764, and bequeathed the portrait to him in his will. The words in the will are, among other things, a final gesture toward the man who had nearly killed Wilkes in protecting his honor.

Events, however, were closing in on Wilkes. Whatever sympathy Martin's bullet gained him in high places was counteracted by the scandalous accounts, spread by the government, of his *Essay on Woman;* but the crowd was still on his side. In May 1763 his discharge had been greeted with crowd action and cries of "Wilkes and Liberty," and in December the crowd prevented the public hangman at the Royal Exchange from burning No. 45, pelting the sheriffs with dirt and carrying away copies of the offending issue. Nevertheless, on

24 December Wilkes slipped out of his house and fled to France, and on 13 January he sent to the Speaker of Commons a certificate signed by two French surgeons that he was too ill to return to England. On 2 January his expulsion from the House had been voted, and even his own party, while attacking the use of general warrants, disowned Wilkes himself and was relieved by his absence. It was soon disclosed that he had cheated the Foundling Hospital while treasurer of the Aylesbury branch. Stories, some true and others false, rose to cloud the reputation of "honest John."

Churchill was living well enough. When he wrote *The Rosciad* he had found no publisher willing to bring it out; so he published it at his own expense, and thereby reaped all the profits of this work said to be "the most popular Poem that has ever been published in England since Pope's Dunciad"—it ran through eight editions in Churchill's lifetime. This financially clever move was of course based on the same principle that ensured Hogarth's financial success with his prints: the elimination of the middleman.

Throughout the quarrel, or at least after *The Times, Plate 1* (which probably alienated many Pittites), respectable opinion, to a large extent, favored Hogarth; Wilkes was feared and abhorred. Living up to his reputation, Churchill appeared less as a bear than a wolf entering the sheepfold and departing with obvious signs of his depredations. In the fall of 1763 he seduced and made off with the daughter of his and Hogarth's old friend Sir Henry Cheere. The girl, after her return, was apparently taunted by her sister until she again ran away to Churchill, who settled down with her in Richmond and later on Acton Common.

Thus from a bourgeois point of view, not too different from Hogarth's own, the wicked escaped punishment or actively flourished. The virtuous were attacked like Hogarth, or fled the country like Samuel Martin. Even Garrick, in a situation not unlike Hogarth's, had departed England by the end of 1763. The preceding season had been his busiest on the stage: he appeared on nearly a hundred nights, as opposed to hardly half as many in most years. But though only in his forties, he was beginning to feel his age, and, as with Hogarth, the London scene no longer seemed as sweet to him as it once had. The mob rule depicted by Hogarth in his recent prints became a reality to Garrick in January 1763 when the "Fitzgiggo" or the "half-price riots" nearly destroyed Drury Lane, and determined him not to play the next season. Inspired by an enemy of Garrick's, Thomas (Thady) Fitz-

patrick, the trouble stemmed from the theater's announcement that the public would no longer be admitted at half price after the third act of a new piece. The mob broke up both Drury Lane and Covent Garden; the following night Garrick capitulated, and shortly after, Beard of Covent Garden also gave in. Reminiscent of the riot of November 1755, this one prompted Garrick to leave at the close of the season for the continent, where he remained for two years, and never saw Hogarth again. His departure was one more symptom of the collapse of order which Hogarth was preparing to express in his autobiographical notes and *The Tailpiece*.

"Finis": *The Tailpiece*

In the early autumn of 1763 Hogarth began to look back over his life. He accompanied his retrospect with writings on the one hand and final revisions of his copperplates on the other, and with one last print, *The Tailpiece* (pl. 130). All of this, even the autobiographical notes, expressed unequivocally the feeling that England was a place he could no longer understand. The England he had known and chronicled seemed to have passed. His friends were dead, gone to the continent, turned against him, or fallen into some sort of disrepute (as, in a sense, he had himself). The deaths had begun with Fielding, Rouquet, Ellys, and Benjamin Hoadly in the 1750s; then in July 1761 William Huggins died, his Dante unpublished, his life an exercise in futility; Roubiliac and Ralph died in 1762, and the following year Garrick and Martin left the country in self-imposed exile. The friends of the *St. James' Chronicle* group were reduced to factions, and apparently only Thornton remained on amicable terms with Hogarth. The Society of Artists was proceeding on its way, oblivious of Hogarth. His own health and powers were rapidly failing, and he naturally projected some of his personal despair into his work. He did not finish another print during this period except *The Tailpiece*, which signaled the end of all things, including his creativity.

It was to the prints, however, that his thoughts turned in the last year of his life: he wanted to strengthen their fading lines and, by revisions, confirm their significance. To establish the meaning of each one, and more, his intention in producing them, he began to write a commentary to augment Rouquet's discussion of the prints up through *The March to Finchley*, including an account of his life. He explains that these are notes on his prints ("not only a discription but

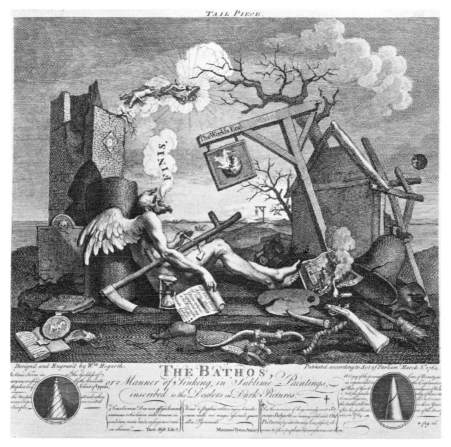

130. Tailpiece, or the Bathos; April 1764; 10¼ x 12¹³⁄₁₆ in. (BM)

also what ever else occur'd to me as relative to them") which he is going to send to a Frenchman as basis for his commentary; the complete life and commentary would then be distributed, as Rouquet's had been, with sets of his prints sent abroad. There seems little doubt that the book would also have appeared in English. Although the commentary on his prints was the immediate cause of his writing his autobiography, he must have been contemplating the subject independently; it was included in the projected title page of "On the Arts of Painting and Sculpture," intended as the work's climax. He understood that what he had to say about contemporary English art was inextricably bound up with his own life; and it is not easy to decide which takes precedence in the notes that emerge.

These notes were more carefully written than most of his jottings, some passages appearing in multiple drafts, the main points repeated over and over as Hogarth sought to express himself exactly. The earliest parts, probably begun in the summer of 1763, were written on various sizes of paper; then he turned to a small notebook and carried the story through to completion there. A column of sums, written upside down on folio 28b, bears the date 26 August 1763, which more or less corresponds to the chronological end of the autobiography with the publication of *The Bruiser*.

The burden of the autobiography is that he was self-taught, a tradesman, a patriotic Englishman; he was a champion of liberty of the individual against printsellers, pirates, connoisseurs, and political extremists; the enemies affronted by his independence and aggressiveness closed in on him and reduced his career from a series of successes to a losing battle with "the system," leading up to the events he considered decisive. He begins the notebook with the generalization: "The three things that hav brought abuse upon me are 1st the attempting portrait painting 2d the analysis 3rly the Prints of the times." Throughout these notes runs a strain of paranoia that cannot be altogether ignored: "I have been severly treated . . . I fear Persecution . . . I have suffer'd a kind of persecution. nevertheless from the bigots." And a little later he says that he never did anyone an injury, can point "without ostentation" to many he has benefited, has made "everybody about me tolerably happy," and has defied the high as well as the low.

The enumeration of the "three things" is followed by several pages of theory; then he reverts to the autobiography and carries it straight through the episode of *The Times* to its strangely provisional ending. He seems about to close on a rather hopeful note, having finished the two portraits of his enemies Wilkes and Churchill: "the satisfaction <and pecuniary advantage> I receivd from these two prints together with constant Riding on horse back restored me as much health as can be expected at my time of life." Then, on the next page, is the cryptic conclusion: "What may follow god knows / Finis." After the page marked Finis there are more jottings on the moral purpose of his art (he would rather be responsible for the *Stages of Cruelty* than the Raphael Cartoons, speaking "as a man not as an artist"), and a few fragments on his life: "when a man is cruelly and unjustly treated he naturally looks round and appeals to the standersby," and "My Phylosophical friends bid me laugh at the Abusive nonsense of party writers

But I cannot rest myself." His final graphic comment, moreover, was *The Tailpiece,* with the last breath emerging from Father Time's mouth marked "Finis"—though this too combines an image of the end of all things and his end as an artist with an inscription that reveals him still busily in pursuit of Beauty, defending and explaining his theory.

But it was the pessimism, not the jaunty victory sign, that he developed in the revisions of his copperplates. Though his notes indicate that he was "improving" his plates, in fact he was strengthening the lines that had become worn, to make sure they lasted and to clarify their meaning (as he now saw it). These were in a sense his last testament—to his public that had stood by him all these years, and to his wife, who would need the plates as financial security for many years to come; above all, his prints, always his one source of appeal beyond his "enemies," were his final plea to posterity. They were a projection of himself into that dark world beyond his present sickness and discontent.

Some of the plates had been altered shortly after publication, and the *Harlot's Progress* was reworked somewhat when in 1744 the second edition was printed. But the final changes date from *The March to Finchley* (engraved by Sullivan), to which he added personal touches and the inscription "Retouched and Improvd by Wm Hogarth, republish'd June 12th 1761." The next was *The Sleeping Congregation,* "Retouched & Improved April 21 1762 by the Author," perhaps republished as a pendant to *Credulity, Superstition, and Fanaticism,* which had appeared only two weeks earlier. The revision of Plate 8 of the *Rake's Progress* is datable by the large coin of the realm for 1763 bearing a wild-haired Britannia and added to the wall of Bedlam, implying that England by this time had itself become a madhouse. Returning to the second plate of the *Election,* he extracted the teeth of the British lion. These were characteristic of the revisions made in 1763 and '64; in the latter year he removed the smile from the lips of his self-portrait (*Hogarth Painting the Comic Muse*), changed the comic muse to the satiric, and replaced the title "Serjeant Painter to His Majesty" with the starkly prophetic "William Hogarth 1764." Until the end he continued to work over the plates, assisted by several other engravers whom he took with him to Chiswick.

It is very difficult to distinguish between paranoia and convention in the autobiographical notes and the final revisions of the copper-

plates. There was the housemaid at Chiswick who said that after Churchill's verses Hogarth never smiled again. On the other hand, the erasure of the smile and the changing of the comic to the satiric muse may simply reflect a convention of Juvenalian satire: in dark times, a darker, more severe tone must be taken. Smollett, for example, after experiences at least as scarifying as Hogarth's, left England for the continent in June 1763, and in his *Travels through France and Italy* (published in 1766) transformed his experience into the railing of a Juvenalian satirist faced with the immorality of the world. Fielding had imposed a Juvenalian convention on his last novel *Amelia* (1751) and included a scene in his autobiographical *Journal of a Voyage to Lisbon,* written as he was dying, in which he describes himself carried onto the ship, helpless on a stretcher, being jeered at by the sailors and watermen who line the way. Evidently the eighteenth-century literary syndrome in England entailed growing pessimistic with age, feeling that one's personal decline implied the decline of one's environment, one's personal loss of empathy the breakdown of all communication and order.

It was not, of course, so simple: Fielding was expressing a real despair in the social life of London and England, from criminal low life up to the highest reaches of the social ladder. Pope, in his last works, no doubt felt real despair in a world governed by Walpoles and Cibbers. But in both cases the fact that the aging, ailing artist was very likely soon leaving it to these fools must have played a part.

Though Hogarth's interpretations and predictions were based on personal feelings, as a shrewd and experienced social commentator he was also speaking for some objective collapse that seemed to him imminent. Disenchantment with Pitt, followed by disenchantment with Bute and perhaps with George III as well, inspired feelings which were in some sense prophetic. Pitt's great empire was to dissolve in little more than a decade; in 1780 the Gordon Riots, a materialization of *Credulity* and *The Times, Plate 1,* would take place; Jane Hogarth would live to see the beginning of the French Revolution; and within only a few years of Hogarth's death the inventions of Arkwright, Hargreaves, and Watt would generate a great industrial upheaval, and national life would never again be the same. A premonition of impending change shadows those last writings, the revisions of the engravings, and the final print.

Before turning to *The Tailpiece,* another strain in the notes Ho-

garth was compiling, also reflected in that print, should be traced. Following a typical pattern of thought, he moves from autobiographical facts to a generalization about his art, then digresses into one of his crotchets, leaving his subject far behind. In one attempt at an opening he starts with his birth, youth, apprenticeship, and the painting of conversation pictures; suddenly portraiture reminds him of drapery painters, and he runs on about this subject. At length he winds down and resumes the story of his life.

After stating the "three things that hav brought abuse upon me," he sets off on some thoughts on a new subject—perhaps a new pamphlet—entitled "Painting & Sculpture considered in a new manner differing from every author that has as yet wrote upon the subjects." Here, intertwined with this new idea for a treatise and accounts of his prints, he sketches his final conclusions about comic as opposed to sublime history, confirming his emblematic representation of himself in *Hogarth Painting the Comic Muse* (not long before he changed it to the satiric muse). He starts conventionally with a discussion of the lowest genres—still life and portraiture, merely another kind of still life in the hands of most artists. Then he works up to the pinnacle of history painting. "Subjects of most consequence," he writes, "are those that most entertain and Improve the mind and are of public utility," proceeding in a nearly incoherent sentence to a favorable comparison of comic and sublime history: "comedy in painting stands first as it is most capable of all these perfection[s] the latter has been disputed with the *sublime* as it is calld." These sentences suggest a truth about his whole career: that even when painting the sublime he knew that his full energies were engaged only by the comic.

By bringing together other fragments, one may infer his ultimate definition of the comic. The subjects that serve to suggest this definition are nature, his method of visual mnemonics (vs. copying), the stage, and comedy. He disposes of "nature" succinctly: "I grew so profane as to admire Nature beyond Pictures and I confess sometimes objected to the devinity of even Raphael Urbin Corregio and Michael Angelo for which I have been severly treated." Life, the stage, and his pleasures are somehow clustered together—he does not quite make the connection himself, but the contiguity of these subjects establishes it. The stage was perhaps his greatest pleasure; life was structured like the stage, whose proscenium arch replaced the frame of those "Pictures" he preferred to ignore for "Nature." Explaining his visual mne-

monics, which he seems especially eager to clarify, he writes: "thus stroling about my studies and my Pleasures going hand in hand the most striking things that presented themselves made the strongest impressions, in my mind." Hogarth's concern with prejudices, whether relating to pictures or human actions, with his faith in the human eye (direct experience) as opposed to the ear (secondhand knowledge) and his sense of the immediacy of a stage presentation as opposed to a painting, together suggest that his particular meaning of "life" or "nature" is real people: whom the artist can immediately experience, cast in certain roles and block in on a stage, with light and shadows placed for effect, and a script that develops their moral significance. As in the *Analysis,* the actor like the dancer can bring out beauty and significance that are lost in an ordinary man's actions. The play would be a comedy. He implies that he will go on to speak of the comic (rather than the grotesque), which the stage analogy allows him to examine, and which art theory would tend to blur. This brings us back to the passage in which he argues that "true comedy" in painting ought to stand first as most certain to "entertain and Improve the mind" and be "of public utility."

In another manuscript note, apparently written at about the same time, he specifically contrasts comedy and tragedy, arguing that comedy "represents Nature truely in the most familiar manner tho not in the most common manner," by which he means "what might very likely have so happen'd," what might "have been so spoke and acted in common life." Tragedy, on the other hand, "is composed of incidents of a more Extraordinary nature[,] the Language more Elevated and the manner both of acting and speaking more heightend than in common life." He thus links caricature with the exaggeration of tragedy: "Tragedy is still true nature but outréd to a certain degree so as to fill the idea." Real figures supplied with tragic accouterments become, as in so many of his prints, bathetic; the whole world regarded tragically when it is of course only comic becomes the subject of the last print, whose subtitle is *The Bathos.*

A surviving anecdote has it that the first thought for *The Tailpiece, or The Bathos* (pl. 130) came "in company, while the convivial glass was circulating around his own table." The portrayal of "the end of all things" was carried out through a profusion of objects that have come to an "end": some are paralleled, the great with the small, a cracked bell and a broken bottle, the sun going down and a candle

guttering out, the world on a tavern sign and the world in *The Times* print being consumed by fire. A gallows, an unstrung bow, and a broken crown indicate the "end" of a robber, a poet, and a king. These examples become increasingly verbal, as Hogarth puns on a scale unprecedented even in his work; Time himself, dying with his scythe and hourglass broken and his pipe snapped, comes to his end uttering "FINIS." Near him is "The Worlds End" tavern, and around him lie the last pages of a play ("Exeunt Omnes"), a rope's end and a candle end, the butt end of a musket, the worn stump of a broom, and a shoemaker's "waxed end" twisted around his wooden "last."

According to the anecdote about the print's composition, when he had done this much he cried, "So far, so good . . . nothing remains but this"—and taking up his pencil "in a sort of prophetic fury," he added the painter's broken palette. "Finis," he is supposed to have exclaimed, "the deed is done—all is over." The print, though made six months before his death, and four before he wrote his will (or at least his final surviving one), may have been started with such a gesture: he was always given to dramatic gestures, but from the day he took down the Golden Head in disgust at the reaction to his *Marriage à la Mode* auction, he tended to make his gestures self-destructive. And the fact remains that he made no other print—indeed may have been constrained by *The Tailpiece* not to.

The Tailpiece was announced in the *St. James' Chronicle* for 14–17 April, and the advertisement sums up its creator's mixed intentions:

> *This Day was published, Price 2s. 6d.*
> Designed and engraved by Mr. HOGARTH,
> A Print called FINIS, representing the Bathos, or Manner of sinking in sublime Painting. Inscribed to the Dealers in dark Pictures. It may serve as a Tail-Piece to all the Author's Engraved Works, when bound up together; at the Bottom of the Print is annexed, a remarkable Circumstance relative to his Analysis of Beauty. All which are to be had at the Golden-Head, in Leicester-Fields.

Since it is hard to imagine how other prints could have been added once this tailpiece was "bound up" at the end of the volume of Hogarth's prints, the readers of the advertisement must have regarded this as a swan song. For a variety of reasons, it made an appropriate tailpiece to the comic histories in the volume.

The Tailpiece was both an end and a continuation. For if the design shows the "end of all things," the inscription under it concerns the "conic Form" under which Venus was worshiped at Paphos, and other matters which "did not occur to the author till two or three years after the publication of the 'Analysis' in 1754." Sometime in the interim he had this symbol of the cone painted on his coach by Charles Catton, the coach painter, who also did the elaborate decoration of Reynolds' coach.

The two cones are introduced, however, as Hogarth's contrast of the "Beautiful" with the Burkean "Sublime." The Line of Grace, coiled around a cone, "by its waving and winding at the same time in different ways, leads the eye in a pleasing manner along the continuity of its variety." Burke's "Sublime," by contrast, is made up of discontinuities, of broken and jagged lines, of decaying and purposefully shattered objects. In *Time Smoking a Picture* Hogarth had shown how only damaged paintings could conform to the fashion. *The Tailpiece*, the inscription tells us, is dedicated to the dealers in "dark pictures," for here Time's darkening means also that the scene is darkening, the sun and moon are failing.

Hogarth's last print is therefore at once an attack on false sublimity and an affirmation of his ideal of beauty. As the subtitle "the Art of Sinking in Painting" indicates, he is thinking in terms of Pope's *Peri Bathous* and the Augustans who were his first inspiration. But while Pope presented a false sublime practiced by his contemporaries, against which he implicitly posed the true (*Peri Hupsous*), Hogarth opposes a false (Burkean) sublime with Beauty, an affirmation of order and continuity; as with Pope, these qualities are in this context moral as well as aesthetic. The fact remains, of course, that disorder has overtaken the world and forced the Line of Beauty out of the picture, has literally broken and fragmented it, destroying the moralist's norm and the artist's palette just as it had Hogarth himself in *The Bruiser*. The print of *The Times* is torn and set afire, a metaphor of the times themselves. The sublime, with the dark masters, has penetrated into the real world of England in the 1760s. Nevertheless beauty is still affirmed as a possibility; from the inscriptions, a historical possibility.

As we look back on his career from this vantage point, it is clear that if integration of the visual and verbal impulses—in both art and personality—is to be taken as normative,·Hogarth must be seen as

reaching the height of his powers in the 1730s. His career began with separate verbal and visual impulses—the verbal from his father, the visual from an unknown source. His first works are emblems, almost purely visual equivalents of the verbal. The story of his career up to the *Harlot's Progress* is one of a gradual integration of the visual and verbal impulses in his character, culminating in a single work. The *Harlot* also represented an integration in another sense: the enriching complexities discoverable by the most sophisticated reader were congruent with a central meaning clear to the lowest intellect. Already in the late 1730s, however, signs of separation were evident between the engraved product and the modello in oil paint; the one a moral, largely verbal object, the other a visual and sensuous painting, In *Marriage à la Mode*, where the colors no longer corresponded to Hogarth's moral concerns, there appeared to be a patent schizophrenia between moral and aesthetic experiences.

The emphasis on art in *Marriage à la Mode*, followed by a flight into pure painting in *The Happy Marriage*, was in a sense a bid for an aesthetically inclined, aristocratic audience; dissatisfied with the results, Hogarth continued his dialectical progression by turning from art as subject, painting as aesthetic experience, and the hope of great patrons, to the simple, popular print. As these prints show, Hogarth's career also embodied a conflict between aesthetic and mercantile values, patrons high and low, the "great" whom he regarded so ambivalently, reflecting his feelings in his progresses, and the *demos*, the great mass of buyers; by the end of his career, he viewed even this group with suspicion. When he reached for the highest level he could not integrate form and content, but when he returned to the lower audience he achieved a very great degree of integration in terms of art and morality, producing readable objects without paintings as modelli, aimed at a very unsophisticated public. The reading structure of these prints, however, still drew on his educated as much as his unschooled audience. Always there remained what Addison had called the "Men of greater Penetration" and the "hidden Meaning" addressed to them, as well as the "ordinary Reader" and the "plain literal Sense" (*Spectator* No. 315). With the popular prints the deeper, more cryptic meaning tended to become increasingly surreptitious, personal, even (if pursued very far) subversive of the first. In the *Analysis* plates this level was conveyed with so much subtlety that it may have remained

semiprivate, and—as the "hidden Meaning" became more personal—in
Enthusiasm Delineated and finally *The Times, Plate 2*, the "love of
pursuit" provoked ambiguity, even obscurity.

At the same time Hogarth continued to paint portrait heads and
work on various unfinished projects that were essentially exercises in
pure painting. When he stopped making the popular prints he began
to write and to create prints based on his writing and aesthetics, and
only (as in the *Analysis* plates) incidentally on morals. Hogarth might
have regarded his career up to this point, in terms of his personality as
well as his art, as a kind of lively *concordia discors,* which reached its
highest point of expression in *The Analysis of Beauty*. But already the
both–and logic was being replaced by a strict either–or. Beginning
with the sale of the *Marriage à la Mode* paintings in 1751, he suffered
a series of disillusionments, and it was at this point that he began to
exalt the one virtuous man in a world of "politicians"—a Prince
George, a Duke of Cumberland, an Earl of Charlemont, and an Earl
of Bute (as in art, the Line of Beauty). The one was right, the many
were wrong. Inevitably he began to see himself in this light, and the
autobiographical notes are his final testimony to his lone unappreci-
ated patriotism and integrity. In the last decade, once the *Election*
was painted, he was silent except for simple exercises in painting and
writing, the latter predominating. All the tendencies toward disinte-
gration intensified, and after 1754 or '55 a real decline set in. The few
prints that followed, though still technically and intellectually inter-
esting, are revisions of, addenda to, or explanations of earlier plates.
In general, they revert to the emblematic mode, as attempts (like the
"autobiographical notes") to make himself understood.

In fact, in the last fifteen or so years of his life, the ontological status
he bestowed on his works began to change: they became less represen-
tations of the world than actual objects in that world. This objectifica-
tion can be traced back to Hogarth's public gestures: disillusioned
with his patrons after the sale of *Marriage à la Mode,* he took down
the Golden Head from above his street door; at about the same time
he replaced the satiric faun in *Boys Peeping at Nature* with a panel
designed by the chaste putto who restrains the faun in the earlier ver-
sion. The advertisement announcing that he was going to cease depict-
ing moral subjects, and perhaps also the heavy scoring-out of his name
in the Society of Arts' book, find their final expression in his gesture
of making a *Tailpiece,* after which he is silent. The print of *The*

Times appears within the represented world of *The Tailpiece,* and *The Tailpiece* itself is both a representation of the end of all things and a concrete emblem of the end of Hogarth's art. The act of executing it was as significant as its content.

Hogarth, who began by playing with the attributes of gods, giving them to contemporary humans, or taking them away, reduces himself in his later years to a few symbolic attributes and then goes through a series of self-destructions. First he removes the Golden Head. Then, disillusioned by the apparent popularity of the Wilkes–Churchill anti-Hogarth propaganda, he destroys his self-portrait of 1745, replacing it with a bearish Churchill, and erases the Line of Beauty from his palette. In *The Tailpiece* his palette as well as his Line of Beauty has been destroyed. The prints themselves were his final personal attribute. I suspect that the phenomenon can be traced back to the collecting of his prints in bound volumes, when people like Townley began to speak of them as "one of the classics," and he and his audience thus came to regard his oeuvre as permanent and authoritative. To such a work an engraved portrait of the artist was as necessary as the apologia that begins Juvenal's *Satires.* By the mid-1750s, however, Hogarth felt that the self-portrait should be kept up to date: the Hogarth of 1745 was not the Hogarth of 1758 (it was the former he allowed Churchill to destroy), just as the England of 1735 in the last plate of the *Rake's Progress* was not the same as the mad England of 1763. Soon he began to make prints that reflect on earlier ones—*Wilkes* requires *Lovat* of fifteen years earlier as a companion piece; *Credulity* relates to *The Sleeping Congregation* of twenty-four years earlier; and the fountain in *The Times, Plate 2,* refers back to the fountain in the *Frontispiece to the Catalogue.*

Hogarth evidently considered that he was related to his engraved works in an important way, and believed they should record his sense of himself and the world (which toward the end seemed to merge with each other) at a given moment in his career. It is unclear, however, whether he wished the final versions he produced in the 1760s to supplement or replace the earlier. The ordinary purchaser of the future would, of course, see only Hogarth's last word. But from the revisions' heavy reliance on the reader's knowledge of the original one can infer that he did not want to give up entirely the happiness or victory of past moments in a few years of bitter old age.

The desire to tidy up and to be understood also occasioned further

attempts to get *Sigismunda* published and placed before the general public. On 2 January 1764, with his writing much shakier than before, Hogarth again opened the subscription book: "All efforts to this time to get this Picture finely Engraved proving in vain, Mʳ Hogarth humbly hopes his best indeavors to Engrave it himself will be acceptable to his friends." Sometime before June he abandoned the idea of engraving more than the head himself. He turned to the young Edward Edwards, employing him to make a drawing of the painting from which an engraver could work. On 12 June Hogarth copied out his account of how he had come to paint *Sigismunda,* apparently for some friend. The words are almost exactly the same as those in the subscription book for *Sigismunda,* but the tone of the conclusion above his signature calls to mind the ambivalent finale to his autobiographical notes, or *The Tailpiece:* "[*Sigismunda*] was after much time and the utmost efforts finished, BUT HOW! the Authors death as usual can only positively determine. / Wᵐ Hogarth."

Hogarth had saved all the letters connected with both the Grosvenor and Charlemont commissions, as contrasting examples of patronage, and he now pasted these into his subscription book following the subscription list, together with drafts of his own letters to Grosvenor and a running commentary. The last subscription for *Sigismunda* had been followed by the artists' exhibition, the painting's showing and withdrawal, and (according to Nichols) an attempted raffle in 1762 using as ticket *Hymen and Cupid,* engraved many years before for *The Masque of Alfred.* The painting's various misfortunes had been played up by Wilkes and others, and, as Hogarth put it in his subscription book, "things having been represented, in favour of his Lordᴾ [i.e. Grosvenor] much to Mʳ Hˢ dishonour, the foregoing plain tale is therefore submitted to Such as may at any time think it worth while to see the whole truth, of what has been so publicly talked of."

The engraving did not materialize and the painting remained unsold, the price set at £400. And so it remained during Jane Hogarth's lifetime, finding a buyer at last at her sale in 1790. It went, appropriately, to Alderman Boydell, whose Shakespeare Gallery was built around such works as Hogarth's *Garrick as Richard III* and perpetuated the sort of painting Hogarth produced in *Sigismunda.* Boydell paid £58 16*s.*

The last spring and summer are not further documented except for

The Tailpiece, the final *Sigismunda* project, and the revision of old plates. No great events were unfolding around him: the political excitement had died down with the peace and Bute's resignation in 1763, and the flight of Wilkes to France at the very end of the year. Blackfriars Bridge was under construction, and in May the artists again exhibited at Spring Gardens. Reynolds contributed, his full-length portraits now selling for 150 guineas, his half-lengths for 70; he had been unaffected by the political struggles of the last years.

In June Benjamin Franklin wrote Hogarth ordering a set of his complete works for the Philadelphia Library Company. The letter was transmitted through the publisher William Strahan, who reported that it was delivered to Hogarth, "but he was soon after taken ill, and still continues so dangerously bad, that he could not yet comply with the Order." Strahan's letter was written on 19 September.

On 16 August Hogarth wrote his will. The copperplates were his main bequest. He stipulated that they were not to be "Sold or Disposed of without the consent of my Said Sister and my Executrix," Jane Hogarth; that they remain in the possession of Jane for her natural life "if she continues Sole and Unmarried and from and immediately after her Marriage my Will is that the three Sets of Copper Plates, called Marriage Alamode, the Harlots Progress and the Rakes Progress,"—evidently his best-selling prints—"shall be Delivered to my said Sister." If Jane died, they were all to go to Anne. Beyond this, unspecified moneys and securities were bequeathed to Jane, and of course the properties in Leicester Fields and Chiswick.

By September Hogarth was apparently too sick to handle the Serjeant Painter's routine business, and Samuel Cobb, his deputy, begins to appear in the records. In September and October he was in Chiswick, working with assistants on the revision of his copperplates. On Friday 25 October he was conveyed "in a weak condition, yet remarkably cheerful," from Chiswick to the house in Leicester Fields. Mrs. Hogarth evidently remained in Chiswick; thus it would appear that he was not considered to be in immediate danger. A letter from Benjamin Franklin was awaiting him—perhaps inquiring about his health, unless it was the first letter, which had never been answered. He died sometime in the night between 25 and 26 October, just a few days short of his sixty-seventh birthday.

His body was returned to Chiswick, a cast was taken of his right hand, and one week later, on Friday, 2 November, he was buried in

St. Nicolas' churchyard. The plot already contained the body of Lady Thornhill, and not far away was the grave of his friend James Ralph. Inside the church, in the Burlington vault, lay his old antagonists Lord Burlington and William Kent. In 1771 his sister Anne was buried next to him and a monument was erected with an epitaph by David Garrick. In 1789, after twenty-five years of selling his prints and furthering his reputation, Jane Hogarth joined him, and in 1808 Mary Lewis.

The plate he was working on when he died was *The Bench;* still concerned that his stand on character–caricature be understood, he erased a strip across the top of the plate and began to introduce faces in varying degrees of caricature, rather like those beneath *Characters and Caricaturas.* Only the sharp-nosed judge is repeated; the other heads are once again those from *The Sacrifice at Lystra* and other Raphael Cartoons—perhaps from Thornhill's old sketches of the heads. It is fitting that Hogarth, like Thornhill, should end his career with these Raphael heads. His career had been devoted to finding ways to use Raphael and to equal him in eighteenth-century England. On the unfinished plate as it stands one of his assistants has added, "This Plate would have been better explain'd had the Author lived a Week longer."

Sources

Frederick Antal. *Hogarth and His Place in European Art*. London, 1962.

R. B. Beckett. *Hogarth*. London, 1949.

Biographical Anecdotes of William Hogarth. John Nichols, George Steevens, Isaac Reed, and others. London, 1781, 1782, 1785.

British Museum Catalogue of . . . Political and Personal Satires. London, 1873–83.

Austin Dobson. *William Hogarth*. London, 1907 ed.

Edward Edwards. *Anecdotes of Painters who have resided or been born in England . . . Intended as a Continuation to the Anecdotes of Painting of the Late Horace Earl of Orford*. London, 1868.

Joseph Farington, R.A. *Diary*, ed. James Grieg. 8 vols. London, 1922–28.

The Letters of David Garrick, ed. D. M. Little and G. M. Kahrl. 3 vols. Cambridge, Mass., 1963.

M. Dorothy George. *London Life in the Eighteenth Century*. London, 1925; 1965 ed.

John Ireland. *Hogarth Illustrated*. 3 vols. London, 1791–98; 1806 ed.

Samuel Ireland. *Graphic Illustrations of Hogarth*. 2 vols. London, 1794–99.

London County Council Survey of London, ed. J. R. Howard Roberts and Walter H. Godfrey. London, 1900–.

Charles Mitchell, ed. *Hogarth's Peregrination*. Oxford, 1952.

Robert E. Moore. *Hogarth's Literary Relationships*. Minneapolis, 1948.

J. B. Nichols. *Anecdotes of William Hogarth*. London, 1833.

John Nichols. *Literary Anecdotes of the Eighteenth Century*. 9 vols. London, 1812–15.

John Nichols and George Steevens. *The Genuine Works of William Hogarth*. 3 vols. London, 1808–17.

A. P. Oppé. *The Drawings of William Hogarth*. London, 1948.

Ronald Paulson. *Hogarth's Graphic Works: First Complete Edition*. 2 vols. New Haven, 1965; revised ed., 1970.

John Pye. *Patronage of British Art*. London, 1845.

The Works of Jonathan Richardson, containing I. The Theory of Painting, II. Essay on the Art of Criticism, III. The Science of a Connoisseur. Strawberry Hill, 1792.

Jean André Rouquet. *Lettres de Monsieur** à un de ses Amis à Paris.* London, 1746.

Jean André Rouquet. *State of the Arts in England.* London, 1755.

J. T. Smith. *Nollekens and His Times* (1828), ed. Wilfred Whitten. 2 vols. London, 1917.

George Vertue. *Notebooks.* 6 vols. Oxford: Walpole Society, 1934–55.

Horace Walpole. *Anecdotes of Painting in England,* IV (1771, released 1780), ed. James Dallaway. London, 1828.

Horace Walpole. The Yale Edition of Horace Walpole's Correspondence, ed. W. S. Lewis. 34 vols. New Haven, 1937–.

Ellis Waterhouse. *Painting in England, 1530 to 1790.* London, 1953.

Ellis Waterhouse. *Three Decades of British Art, 1740–1770.* Philadelphia, 1965.

Henry B. Wheatley. *Hogarth's London.* London, 1909.

Margaret Whinney and Oliver Millar. *English Art 1625–1714.* Oxford, 1957.

W. T. Whitley. *Artists and Their Friends in England, 1700–1799.* 2 vols. London, 1928.

Index

Page numbers in italics refer to plates

DATE DUE

APR 19 2012		

GAYLORD #3522PI Printed in USA